Stephen King on the Small Screen

Stephen King on the Small Screen

Stephen King on the Small Screen

Mark Browning

intellect Bristol, UK / Chicago, USA

First published in the UK in 2011 by
Intellect, The Mill, Parnall Road, Fishponds, Bristol, BS16 3JG, UK

First published in the USA in 2011 by
Intellect, The University of Chicago Press, 1427 E. 60th Street,
Chicago, IL 60637, USA

A catalogue record for this book is available from the
British Library.

Cover designer: Holly Rose
Copy-editor: Emma Rhys
Typesetting: Mac Style, Beverley, E. Yorkshire

ISBN 978-1-84150-412-4

Printed and bound by Gutenberg Press, Malta.

Contents

Introduction

What I know of other places I have gotten mostly from three sources: the television, the radio and my imagination.

(Scott Landon in *Lisey's Story*)[1]

Goals of the book

This book arose naturally out of *Stephen King on the Big Screen* (Browning 2009), which dealt with those filmic adaptations from King's works that have been given a theatrical release. This however left a substantial number of television versions and it seemed logical to consider them too – hence this book. The first book was underpinned theoretically by notions of genre theory and structured accordingly and this book will follow a similar pattern but with a key distinction. Consideration of auteur and adaptation theory are set out in the first book and unnecessary to repeat here but what became obvious quite soon in researching this book is the relative lack of theoretical consideration about what precisely makes television different from film. There are plenty of individual chapters in books covering media history, which set out the development of television, its rivalry with cinema and its technical nature. Similarly, there are an overwhelming number of studies, more recently especially, setting out studies on particular TV genres, issues of representation and the splintering of the market into subgenres such as cult TV, or so-called 'reality TV'. Reception Studies, particularly around issues of violence, is also a standard part of most Television Studies courses. What is largely neglected is analysis of the precise nature of the difference between television and film – how would it feel for example to be sitting in a cinema and for an episode of *Lost* (ABC, 2004–present) to appear on screen? What is the difference between a film made for cinematic release and a made-for-television product? The questions may sound simple but in the case of television derived from Stephen King literary works, we have a unique example in the history of modern adaptation, of a large body of work that has been converted to both big and small screen.

Ironically, in *Hollywood's Stephen King* (Magistrale 2003), Tony Magistrale shows little sign that he is aware of the academic disciplines of Film Studies and more particularly Television

Studies. His coverage of King's work on TV is limited to a catch-all chapter at the end of the book. This is especially unsatisfactory as he has organized his comments thematically up to this point, explicitly 'ghettoizing' the TV mini-series as unworthy of equal time and critical space.

He usefully explains the process of 'the sweeps season' and the ratings mechanisms but he only sees features such as commercial breaks as a negative concept rather than considering precisely what effect they have on the programmes themselves. Earlier studies, such as Jeff Conner's *Stephen King Goes to Hollywood* (1987), Michael Collings' *The Films of Stephen King* (Collings 1986), Ann Lloyd's *The Films of Stephen King* (1993) and even Stephen Jones' more recent *Stephen Jones' Creepshows: The Illustrated Stephen King Movie Guide* (2002), also all relegate TV work to final, fairly brief chapters and analytical content is overwhelmed by generalizations (such as the intrusive nature of commercials). Furthermore, even if their initial exhibition context featured advertising, for audiences outside the United States, these texts may not be experienced primarily as TV but on video or DVD (i.e. without commercials). Given the global nature of the TV market, generic factors, especially relating to mainstream horror, are ultimately more influential upon content and style than narrowly American institutional factors.

This book will discuss adaptations either purposely made for television or which went straight to video or had such a limited global release that they were virtually unseen (i.e. that their prime viewing context is on the small, rather than the big screen). It will seek to answer a number of questions. Is there something particular about King's work that makes it suitable to television? Does analysis of King's TV adaptations tell us something about the distinctive features of televisual narratives? Are there certain kinds of narratives which television can convey more effectively than film? How might we categorize the *Children of the Corn* series (1984–2009) and indeed, why would we want to? This book is concerned with what makes programmes like *The Stand* (Mick Garris, 1994) effective when viewed on DVD today on a small screen. Why does Pennywise still continue to unsettle viewers of *It* (Tommy Lee Wallace, 1990)?

For the purposes of manageability and partly quality control, the so-called 'dollar babies', those films produced by film students for a nominal dollar fee, are not discussed in this book, although interested parties should seek out the growing number that are appearing on YouTube and other video-sharing portals. The reduction of size and cost of light-weight cameras and digital technology means that amateur films can be produced relatively cheaply and via the Internet reach an increasing audience, especially via mobile phone screens.

The first book discussed the notion of cultural status linked to particular genres, particularly horror. It raised the issue of how you might approach a so-called 'horror' narrative that is not (nor even trying to be) horrifying. In this book, many of the adaptations represent a coming together of certain generic elements, such as horror and science fiction (a particularly-contested term), television for mass audiences and Stephen King. For some viewers and critics this constitutes a 'perfect storm' of low status indicators. Add further elements in the horror sub-genres, such as 'stalk and slash', and it is possible to partly see why there has been a scarcity of critical work on these works.

The importance of genre

Stephen King on the Big Screen viewed King's cinematic adaptations using genre theory and intertextuality as its primary theoretical approaches. This book continues this but develops the argument to focus on televisual genres, a relatively under-theorized area of Film Studies. Genre is inherently intertextual. Audiences are being asked to place a narrative within other known narratives – it is often the means by which we make sense of the experience of watching a film. Difficulty in doing so often leads to a range of emotions, very occasionally surprised pleasure but more often disappointment, confusion and possibly even anger. This book is looking at a very specific sub-genre, televisual adaptations derived from the work of Stephen King, but its considerations have wider ramifications for the operation of genre and the use of literary properties on television, such as whether generic hybrids foreground their generic credentials more strongly than 'purer' examples, for their blending to work effectively.

Genres are a key mechanism by which expectations are managed. In different contexts, the 'managers' of these expectations might be networks, producers, writers or even ourselves as viewers. It is often said that programmes 'find their audiences' as if they have some kind of sentient power, but what kinds of expectations are raised, their intensity, and how far they are met, play a crucial role in how a given piece of television is scheduled, how it is received or indeed whether it is made at all. Arguably, generic categorizing in television is even more important than cinema. Both media need to find their audience and for the audience to find them, but in the case of cinema, that battle is won by the time viewing commences (even if individuals walk out, tickets have been sold). The commencement of viewing guarantees little in the context of television, where there is instantly, via the remote control, access to an array of other viewing choices and the home environment, with increasing numbers of multi-media platforms, as well as social interaction (such as with family, friends, and even pets) means that the television must fight with an array of potential competition for the attention of the viewer.[2] As Robert Allen notes, TV 'transforms the space it occupies.'[3]

As a result, generic signs must be flagged up even more prominently, so that in the case of the programmes discussed here, the term 'a Stephen King adaptation' becomes a generic label in itself – with potential overtones of science fiction and horror but often only tangentially delivering those elements. The steamroller of the King brand is such that it is a means of delivering a large audience drawn from his readers and fans of previous movies and TV adaptations and, in America at least, an apparent commitment to 'quality' drama. In Great Britain, such implicit status (designated by early evening or prime-time scheduling) is rarely given to King adaptations, which routinely occupy later night slots (except the more mainstream coming-of-age narratives, like *Stand By Me* (Rob Reiner, 1986) and *Hearts in Atlantis* (Scott Hicks, 2001), both discussed in the first book. Here there is a synergy of marketing interests with historical televisual development, in British public service broadcasting at least, in which 'the TV series' might be seen as the twentieth century's equivalent of the nineteenth century novel, hence the BBC's production of costume

drama adapted from so-called 'classic' literature. This could also be seen to have a further consequence in possibly producing a greater drive for narrative closure in the case of a mini-series where a viewer has invested more time than in a feature film. Like the standard epilogue in a nineteenth century novel, where readers are told what happens to fictional characters in the 'future', so it takes a great effort of will and commercial muscle to kill off a main character or leave narrative strands open in a TV (mini) series.

More broadly, the rise of the tendency towards remakes and sequelization in mainstream film production, both feeds and reflects the influence of television, particularly post-1980, in a drive towards characters and situations which are already familiar to audiences. There is an inherent conservatism in such a process, where generic risk is minimized at all costs to avoid alienating an audience, who, in a televisual context, can instantly punish the programme producer by zapping to another channel. The tendency is also a commercial one; via global syndication and the possible purchase of first video and then DVD box-sets, there is a far greater range of revenue streams for the serial over the discrete experience.

Much academic work on genre, whether collections of essays on TV, or rarer, single-authored studies, groups together genres which are so disparate that they actually have very little in common. Notions of genre have traditionally been applied more enthusiastically to some areas that others, such as news programmes, cop shows and sitcoms. This is often also linked to undergraduate studies that focus on representational qualities of race, gender and sexuality as a means of interesting students by drawing on their own viewing and linked to popular reality television and long-running serials, such as *The Sopranos* (David Chase, HBO, 1999–2007).

Specific theory on television genre is rare. As one of only a handful of academics working in this area, Jason Mittel (2004) places genre firmly within a wider process of Cultural Studies rather than focused purely within components of a given text. Mittel refutes ahistorical analysis with some persuasive examples, where the cultural role of genre is a key part of how audiences consumed a particular programme, such as cartoons, talk shows, or quiz show scandals in the 1950s. Mittel states that 'the text alone cannot determine its cultural meanings', with which this author would agree.[4] However, *neither can its cultural meanings be determined without it*. Television is clearly a social medium, found in most homes, often in many rooms within one domicile and programmes are frequently watched or at least experienced within a domestic environment. This has implications for reception studies and behavioural science but also *for the text itself*. Meaning is not generated solely outside it. This book does not deny the importance of industrial or reception factors but the lacuna here remains the text itself, which is often talked around as if its meaning were transparent. The importance of contexts of production quickly fade and contexts of reception vary and are extremely difficult to analyze. What remains is the primacy of the text as a repository of meanings, which are not given but contested, primarily in relation to other texts, both print and filmic, the significance of which, in the cases discussed in this book, has been largely ignored.

With the apparent redundancy in simply generating lists of generic features, media theory has largely dismissed the text as an appropriate analytical focus, and moved on,

assuming that the bones have been picked clean from the corpse of textual study. The ways in which generic terms are derived and used surrounding a text, are important but this circling around a text should not prevent direct engagement with it. This is not to indulge in a futile pursuit of labels or producing lists of expected features. This book is seeking to understand how genres operate in the context of fictional drama. It is not a search for a pre-existing, mythical model of generic perfection but analyzes the programmes as they operate firmly within generic boundaries, where they stretch them a little or where they break out entirely.

The importance of genre lies not in finding and agreeing on the purest example of each form (something which, while entertaining, can quickly become something of an irrelevant parlour game as undisputed examples are extremely rare). However, neither the tendency to blend genres nor the explosion of television programming available, deny the importance of genre as a concept. In fact, the opposite is true. With so many programmes vying for our attention, rapid audience identification of and with material is ever more important. When Jeffrey Sconce (2004) asserts that, 'If a series is to succeed [...] it must feature an appealingly familiar and yet ultimately repetitive foundation of premise and character relations'.[5] He is also articulating the fundamentals of genre theory, of the tension between familiarity and novelty.

Some generic categories privilege a location (western), some audience-response (comedy), others focus on typical characters (gangster movies). This book focuses on films drawn from a common literary source – the writings of Stephen King. However, it also considers whether this produces or draws upon common generic features, which make televisual adaptation more likely, and how these adaptations contribute to various subgenres themselves. For the examples in this book, notions of duration will be relevant. Some texts have been adapted as 'made-for-TV movies', whilst others are two – or three-part mini-series. There is some fluidity in how such terms are used but generally a 'made-for-TV movie', as the phrase suggests, is a movie made for exhibition primarily on TV (followed on fairly rare occasions by a cinema release), whereas a mini-series has a completed narrative but spreads this over more than one day, usually consecutive days, although there can be a hiatus between episodes of up to a week. The serial drama is something that contemporary cinema cannot accommodate (having left it behind with Saturday morning adventure serials for children in the 1940s and 50s) and due to scheduling pressure, the basic running time of most features runs to around 90–120 minutes.

Scheduling

The proverb 'If it looks like a duck, swims like a duck and quacks like a duck, then it probably is a duck', (sometimes attributed to Indiana poet James Whitcomb Riley), later picked up in Justice Stewart Potter's infamous description of pornography during the 1964 obscenity trial surrounding *The Lovers* (Louis Malle, 1958), has some relevance for genre.

The so-called 'duck test', the sense of having an instinctive sense of a category from what a thing does, rather than what it is, although historically used during the cold war to describe Communist tendencies, might also usefully express a widespread sense of generic transparency. Simplistically, one might say that if a programme appears on a channel that names itself after a particular genre, presumably to make its identity clear and attract viewers interested in that given kind of programming, then that must be the label best suited to describing that particular programme. The fact that the most recent version of *Children of The Corn* (2009) was partly-funded by and played on The Syfy Channel, suggests at least a nominal identification with this particular genre. However, that then raises the question of what that particular channel defines as 'science-fiction' (especially since it has also screened Martin Campbell's Bond film *Casino Royale* [2006]). In the United Kingdom, Zone Horror, a generically-identified TV station, seemed happy to run a season of Stephen King films in 2009. The development of channels with genre-specific names both foregrounds genre in viewing choices and also contributes to an entrenchment of categorization once made. There is also a status-related issue here too, dependent on the channel concerned, whether they are viewed as a niche market, offering a specialism of product for a discerning viewer or just 'ghettoization' underlining a programme's low cultural value.

In multi-part series, the ratings of the first night or a significant drop-off in subsequent ratings become key and a reportable item for news media in itself. Poor first-night viewing figures can doom a programme before it has even run its course. The interpretation of such figures and whether they are disappointing or not has become like post-mortem comments on election results. If genres operate to manage expectations, then public analysis and comment on viewing figures also contributes back into the categorization process, creating notions of quality and desirability via protean terms, such as 'critical success-commercial failure', 'big-budget flop' or 'must-see TV'. The concept of cultural value is made more complicated by scripts that do not have a literary precedent, such as King's original screenplays (*Golden Years*, *Rose Red* and *Storm of the Century*). In such cases, it is TV critics and popular ratings which may be the first to cast a judgement on the worthiness or otherwise of a particular adaptation.

Postmodern critics might suggest that genre plays a much-reduced role in the larger picture of interwoven influences on the generation of cultural meanings. However, in terms of viewer choice, it does still remain paramount. In a sense, what viewers make of what they see, is of less importance to programmers than simply 'hooking' viewers. Once they have attracted viewers to tune in at a given time, they can say that they have met their number one commercial imperative, which is to keep advertisers happy. Clearly, if they can hold onto viewers across several nights' viewing so much the better, but it is the initial bite at the generic worm, which is key. One key part of the process in finding an audience is generic identification, persuading viewers from a few clips and minimal information, that a forthcoming programme is one they would like.

Viewing choices, at home or in the increasingly-scarce video store, are guided by generic categories. In stores, adaptations of Stephen King are often placed within 'horror'. However,

as *Stephen King on the Big Screen* found, very few King-derived narratives actually deliver the thrills and pleasures that marketing material and generic categories promise. Some of these assumptions find their way into television too, with trailers routinely emphasizing (and some might say distorting the importance of) the frightening, uncanny and supernatural elements prior to transmission (and even during this period too as mini-series have several minutes of 'recapping' material between episodes). Trailers exaggerate to a degree (taking thirty seconds or a minute from a narrative of several hours is bound to 'misrepresent' the full version in some way) but in the case of King, there is a strange tendency to perpetuate a myth that these are horror narratives.

Film vs Television – a sustainable distinction?

The difference between film and television might seem obvious at first but distinctions between the two media are not always as clear-cut as might seem the case. It is nearly 40 years old now, since Raymond Williams developed his notion of 'flow'.[6] The idea of his sense of disorientation on first being exposed to American television in a Miami hotel room seems almost as alien as that of Thomas Jerome Newton (David Bowie) in *The Man Who Fell to Earth* (Nic Roeg, 1976). Today, with the increasing segmentation of the market, including specific content-based channels, such as The History Channel, it is entirely possible to view TV day and night that will only confirm an individual's tastes and views. The dislocation that Williams experienced may only be possible now in a foreign country with an unknown language, a little like the bemused incomprehension of Bob (Bill Murray) and Charlotte (Scarlett Johansson) in watching Japanese TV in *Lost in Translation* (Sophia Coppola, 2003). It is easy to dispute the concept of a passive viewer, being passed baton-like from programme to commercials and back to programme as part of a seamless whole. The growing potential to disrupt monolithic scheduling via remote control use, recording programmes, split screen devices, and the reduced on-screen status of credit sequences so that these are often shortened; run-through at great speed or sometimes even cut altogether, all seem to disrupt any idea of 'flow'. John Ellis suggests that since the 1980s, the semantic unit is 'the segment' of no longer than five minutes in length and certainly, in terms of current practice in US television, commercial breaks can be that frequent, or seem so at least.[7]

However, the signal markers of such a process, such as regular commercial breaks, featuring trailers for upcoming shows and especially increasingly-intrusive, on-screen captions and pop-ups during the programmes themselves – these are nevertheless ubiquitous parts of the viewing experience. Some channels, such as Bravo, split the screen horizontally to run closing credits, while beginning the next programme. At the same time, a sense of 'flow' has invaded programmes themselves so that the traditionally low-status feature of the cliffhanger has been elevated into a stylistic art form in *24* (Joel Surnow and Robert Cochran, Fox network, 2001–present), with its use of split- and sometimes quartered-screen. The notion of flow has spread across into traditional print media too so that we now have teaser extracts at the

ends of novels of an up-and-coming release. Cinema, with its trailers and commercials, has much in common with that same notion of 'flow', i.e. it is not necessarily a distinct feature of television. Nick Browne's notion of the 'super-text' (defined as the programme and all the programming material related to it, including commercials run during transmission, which are central rather than peripheral to the text) perhaps carries more weight than Williams' approach, which is dominated by a Anglocentric model of televisual history with only three national channels at the time and strong historical links to notions of gritty, working-class social realism and public service broadcasting – largely absent in the broader scope of American television history.[8]

In an updated postscript to his seminal *Visible Fictions* (1982), Ellis asserts that 'the sharp distinction which I drew in this book between cinema and television still holds', may have been true back in 1992 but is crumbling fast.[9] Ellis asserts that cinema and broadcast TV are 'not in direct competition with each other' but that is not strictly true.[10] It may be so that the oft-prophesized death of cinema has not come about as a result of increasing use of first video and then multi-media viewing platforms. However, it is not literally possible to be in two places at once and television is clearly seeking to keep people at home, while cinema seeks to lure them out. In terms of exhibition, budget, censorship issues, scheduling and dominant genres, the difference initially seems clear but it is possible to find exceptions to almost any generalization about the uses and propensities of the two media.

Imagine you have travelled to your nearest cinema, if you have still one, you pay your money, find a seat amongst other people, settle back, some kind of a curtain is pulled back, you sit through a series of adverts (perhaps local as well as national), you see logos and a certification certificate that suggests the film is starting, a hush falls over the audience and on the screen a film starts. However, not all of the above factors hold true. You may not have anything like a cinema near where you live, you may be unable to find a seat, you may be surrounded by people making so much noise you cannot hear the dialogue (or you yourself may be one of the noisemakers). Clearly, the viewing context of a film designed for cinematic release may be very different than a film designed for home viewing. However, this distinction is disappearing. The cinemas themselves, if they survive at all, have developed into larger entities, often multiplexes, and to compete, screens used in a domestic environment are getting bigger. Phrases like 'home cinema' are now widely used to denote the expansion of flat-screen, high definition picture quality expected as standard, and the cinematic success of big-budget 3D cinema, such as *Avatar* (James Cameron, 2009) and *Alice in Wonderland* (Tim Burton, 2010) has given a further boost to the technological development of 3D television.

Competition between the relatively small and big screen is nothing new. Technological innovations, whether they be wide-screen, 3D, or Surround-sound have all been trumpeted as part of the cinematic experience only to be stolen or at least mimicked in home viewing systems. At the time of writing, the practice of visiting cinemas to see films has not died out completely but the types of films drawing audiences away from their televisions at home, perhaps has. Cinemas have to offer something more, something bigger. A bigger screen,

with better quality sound and image, is part of this but so is the social aspect – viewing a film in a cinema is a social act. Even if you go to a cinema alone (quite a brave action in some social contexts), you share the viewing experience with others and their emotional, verbal, and physical responses, may in some measure trigger or reflect your own. What might be a cause of irritation at times can also be a key part of communal viewing, especially for cult films where rituals of shared dress, props and actions (such as calling out key parts of the dialogue) have evolved to be part of the pleasure of viewing that particular film.

Unlike book purchases, there is (as yet) no relation between the budget of a film, i.e. the costs of its production, and the cost expected of the customer. There is however a related expectation linked to the location of where you view a film. Having paid money to a so-called gatekeeper (in some cases fairly high amounts) your expectations may be higher than that of flicking on the TV at home. Such a financial outlay, may well lead you to expect the entertainment on screen to reflect the nature of that transaction. Spectacular special effects, big-name stars, an engrossing and satisfying narrative – these factors may be more readily expected when the customer has paid more for the viewing experience. Audiences may demand more obvious production values, i.e. where the money, in a sense *their* money, has gone. Large budgets are usually associated with the scale of production so large sets, casts, and the wholesale destruction of property in explosive action, all signal budgetary excess. Certain genres, such as action and sci-fi films traditionally involve elements that audiences may associate with large budgets, whereas others, such as comedies, may not. At the same time, the use of the label 'low-budget' is also used for marketing purposes, partly to limit audience expectations but also to imply an association with more crafted, character-based films, particularly if a director, who can be described as an 'auteur' is attached to the project.

Graphic sex or violent content, both extremely subjective terms, may indicate a cinema as a viewing context. This book is not a study of censorship but it is worth noting that obviously cinemas operate with a gatekeeper, someone who takes your money at the door and can prevent your entrance if in their eyes you do not meet the age restrictions of the film's certificate. Exactly how effective this is depends on the security of individual premises but certainly it is much more stringent than home viewing, where the only gatekeepers are family members who may countenance (or be unaware) of the same material being viewed by 'underage' viewers. The phenomenon of video and DVDs, which can be obtained by one individual and then viewed by another, the widespread ownership of TV sets in children's own rooms, home recording subverting watershed programming, and parental locking devices, which can be hacked, all renders the notion of a gatekeeper within the home, largely 'by-passable'. Due to institutional restrictions over televisual representations of graphic or disturbing material (manifested in Standards and Practices committees), producers for such exhibition environments may well also self-censor their films to avoid potential problems.

The timing of a viewing may tell you that you are watching a film in a cinema rather than at home, since traditionally films are released first in cinemas, then for hire, then for purchase, and lastly released on TV. However, this sequence has come under increasing

strain in recent years with some questioning its logic, which is overtly based on maximizing revenue streams. Like bands, such as Radiohead, experimenting with releasing individual tracks or even whole albums to download free on the Internet, there have been a few examples of directors challenging distribution practice, with simultaneous releases on DVD and in cinemas (such as *Bubble* [Steven Soderbergh] or *The Road to Guantanamo* [Michael Winterbottom], both from 2006). Television, by usually being available 24 hours a day, is inherently less 'special'. Indeed, Ellis describes the overall development of television as moving through three phases – from 'scarcity' to 'availability' to where we are now, 'plenty'.[11] In the words of James Monaco, television constitutes 'the background of everyday life' with the average viewers clocking up a large number of hours experienced per day.[12] The fact that shows are repeated or can be taped means there is no need to pay attention to the screen at a given time. Even if cinemas show a certain film several times a day, there is still only a window of opportunity to see it at a time dictated by the cinema manager rather than the audience.

There are institutional factors, particularly concerning scheduling, which have consequences for the form of the medium. Since television programmes have allotted times, it is more likely that they will be padded to fit that given slot rather than films for cinematic release, which although averaging around 90 minutes, have some flexibility to move between a threshold of commercial and audience acceptability. Obviously, they must accommodate the rhythm of interruption via commercial breaks imposed upon stations by their inherent financial restraints and the flexibility of audiences to choose their own bathroom breaks, i.e. these factors make regular repetition of key plot details and a sporadic 'winding-back' of the narrative after a commercial break, inevitable. A further consequence of this is the need for narratives to be inherently episodic with a mini climax every 8–10 minutes and not to require extensive background knowledge of a situation. There are wider financial implications of 'serial programming versus one-off scheduling'. If sets and casts can be used over an extended period of time, the cost per minute can be reduced (especially with 'a recap' at the beginning of each episode, such as 'Last time on *24*'). Also, if it is possible to split a feature across more than one evening's viewing, there is a chance to 'hook' viewers for subsequent programmes on more than one evening, producing greater financial returns for the same outlay.

As Monaco observes, 'the basic unit of television is not the show but the series'.[13] Therefore, 'we tune in not to find out what is happening [...] but to spend time with the characters'.[14] The audience of a TV series might expect to be taken on a brief journey amongst familiar faces but to be returned more or less safe and sound, back where they started. There may be exceptions to this but character development is usually minimal. Typical audiences of film expect a broader character arc in which fictional figures are faced with a series of obstacles, overcome them in some way and are changed in the process. The extent of the emotional journey that film audiences expect is in large part reflected by the special circumstances in which they view the screen. Like a 'big' ride at a theme park, the visceral thrill has to be worth the sacrifice (of queuing here perhaps).

The corollary for television generally holds true. As Sarah Ruth Kozloff notes, 'because episodic series on television are so formulaic [...] we rarely feel the same anxiety with TV, as we do with a film or novel'.[15] The greater the move towards a serial form, the less chance there is of creating and sustaining suspense and the greater the sense of revisiting familiar characters, which do not appear to have a sense of memory or learn from their experiences. Television tends to form a generic pact with the audience, in some ways more personal and intrusive than cinema, like a guest invited into a family home. Whilst the tension between the familiar and the unknown is what circumscribes notions of genre, it is often easy for critics and theorists to underestimate the pleasures of meeting generic expectations exactly. As Winston Churchill once replied to the cliché 'Familiarity breeds contempt': 'without a fair degree of familiarity, it is impossible to breed anything'.

Structure

Television is important to understanding fully Stephen King's written works and the adaptations based upon them. He is very much a child of the television era growing up in the 1950s and 60s and he is certainly a big fan of particular TV genres, like the late night anthology, such as *The Twilight Zone* (Rod Sterling, CBS, 1959–64) and in particular how it 'presented ordinary people in extraordinary situations, people who had somehow turned sideways and slipped through a crack in reality', especially those episodes written by Jack Finney who created fantastical situations without apology or explanation.[16] In some of King's most powerful television adaptations, he too conveys a sense of unreliable boundary states, such as Georgie's winking black and white photo in *It* (possibly borrowed from David Bowie's video for 'China Girl' [David Mallet, 1983]). He has written about his personal favourites at some length in *Danse Macabre* (1981) but such comments about television are largely from a historical, rather than analytical perspective.

The adaptations in this book have been tentatively grouped into generic chapters but the aim is to consider the programmes in the light of generic expectations to see how particular texts work, not in order to categorize them and move on. Chapters are based around those dominant subgenres into which King's works have been adapted, such as narratives featuring vampires, ghosts, monsters or global apocalypse. The general movement through each chapter is chronological, especially when discussing films produced as part of a body of sequels. However, in the vampires chapter, *It* is placed first as it provides a useful 'control' by which to compare the different versions of *Salem's Lot* (Tobe Hooper, 1979; Mikael Salomon, 2004) and *The Night Flier* (Mark Pavia, 1997) respectively. The study is not designed as an exercise in generic book-keeping. As Jan Johnson-Smith observes, 'Genre theory is therefore more useful for co-ordination and location rather than a means of pure delineation, inclusion and exclusion'.[17]

Notes

1. Stephen King (2006), *Lisey's Story*, London: Hodder and Stoughton, p. 543.
2. See Tania Modelski on soaps in 'The Rhythms of Reception' in Ann E. Kaplan (ed.), *Regarding Television* (Santa Barbara, California: Greenwood Press, 1983), pp. 67–75.
3. Robert Allen in Robert Allen and Annette Hill (eds.), *The TV Studies Reader* (London; New York: Routledge, 2004), p. 106.
4. Jason Mittell, *Genre and Television: From Cop Shows to Cartoons in American Culture* (New York; London: Routledge, 2004), p. 5.
5. Jeffrey Sconce in 'What If?' in Lynn Spigel and Jan Olsson (eds.), *Television After TV: Essays on a Medium in Transition* (Durham, North Carolina: Duke University Press, 2004), p. 100.
6. See Raymond Williams, *Television: Technology and Cultural Form* (New York: Routledge, 3rd edition, 2003 [1974]), pp. 77–121.
7. See John Ellis, *Visible Fictions: Cinema, Television, Video: Revised Edition* (New York; London: Routledge, 1992 [1982]), p. 149.
8. See Nick Browne, 'The Political Economy of The Television (Super) Text', in Nick Browne (ed.), *American Television: New Directions in History and Theory*, Studies in Film and Video (New York; London: Routledge, 1994), pp. 69–80.
9. John Ellis, op. cit., p. 283.
10. Ibid., p. 1.
11. See John Ellis, *Seeing Things: Television in the Age of Uncertainty* (London; New York: I. B. Taurus, 2000).
12. James Monaco, *How to Read a Film: The World of Movies, Media, Multimedia* (Oxford: Oxford University Press, 2000), p. 506.
13. Ibid., p. 488.
14. Ibid.
15. Sarah Ruth Kozloff, in 'Narrative Theory and Television', in Robert C. Allen, (ed.), *Channels of Discourse Reassembled: Television and Contemporary Criticism* (London: Routledge, 1992), p. 56.
16. Stephen King, *Danse Macabre* (New York: Berkeley Publishing, 1981), p. 276.
17. Jan Johnson-Smith, *American Science Fiction TV: Star Trek, Stargate and Beyond* (London; New York: I.B. Taurus, 2004), p. 18.

Chapter 1

Vampires

A s *Stephen King on the Big Screen* discovered, King's fiction, and the adaptations deriving from them, tends to be repeatedly drawn to certain representations of monstrosity, often appearing to favour forms which are increasingly anachronistic to contemporary audiences. Key amongst these is the vampire. *Dracula* (Tod Browning, 1931) brought much of the vampiric folklore surrounding these mythic entities to a wider audience – the use of crucifixes and wolfsbane to act as a deterrent, the lack of reflection in mirrors, and destroying them via staking or bringing into sunlight. This chapter considers how King draws on such conventions as it suits his dramatic purposes, where he extends generic boundaries and where he operates completely within them.

It (Tommy Lee Wallace, 1990)

> A clown can get away with murder.
>
> (John Wayne Gacy)[1]

The film has two prime points of interest: the dramatic structure (co-written by Lawrence Cohen and director, Tommy Lee Wallace) and the realization of Pennywise, who appropriates a number of features of the quintessential cinematic vampire. In the view of Wallace, Part One of *It* is 'a unique piece of work for television' and 'the best example of the seven act picture ever performed on television'. Certainly the seven-act structure meshes very well with the introduction of seven characters and the linkage between their past and present

lives. A phone call from Mike Hanlon (Tim Reid), the only one of the group to stay in Derry, sometimes heard in part, sometimes just referred to, triggers a flashback for each character in turn.

As a group of outsiders who come together to support one another, 'The Losers' Club' has similarities with the group of boys in *Stand by Me*. Like Gordie (Wil Wheaton) in the earlier film, Bill (Richard Thomas) also tells the group stories and suffers the death of a brother, whose room is turned into a shrine; like Vern (Jerry O'Connell), we have a bullied, chubby figure in Ben (John Ritter) and in almost every case, parents, especially fathers, are absent or abusive. The attempted sentiment is similar, like the group hug at the end of Part One, and the quality of the child actors is high but the characters just do not have the depth of *Stand By Me*, where they carry the whole of the film and not only a (albeit more interesting) half.

Tim Curry's dramatization of the nightmarish figure of Pennywise is a piece of inspired casting. The mixture of camp, threatening, sadistic pleasure draws on the same ability that he showed as Frank-N-Furter in *The Rocky Horror Picture Show* (Jim Sharman, 1975) and creates one of the most enduring and genuinely disturbing features of the film. Curry has had an extensive career as a voice artist, which is important, given the make-up that partially obscures his features and also the potential contrast between his smiling face and a snarling, aggressive voice. Pennywise is mostly not threatening *until he speaks*. His repetition to Audra at the petrol station about a balloon – 'Don't you want it? – only gains a nasty sexual undertone in its delivery, bizarrely echoing real-life killer John Wayne Gacy in his self-styled persona of as the 'Killer Clown', including switching between multiple personalities, deepening his voice to shift from playful to murderous.[2] Tim Curry's performance, especially in the attack on Georgie from the storm drain, contains a similar chilling shift, focusing on the term 'float' with its ambiguity between relaxed leisure and abject lifelessness.

Like the hazy motivation and back story of Freddy Kruger in *Nightmare on Elm Street* (Wes Craven, 1984), Pennywise is used as a repository of deep-seated cultural fears – a beguiling entertainer using his privileged position to get close to children only to abuse that trust as a murderous paedophile. Typically for King, the exact nature of Pennywise's powers are never made clear – he can apparently appear and disappear at will in different guises, and like Kruger, he appears in characters' dreams but also starts to impact upon their physical world. There is also a strange dissonance between the childishness of his role and behaviour, telling jokes and laughing with his deep voice and apparently-receding hairline. Despite frequent parodies, the Pennywise character still has the power to frighten as he never takes himself too seriously in a way that the troll in *Cat's Eye* (Lewis Teague, 1984) does for example. The sinister balloon-seller is a motif used elsewhere, such as in *The Living Daylights* (John Glen, 1987), where Necros, a KGB assassin leaves a balloon with a message for Bond ('Death to spies') after killing an agent but most powerfully in *M* (Fritz Lang, 1931), where Peter Lorre uses balloons to entice, abduct and then murder children.

In the opening sequence, we hear a little girl singing 'Incy wincy spider', foreshadowing the coming storm and the final manifestation of *It*. The girl bends down to pick up a doll at which point we hear Pennywise's laughter before we see him. She looks up at sheets

billowing in the wind and catches a glimpse of him. A subjective point-of-view shot past sheets, usually has a romantic context, such as the bed scene between the lovers in *Romeo and Juliet* (Baz Luhrmann, 1996). Here the obscured view in the shot-reverse-shot exchange initially seems harmless but then we have a quick shot of Pennywise's smile fading mirrored by the girl's, as playfulness is replaced by dread. We do not see the attack itself, but the parental nightmare is conveyed in the iconic image of an abandoned trike, its wheel still spinning and a screaming mother's face.

We are first introduced to Bill, one of King's many writer-surrogates, via a flashback of his little brother Georgie. A naturally-motivated tracking shot follows his paper boat being carried along a road by torrential rain before disappearing down a storm-drain upon which the camera lingers for a second. An unusual axis is set up with the boy peering into down and an extreme low angle of him from within the drain as Pennywise bobs into view with a *Psycho*-like high-pitched violin note. It is only when Georgie reaches out for a balloon, that Pennywise grabs his hand, delivering his mantra that 'When you're down here, you'll float too' and we see a close shot of Pennywise's upper set of shark-like teeth before his face encroaches the camera's focal distance and the shot cuts to a blur. These are not the teeth of a stereotypical vampire but their sudden appearance does allude to that horror subgenre.

Having escaped some predatory bullies in 'the Barrens', Ben hears a familiar voice and turns to see a vision of his father standing in the lake, holding balloons. As we cut in on the axis, the voice modulates to Pennywise's and fluffy buttons appear on the man's uniform. Later, Richie's meeting with Pennywise similarly fuses with a vision of a werewolf, so that we hear a lion-like roar but the creature suddenly has clown's feet. These relatively simple effects, creating a visual dissonance, are more unsettling than the skeletal hand that makes a grab for Ben or the full shot of the talking skeleton delivering Pennywise's line about floating. Eddie's flashback is in a shower, a place which one might assume to be private and safe. Here the victim is alone, rather than mocked by a group as in *Carrie* (Brian De Palma, 1976) and there is no disguised attacker as in *Psycho* (Alfred Hitchcock, 1960). The shower nozzles extending from the walls and turning on by themselves seem the stuff of low-budget 1950s horror but this is strangely appropriate given the time-setting and the fact that we see the group sharing a passion for Gene Fowler Jnr's 1957 *I Was a Teenage Werewolf* (prompting Richie's own vision of Pennywise).

Like the novel, the film raises the question of why clowns should be disturbing. The fear of clowns or coulrophobia, is reflected in *It*'s spawning of a horror subgenre of its own – the *Fear of Clowns* franchise. The wearing of make-up personifies innocence and subverting norms of behaviour, usually for comic ends, but it also obscures features and could act as a disguise for anyone wishing harm to their prime customers, children. There are clear overtones of paedophilia in Pennywise's choice of victim, so that balloons, usually symbols of childish innocence, act as lures in a trap – he personifies the warning not to accept treats from strangers. He has a childish, playful element delivering jokes and songs but at the same time has razor-sharp teeth (drawing in part on Michael Landon's Teenage Werewolf). He can appear at will, especially around drains, can shape-shift and appears to have no real

raison d` être other than to frighten. Pennywise is revealed piecemeal in the first part but in the second we see all of him from the first scene. This allows Wallace to use the part for the whole in telling details such as his bright yellow trousers or red shoes.

The most disturbing manifestation of Pennywise occurs as Mike is showing the others his father's scrapbook and they come across an old black and white picture of a street-scene. There is a blend of disturbing action with disturbing televisual form. There is a more historical element of Rabelaisian misrule about his cracking corny jokes, turning cartwheels and the monochrome scrapbook places the action within the comfort of the past. At the same time, Mark Dery's description of Sam Torrance in Kubrick's *The Shining* (discussed in *Stephen King on the Big Screen*), applies to Pennywise here – 'There's a jump-cutting, channel-surfing quality to Torrance's madness […] mugging for an imaginary camera, framing its brutality in pop culture quotes'.[3] More than the first example of a photo appearing to move, when Georgie gives a wink, here the picture comes fully to life. Pennywise is cavorting about, dancing and hopping in the guise of an entertainer.

However, he freezes in mid-distance and breaks the fourth wall to look *directly out at the camera*. It is this point that is most chilling – not that pictures move but that figures within them can see and react to those outside. Movement in the opposite direction, into a picture, is the stuff of imaginative fantasy, often for younger viewers, such as the jump into a chalk drawing in *Mary Poppins* (Robert Stevenson, 1964). Here, Pennywise runs forward, almost disappearing out of the frame before clambering up a lamp-post in the foreground. There is a subtle shift as his hair becomes clearly red and then his whole face leers into the camera in close-up. Movement through and almost beyond the frame, is achieved despite the shot using only a static camera position, creating the effect of a surveillance camera shot, particularly odd given the period setting. A similar sequence is used in Takashi Shimizu's remake of *The Grudge* (2004), where Nakagawa watches a ghostly figure approaching a surveillance camera down a corridor, only to magically appear in extreme close-up looking right into the lens. We cut back to a shot of the group looking in horror at this but there is a further shock as a gloved, grabbing hand shoots out of the book. The idea of a moving picture or of a hand reaching out is not new, as in *And Now The Screaming Starts* (Roy Ward Baker, 1973) but what is unsettling here is the problematization of borders – what is and is not contained within the frame of a picture.[4] The idea of pictures having a monstrous life of their own, which threatens to erupt into 'reality' is also explored in other King's short stories like 'The Sun Dog' (1990) or 'Stationary Bike' (2008) but it is the tightness of the framing, which increases the power of the idea here. With a large ensemble cast, Wallace often has to fill the corners of the frame and exceed proxemic norms by pushing actors closer to one another. This is also touched upon in the opening credits, where the camera first zooms in and then out, not on one of the pictures, *but on the space between them*.

The inhaler, upon which they all draw a breath before entering the underground passageways to confront It, the nameless monster that supposedly exceeds Pennywise in evil, stands as an effective symbol of childhood belief. Negatively, it allows It to exist, feeding on their fear and allows Eddie (Dennis Christopher) to be dominated by his mother, who

knows full well that he does not have asthma and that there is only water in his inhaler. However, this shared belief is what also binds the group together in rejecting evil. It is what Eddie sprays in the monster's face, asserting that it is battery acid. As a varied projection of fear, this works but the ending to the second part is probably the most disappointing in any of the films discussed in this book. It is clearly a problem trying to manifest a concept of evil onto which individual characters project their own subjective fears, which leads to the clichéd spider monster. Even in the first part, the monster's hand changes into something clearly non-human before disappearing down the hole but exactly what, is not clear. King complained about Wallace's monster but it appears in his book too.

In the first confrontation with the monster, its approach is signalled by some *Hellraiser*-style lighting as it passes along a pipe and a forward tracking shot with a negative-style effect, similar to that used in *Children of the Corn* (Fritz Kiersch, 1984). One bully, Belch Huggins (Drum Garrett), is despatched by being sucked slowly into a pipe, his legs being bent up at an unnatural angle like Deke in 'The Raft' in *Creepshow II* (Michael Gornick, 1987). The fight against It uses plenty of *Alien3*-style-Steadicam and *Close Encounters*-style lights passing overhead (more reaction than action shots) as the room mists over and a roll-call with them all holding hands ends with Pennywise appearing amongst them. He is hit by Bev's catapult shot, firing a silver dollar with its mythic vampire-slaying properties, and somersaults down the drain, almost pulling Bill with him.

Ironically, the limited budget forces some creative thinking and produces more powerful effects than the climactic battle, such as a balloon wandering down an apparently-empty street (pulled by a man with a fishing pole way in the distance). The experience of Bev (Annette O'Toole) with a dripping tap, magically filling a basin with blood, is also effective. It provokes no reaction from her father, who puts his hands right in it and clearly sees nothing. His subsequent gesture of affection, putting his hand to her face, thereby smearing her face with blood he cannot see, is thus all the more effective. This also makes the following scene (although not seen until later) in which the others not only come and help her tidy up but thereby validate her view of the world, more touching.

The second part opens with Bill as an adult visiting Georgie's grave. There is a slight allusion to the opening of *Night of the Living Dead* (George A. Romero, 1968) in the background topography, complementing the appearance of Pennywise's wig, bobbing up from an open grave. This second part is about the power and importance of memory and each character is thrown (sometimes reluctantly) into a flashback. The toast that Mike and Bill drink to, 'Here's to remembering', reflects the importance of not burying the past but recognizing its place in the present. It also facilitates some truly awful sentimental episodes, such as the bike scene, where Bill attempts a moment of childish levity a la *Butch Cassidy and the Sundance Kid* (George Roy Hill, 1969), and at the end where Bill's ride through downtown traffic supposedly wakes Audra (Olivia Hussey) from a coma-like state

Pennywise's appearance to Richie in the library is a quiet, apparently undramatic scene, until the clown speaks, commenting from an upper floor on Richie's lustful glance at a young librarian. The clown is sitting amongst other readers, none of whom can apparently

hear or see him, making Richie's shock and fear all the more difficult to control. The picture composition puts the librarian and Richie facing each other and Pennywise in the middle of the T-frame as he laughs, recites bad jokes and waves a football rattle. With a single *Psycho*-style violin note, he makes bunches of balloons fall around Richie, bursting with a bang and spraying blood on people, who with the surreal quality of a nightmare, do not react. A repetitive element and an increasing sense of diminishing returns is seen in Pennywise's appearance to Ben, motivating a blend of past and present as he helps a younger version of himself, also being bullied, before seeing his father again but only the less unsettling skeletal figure. Ben sees Pennywise from the taxi and when he turns back a single balloon appears in the frame with 'Turn back now' on it.

Eddie's visit to a chemist seems normal enough until he hears a familiar voice and behind a curtain meets old Mr Keane, who had tried to explain the truth about his asthma many years ago. On the key word 'water', the man's voice starts to distort and a sentimental moment in which the two embrace is broken when we see a scaly arm (the same glimpsed at the end of Part One) grab Eddie and a warning to get out of Derry is delivered in Pennywise's voice before the man reverts to his normal appearance again. What makes the scene effective is that no one else sees this and so like the library scene, this eruption of the supernatural into the everyday makes characters (and possibly us) question our senses.

When Bev visits her old house, the name on the bell changes from Marsh to Kersh, suggesting all is not what it seems in this house. With a fairy-tale motif, the sweet, old lady offers her tea but later starts to slurp her tea through blackened teeth. Bev looks down and sees her cup is full of blood, causing her to drop it. As the woman mops up, her voice changes, although we only have a high-angle shot of the top of her head. The action does not cohere, for when Bev rushes out, the woman, now grotesquely aged, grabs her but also warns her to stay away. Despite apparently boundless powers of shape-shifting, he lets Bev just brush him off.

The characters meet up in a Chinese restaurant and as they start to share their recent visions, Bev faints, claiming that the power of memory was 'like a tidal wave', water imagery again linked to Pennywise (Richie, the character most strongly in denial, says 'Maybe it's in the water'). He initiates an attempt at a party atmosphere and we have a rotating shot round the table as used in the opening credits of sitcom *Roseanne* (Roseanne Barr and Matt Williams ABC, 1988–97). The restaurant scene is intercut with Henry Bowers (Michael Cole) in prison and his visions of Pennywise (superimposed over shots of the moon, suggestive of werewolf mythology more than a vampire motif), instructing him to kill all the surviving members of the Losers' Club. We cut back via a graphic match from the moon to a top-shot of a plate with fortune cookies. In answer to Richie's cynicism that they will be told 'You're gonna be eaten by a big, greasy monster', the cookies contain a visual representation of what they most fear – blood, a cockroach, a swivelling eyeball, a set of shuffling claws and a baby bird. The effects, crude but still visceral and unpleasant for network TV, anticipate a very similar scene in *eXistenZ* (David Cronenberg, 1999), where primal fears are also projected onto Chinese food. In a rare comic moment (as a parody of polite reluctance to complain),

Bill throws a napkin over his cookie, which still has one spidery leg poking out, before their collective nerve cracks and they run out.

Later in the library, they learn of the suicide of Stan (Richard Masur) and Bill tells them about Stan's meeting with Pennywise. The flashback to the flight on their bikes works well because we have an apparently-simple tracking shot of Bill pedalling wildly with Stan, a petrified pillion passenger, looking back, but we do not cut to what he sees (Wallace had worked alongside key exponent of the fluid tracking shot, John Carpenter, on *Halloween* [1978]). Via Bill, we see Stan's experience whilst bird-watching, being called into an abandoned house, where an apparently mummified Pennywise descends the stairs, reciting birds' names, although as in Bev's experience, he is unbelievably allowed to run away. Mike retells his experience of opening his fridge at home and being met by Stan's head who delivers some home truths on what a loser he is as the only one who never moved away. However, the elaborate *Poltergeist*-style effects in the library of doors slamming, glass being blown out and books flying off the shelves one-by-one like Busby Berkeley swimmers, is too formulaic to be truly disturbing.

The final battle with the spider creature feels like a throwback to an earlier era of special effects. A decade after *Alien* (Ridley Scott, 1979) and *The Thing* (John Carpenter, 1982), this feels closer to a dinosaur epic. The incredibly slow-moving creature is hit on the third attempt by Bev's catapult and dies without much ceremony, crawling away in apparent embarrassment at having taken up our time in pursing it for nearly four hours of screen time. Bill leads a pursuit and inspires the others to punch and kick it to death, reaching in and ripping out its heart, shown in shadows on the cave wall (all in surprising good light, like all of the underground scenes). Unfortunately, there is not a great deal of difference in the creature's appearance when it is supposed to be alive or dead.

Like the novel, the film is overlong. In the foreword to *Secret Window, Secret Garden* (1990), King admits that in *It* he took 'an outrageous amount of space to finish talking about children and the wide perceptions which light their inner lives'.[5] However, Lawrence Cohen does a good job of honing several hundred pages down to a coherent drama in the first part. We see a neighbour, Mr Ross, turn away from helping Ben from being bullied but the social aspect of the murders, the wilful blindness of the Derry population, is downplayed (as it is in the filmic versions of *Salem's Lot*) to make the nearly 1000 pages of the novel into a workable script. The graphic resonances of visual 'tags' (Ben putting his finger to his mouth, Stan's ear-tugging and most obviously, Bill's stutter), help link past and present, child and adult, and parts one and two. However, the numerous flashbacks only underline that the adult actors are not as engaging as their junior counterparts and director Tommy Lee Wallace's insistence in putting more elements of the novel into the second part only serve to weaken its dramatic momentum. The result is a second part that feels more like a pale echo than a natural and necessary continuation of the first. Like *The Magnificent Seven* (John Sturges, 1960), much of the power of the first part comes from the 'building-of-the-team' motif. However unlike the western, which has an exciting climax too, here the team is built again and followed by a less-than-convincing climax.

The logic of the supernatural element does not really bear scrutiny – Pennywise claims 'I can take care of them if they only half believe' but he needs Henry to kill them, if they do not believe in him at all. As a concept, a projection of fear is interesting but once it starts to take on concrete form, as in the spider at the end (or in *The Dark Half* [George A. Romero, 1992] or *Secret Window* [David Koepp, 2004], it stretches credibility beyond breaking point. There are too many static, talk-based scenes in Part Two so that down in the sewers, it feels more like a Nancy Drew adventure – our plucky heroes have a map, a monster to fight and keep stopping for regular pep-talks and group hugs, interspersed with crushingly-awful west-coast hippy-speak about 'being yourself'. *It* may not have the emotional resonance of *Stand By Me* in its depiction of childhood but it has something the earlier film lacks: Pennywise. Despite the fact that Mike provides a superficial sense of closure with a novelistic summary of the characters' future lives and the sequence with Audra and Bill on the bike closes the film, the last sounds we hear are a fairground theme and Pennywise's laugh. Earlier 'Bev' tries to seduce Ben, only for him to spot Pennywise's outfit under her clothes at the last minute and fight him off. Oddly, when the 'real' Bev subsequently shows affection for Ben, and he says understandably 'Damn it, is it you or the clown ?', we actually wish it were the clown rather than just a predictable romantic scene.

Salem's Lot (Tobe Hooper, 1979)

Do you believe a *thing* can be inherently evil? [...] Does an evil house attract evil men?
(Ben Mears in *Salem's Lot*)

Alan Silver claims this adaptation 'depicted vampirism in a traditional manner,'[6] but there are some challenges to generic conventions, particularly in the depiction of the main vampire, his relationship to an underling (here played by James Mason) and how the attacks are depicted. Particular points of interest here are the reduction of the sociological background, the presentation of Barlow, and the structure and pacing of the film. How far director, Tobe Hooper, manages to produce powerful scenes of genuine dread, juxtaposed with others that operate firmly within expected generic boundaries, is discussed too.

Magistrale (2003) makes much of the negative influence of the TV-mini-series format and the intrusion of commercial breaks and yet the script was purposely written for this format and it is highly episodic, allowing for regular breaks. Having acted as producer of *Carrie*, Paul Monash produced the script for *Salem's Lot* and the novel's overt three-part structure seems to be looking towards a filmic adaptation. The pace of the plot is purposely slow at first, building up to the graveyard scene where Danny Glick (Brad Savage) bites the neck of Mike Ryerson (Geoffrey Lewis). As a two-part TV mini-series, some kind of cliffhanger is clearly important to hook viewers for the following episode. The majority of the first half establishes small-town setting, characters and situations, which are then disrupting by the appearance of the monster with increasing frequency in the second part. As critic Robin

Wood describes such narrative forms, 'normality is threatened by the monster'.[7] As such, the film works in a similar way to *Alien*, released the same year and also using a slow-burn narrative that only shows glimpses of 'the monster', picking up pace in the second half, with more frequent and complete shots of it.

Salem's Lot does not attempt to recreate a mythical Transylvania but imagines what would happen if vampires appeared in present-day Maine. As an updating of Bram Stoker's *Dracula* (1897), King employs a number of similar narrative devices such as a variety of sources from different media (as he did with *Carrie*) and the prologue and epilogue structure of Ben (David Soul) and Mark (Mark Kerwin) on the run, forming a frame story. Like Stoker, Hooper draws on a similar element of pathetic fallacy, signalling the imminent appearance of the vampire (such as the wind through the trees before the sudden attack in the woods or the storm that surrounds The Marsten house). Vietnam and especially Watergate that lie thinly-veiled behind the tensions in the novel, vanish here altogether. As with *The Running Man* (Paul Michael Glaser, 1987), Magistrale (2003) bewails the loss of a sociological subtext but it is hard to imagine any film, especially a TV mini-series, finding space for the kind of lengthy small-town history lesson King gives us or the number of minor, arguably disposable characters (such as Mable Werts, the town gossip).[8] The telling detail or line of dialogue must stand for the whole – the lecture by Dr Norton (Ed Flanders) about life in Salem's Lot, is reduced to a couple of examples and the knowing phrase exchanged with Ben, 'life in a small town'.

Debates amongst fans tend to focus on a few narrow issues of fidelity, like the changes to the conception of Barlow (Reggie Nalder) from the novel. King himself was not impressed with the clear lineage from Max Schreck's Count Orlock in *Nosferatu* (F.W. Murnau, 1922). However, the Murnau picture is often more referred to than actually seen and would never get scheduled on prime-time American TV, so perhaps bringing this concept to a wider audience is justified. Viewers unfamiliar with silent film, which is likely to be a fair proportion of those watching, may well associate the Dracula persona with a baroque, cape-wearing Bela Lugosi, Frank Langella or Christopher Lee figure. King's own dialogue is equally derivative at times- if the film had retained lines like 'I love the predators of the night', it is likely that viewers in 1979 would have found such Lugosi overtones, equally unoriginal.[9] Furthermore, it not such a straight 'steal' as King and others have suggested. Hooper's use of a strong blue colour is quite a departure (although Murnau was clearly working within more constraints here) and there is a specific focus on just the face, particularly the mouth and eyes. Part of the memorable quality of Schreck's performance is in his whole-body movement, especially the final sequence on the stairs. We only see glimpses of Barlow piecemeal and he is not given any dramatic business other than killing.

Moreover, those who complain about his loss of lines and dramatic status in the film, miss the point. It is true that he may not seem like 'the Master' as he is referred to but the division of roles between Barlow and Straker (James Mason) allows Hooper to convey a greater range of threat, covering appearance and reality, public and private, and night and day. Prosthetics would have made Nalder's Barlow unable to deliver sweeping and eloquent speeches (much less the verbose language in Barlow's written note found in the climactic search of the house)

and perhaps this also would have detracted from the aura of a supernatural creature. Above all, it allows James Mason to give a superbly disembodied performance. Sophisticated, articulate, always smart, he is the personification of urbane politeness and a formidable adversary for the rather flat Ben Mears character. More precisely though, there is a strange dislocation between the words Mason utters, the tone which he uses and his body language. The novel speaks of 'a flat, uninflected tonelessness that made Larry think of the recorded announcements you got when you dialled the weather'.[10]

Whilst never less than polite, Straker rarely maintains eye contact, staring off into space, giving a good impression of boredom or at least studied indifference. At the same time, a tone of avuncular friendliness makes potentially blunt statements seem almost charming, such as his comment to police officer Gillespie (Kenneth McMillan) – 'That makes me feel so much safer'. Later when the Sheriff tells him that they are looking for Ralphie Glick (Ronnie Scribner), he replies, 'What a shame. Is there anything I can do to help?' whilst twirling a letter knife in his hands. This is also in the context that we have seen him only a few minutes earlier unwrapping the boy's body with a look of calm satisfaction at a job well done. There is even time for some polite pedantry in the verbal sparring with the officer to whom he says 'Ciao' as a farewell. Gillespie comments 'I didn't know you were Italian' to which Straker replies 'I'm not but the word is' and also some deliciously-playful irony in Straker's apparently-friendly statement to Ben, 'You'd enjoy Mr Barlow. And he'd enjoy you'. The depth and subtlety that Mason brings to his role and his relationship to an inarticulate monster, unfortunately only underscores the two-dimensional nature of the force of good in Ben Mears' character.

In terms of camerawork, Hooper uses a few distinctive touches. Several times he tracks alongside his subjects for a second before allowing them to move out of shot, as when Ben first drives into town, when Straker brings the suits to Gillespie and in the final sequence where Susan (Bonnie Bedelia) approaches the cellar entrance at the side of the Marsten house. The effect of this is a momentary sense of fellow-feeling before letting the characters have a life of their own, creating a subtle shift from empathy to sympathy. There are more subtle touches too. Near the beginning of the film, a sweeping panning shot connects Ben's jeep driving into town with Mark, whom he has not yet met and when the boy walks out of the frame, the shot is held for a second on a satanic-looking item in Straker's shop window. Hero, helper and villain are connected in fluid and visual terms. Before the final confrontation with Straker and Barlow, there is a wide shot of the town past the cemetery, constituting the vampires' view from the Marsten House and suggests the presence of a brooding and knowing evil.

Some characterization suffers in adaptation. We see Jason (Lew Ayres) doing some research on vampirism but we are not really shown the source of Ben's expertise. He may have seen a ghost as a child but that does not prepare us for why he tells the doctor not to look in the vampire's eyes in the morgue scene or the rationalization in the car that Straker is just 'the watchdog', who 'prepares the way' for Barlow. In the translation from novel to film script and in various cuts, the character of Father Callaghan is slashed to virtually nothing,

so that when he does appear to face Barlow, we have little sense of much being at stake. Callaghan's battle with his own personal demons (alcohol and a weakened faith), are almost completely lost. The choice of Kerwin in the role of Mark is too old for some viewers (he is only twelve in the novel), making his continued fascination with monsters seem immature, although casting an older figure allows Hooper to make him a little more credibly active in the final confrontation at the Marsten House. Similarly, one might quibble with David Soul as Ben, who clearly does not have 'a thick, almost greasy shock of black hair' but his character is not particularly engaging in the novel either (King 1975: 76).

As someone who has worked almost exclusively within horror film, particularly as director of the seminal *The Texas Chainsaw Massacre* (1974), Tobe Hooper knows how to make even small scenes chilling. Ben is strangely drawn to the Marsten House and Hooper cuts in on the axis and alternates shots three times between a low angle of the house and Ben's wistful, almost longing expression, gazing upwards at a single light on in the top room, underscored by the spooky, whistling music. Ben starts to back towards the jeep, puts his hand out and into shot appears Straker, standing perfectly still and holding a cane in a gesture that might be a greeting or a threat. We do not know how long he has been standing there. Hooper does not give us the cliché of a sudden intrusion into the frame but a gradual expansion of vision, revealing something that lay just beyond our sight, which is more unnerving. With a rapid cut to a close-up of Straker's face, a copy of Ben's action, he too stares up at the house before looking back at Ben. A triangle of gazes is created which conveys Straker's curiosity about Ben's connection with the house but which also denies us any resolution. Straker only says 'Good evening' and walks on up the driveway. Ben, clearly sweating, puts his glasses on and gets into the jeep. At the doorway, Straker stands on the threshold for a moment (a key liminal state for vampire lore) before closing the door. Ben, and the viewer, are unsettled by a *lack* of speech and action, not a sudden loud noise in the dark and a potential threat denied rather than delivered.

Romantic scenes have a slight edge of unease to them too. In the novel, it is Susan who recognizes Ben and watches him for a while before speaking to him. In the film, without any preamble, Hooper shows Ben effectively creeping up on Susan as she lies by a tree, sketching. The panning shot around the tree from Ben's point-of-view casts him almost in the guise of a stalker, at the very least as predatory. He instantly spots his own book and the speed with which he 'hits on' Susan and delivers his patter, the easy self-deprecation, apparently expecting a simple conquest from a literary groupie, suggests this is a tried technique. There is something quite unpleasant here about his manipulation of the situation, gesturing to a photo on the back cover, which shows a spruced-up image of a younger self. Without Barlow in sight, Ben is the only predatory figure, snapping out the non-sequitur 'Wanna have some dinner?' The dialogue slows down for some clunky, expository back-story about her family but the speed of her acquiescence to his 'attack' both makes him a less appealing character and adds a slight feeling of justification to her former boyfriend's jealousy and that she has been too 'easy'. When asked later where she wants to go, she opts deliberately for the lake, code for a make-out spot. At this stage of the narrative, there are parallels between Ben and

Straker, perhaps marking him out as a suitable adversary for him. Ben works late at night and evasively deflects his new landlady's questions about his work and what he is currently doing. After asking Susan out, we next see them together at her parents, which is either a slight jump in continuity or a rather odd concept in what constitutes a dinner date. Either way, Ben seems to have won the confidence of Susan's family very quickly. Charm, it seems is not a characteristic, restricted to Straker.

When Ned (Barney McFadden) and Mike go to fetch the crate, Hooper denies us access to the contents of the box (foreshadowing 'The Crate' section of *Creepshow* [George A. Romero, 1982]) and provides a creepy creaking sound effect when the crate is lifted. The two-shot of the cab places the mysterious crate in the centre of the T-frame, dominating the viewer's attention. Like De Palma's framing in the telephone scenes in *Carrie*, characters in the foreground discuss something that we can see (but they cannot) in the background, as they are facing forwards. Dramatic irony and fearful facial expressions are juxtaposed with the source of that fear. Ned's continuing anxiety about the cold is complemented by the bluish lighting used for the space around the crate. The primal fear of something unknown appearing behind them links with a cinematic version of grandmother's footsteps as the crate appears to move, complemented by further creaking sound effects. Ted's belief that the crate 'just ain't natural' is emphasized by being juxtaposed with relative normality – we cut back several times to Ben and his former teacher Jason Burke at dinner and Mark trying, and failing, to explain his fascination with 'ghouls' to his father. Hooper gives us some horror conventions, such as the presence of rats around their feet and mysterious noises upstairs, and denies others. He gives us the cliché about returning to the source of fear as Ted takes the padlocks to the cellar door but no monster leaps out at him as he just throws them down. By this stage too, Ted's fear seems to have either infected Mike or he was just in denial all along as there is no need to explain the fear they palpably both know – they just *feel* it.

In the scene with Danny and Ralphie Glick's shortcut home, conventions of the fairy tale ('We shouldn't have gone through the wood') and horror movie (a very obvious set, dry ice, and a predictable owl hoot sound effect) combine. However Hooper adds a twist to such clichés. The wind suddenly gets up and whilst this is clearly the product of a wind machine and we have seen similar effects before, what Hooper then adds is silence. It is only a second or two but it allows the viewer's nerves to be lulled before an unknown black shape suddenly rises into the frame accompanied by a sudden synthesizer chord. The same effect is used in the attacks on Larry Crockett (Fred Willard) outside the Sawyer's house and on Ted in the jail later. The silence denies us the conventional emotional guidance that horror scores provide, creating a split second in which we sense something not being right, not only in the immediate plot but in the disruption to generic conventions.

The attack on Larry is also prefaced by the apparently extraneous scene of marital infidelity and revenge between Cully and Bonnie Sawyer (George Dzundza and Julie Cobb). Sexual comedy grows into real tension as Cully forces Larry to put the barrel of a shotgun slowly into his mouth and then close his eyes. The click of the unloaded gun provides a moment of relief, for the viewer as well as Larry, and he runs out the door in sheer panic,

takes a breath, thinks he has got away with it and then the monster strikes. This time, in addition to the sudden appearance of the figure in black and the music, we have a freeze-frame of Larry's terror-stricken face and then a motorized zoom onto a new detail of the attacker – some sort of hand but a thin one with long nails – clearly not human. The novel's implicit scene of domestic violence in Cully's revenge on his unfaithful wife is transposed in the film into an explicit scene of a supernatural threat. Like the brutality of Leatherface's slammed door in a previous Hopper film, *The Texas Chainsaw Massacre*, the judicious use of sound that is sudden, loud and brief, makes the portrayal of monstrosity more effective. Barlow's sudden murder of Mark's parents by crashing their heads together is as shockingly *undramatic*, making it all the more horrific.

Particularly powerful is Ralphie's visit to Danny in hospital. Again, using no music, Hooper's camera tracks slowly up to Danny, until the camera appears to be standing right over the bed. We keep cutting from Danny as he gradually wakes, looks and sits up, to reverse angle point-of-view shots of the window with curtains open and a swirling mist outside, in which a shape gradually forms. It is a boy, apparently floating, who begins tapping on the window, producing a scratching sound like a stone on glass. Danny gets up and walks over to the window. His trance-like state is conveyed by his IV drip, which falls with a smash and to which he gives no reaction. In a side-on medium shot we see Danny walk to the window, open it and take a step backwards. This shot composition is repeated later when Mike jumps into the grave and a single shot, with meaning primarily on the right-hand side of the frame, becomes a two shot, effectively balanced by the appearance of a supernatural doppelganger. We then have an over-the-shoulder-shot from behind Danny as the boy floats in and the mist appears to be sucked out of the window (a fairly cheap piece of reverse filming but effective nonetheless). The vampire slowly rises up, gives a cry and only then, after several minutes build-up, does it fall on his brother's neck and the shot fades to black. Very slow pacing, incremental repetition in the cutting and a sound-track that refuses to allow the viewer to identify the action easily with horror film conventions and therefore as not real, all create an effective sequence. This is neatly juxtaposed with the following scene which shows the discovery of Danny's body. A nurse walks slowly down the corridor, carrying what looks like a breakfast tray. We cut to a close-up of a clearly-dead, open-eyed Danny lying in an unnatural pose, then almost a whip pan to the nurse's reaction as she drops the tray and screams. Hooper shifts from slow to fast, quiet to noisy, and action to reaction.

Strangely evocative of, but probably not inspired by, the opening of *Plan 9 From Outer Space* (Ed Wood, 1956), another of Hooper's set pieces occurs at Danny's graveside. After the burial service with the sun glinting brilliantly off the metallic coffin and the priest's wish (ironic as it turns out) for God to 'bless this grave and send your angels to watch over it', some fairly cheap effects (cloud across the sun and the sound of thunder) and clichéd pathetic fallacy signal that things will not turn out quite that way. Later that day, Mike Ryerson starts to fill in Danny's grave. The scene begins with a close-up on the coffin as a spadeful of earth hits it – the coffin and what it contains lie at the heart of the scene – and draw the attention of both Mike and the camera progressively towards it through the course of the following

action. Cutaways of wind in the trees and bouquets being blown over distract Mike and he pauses to look down, dropping the spade. Like Danny in the hospital, he seems to slip into a dream-like state and keeps looking down. Something is not right; something, which we cannot see but which he can feel. The camera tracks forward and cranes up over his shoulder and then down as if we share his curiosity. We then cut to a reverse low angle from the grave (almost from a point-of-view of the body in the coffin) looking up at Mike. The shot composition, from below ground level up into the sky, from dark to light, from death to life (foreshadowing the shot from the well in *Dolores Claiborne* (Taylor Hackford, 1995) is redolent of the fascination of the horror genre as a whole – Mike is drawn (and so are we) to peering into the grave. Hooper cuts back three times from the side view of Mike looking down and the coffin point-of-view looking up. The relative length of these cuts especially of Mike looking and, after the 'peeping' crane shot, the denial of another shot of what he is looking at, slowly builds tension. We might expect the action of jumping into an open grave to signal a perverse desire for death or of something beyond death like Hamlet jumping into Ophelia's grave, but here the prime motive is curiosity.

From a point-of-view as if we are sitting on the other end of the coffin, we see Mike brush earth away. There is no sound now as we cut to a shot taken from beyond the end of the coffin (as if we have climbed off to allow Mike to open it) and dropped down to his eye level. Then we have another over-the-shoulder shot, this time peering not only into the grave but past the further threshold, into the coffin itself. Danny lies there with eyes open and glinting, malevolently. Mike recoils slightly and then looks up at the sound of wind and thunder, exposing his neck and so we can see his facial expression from the same over-the-shoulder position. We cut to a side-on one shot as he turns back, which becomes a two-shot as Danny suddenly sits up accompanied by a sudden burst of music. Mike is literally face-to-face with an evil on its home territory, which he has entered of his own freewill. Like Danny in the hospital, we see a slow over-the-shoulder shot of a boy biting into a neck of a willing victim and the scene ending with a fade to black but we also have the device used in the attack on Larry of a motorized zoom into a freeze-frame, here with the final image focusing on the face, particularly the eyes of the vampire. Over-the-shoulder shots are a staple of vampire films, allowing the precise site of attack and the face of the vampire to be in shot simultaneously. As the attacks increase in frequency we have been progressively shown more of the 'monster', we have seen a progression from general shadowy presence (Ralphie) to the addition of a non-human hand (Danny) to a full-face shot (Mike).

Both book and film suggest that a willingness to entertain the possible existence of non-rational, supernatural entities, can help when challenged by something beyond the everyday. The night-time scene where Danny visits Mark clearly parallels the earlier hospital scene of Ralph coming to Danny. In the novel, Danny is just suddenly *there*, at the window and although this works to a degree, the film generates tension more effectively with the same slow build-up of shots cutting between a sleeping boy and a window with plenty of dry ice and the film run backwards. Having established what a vampire does if invited past a threshold, Hooper does not need to repeat the threat. There is also a contrast between

Danny and Mike, who both represent malleable opposition for the vampires and Mark, armed with knowledge of the genre. The turning point comes when Mark reaches up to the latch but instead of opening the window, he locks it. Through tears, he breaks off a cross from one of his model figures and holds it up, provoking a cry as the vampire recoils and a bell chimes. Unlike George A. Romero's eponymous hero, *Martin* (1975), who makes fun of the cultural paraphernalia around vampirism and dies, staked by his own uncle, Mark uses his knowledge to repel the vampire, emphasized also by the shot composition at the window. He is framed side-on, the shadow of the crucifix cast on his face, at 90 degrees to a poster of *The Wolf-Man* (George Waggner, 1941), which had been glimpsed in an earlier scene, when his father tries and fails to understand his son and his interest in horror. Magistrale (2003) picks up images of confinement and freedom in *Carrie* but there is a similar image pattern at work here too. With a nod back to classical literature, both appearances of the Glick brothers use similar dramatic devices to *Wuthering Heights* (Emily Bronte, 1847), where there is a ghost of a young person at a window, trying to seek entry by knocking, and whose narrative features images of keys, doors and boundary states.

In the confrontation between Jason Burke and Mike, now a vampire, there are echoes of *The Exorcist* (William Friedkin, 1973) as Jason's poring over books about the supernatural is interrupted by a mysterious sound from upstairs. Hooper cuts all incidental music as Jason investigates so that there is a climax as he bursts into the room and finds Mike in a rocking-chair, the creaking of the chair coming to a sudden halt as Mike looks up and hisses. The distorted voice of the floating Glick brothers is developed a stage further as Mike commands Jason to 'Look at me' several times. Geoffrey Lewis' performance here with glowing eyes and a soft, but also paradoxically very threatening, whisper is one of the enduring images of the film. On being confronted by Jason's crucifix, he rears up like a puff adder but instead of striking, he is driven back through the window. Jason staggers forward and looks down, only to witness the strange and inexplicable sudden absence of the body – a technique John Carpenter uses to great effect in *Halloween*, for the disappearance of Michael Myers having supposedly been despatched by Dr Loomis (Donald Pleasance) to create unease and a sense of Myers as an archetypal 'unkillable thing'.

Although it is short, the sequence of Ted in prison remains memorable. Containing no dialogue, it constitutes Hooper's version of Murnau's *Nosferatu*. A slow tracking shot along the cells brings us to Ned sleeping. Shadows flicker across his face and half wake him. A hand, like the one seen in the attack on Larry, waves at the lock and the door flies open. Ted sits up, rubbing his eyes. Only after several seconds silence and shadowy movement, we are given a sudden close-up of Barlow in all his blue-faced glory as he bobs up into the frame and hisses. His crooked teeth (with two prominent central incisors, like Max Schreck), pointed ears, bloodshot eyes and weird growling sound, all mark him as clearly non-human, contrasted with a close-up of Ted, open-mouthed, wide-eyed and too terrified to scream. Here might have been a better place to cut but Hooper gives a few more frames from a bird's-eye view as Ted cowers and the vampire pounces, mist and his cloak obscuring his exact actions.

By the time of the attack on Mark's home by Barlow and Straker there is a complete collision between the everyday and the supernatural. A family conference around the kitchen table is interrupted by the flickering light, the phone ringing and the light bulb brightening before bursting, signalling the arrival of true evil. Foreshadowing the kind of cumulative domestic special effects he was to use working alongside Steven Spielberg on *Poltergeist* (1982), Hooper builds tension by having the table shake, the wardrobe fall over and the windows burst inwards, before slowly tracking forward to peer down at the black 'thing' that has inexplicably appeared on the floor. Slowly a shape rises up and is visible as the creature that attacked Ted but Hooper dwells on the terrified reaction of Callaghan (James Gallery) rather than lengthy shots of Barlow, whom we see in full-shot for the first time here. Straker, who we did not even know was in the scene, appears suddenly almost in a jump-cut in low angle at the doorway, declaring that 'You can do nothing against the master'. The so-called 'battle of faiths' as described by Straker in pitting Callaghan against Barlow, is a fairly one-sided affair and in a truncated narrative, Callaghan's weakness elicits little sympathy. The close-up of the twisted crucifix that Barlow sweeps aside sums up the weakness of Callaghan the man rather than his faith, since Jason, Mark and Ben all use crucifixes successfully to repel vampires.

Hooper shows a preparedness here to challenge generic conventions by having the vampire cross thresholds even if uninvited. Furthermore, to be effective, the iconography of generic vampire narratives including the cross, must be accompanied by its referent, i.e. religious faith. Callaghan is killed not because he does not have a cross to hold before him but because he does not fully believe in what it represents. As a small comment on the weakening of religious faith or the dominance of the symbol over the substance, it is a powerful moment, but in a sense, it is a greater comment on the weakening of specific generic iconography, especially since the force of evil seems to know this, whereas for Callaghan it is a shock. The age or value of the cross itself is irrelevant as Ben manages to repel vampires with a crucifix patched together from tongue-depressors.

In another sequence initially without music, we track into the morgue where Ben is producing makeshift crucifixes. Behind him, the body of Marjorie Glick (Clarissa Kaye), Danny and Ralphie's mother, lies under a sheet. Hooper creates tension and breathes life into another horror cliché by leisurely cutting between Ben, the body and the clock on the wall, refusing to cut in on the axis and creating a sense of the viewer sharing Ben's patience, waiting for something to happen. Eventually after a round of five cuts, something stirs under the sheet and a hand shoots out, accompanied by sudden music. Ben begins to mutter the Lord's prayer and yell in panic for Doctor Norton to come back. However, much of the suspense is then dissipated by the close-up of the woman as she sits up. She has a deathly pallor, strange glowing eyes but unlike the confrontation between Mike and Jason, here the vampire looks all-too-human. There is a Halloween element to the make-up, an impression increased by her lumbering, zombie-like movement in a stark contrast to the speed of Barlow or the floating otherworldliness of the Glick brothers at the window. If all the vampire sequences were like the one in the morgue, the film would not work. Ben

presses a crucifix upon her forehead, causing a burning effect. The vampire screams, fades and disappears, contradicting the usual mythology about staking through the heart and giving the creature more of a ghostly, i.e. unreal, presence – something the rest of the film is at pains to avoid.

The novel mentions Mike's drive up to the cemetery past 'the skeletal, leafless trunks of the trees that had burned in the big fire of '51, like old and mouldering bones'.[11] Hooper appropriates this in a lengthy crane shot down an angular, dead-looking tree before Susan drives into shot en route to the Marsten House. In combination with the low angle shot of the house through the windscreen, from the point-of-view of a lone heroine, this is redolent of the landscape of *Psycho*. However, unlike De Palma's self-conscious Hitchcock referencing, Hooper here chooses elements, which contribute to an atmosphere of threat and convey a death-like atmosphere. Twice in the final sequence, Hooper has Susan pause before a doorway, into which Mark has just disappeared, before running in. Hooper denies us the horror cliché of some sudden act of violence by giving us no immediate clues (visual or aural) as to what has happened to her for several seconds. There is no noise at all. After a few seconds she takes a deep breath and follows Mark in, only to see him fall at her feet and the door slam revealing Straker.

Hooper's conception of the interior look and space of the house works well. The abandoned, derelict house, filled with feathers that seem to float everywhere, is a physical reflection of the vampire's moral corruption. Hooper tracks back to reveal the central staircase and Mark walking across the landing at the top, conveying several vectors of movement within the frame as well as the basic geography of the house and its sheer size, emphasized by the obliviousness of the characters to one another. There are haunted house clichés (Susan backs into a stuffed hunting trophy) but there are surprises too. Mark opens a drawer slowly and breathes a sigh of relief as there are *only* some squealing rats inside. Cutaways to stuffed animals again reference *Psycho* but the expected gives way to the unexpected as stuffed cats are followed by a dog impaled on some antlers, foreshadowing the murder of Susan's father.

When the Doctor and Ben arrive, they soon commit the cardinal sin in haunted house movies, of splitting up. The Doctor, unwisely, climbs the stairs to the landing and behind him in the background we see a strange door with animal horns on it. The noise of a slamming door draws his attention the same way that Mark and Susan had headed but this time Straker suddenly opens a door ahead of him and walks forward quickly as if to meet him. Shot from a bird's-eye view and without music, the scene evokes Arbogast's murder in *Psycho*. As in Hitchcock's film, the victim can do nothing to defend himself – Straker picks up the Doctor by the shoulders (conveying his inhuman strength) and simply walks forwards, impaling him on the animal horns seen earlier. In the version of the film released in Europe, more graphic violence such as this scene remains in the film and although, George Beahm states 'the better versions tend to be longer,' as is often the case with DVD extras, more is not necessarily better.[12]

Straker's own demise is much less effective. In the novel, Barlow sacrifices him but in the film having demonstrated his physical power, Straker strangely chooses to break off a

banister and walk slowly down the stairs, giving Ben ample time to shoot him repeatedly. In an apparent junk-room, Ben and Mark discover a low door, which leads to the cellar, Barlow's coffin and several rather drowsy vampires. A cut to the narrow window shows that light is fading, creating a final race against time in the deepest recesses of the house. Any vampire film has to have a staking scene. Here, the pair drag the coffin out of the inner room and Ben prises it open, giving us another clear shot of Barlow. As in the attack on Ted in the prison, Hooper uses sudden movement as Barlow's eyes fly open and he turns his head to look right at the camera and hiss. There is a strange mixture here of the horrific and the comic. Hooper places Ben's bag of holy water and anti-vampire paraphernalia in the centre of the frame and then Barlow's head suddenly pops up above it, almost like a curious child. The movement is repeated in the following shot as we see Barlow sit up from sideways-on, only to be shoved back down Jack-in-the-box-style by Ben. We see Ben's hand raised for a second before plunging down with the stake, knocking the low light above his head slightly. This motivates a chiaroscuro effect as Ben battles Barlow's blue, grabbing hands and squealing protests and creates the great shot of Mark looking on in horror while we see over his shoulder, several lesser vampires crawling towards him. Hooper cuts back and forth five times from a frenzied Ben to an oblivious Mark, building the tension until Mark finally spots them, slams the door and Ben's staking operation is over. Barlow's body is shown once in a state of decomposition and then focusing on the skull, in particular that feature, which is most closely associated with its non-human physiognomy – the prominent front teeth. Hooper even throws in a final touch of the mouth falling open, suggesting Barlow has the final word and that it might even be with a laugh. The burning of the house is shown in a brief montage accompanied by the screams of those caught up in it. The final shot zooms in on the cellar, where a glass breaks, reflecting the intensity of the heat but also the possibility of escape.

The very final sequence of the film, taken from the prologue to the book, with Ben and Mark on the run in South America ties up one main loose end by having Susan re-appear and forcing Ben to face the fact that she is one of the undead and must be staked. However it also underlines the plot hole of what exactly happened to Susan in the Marsten house. In the novel, in answer to Ben's demand to know what has happened to her, Straker replies 'I have taken her where she wished to go', adding she will 'meet the man she came here to meet'.[13] However, deleted from those two statements are the three words, 'Into the cellar' and indeed in the novel Ben stakes her as one of the vampires in the cellar. However, in the mini-series, Barlow has not risen from his coffin and she does not appear at all in the cellar, so exactly how she could have been made into a vampire, remains unclear. In a sense, the ending of both book and film is inconclusive. Fire may purify, as Ben notes, but knowing what they know about vampire habits, they could go back and stake them all during the day (as Larry Cohen has them do in the first sequel). Lighting a fire and then running away might provide an open ending to an eternal threat but dramatically it is weak and unsatisfying. The final shot, introduced by a dissolve, features a superimposition of a skull over the moon, clearly alluding to the Hitchcock's skull shot over Anthony Perkins' face in *Psycho*, suggesting that evil endures.

There is no Van Helsing figure – evil is defeated ultimately by a jaded writer and a boy, passionate about horror stories. It seems the need for a knowledgeable, older mediator has passed. Immersion in popular culture of comics, stories (and nowadays, the Internet), provides a more effective education than traditional literature (Burke's exhaustive research from print material yields some insights but cannot save him). There is no leadership amongst the townsfolk (figures of authority, such as the police chief, seek to leave) and it is left to a battle of generic knowledge. Like the unnamed boy in *Creepshow*, Mark Petrie's knowledge of vampire lore helps him to defeat the monsters.

Salem's Lot is more than the sum of its parts. Set-pieces like Mike being drawn to jump down into Danny's grave, the attack on Ted in the prison, and the Glick boys at the window still have the power to frighten 30 years later (the latter example reflected in a parody sequence in *The Simpsons, Treehouse of Horror IV*' [Matt Groening, Fox Network, 1993]). Magistrale (2003) is weighed down by the burden of fidelity criticism, seeing changes in the conception of Barlow for example as necessarily a dilution of what *should* be on screen. However, what he sees as a criticism, such as the loss of a political context ('the film might as well be set anywhere and at any time in the twentieth century') might equally be seen as a strength.[14] Far from being a 'campy, minor vampire story', given the restrictions on American TV about what can and cannot be broadcast (especially nervousness about direct representation of violent acts concerning children), it is a wonder it was made or shown at all and although Hooper is still best known for his *Texas Chainsaw* films, *Salem's Lot* deserves more credit than it gets as a highly effective horror narrative with some powerful and memorable scenes.[15]

A Return to Salem's Lot (Larry Cohen, 1987)

Although Larry Cohen had managed to craft a successful script for *Carrie* from a fragmented source text, his direction of a sequel to *Salem's Lot*, is not so successful and is almost always summarily dismissed by critics (it receives no mention at all from Magistrale [2003]). It is not the purpose of this book to salvage the unsalvageable but despite palpable weaknesses, there are still some noteworthy features here. Indeed, any parody, sequel or homage, however much a pale echo of the original, can still provide an interesting contrast with the source text and underline why one version works better than another.

The slightly original premise here is that a community of vampires are looking for someone to write an academic account of their race, a 'Bible' as they term it. The head vampire, Judge Axel (Andrew Duggan), claims that this is 'to change the ways outsiders feel about us forever' but why they should care about this is far from clear. They claim to only drink blood from specially-bred cows and yet that does not prevent a group of partying youngsters being set upon and killed. An amoral anthropologist Joe Weber (Michael Moriarty), a self-confessed 'ambitious asshole', is forced to look after his unruly son Jeremy (Ricky Addison Reed) and the two spend some quality time together, getting to know one

another in Salem's Lot, where Joe's Aunt Clara (June Havoc) has kindly bequeathed him a rundown house. The character development, such as it is, involves a battle for the soul of the boy, whom the vampires hold as hostage in the latter part of the film until Joe completes the book. This could produce tension with characters' lives held in jeopardy Scheherazade-like but the basic premise is all-but abandoned mid-way through. Hooper's original film focuses on the mystery of the Marsten House and although Ben Mears talks about his writing quite a bit, we do not see him actually doing it. Here there is no mystery, we do see Joe writing and the pace drifts accordingly towards the pedestrian, reflected in the name of the village, Purgatory, capturing King's tendency to literalize metaphors.

The concept of 'new-age' vampires put off human blood by the prevalence of drug- and alcohol-abuse, hepatitis and the AIDS virus, and the Judge's dismissal of old mythology about vampires not casting reflections and being afraid of garlic, could all be interesting if it were placed within a more engaging drama. Beyond the need for a couple of gratuitous sex scenes, exactly why Joe submits without any qualms to the sexual advances of the beautiful Cathy (Katja Crosby), his long-lost love during idyllic childhood stays with Aunt Clara, and who is clearly a vampire masking her true age and degeneracy, is not convincing either. The keeping of human 'drones' to run the public side of Salem's Lot is quite a nice satiric touch about the soulless nature of small-town tourist museum culture but the parallels between capitalism and a vampiric life are fairly heavy handed – when asked where they get their money from, the Judge's wife replies 'vampire life and financial security go together'.

Van Meer (Samuel Fuller), a thinly-disguised Van Helsing figure from Stoker's novel, appears in the second half of the film. He is a cranky, gun-wielding, cigar-chewing New York Jew, looking like a cross between Groucho Marx and Scottish actor Frank Finlay, who claims bizarrely to be expert in hunting down both Nazis and vampires. The elision of the two groups could be explored quite interestingly but it passes without comment. Joe and Van Meer plan to stake the whole town after holing up overnight in the church, where they craft makeshift stakes by chopping up and whittling down the wooden chairs. By having his characters oversleep, Cohen eventually invests the plot with a modicum of suspense with many bodies to find and little time in which to do it.

The film includes quite a number of standard horror features, including stereotypical characters such as an unfriendly local at the garage who tells them, 'We like to keep things as they are'. The means used to create tension are obvious and unsuccessful, from the owl sound effect to signal nightfall to when Jeremy looks round the apparently-deserted school on first arrival, a large bearded man suddenly pops up from a stairwell, bellowing 'What are you doing here, boy?' Similarly as the trio attempt to drive to the church to find a place of safety, without warning a vampire hurls himself on the car, flying into the frame accompanied by a sudden noise. This latter example is redeemed slightly by the comic action of Van Meer shooting the vampire in a rather contorted manner from out of the driver's-side window so that he does not have to pay for the cost of a new windscreen.

There is virtually no suspense created in the film. Unlike Hooper's version, we see a vampire getting out of his coffin within the first fifteen minutes of the film. Two of the teens run into

a wood where they are attacked by a figure, who looks dressed for a Halloween party in a rather unconvincing mask and gloves. By contrast with Hooper's piecemeal presentation of Barlow, the 'monster' here is shown in its entirety from the outset and just looks ridiculous. The vampires here, in their movement towards the teens, move so slowly that they more closely resemble George A. Romero's zombies, making their capture of any victim fairly unbelievable. The trope of demonic children calmly exterminating adults is used to good effect in *Village of the Damned* (both the 1960 Wolf Rilla version and John Carpenter's 1995 remake) but here a scene where a group of small children gradually surround a couple of winos, is made redundant by such zombie-like movement.

However, amongst the low production values and the pedestrian plot, there are some examples of witty dialogue – when one vampire comes back from attacking a group of young kids, still with blood on his face, the local cop, Constable Rains (James Dixon) gives him a look of disgust much like a parent at an unruly teenager, telling him 'And wipe your mouth'. Later, the wife of the chief vampire confesses that she still prefers the blood of humans to cows and ruefully admits, 'Axel says I have a drinking problem'. The cliché 'Go tell it to the judge' is literalized as a panic-stricken girl seeks sanctuary at the Judge's home, only to be handed over to the vampires who make up his other dinner guests. When Joe tries to remonstrate against his son taking his 'vows' and joining the vampires because he would then be dead, the Judge's wife declares, 'Why you make it sound so all-fired awful?'. Michael Moriarty as Joe effectively delivers some sarcastic comments on his situation. When his son says the townsfolk are no worse than the predatory nature of wider American society, his father replies, 'I just don't like people who suck your blood and have conversations afterwards'.

There is an echo of the rote-learning of US education in the night-time lessons in vampire history down at the schoolhouse, where father and son pass a poster for an upcoming school production – *Dracula*. However, references to The Spanish Inquisition as an example of 'man's inhumanity to man' hardly matches the metaphoric resonance of films such as *Planet of the Apes* (Franklin J. Schaffner, 1968). The sight of the children taking their vows, all dressed as if for a wedding, is slightly unsettling but it is only a brief sequence and the disturbing nature of the role reversal is not taken any further, unlike the *Children of the Corn* series.

There one or two effective shots, for example the Judge's old wife held in close-up as she licks blood off her lips and a later shot where she feasts on the blood of the girl seeking help and then gets out a compact to touch up her lipstick. The faces of the vampires pursuing the girl pressed up to the windows of the church where she seeks sanctuary is potentially unsettling but probably the best exchange is a conversation between the Judge and his wife before turning in for the night. This latter scene is given an ironic twist by the Judge wishing his wife a friendly 'Good day' before the camera pulls out to reveal that they are about to lie back in their coffins. Amanda (Tara Reid), a girl who has befriended Jeremy, all dressed up in her wedding outfit, floats up to the church window but this is no repeat of the Danny Glick sequence in *Salem's Lot*. Here, this is a single shot, lasting only a few seconds. Hooper's subtle build-up of suspense with lengthy shots, mist effects shown in reverse and the judicious use of silence to counterpoint scratching on glass, has no equivalent here.

In the final staking sequence, most of the vampires are shot side-on and all we see is an unconvincing claw and perhaps a glimpse of a mask thrashing about. The budget does not extend to *Howling*-style Stan Winston/Rob Bottin-produced state-of-the-art transformation sequences. The systematic staking of the whole town does have the surprise element that the Judge is not in his coffin and that the local cops have to be overcome in a shootout. In this latter exchange of gunfire, Van Meer manages to distract one for a split second by pretending to be dragged into a coffin, which is effective at the time and slightly comic in retrospect.

During the house-to-house operation, Cohen crosscuts between Van Meer caught in a man-trap, vampires slowly emerging from their coffins and Joe who only arrives to rescue him just in time but there is still little real sense of dread (unlike Hooper's cellar scene) as the vampires are inexplicably despatched with holy water alone, without being staked.

For the final barnyard despatching of the Judge, there are some echoes of *Carrie* in Joe's use of random agricultural cutting implements as weapons against his enemy. Here however, there is no allusion to Argento, no sense of Biblical/mystical peace, just a heavy-handed nationalistic reference as Jeremy stakes the creature from behind using a handily-placed stars and stripes. Small-town America strikes back. We cut back to the vampiric body at four different stages of decomposition, from punctured rubber suit to dusty skeleton. The final dialogue sequence echoes the lame ending of King's novel, which concludes with the setting of a fire and the vague hope that that has 'purified' the town. In a saccharine ending, the boy declares, 'I guess getting old isn't so bad', Van Meer comments 'I think he's becoming a human being' and Joe mutters 'Don't let his mother find out'. Even the cows calmly grazing in the closing shots appear to have lost interest.

Salem's Lot (Michael Solomon, 2004)

Susan Norton: A haunted house? It's not your genre.
Ben Mears: Complex characters can elevate genre.

(From the film *Salem's Lot*)

Mikael Solomon's remake of Tobe Hooper's 1979 two-part mini-series reads like a long list of features cut from the original version or responses to criticism of it. This in part is borne of a desire to be distinct from the former film, to be more 'faithful' to the King novel by bringing back material missed out before and possibly by the ambition to create a better film. In all of this, Solomon is in part successful. What we have here almost feels like a photographic negative of the Hooper version – the same outline plot is visible in places but the spine of the story is held together by different characters. Ben Mears (Rob Lowe), is now closer to the moody, dark-haired figure in the novel who delivers a troubled, world-weary, almost noirish first person voiceover as introduction and periodic comment on the unfolding action. The mournful chanting music reflects how his whole life has been scarred by the events in the Marsten house, which we see in incremental repetition via flashbacks sprinkled through the

narrative, rather than placed in one confession (his character's anecdote to Jason Burke in the former version). It becomes a key part of his character development to expiate what he perceives as his guilt for the death of a young boy, during a dare to enter the supposedly haunted house and grab a souvenir. It is only when he sits with Susan in the hospital that the speed of cutting in the flashback sequence slows sufficiently for us to see that the souvenir was Hubie's glasses and that, via Ben's explanation, we 'see' what he saw – the body of Marsten's wife with shotgun wounds and Hubie drawn by an unseen entity to hang himself. As a 9-year-old boy he was frozen by fear all night until discovered the next morning. He has lived his whole life believing himself to be a coward, unable to act to save the boy in the bathtub.

The opening is very different with Lowe appearing as a derelict amongst other urban derelicts, confronting Father Callaghan (James Cromwell) in a soup kitchen and initiating a struggle, which leads to a spectacular slow-motion fall both from a high window. There are echoes of Cronenberg here – not just in the *Videodrome*-style Cathode Ray Mission or the hero as a derelict but in the use of touch as a means of psychic communication. Like Johnny Smith in *The Dead Zone* (David Cronenberg, 1983), it is the point at which he grabs Callaghan that the priest realizes the man before him has some kind of special knowledge. Indeed, the Ben of the frame story is akin to Coleridge's 'The Rime of the Ancient Mariner' (1798) who fixes the doctor with his 'glittering eye' and holds his rapt attention by the power of his tale, which he feels forced to tell. This is particularly so at the beginning of Part Two (if the story is shown in two parts), when the doctor's shift ends but he chooses to stay on when Ben grabs him and mutters 'There's more'. The body of the narrative in a sense is an answer to the challenge issued by the doctor to Ben when he is first brought in, 'Give me one reason, as a good Christian, why I shouldn't let you die right here?'

The character of Father Callaghan is 'beefed-up' from the Hooper version. His first appearance shows him as a caring individual, stopping before the apparently-lifeless body of Danny Glick (André de Vanny), lying in the middle of a country road. However as he opens the door, a miniature falls out, giving us a clear clue as to the nature of his weakness. He is shown later taking a quick swig before Danny's funeral, immediately offers Ed (Martin Vaughan) a celebratory drink at news of his wedding and later uses the miniature bottles to fill with holy water before approaching the Marsten House. In conversation with Matt (Andre Braugher), Callaghan admits, 'the Church's concept of evil has undergone a radical transformation this last century' and that Satan and devils are viewed 'as manifestations of the human psyche', reflecting psychological interpretations of horror narratives and about which he does not seem wholly convinced. He appears a marginal figure, who relishes the concept of what he terms 'a true battle' not just to test his faith but his value to society in a largely secular age. When he muses, 'perhaps there's a need for this religious old relic after all', he might equally be referring to himself or his faith. A symbol of his weakness is used in the oncoming battle with good and evil. His faith is not sufficiently strong, underlined in both films by a similar close-up of his crucifix lying broken on the floor, when he is attacked by Barlow (Rutger Hauer), foreshadowed by a slow-motion shot of Duds' spray-can falling to the ground. In the opening sequence to the film, we share Ben's point-of-view when

he approaches Callaghan from behind whilst he is kneeling at prayer. However his faith is only a façade – beneath his robe he is holding a gun. As he notes at Matt's bedside later, 'Sometimes the powers of prayer in local facilities have their limits.'

Events are put back in, like the dog hung on the cemetery gates, Ben's visit to Matt's English class and the town dump is reinstated as a setting from the novel (as a metaphor for the detritus of the town) and with it the character of Duds Rogers (Brendan Cowell), an isolated, lonely limping figure. He is the object of prejudice at work (he is fired by phone) and derision amongst his peers, jeered at school for daring to speak to Ruth (Penny McNamee) who declares she was only flirting with him to antagonize her father. When Barlow offers him 'the chance to be equal to those other boys and girls. Maybe more than equal', his willingness to acquiesce is hardly surprising.

The character of doctor Jimmy Cody (Robert Mammone) comes back too, providing greater flexibility and credibility in the hospital scenes, grounding the vampirism as a mystery disease and allowing the inclusion of the blackmail subplot with the 'trailer trash' characters of Sandy and Roy McDougall (Bree Desborough and Paul Ashcroft). His discovery, in bed with Sandy, seems like a set-up and although a shotgun is waved at him, there is absolutely no suspense as Roy will not destroy this chance of gaining money, and we feel little sympathy for Cody who has abused a position of trust. His death, falling through a purposely-cut staircase onto a spinning saw in the cellar of the Marsten House, is in the novel but is shown here with such restraint that it barely seems either credible or disturbing. In this version, it is Cody not Crockett (Robert Grubb) who is having an affair. Crockett's portrayal is rounded with his over-protective stance towards his daughter and his irrational hatred of Duds, whom he blames for corrupting her. In pseudo-western language, he commands the Sheriff to 'run (him) out of town' and even implies Duds is somehow linked to the disappearance of Ralphie Glick.

Silver (2004) cites King's claim that in his novel, he decided 'to largely jettison the sexual angle' but perhaps more accurately the adaptations reflect an accommodation and codification of an underlying homo-erotic tension.[16] Unlike, his source inspiration *Dracula*, with its breathless heroines, King's victims are primarily male (Glick, Burke, Mike and Ted) but by the second adaptation, this apparent transgression has become 'normalized'. Matt Burke undergoes changes in his name (from Jason), his ethnicity and his sexuality (if not altered then at least clarified). This more closely reflects the diverse nature of contemporary American society but also gives Solomon the interesting opportunity to exploit a little homophobic tension in small-town life. When Mike (Christopher Morris), apparently ill, is offered a place to stay the night as a gesture of good-neighbourliness on Matt's part, there is an interesting point at which Mike takes off his shirt revealing some impressive bruising but also some well-trained abs. He realizes that this might make Matt uncomfortable but the older man laughs it off and leaves him to sleep. Later when Mike has changed into a vampire, he refers explicitly to why Mike let him stay, implying some predatory ulterior motive. In questioning Matt about the mysterious events of the night, Sheriff Parkins (Steven Vidler) asks why Matt called Ben (another clearly single man) for help, rather than the police, hinting there is linkage between the profession of writer and something sexually deviant.

The plot is shifted from the early 1970s to the present day. There are updated references to Mears' most recent controversial book, now dealing with Afghanistan rather than Vietnam, his theory that Mike's death could be caused by 'some designer drug' and Mears himself often finds out information via his cell-phone (although some of these exchanges in the middle part of the film, especially with Susan are dramatically empty and could be cut). Susan refers to e-mail contact that she has had with Ben previously, Roy McDougall sings in a karaoke bar (a tongue-in-cheek version of 'Stand By Me' for the attentive viewer) and Ben writes on a laptop not a typewriter, which is also where Callaghan appears to be doing some crafty research on all things demonic, when Ed comes to visit him. Mark is no longer shown with an obsessive interest in horror based in the 1940s and 50s. Gone is the poster of the Wolf-Man and what we have instead is a close-up of a figure who looks suspiciously like one of Clive Barker's 'cenobites'.

Samantha Mathis' Susan Norton is also markedly different from the Bonnie Bedelia rendition for Hooper. Here, it is Susan who initiates the first contact with Ben in a restaurant, dominating and driving their conversation. She has a jeep very like the one driven by David Soul in the earlier film and later she is the one who breaks off contact with him when she feels that he has betrayed her trust by secretly planning to write about small-town evil rather than the Marsten House (as he claimed) and only picks him up from the prison because of Matt's heart attack. The first kiss with Ben only comes after he 'confesses' the truth about the events in the Marsten House, i.e. it is hard-won. At the end, she is clearly one of the undead rather than the loose plot thread of Hooper's film, but Ben's plea to leave her and deal with Barlow first and then come back to her, seems more like a *Scary Movie* character choice than credible with his character elsewhere. Even at the end as a vampire, she does not become a passive, doe-eyed victim, although here this really does not work. Unlike all the other characters who undergo some kind of monstrous change in their nature on becoming a vampire, she speaks to Ben in exactly the same way that she has addressed him up to this point, sentimentally declaring that she could love him and consoling him with the fact that the boy in the bathtub for whose death Ben has blamed himself for many years, was already dead, expiating his guilt.

The character of Eva (Julia Blake), the landlady at Ben's boarding house, is given more depth from the rather stereotypical nosey figure in the earlier film. Here she has a back-story, as a young girl drawn into Hubie Marsten's sexually-deviant goings-on up at the house and as an older woman feeling guilty about this and the lack of affection she has shown to long-time admirer and resident, Ed. We have the highly unusual spectacle on network TV of consensual sex between elderly people and more unusual still, Eva's subsequent reaction, afflicted with guilt, casting the experience as a one-night stand. In the concluding section of the film, we see her change position again, agreeing to marry Ed but when he appears as a vampire, instead of rejecting him, she walks down the aisle but away from the Christian icons that fill the church and towards Ed and a life with the undead as a positive choice. Her orgasmic reaction to being bitten is in keeping with her character as a sexually active older citizen who actively embraces vampirism as preferable to the suffocating nature of small-town life.

Donald Sutherland as Straker has an almost-impossible task in being compared to James Mason from the Hooper version but he has some effective moments too. Playing the role a little more flamboyantly, his whispered delivery and shock of white hair, make him quite a playful character. When Crockett expresses an interest in a necklace, an eighteenth century harmony pin, showing a goat's head with red eyes and a pentangle on its forehead sitting amidst a spider's web, Straker gives it to him, explaining that it 'belonged to a whoremaster's mistress,' Crockett missing the irony of how he is thereby marked as a servant of evil. Ben follows Straker round the back of his shop, Solomon cutting between handheld point-of-view tracking shots and reaction shots of Ben to heighten the tension. He enters a storeroom, only for Straker to appear behind him in the doorway, effectively trapping him. Through the subsequent pleasantries, Sutherland conveys a suitably creepy persona in his whispered delivery and slightly manic gestures. When Ben asks if he likes the house, Straker confesses 'It's quite a handful' at the same time as ironically keeping hold of Ben's initial handshake. Straker shows an unnatural knowledge of Ben's motivation in connection with the house, stating that he never actually intended to live there – something that even Ben does not recognize himself – and Straker rather finishes the comment with delightful eccentricity, calling him 'Mr Typist, click, click, clickety-click'. In asking Eva later whether Hubie used to wear his goat-mask, he sticks his tongue out and pulls a face, a mixture of something childish and yet simultaneously sexually deviant. His demise, hung and bled dry by Barlow, reinstates an element from the novel and the sound of a drop of blood onto Callaghan's collar causing them to look up, alludes to the death of Brett (played by Harry Dean Stanton) in *Alien*, an effect also used in the death of reporter Bollinger in *Rose Red* (Craig Baxley, 2002).

The figure of Barlow was a contentious element in criticism of Hooper's version and Solomon has clearly responded to that. Rutger Hauer as Barlow has more spoken lines and in appearance is closer to the debonair, mysterious figure of the novel. However, he only appears in one more scene than in Hooper's movie (the initial temptation scene with Duds on the dump) and although he has more lines, it is debatable whether he has any more impact. Hauer's delivery is different from Reggie Nalder's but is so underplayed that he is some way from the bookish, charismatic figure of King's novel. A touch of the otherworldy weirdness of Roy Batty from *Blade Runner* (Ridley Scott, 1982) would perhaps have been welcome here. Gone are any *Nosferatu* references and all vampires in the film have the conventionally wide-spaced front incisors. At the moment of his demise, he offers Ben 'Fame, money, women. Think, you're the writer,' to no avail. However, there is no real tension here and we have a close-up of his snarling face inter-cut with an internal shot of his heart as it is pierced by the stake and his blood slowly rises in droplets. He passes through all the people he has 'possessed' like the death of the T-1000 in the furnace in *Terminator II: Judgement Day* (James Cameron, 1991) and then through a mixture of CGI dissolves and superimpositions, his face breaks apart.

There are inconsistencies in this version, apart from Susan's manifestation as a vampire and why she does not die when Barlow is staked. Why some vampires are capable of human feelings (Ed's for Eva and Susan's for Ben) whilst others remain bloodsucking monsters,

is not clear. Those vampires left at the end suddenly look and move more like Romero zombies than any manifestation of vampirism in the film up to this point. Exactly why Ben is imprisoned is not clear (other than to motivate Floyd's approach through the vent). He was the one attacked and the Sheriff admits as much when he asks Ben in the morning, 'If you want to press charges...?' Callaghan's accent suddenly becomes much more Irish in sitting with Ed and proposing a toast to his forthcoming wedding, which might suggest a relaxation of formal language given the context but to slip suddenly into colloquialisms like 'mesself' sounds odd. Cody is clearly bitten by Marjorie Glick and yet develops no vampire tendencies. The administering of a tetanus injection straight afterwards, if vampire lore is to be believed, would make no difference. The mini-mystery of Barlow's exact location is strung out a little (at one point using the idea of the school basement as in *A Return to Salem's Lot*) and before the final staking scene, it is not clear why the saw blade onto which Cody falls is running and why they did not hear this before.

Those set-piece scenes, which work so memorably in the Hooper version (the journey with the crate, the Glicks' visitations to Danny and Mark or Mike's graveside epiphany) are present as the palest of echoes here. It is as if Solomon has to cover those scenes but only devotes the barest of attention to them, knowing that he cannot improve them and so concentrates his efforts elsewhere. Hooper's careful picture composition and editing to create tension, find no equal here. Generally less sophisticated methods to create tension are used, such as sudden noises or objects appearing in the frame. The journey with the crate seems just more 'obvious' from the coffin-like shape of the crate to entering the house itself (which happens much earlier here than in the Hooper version). There is the speeded-up shot of an approach to Floyd as he reaches the top of the stairs as if some spirit is rushing up to him, but nothing comes of this. Outside, he looks in a parked car at a suspicious package and is startled by the sudden reflection of Straker looking down at him from above but this does not generate the same sense of unease as the sequence in the earlier film.

The visit of Ralph to Danny is transposed to a hospital scene. There is some tension created by the distortion of Ralph's face pressed up against the semi-transparent curtain that surrounds Danny's bed. Visible on more than one side at a time and accompanied by ghostly whispering, these images, shown through Danny's point-of-view suggest his confusion, leading him to invite the creature in. We see in close-up, two hands with pointed, non-human fingers, pull the curtains apart and then Danny's face in terrified close-up, the frame frozen to the accompaniment of a monitor flat-lining. It is quite effective but makes no attempt to generate gradual tension like Hooper's film. Indeed it is closer to the sudden attack on Floyd in the jail from the previous film – some kind of doorway is opened, we see the vampire (albeit only in part here) and it attacks. The discovery of Danny's body is less dramatic than in Hooper's film and instead of whip pans, we have Cody slowly drawing down a blanket to reveal the wide-eyed, shocked face of the victim.

Mike's scene at the graveside is greatly truncated from Hooper's version. He still jumps into the grave, this time from a mechanical digger and due to the sound of his mother's voice and the imagined sight of her eyes looking at him, but with much less ceremony

and without the Hooper's gradual otherworldly sense of dread. What does work here is Solomon's unwillingness to give us the expected sight of the vampire itself and he cuts from the opening of the coffin to a graphic match of Mark opening a box in which he keeps one of his action toys. The transition foreshadows the vampire's visit to Mark and underscores that he will be able to resist by using his knowledge from such toys. Danny's attempted visit to Mark is dealt with in almost cursory fashion. With the clear use of a blue screen, no mist to obscure our vision, it is almost a fairly straight question-and-answer exchange. The vampire asks if he can come in, Mark says yes and then burns him on the cheek with a crucifix taken from one of his model figures. There is no real fear shown on Mark's face, (the cables are a little too obvious in Danny's progress through the room with his back legs rising higher than his torso) and it is almost as if he is 'wishing the vampire away' like Emery with the ghosts in *Rose Red*.

The morgue scene is not particularly disturbing at all. Cody confesses his blackmail problem to Ben while waiting for something to happen but all that disturbs their conversation is a hand flopping down from beneath the sheet, which then falls away completely to reveal Marjorie Glick, still lying, who turns her head 90 degrees to look at them. There is a little example of her body floating without a visible means of support (reminiscent of the levitation of Linda Blair as Regan in *The Exorcist*) but here this feels more like a cheap magic trick and her make-up belongs to a standard costume party (she is not pale at all). Her demise, flying up to the ceiling, where she apparently disintegrates into dust, her clothing falling back to the floor, sets the pattern for the subsequent staking of Mike, Susan and Barlow. The confrontation with Straker is less powerful than the original. He is prepared enough to have an alarm system to alert him and he accuses them of trespassing and vandalism with a wild stare before grabbing the gun from Susan's hand and hitting Mark with one of his own stakes. Straker stalks Susan who cowers before him and he delivers the line 'Time's up' before we cut to a long shot of the house and hear Susan scream.

Barlow's appearance at Mark's house uses the same tropes of blown-in windows as in Hooper's film but instead of rising from the floor like Reggie Nalder, we see Rutger Hauer on the ceiling in a crucifix pose. He flips over and crawls across the ceiling like a fly, unnaturally quickly. He shows the same disregard for human life but uses slightly different methods, lifting Mark's mother up by her hair and spinning her body to break her neck. It is sudden and shocking but somehow not quite so brutal or perverse as the knocking together of heads of the original version, which both makes Mark as an orphan in a second but also uses his parents' own bodies as a murder weapon. A few more seconds are devoted to Barlow's 'seduction' of Callaghan who is forced to drink blood and is not killed but left to serve. His wavering question 'Is there a god?' is answered by Barlow's 'Whoever feeds you, is your god.'

However some scenes work better than in Hooper's film. The chase of the boys through the wood is shot either on location or just in a higher quality set without dry ice. A clearly-human figure grabs Ralphie and pushes him under the frozen pond, creating the effective shot of a close-up of the face of a small figure under the ice, their flashlight still on. The

scene where Floyd runs into Duds on the street seems straightforward and after greeting him, Floyd moves on but his progress is blocked by Duds somehow 'whooshing' magically around to be in front of him again. Before Floyd can process what he is seeing, Duds moves out of the frame only to suddenly make the same unnaturally-fast movement to be behind Floyd. With the simple statement, 'I need some food, Floyd,' he bites him. There are moments of restraint and teasing knowingness too in the film. Marjorie Glick answers her doorbell and on opening the door, she looks right at the camera but instead of cutting to what she is looking at we only see a grey blur and hear a child's voice. Later Mr Glick is woken in the night by his wife apparently fitting. The camera tracks across her and at the moment that he flicks on the light, we see Ralphie kneeling by her bedside, feeding from her wrist before lunging at him. It is a shocking image, only implied in the original film where there was mention of them visiting the morgue to explain how Marjorie became a vampire and is strongly reminiscent of the scene in *Night of the Living Dead*, when a daughter attacks her own mother.

In Matt's house, we see his eyes flick open at strange noises coming from upstairs. The camera tracks back to take in his alarm clock, showing 1.33 am. He gets up slowly, crosses the room which we see from his point-of-view, approaches the front door, puts his hand up to the latch and (like Mark in the first version) flicks it shut. Later Matt and Susan hear further noises and he goes up to investigate. We cut between foot-level shots as he stalks towards the room, wincing en route as he steps on a squeaky board, and his point-of-view looking down the corridor. We hear his breathing becoming progressively heavier and louder (preparing us for his heart attack) and Susan's complaining from downstairs where he has told her to stay. He pushes the door open and in an over-the-shoulder shot we see into the room, partly obscured by his head. The room is empty in a momentary anti-climax. However he pushes the door a little further and there stands Mike. In an interesting twist, the same dialogue that Geoffrey Lewis as Mike Ryerson had delivered so menacingly in Hooper's film, alters its meaning. Mike looks at a nearby mirror and sees he casts no reflection, and cries out twice 'Look at me' but here, in conjunction with 'Look at what's happened to me', the effect is of a piteous rhetorical question. He is not aware of what he is and Matt has to deliver the apparently impossible line, 'You died'. Like the replicant Rachel in *Blade Runner*, there is some poignancy in recording the moment at which a creature/entity realizes that it is not human.

Icons of small-town life like the school-bus, are brought back from the novel and the sadistic bus driver, Charlie Rhodes, is realized with big curly hair in a tongue-in-cheek allusion to Otto from *The Simpsons*. The exact nature of the photos that he has in his bus are not clarified (whether porn or atrocity pictures from Vietnam), neither is his punishment clear as he drops out of the narrative only to appear at the end as a possessed vampire. However, the use of vampiric children, climbing over the seats and particularly crawling across the ceiling, is an effective sequence, albeit their thunder is somewhat stolen by Barlow who has performed the same stunt a little earlier. The idea of breaking more than the rule about sitting quietly and gaining revenge on a sadistic figure who seemed to take pleasure

in putting kids out of the bus miles from home in the snow or using his dog to sniff out, not drugs or guns but those who foolishly make a joke, seems an example of poetic justice here. The sequence where the kids inside the bus crawl towards the camera upside-down on the ceiling is a conscious reference back to the literary heritage of the narrative. Dracula has the ability to scale walls, visualized in previous adaptations of Stoker's novel sometimes effectively, sometimes laughably (the effect of making a character look like they are apparently climbing a wall by placing it on its side can be seen in the TV series of *Batman* (multiple directors but mainly Oscar Rudolph and James B. Clark, ABC, 1966–68) and parodied in the Eminem video 'Without Me' (Joseph Kahn, 2002). The film borrows the bus motif from the lamentable first sequel, which had featured a busload of unwitting characters diverted through the town so that they could be killed in front of the hero to show what happens when he breaks his word. At the end in that film, the protagonists make good their escape on the bus with the remaining vampires pressing at the windows zombie-style but they are all burnt off (rather luckily) by the timely appearance of the morning sun. By 2004, developments in special effects (particularly costumes, modelling and CGI technology) had already allowed predatory creatures to be shown scuttling along walls and ceilings in films such as *Aliens* (James Cameron, 1986), *Alien 3* (David Fincher, 1992) and *The Mummy Returns* (Stephen Sommers, 2001) respectively.

In prison Floyd talks to Ben down an air vent and we cut between point-of-view shots down the vent with their voices distorted by the echo. Ben suddenly hears mention of the Bloody Pirates, the gang he had wanted to join in taking the dare to enter the Marsten House. We cut between Floyd's point-of-view making his way down the vent and a shot of his foot disappearing into it. We hear him grumbling that he has broken his collar bone but the really powerful shot occurs as we cut from Ben who has been resting his head against the vent to what he sees as he turns in response to the voice that seems to be getting louder. We see a distorted picture of red-eyed Floyd inching towards him and then the sudden slap as his face presses up against the grille, motivating Ben to scramble back in fear. These are simple enough effects but in combination they work well. The concept is not new and appears twice in the character of Eugene Tooms (Doug Hutchison) in the very first series of *The X Files* (Harry Longstreet, episodes 'Squeeze' and 'Tooms', Fox Network, 1993), whose eyes also glow (yellow rather than red) whilst stretching himself into impossibly small spaces. The idea may also have been inspired by a comment by Howells in the novel of *The Green Mile* after seeing the mouse, that 'It's a good thing the cons can't make themselves small like that'.[17] The sequence with Floyd in the vent provides the dramatic climax for Part One from which we move via a 'flashbulb' cut to Ben retelling his story in the hospital and it provides enough motivation for the doctor (and by implication the viewers) to want to hear more. A further cliff-hanger is created by the appearance of some hands into the frame around Father Callaghan, checking for signs of life but at this stage we do not know who this is or if their motives are friendly or hostile. In addition, Ben's condition is defined as 'touch-and-go', meaning that we could be listening to the last words of a dying man – which is how it transpires in the end.

There is an apocalyptic feel to parts of the film, especially in the introduction to both parts. The slow motion titles with images of human habitation abandoned (a wheelchair, a mail trolley, and a shopping cart all tipped over), shot in black and white, feels like a montage of a catastrophic event that has already happened. The narrative point-of-view in Ben's voiceover is describing a day, when everything was actually dead but people did not yet realize it. It is slightly reminiscent of the opening of *American Beauty* (Sam Mendez, 1999), also accompanied by a similar first-person voiceover, although in that case the 'death' is based on one individual and their family, whereas here it is the death of a community (see Chapter 5). The casting of Lowe, who had played Nicky Andros in *The Stand* (Mick Garris, 1994) adds to the apocalyptic feel and the shift from black and white to colour as we track past the gas station, echoes the juxtaposition of Armageddon flashback scenes in *Terminator II: Judgement Day*, where a contemporary narrative is also underpinned by a society that does not know that it is dead already.

Like Craig Baxley's *Storm of the Century* (1999), (which also uses close-ups of a flashing warning traffic signal swinging unnoticed above the town, conveying a lack of attention by the residents to an oncoming disaster) the film explores the dark underside of small-town life in a way, which the Hooper movie did not. The presence of the McDougalls and Duds are examples of a social underclass, excluded from participation in the wealth of the community or country at large. The glimpse we have of alcohol-fuelled domestic violence in the McDougall trailer leads to hospital treatment for the baby but also highlights blackmail as the only way out of such conditions. It is an index of their hopelessness that vampirism seems tempting. As Ben solemnly notes, 'beneath the postcard camouflage, there's little good in small towns. Mostly boredom, interspersed with a dull, mindless, moronic evil.' From this line we cut to Straker declaring 'We love them,' which hangs ambiguously for a moment or two before he clarifies that he is referring to architecture, 'these brick walls.' Matt asserts that there is more good than bad in the town but this faith would seem to be misplaced. Granted, with the addition of Father Callaghan and Cody, this version shows a small group of characters who stand up to the vampires but the two additions are morally-flawed characters, and the fact remains that here the vampires vastly outnumber the forces of good and they do not all conveniently die at the moment of Barlow's staking (and yet why the vampires around him do, is unclear).

As in the earlier film, the forces of law and order flee the scene, looking after themselves first rather than their civic duty. The deliberate and wilful blindness of the community is stressed via Ben's solemn voiceover – 'they did not look out their windows […] that above all else'. Like Mike Hanlon in *It*, Ben moralizes that 'you stay because a small town knows you and therefore owns you.' There is perhaps though an element of snobbery in Ben's approach to the town. His writing talent and ability to capitalize on this have allowed him to move away and actively exploit the townsfolk for material. As Barlow notes at the end, Ben could be seen as the real vampire here. In some ways, the film highlights a truism set out at the beginning, when referring to property agent Larry Crockett, who like his neighbours 'relies upon his neighbours to keep his secrets'. One of the consequences of the vampirism

is a greater willingness to look small-town life in the face as Barlow challenges Callaghan to 'tell the truth and shame the devil'. Things fall apart in Jerusalem's Lot because of the fragile tissue of lies upon which the façade of respectability stands. Cody is weak in the face of sexual temptation, compromising his professional standards, Callaghan is a not-so-secret drinker, Crockett has done a property deal with Straker inviting the evil into the town for material gain. Even Ben is living a lie. After discovering the body of Hubie Marsten and his murdered wife, he gains sympathy as a victim but secretly believes (wrongly as it turns out) that he is responsible for the death of a child at the same time by his inability to raise the alarm. Only Susan appears to be devoid of secrets and possibly why her character appears flat by comparison with others (Ben describes her at first as 'an interesting blond' and she does not really develop much from there).

There is a more believable sense of openness to the ending. As Cody says to Ben, 'This isn't going to be over today.' and the logic of their position would require them to do what they did to Mike, i.e. a horrific staking process, hundreds of times over. Apart from the sheer logistics, as Cody notes, it would drive them mad. It seems clear that any victory over the forces of evil in this film, can only be seen as symbolic and pyhrric. More precisely, the doctor confronts Mark at the door of the hospital where he is trapped and claims, 'I don't believe you,' but follows this with the admission 'I can't' and lets him out. This is a concrete representation of Todorov's notion of the fantastic – for the doctor to admit the tale is true, would mean a re-evaluation of everything upon which his life, one based on scientific fact, rests. The pause at the door reflects the key moment of hesitation during which all things are possible – in opening the door, the doctor is accepting that the events could have happened and all that we hold to be empirically true in life, may well not be. The closing shot of the film as the camera gradually cranes up from medical teams uselessly trying to save Ben's life, makes him not only smaller but almost claustrophobic like Floyd at the end of the vent in prison. Such feelings may not touch Ben by this stage but it diminishes the stature of human existence, especially when accompanied by his solemn final words: 'And in the dark, the town is yours and you are the town's. And together you sleep like the dead, like the very stones in the old north sea.'

There are some interesting shots, such as Sheriff Parkins (Gillespie in the earlier film) practising his golf swing right outside the police station (making ready to abandon the town for leisure in Florida), Callaghan shot in low angle through the water of the font as he fills miniatures with holy water (his faltering faith the prism through which we might judge his character) and the striking rotating low angle of the full moon, shot through trees. The helicopter shot of the town, encompassing the burning house and the vampires closing in on Callaghan encapsulates simultaneous action well.

There some examples of effective dialogue. At the end of a worried query by phone as to the whereabouts of her son, Marjorie Glick says in an offhand way to fellow parent Mrs Petrie, 'We'll have to meet' to which the other responds 'That'd be nice'. It is only when Mrs Glick has replaced the receiver that she mutters to herself, 'Not in this life'. It is a small touch but a nice one nonetheless and also serves to foreshadow Mrs Glick's vampirism. There is a

certain playfulness about horror conventions in some of the dialogue, such as Callaghan's musing as they approach the Marsten House, 'It would have been a little easier to accept if you had arranged for a thunderstorm or a power failure,' or Susan noting earlier, tongue-in-cheek, that 'Now we're stuck with Matt Van Helsing' and later wonders, 'What if Barlow's just an ordinary serial killer?'

The differences in Solomon's version, interestingly, do not necessarily produce a better version, serving to underline a fundamental point about the adaptation process. Simply re-instating edited material does not necessarily produce a more 'faithful' film. As Bill Phillips, the screenwriter of *Christine* (John Carpenter, 1983), notes in a interview for the DVD, 'reading a book is a 20 hour experience, watching a film is a two hour experience. Something's gotta give'. Solomon may have included some new material but in doing so also has to, as dictated by the nature of the medium, excise other material. What we are left with is a *different* version, not necessarily better or worse overall but with its own strengths and weaknesses.

The Night Flier (1997)

> Never believe what you publish. Never publish what you believe.
>
> (Richard Dees)[18]

The film develops vampire lore slightly with light aircraft being the mode of transport for the night-time killer who carries a cargo of deathly, parasite-infested soil with him. The plane's blood-red interior, becomes a coffin-like structure and the monster appropriates Bram Stoker's name for Dracula's acolyte (Renfield) and the Christian name of the actor who played the part in Tod Browning's *Dracula* (1931), Dwight Frye. That said, *The Night Flier* is less about vampirism per se than fractured identity; less *Dracula* than *Jekyll and Hyde*. King's short story upon which the film is based, leaves open the possibility that Dees is the killer, an alter ego which he is disavowing as in *Secret Window* and *The Dark Half*. King describes Dees (Miguel Ferrer), who first appears in *The Dead Zone* (David Cronenberg, 1983) trying to get Johnny Smith to write a psychic column for *Inside View*, as 'the essential unbeliever' who is forced to confront a truth that is stranger than the fiction he writes.[19] Director and co-writer Mark Pavia takes this a few stages further, primarily in Ferrer's portrayal of the central character and his gradual elision with the enigmatic vampire figure, dubbed 'the Night Flier'. King's basic concept, and the film based upon it, owe their premise to *The Night Stalker* series (Jeffrey Grant Rice, ABC, 1974), featuring Carl Kolchak (Darren McGavin) as a world-weary, noirish reporter tracking a series of murders, apparently committed by a vampire.

The film opens with an attack on an airport worker inspecting a plane that has landed unannounced at a small airfield. We share the victim's point-of-view as he sees a large silhouetted figure with a high baroque collar and a cape, which he flaps like a bat. The

cut to the second scene (and also later at the end of Dees' barroom speech) uses a similar cape as a wipe, linking the monster with the tracking shot through the office of scandal magazine, *Inside View*. This leads up to our first sight of Dees, shot in slightly low angle and momentarily, like the vampire, with a similar black, rounded collar, also up, on his bomber jacket (the same shape as Claire's grave later and the shots of Dees on his celebrated front pages). He is looking at a female reporter in a fairly predatory way, before walking forward, grabbing a copy of the magazine and demanding 'Where's my picture?' The framing, visual style and manner strongly associate him with the vampire from the outset, especially since his brand of journalism involves exploiting human suffering and producing spurious stories for vicarious pleasure about alien abduction and 'attacks on the handicapped' but 'only if there's some kind of kinky sex in there'. The parasitical nature of tabloid journalism is made explicit in the speech of pretentious editor, Merton Morrison (Dan Monahan), who claims the magazine is 'a cultural microscope' and 'the collective unconscious of the American populace', eliding popular journalism with a Robin Wood-influenced description of the horror genre. In a sense, Morrison is the true horror here, luxuriating in the prospect of the story and appropriating dialogue which King originally gave to Dees – 'the fatties in the supermarket are gonna love this. God, I hope he kills more people.'

The similarities between Dees and the monster become more obvious as the film progresses. Both work alone, fly at night, seek out scenes of gore (we see him in the morgue, where he literally seeks out the body under the sheet) and Ferrer's receding hairline, furrowed brow and slightly jowly look, make him a visual counterpart to the vampire. In the graveyard, as Dees smears blood across his face, a plane buzzes overhead, underlining a closing connection between them as they now appear in the same sequence and we cut between Dees and the monster in profile, both in close-up. In his motel room, Dees looks up to see a face pressed against the curtains and then in an over-the-shoulder shot, a blurred monster looks down and reaches out for him before he wakes up. Although this appears as an unsignalled dream sequence, the two figures have now occupied the same screen space. With a shot of the bottle by the bed, it is tempting for him (and us) to see this as just a projection until he reveals the message, 'Stay away' apparently written in blood, deepening the connection (albeit an antagonistic one) between the two, although Dees himself tries to deny that possibility, blaming the writing on 'fucking hicks'.

The first person, Chandleresque talking into the recorder, both in his motel and in the plane, constitutes a slightly clumsy on-screen voiceover as Dees begins to address the Night Flier directly and by his first name, Dwight. Dees clearly sees the monster as a 'one-way ticket back to the front page', ironically showing similar exploitative tendencies, and anticipating his later tricking of Kathy (Julie Entwisle). Like the monster, he 'likes to linger', such as at the pile-up and when Dees murmurs to himself 'sick fucker', he might equally be talking about himself. He poses as an FBI agent, complete with fake ID and breaks into a crime scene. Like Will Graham (William Peterson) in *Manhunter* (Michael Mann, 1986), we cut between the slow exploration of a crime scene and the initial discovery of a murder and like Graham, Dees is showing progressively more of the predatory nature and tenacity of his quarry in

order to capture him. Like Mann's film, which also features an unprincipled journalist killed by a serial killer whom he thinks he can exploit, the key clue lies in fragments of a mirror – here showing Dees' fragmented reflection, momentarily making him look like his alter ego (an effect repeated shortly afterwards in his payphone reflection). The pursuit picks up pace as Dees chases after a figure in a bar, only to grab the wrong man and then pursue a flapping noise round a corner, only to be met by the US flag and a small plane swooping overhead.

A loner, Dees has his camera and his stories, which he claims are 'all I need'. He is a world-weary, cynical, hard-drinking, tough-talking figure akin to the stereotypical burnt-out cop of film noir. Morally, however he is quite removed from this. He dubs the pile-up 'bonus day' before adjusting a recently-dead body with his foot to get a better shot. We see him prepared to desecrate a grave, kicking it over and grabbing some dead flowers, in order to get the picture he wants and then openly lie about it. He does not react to Morrison's criticism that his work 'has been lacking' but later out in the car, he repeats the phrase to himself, suggesting the words have stung him. He is clearly pleased that Morrison gives the story back to him and seems quietly satisfied with the soubriquet, 'the godfather of gore'.

The pursuit of Dees by ambitious rookie journalist Kathy Blair begins from the first time they meet, her eyes following him as he walks out of the office, apparently uninterested in the vampire story. She follows him outside and the camera cranes down to shoot through her back window as she stakes him out. Although in the beginning she appears more innocent and a little prissy, she rips up her air tickets in a fit of pique (shown from above in slow motion like Sharon Stone tossing chips in *Casino* [Martin Scorsese, 1995]) at having to hand the story back and most tellingly, as Morrison tells her to 'beat' Dees she has to 'play' like him, i.e. dirty. The montage of Kathy and Dees pooling their resources neatly juxtaposes the two approaches in their phone technique ('I'll hold'/'No, I won't hold') and their methods converge as both become equally aggressive and she grows closer to the role of his successor, which she assumes by the end of the film.

The denouement occurs *Casablanca*-style at an apparently-empty airport at night, where the hero and anti-hero finally meet face-to-face and reach an understanding, if not a beautiful friendship. Dees parks his plane, the same model, next to the vampire's black Cessna, inside which he finds copies of *Inside View*, suggesting the parasitic nature of the magazine and also that Dees is to be used as a cover to escape (although the idea that he would calmly search the small enclosed space of the vampire's cockpit, dripping with blood, stretches credulity).

The early shots of the caped figure walking from the plane as remembered by an eye-witness, makes the monster look more like someone going to a costume party. However, the more powerful gorefest at the airport, including one man missing an eye, which sits neatly on a nearby crisp packet, finally freaks Dees out (unconvincing in both book and film) and panicking, he slips in a puddle of blood. Cleaning himself up in the bathroom, he sees a figure urinating blood and the mirrors are smashed one by one until the vampire stands right behind him. King's story ends here, content to parallel the two figures but Pavia pushes further to *converge* them, so that the reflected image of Dees' face is framed by the cape and collar of the

monster. We cut between Dees in the mirror, now dressed as the Night Flier and a side shot where we can see the monster more clearly, although it is still unclear whether it is a projection until Dees looks down and sees the creature's shoes. The dialogue here becomes clumsy as what was suggested is made overt ('We have a lot in common, you and I'), paralleling sections of overwriting in the short story where, for example, we are told explicitly that Dees looks like a vampire.[20] Dees commands the creature to show his face, which he does, declaring, 'Your whole existence has been a search for me'. In a sense, this is true as it is only now that Dees gains the fame and notoriety which he has been seeking throughout his life. The creature roars and we cut between a close-up of his unnaturally-extended jaws and Dees' screaming face as he is forced to drink blood. He is shown a vision of hell as all the victims re-emerge as sepia zombies in a sea of dry ice and start to close in on him. As in *The Shining* (Mick Garris, ABC, 1997), we cut from a subjective, ghostly vision to a more colourful present, as cops confront Dees flailing wildly (a little like Jack Torrance) with a fire axe and he is shot down in slow-motion, accompanied by a melancholy orchestral score. This however is not a tragic death. Dees is an interesting character but the film shows much more of the monster in him than the human, which might have encouraged us to feel his demise more keenly.

Kathy sees the monster walk to the plane and so knows the two figures are distinct but follows the Fordian advice and 'prints the legend'. When a cop asks who he is, she replies 'We call him the Night Flier', completing the convergence of the two figures and giving him the front page coverage he craves so much. Superficially, *Inside View*, is an ironic title, considering the mix of tabloid scandal and sensationalized fictions it prints. However, in its final cover here, it does show a partial truth of what Dees has become. We zoom back into her picture to see her by-line, now reading 'Kathy 'Jimmy' Blair', appropriating his dismissive nickname as part of her professional persona.

There are a few effective sequences. The short scene with the mad dog on the roof, apparently ready to jump on Dees before he reaches his car but then suddenly disappearing from view, works well as a sudden injection of drama. One of his first victims is seen from behind with his head tilted back before the camera comes around the figure, revealing that the head is barely attached to the torso. However, the plot has little real suspense. Superficially narrative momentum is created by the hunt for the monster but that is of secondary interest to the driven personality of Dees. Some of the transposition from story to film is quite literal but still works nonetheless. Pavia uses a number of shots tilting up to or down from, the sky, to begin and end scenes, suggesting the aerial source of threat. Also King describes Dees' sudden revelation that he could be the hero of the story (the 'idea went off like a flashbulb in his mind') and Pavia uses a flashbulb cut at the pile-up as Dees makes a subconscious connection between bloody corpses and his alter ego.[21]

At the end, a cop warns junior reporter Kathy Blair to 'keep your distance'. We see what happens if you do not, when the reporter becomes the story in the example of Dees' predecessor, Dottie Walsh, who kills herself and there is the strong suggestion that lengthy exposure to the sick side of society infects one's character. As a comment on the vampiric nature of tabloid journalism, the film is partly effective. King himself has often recounted

signing a book for one particular quietly-spoken fan, who gave his name as Mark Chapman, the man who went on to kill John Lennon. As Dees himself says in book and film, when you give blood you just get a cup of orange juice but when you take blood, 'you get headlines'.

Conclusion

In the wide-angle close-up the attack on Georgie, Pennywise suddenly sprouts fangs. Perhaps in the context of *It*, this works if Pennywise is supposed to represent what his victims fear most, i.e. a composite of icons of cinematic horror. However, placed in the context of other King adaptations, what this emphasizes more strongly is how King's monsters become compositions of *King's* cinematic horror icons. Like the slasher is the default generic setting, the vampire becomes the default monster setting in King adaptations, a tendency present in the fiction but emphasized more powerfully on screen.

In the case of Pennywise, this is married to a specific cultural fear of paedophilia and child protection and this is energized by a questioning of what is possible in the context of moving pictures (first in a blinking photo and then in speaking outwards and reaching outwards from the scrapbook). Pennywise is chilling because he problematizes borders, not just in the conventional sense of appearing and disappearing, fun and prank, but in the scrapbook scene, his actions question borderline states between characters and layers of reality *within the fiction,* of which they themselves seem unaware until brought face-to-face with the cinematically impossible – quite a radical concept for network television.

The adaptations accept a certain level of vampire lore, such as the need to invite vampires into a dwelling for them to enter, that they can be repelled with garlic, that they must sleep in the day in their own special graves/earth and that they can only be killed by a stake driven through the heart, while older 'sub-regulations', such as that vampires cannot cross rivers, are allowed to fade into obscurity. King's conception of vampires is a far cry from the charming, cultivated seducer of Christopher Lee's incarnation of Dracula. There is little complexity to the motivation either of individual vampires or Barlow and his monster – anyone infected simply obeys their master. Although there are unsettling elements (children attempting to feed on their parents as in *Night of the Living Dead* , in examples such as the morgue scene in *Salem's Lot*, the vampires seem closer to the George Romero's zombie movies, slow-moving creatures, shuffling forward arms-outstretched. There may be the aspiration to a modern-day *Dracula* but the dramatic focus shifts, reflected in the title, from a single iconic individual to a place and a milieu.

The vampires that appear in the films in this chapter are primarily monsters, sources of fear, lacking in sophisticated motivation and thereby unable to provoke strong empathy with an audience. Problematically, for King, he seems repeatedly bound to subgenres which have become largely shorn of their ability to shock or scare, most notably the zombie and vampire movies. Cross generic hybridity, such as the global success of Angela Sommer-Bodenburg's children's book *The Little Vampire* (1979) (adapted for television in Canada in 1985 and in

Germany in 1993) or the more literary parodies such as *Pride and Prejudice and Zombies* (Seth Grahame-Smith, 2009) and *Abraham Lincoln: Vampire Hunter* (Seth Grahame-Smith, 2010), all reflect consumers, of an increasingly-young age, who are willing to use generic conventions in a playful rather than fearful context.

Notes

1. John Wayne Gacy, cited in Mark Dery, *The Pyrotechnic Insanitarium: American Culture on the Brink* (New York: Grove/Atlantic, 1999), p. 72.
2. Ibid.
3. Ibid., p. 80.
4. See Browning (2009: 19–21) for my discussion of the logic of the parergon.
5. Stephen King, 'Secret Window, Secret Garden', in *Four Past* Midnight (New York: Viking, 1990), p. 305.
6. Alan Silver and James Ursini, *The Vampire Film: From Nosferatu to Bram Stoker's Dracula* (London: Limehouse Editions, 2004), p. 205.
7. Robin Wood, 'An Introduction to the American Horror Film', in Andrew Britton, Richard Lippe, Tony Williams and Robin Wood (eds.), *The American Nightmare: Essays on the Horror Film* (Toronto: Festival of Festivals, 1979), p. 14.
8. Stephen King, *Salem's Lot* (New York: New American Library, 1975), p. 30, 137 and 218.
9. Ibid., p. 158.
10. Ibid., p. 66.
11. Ibid., p. 53.
12. George Beahm, *Stephen King From A to Z: An Encyclopedia of his Life and Work* (Sydney: HarperCollins, 1999), p. 186.
13. Stephen King, *Salem's Lot*, op. cit., p. 296.
14. Magistrale, op. cit., p. 181.
15. Ibid., p. 183.
16. Stephen King, cited in Silver, op. cit., p. 151
17. Stephen King, *The Green Mile* (New York: New American Library, 1996), p. 57.
18. Stephen King, 'The Night Flier', in *Nightmares and Dreamscapes* (London: Hodder and Stoughton, 1993), p. 138.
19. Stephen King in ibid., p. 822.
20. Ibid., p. 122.
21. Ibid., p. 134.

Chapter 2

Stalk & Slash?

> Welcome to *Sesame Street*. Today's word is expiation.
>
> (Ollie Weeks in *The Mist*)

The films in this chapter seem to have collected about them virtually every imaginable cultural signifier of low status – low rather than high budget, unknown actors rather than stars, limited rather than varied locales, and not just horror but apparently linked to a particularly problematic sub-genre, identified with exploitative violence – the slasher movie. Add the name of Stephen King, a 'straight-to-DVD' exhibition route and routinely negative reviews, and the reasons for critical neglect seem less strange. The fact that the DVDs for the last four sequels have no extras to speak of, suggests that these are films with little to say. Critical work, which has done much to reintegrate the slasher movie into the critical field, such as that by Vera Dika, does not easily apply here. There is no revenge motif, no single Boogeyman like Michael Myers, Freddy Krueger or Jason Vorhees, and little by way of coherent character motivation. These films then are more slash than stalk, except in relation to the fields where they take place. However, this chapter does not seek to rehabilitate the series as masterworks of cinema but to question more closely how the films work and why they exist at all.

Children of the Corn (Fritz Kiersch, 1984)

Ten dead bodies. One dead dog. No breasts. One motor vehicle chase. About two pints blood. Heads do not roll. Hands roll. Excellent groundhog-mushroom-cloud monster.[1]

It would be easy to dismiss this film and those that follow in its wake as low-budget derivative dross. In 1985, King himself lists it at number six in the top-ten worst films of all time.[2] Collings (1986) asserts rather than argues that 'the film version missed on almost every count' and Magistrale (2003) terms the original film and its sequels as 'unnecessary permutations' and 'difficult for an adult to watch – much less appreciate – and nearly impossible to write about'.[3] However, such literature-based approaches, skate over how such films actually work, assuming the written word to be inherently superior. Certainly it is derivative – the basic premise is clearly influenced by the powerful short story 'The Lottery', (Shirley Jackson, 1948) (King frequently cites Jackson amongst his favourite authors), which dramatizes a barbaric and murderous sacrifice act to palliate unseen gods and secure a better harvest in an agrarian community. There are also cinematic similarities with *The Wicker Man* (Robin Hardy, 1973) (an isolated, agricultural-based cult, whose practices involve child sacrifice drawing in a stranger) and *Village of the Damned* (Wolf Rilla, 1960) (a village is taken over by a group of destructive children, although this is under an extra-terrestrial influence rather than a dogmatically-religious one). Certainly it has plot-holes – is it really credible that a sizeable village in modern America can 'disappear' from the collective radar? Certainly the characterization is paper-thin and the acting performances are unlikely to win Oscar nominations.

Critics of the film suggest such King adaptations have a 'straight-to-video' feel.[4] However, this is not necessarily a failure. The *Children of the Corn* and, to a lesser extent, the *Sometimes They Come Back* series are made purposely for this market. Even if it does show the law of diminishing returns critically, it remains the only film adapted from King's works to have spawned a further *seven* films at the most recent count, representing a sub-genre all of its own (in contrast to the sequels to *Carrie* [1976] and *Pet Sematary* [1989]). What it does have is a simple premise of an isolated situation, into which a virtually limitless sequence of outsiders can unwittingly wander. Cornfields themselves, provide a low-budget, literal means by which supernatural entities appear and disappear, in the act of walking into or exiting a field, which renders a figure invisible or vice versa in seconds. This is used elsewhere – benignly in *Field of Dreams* (Phil Alden Robinson, 1989), directly referenced in the rejected subtitle of the fifth *Corn* film, or to suggest a brooding otherworldly presence as in *Signs* (M. Night Shayamalan, 2002). As the plot dictates that children are sacrificed at the end of their eighteenth year, there can be a succession of instantly-replaceable child actors. The premise casts the main part of film as a chase sequence, requiring no complex back-story or character motivation and an episodic structure, which can facilitate speedy shooting. Without stars, elaborate sets, or the need for particularly complex special effects, it has an inherently limited budget, making a commercial virtue out of its straight-to-video nature. Its main effect, the cornfields, are ubiquitous in a number of States and given some planning, filming can be swift enough to work around harvest schedules. Moreover, it can explicitly or implicitly trade on the familiarity if not the critically-acclaimed nature of the King brand. The blurbs on the back of the DVDs, especially parts 4–7, offer thrills for horror fans, not in-depth characterization or profound thematic statements. The film taps into fears about the ease of getting lost both in a uniform landscape and within a maze-like structure, (i.e. a cornfield)

and also articulates broader concerns about an overbearing religious ideology in the very heart of America. The *Children of the Corn* premise, of a society without the restraining hand of adults, both looks back to *Lord of the Flies* (William Golding, 1954) and forward to the current popularity of *Gone* (Michael Grant, 2008), although with the key difference that both these literary narratives are based around events that happen to the children outside their control, rather than deliberate actions, justified by recourse to Biblical scripture. The anachronistic existence of isolated, Amish-like communities, spurning twentieth century technology; religious radio stations completely dominating regional airways, alongside more bullish, survivalist groups, preparing for various apocalyptic futures, provide a credible and recognizable backdrop for regressive, ritualistic behaviour.

The opening sequence, especially the first image of an abandoned windmill looking like a crashed helicopter, uses several cutaways showing rural deprivation. This both anticipates the neglect of the land around Gatlin ('the nicest little town in Nebraska' a sign ironically tells us) but also possibly that the Bible Belt really is another world, economically as well as in its religious affiliations. The narrative is told initially in a first person voiceover by a small boy called Job (Robby Kiger). However after some point-of-view, low angle shots of his father at church and some background information, this narrator is almost completely abandoned, as a group of children attack and kill all the adults in a cafe under the direction of Malachi (Courtney Gains) from within and Isaac (John Franklin) outside, including Job's father. At the same time we see, via a bird's-eye shot, a little girl on her bed, later identified as Sarah (Anne Marie McAvoy) who subsequently starts to draw such scenes, suggesting she has some kind of telepathic ability. We zoom in and out from the drawings during the credit sequence, showing TVs being burned and corn planted and accompanied by the forbidding choral singing, which regularly returns when the children threaten violence. The sequence ends with a graphic match from her drawing of a yellow car outside a motel to the real thing. In conjunction with subtitles, this confirms the girl's prophetic ability.

In the motel, we see the legs of an unidentified woman. They are revealed as belonging to Vicky, (Linda Hamilton) and a standard horror/suspense motif becomes a romantic scene by a change in music and friendly outcome – she blows a kazoo in the ear of her boyfriend, Burt (Peter Horton), and offers him a birthday cake. However after a cringe-making dance and an attempted seduction, he rejects her advances, reminding her that he has many patients to see and we see tensions in their relationship in a flicker of disappointment and even perhaps anger in her expression. This is picked up later in the car when they are making fun of the religious service on the radio and Vicky says 'No commitment' to which he answers 'Amen to that'. A copy of *Night Shift* (1978) (the King collection containing the short story on which the film is based) is visible on the dashboard and it is an interesting question whether we are meant to believe that Vicky has read her own story in *Night Shift*. If she has, then this adds to the sense of inevitability and stupidity of her character; if not, this adds to the sense of a poignant, possibly tragic missed opportunity. Character development (linked to the incoherences in the plot) and hence audience empathy, rarely reaches such a level that we

feel such identification with either of the protagonists so we are left, as in *Cat's Eye*, with the multiple references as an intellectual game, a nod to the initiated.

The boy, who tries to escape through the corn, becomes disorientated, reflected in the handheld camera shots and we see the legs of a pursuer (a shot we will see a lot in these films) stalk and catch him. We see blood fall on the boy's case but like the cafe massacre and the later murder of the garage owner, the violence is mostly restrained and shown by close ups of a raised weapon and then some blood falling. In looking at the map, Burt does not concentrate on what is ahead and it is only when Vicky screams that he looks up and we cut rapidly to the boy standing in the road, holding his neck. From a crane shot above and behind the car, we see it strike a dummy, and skid to a halt. Burt tells Vicky to stay in the car, the first of three times he does this (and three times she disobeys him), signalling a disconnect between the pair, a feisty side to her character and of course, a standard *Scary Movie*-style genre convention. Like the opening sequence, there are a couple of shots of cornfields without music and although there is no obvious threat, Burt senses something and picks up a jack as a weapon. We have Malachi's point-of-view from within the field, watching Burt and using a hand to part the corn. Burt spots the boy's case (frankly unlikely) and walks in to investigate, shown in shaky, close handheld shots. In a reverse angle, we cut to Vicky in the car, watched in the background by Malachi, now clear of cover. The threat seems to increase with the shadow of a curved knife on the car, a quick shot of Malachi in the side mirror and Vicky getting out and approaching the body. She begins to apologize to the corpse, which suddenly sits up and we cut to Vicky waking in the car, problematizing the status of the last few minutes' action. This unsignalled dream sequence is effective but how Malachi's movements could be part of her dream, is unclear. We cut back to his point-of-view again, panning right to left as the car moves off.

Isaac's totalitarian regime works through a variety of tools of oppression – rituals, chanting slogans, blunt threats ('Question not my judgement') and carrying out purgative sacrifices to objectify and destroy. The children are forbidden music, games and drawing, which is why Sarah and Job go and play in their old house. There are clear inconsistencies in Isaac's rules, allowing Sarah to play with forbidden things because she has the gift of second sight and can warn them about coming strangers. He adopts the anachronistic language and speech rhythms of a Biblical preacher, (which Job says he used to be) using examples to persuade and the threat of Malachi as an 'enforcer'. He claims the sole ability to hear 'He Who Walks Behind the Rows', the mysterious god whom they fear and worship. Given Isaac's demagogue-like character, it is tempting to think of the whole cult as a manipulative power game for his benefit but the film turns slightly when it is clear that this is not just a travesty of Christianity, there *is* an entity in the fields. After the couple leave the garage, the owner's dog barks at the fields, clouds roll overhead unnaturally fast, and the mechanic shouts that he never told the strangers anything. In a sense, this adds validity to the children's actions but again a King narrative is weakened by a failure to even try and explain its supernatural premise. What is this entity? Is it the fire-breathing dragon that Burt sees in a child's picture? Where has it come from and what does it want?

The quality of child acting is really quite poor with the possible exception of John Franklin as the androgynous, helium-voiced Isaac. Malachi practises a mean stare for most of the film and has few lines to deliver, his snarling command to 'Seize them' being about as expressive as he gets. The power struggle between Isaac and Malachi seems fairly brief and the children switch allegiances without much explanation. Malachi may have killed Joseph without giving an offering and murdered the garage owner without thinking about their need for petrol but he understands the need to provide followers with actions rather than promises. Linda Hamilton, for whom 1984 was an important year with *The Terminator* (James Cameron, 1984) also being released, is adequate as is Peter Horton (who was briefly married to Hamilton) before his breakthrough role in *Thirtysomething* (ABC, 1987–91), apart from a ludicrously-theatrical trip and later walking straight into a beam whilst being pursued around the town.

There are a few effective shots. The couple's car is seen passing the garage a second time via an oblique reflection in a car window, from the point of view of one of the killers from which we pan down to a shot of a bloodied hand. The children's inexorable passage through the house is made more unsettling by cropping their shots so we only see legs and weapons held. Vicky asks Sarah about one of her pictures but we do not see it immediately. It is only when Burt returns, that we pan down to a sketch of a woman being taken to be crucified and he and we realize what is in store for her and the rotating shot from Vicky' point-of-view as she is raised on her cross, brings us face-to-face with a parallel rotting corpse.

The film' derivative nature can be seen in the shot of Vicky's face next to the door as an axe comes through it, almost identically to Shelley Duvall in *The Shining* (Stanley Kubrick, 1980). The surveillance culture of the children's cult, the rooftop call of 'Outlander' and finger-pointing at Burt in flight, echoes the remake of *Invasion of the Body Snatchers* (Philip Kaufman, 1978). The sacrifice of the children when they reach a certain age is a youthful version of *Logan's Run* (Michael Anderson, 1976) and the final manifestation of the monster (which in King's story is described as 'something green with terrible red eyes the size of footballs') looks more like the Id projection from *Forbidden Planet* (Fred M. Wilcox, 1956), with a roar that starts like an animal and ends like an aircraft landing.

Plot-holes abound. Why does Burt put the dead boy in his car and then, with only one other mention in the film, virtually forget about him? When his car is attacked by a group of children, why does Burt run *after* them and not away? Getting lost on backroads is one thing but is it credible that the couple would end right back at the same garage where they had just been? In John Carpenter's *In the Mouth of Madness* (1995), given a supernatural explanation this works, but here it just seems ridiculous. When Burt is looking for Vicky, the corn momentarily parts for him and for no particular reason, he steps in, only for it to close behind him. However, instead of gaining a dramatic incident from this, Kiersch throws away the opportunity and Burt just steps out again, for little clear reason. Uncredited scriptwriter Dennis Etchison asserts that 'authentic demonstrations of character are nearly always left out of the films made by others from King's works', claiming for example that such qualities were in King's original script for *Children of the Corn* but not in the finished film.[5]

The way closure is affected is fairly perfunctory. Burt discovers the so-called 'Blue man' had tried to burn the monster and so he floods the fields with gas and sets them ablaze. En route, he is snagged by some corn, from which Job cuts him free and perhaps most ridiculous of all, the boy escapes the mole-creature to return Burt's Molokov cocktail, giving him a second throw. King was involved, as with *Cujo* (Lewis Teague, 1983), in contesting script credit but ultimately the Writers' Guild of America awarded sole credit to George Goldsmith, who added an upbeat ending and two pairs of children – one who want to flee the cult (Job and Sarah) and one who wants to stay and dominate it (Isaac and Malachai), but whose ages between the first attacks and the main plot do not tally (thirteen years in the short story, three in the film, even though the children's appearance does appear to change at all). King was quite bitter about the arbitration process, claiming the script he was shown contained large portions of his work, even though it was not what appeared in the finished film. Earlier drafts by King (along with Harry Wiland) had featured a Vietnam subtext with Burt as a Vietnam vet and the events taking place in 1968, which do not resurface until the 2009 version. In the original short story, Burt and Vicky are both killed, Isaac lives and lowers the age of sacrifice to eighteen and several children walk into the corn, which remains a powerful force of evil. Rather than being sacrificed to an unseen He Who Walks Behind the Rows as in King's text, the film of *Children of the Corn* has the central couple escape alive with enough children free from indoctrination to represent a new nuclear family. The couple make some goofy remarks, completely out of sync with the tone of the preceding film, about how long Sarah and Job can stay with them, laugh and set off on foot for the next village, carrying their new surrogate family. There is no mention of the murderous trail of destruction they have just been through or the final attacker in their car who is comically despatched by slamming the door in her face.

The pleasures of such films rely on their repeated use of often quite predictable stalk and slash horror techniques. These range from the sudden noise (a rat squeak in the abandoned cafe), to turning and running into someone just off-frame (as Burt does in the abandoned house) to repeated cross-cutting between male rescuer and potential female victim. Placing children at the centre of the narrative reflects the youthful demographic of horror audiences. The style of the film is fairly typical, often using basic cross-cutting for simultaneous action and to generate suspense, for example when the couple separate and Burt goes to explore the town hall and Vicky stays in the house, we see several subjective point-of-view shots of him being watched and followed at the same time as Malachai and the others close in on Vicky. This alludes to the killer's point-of-view often associated with the stalk and slash sub-genre, but this device is abandoned fairly quickly and the identity of the force of malevolence is soon revealed as an indistinct group, not a specific individual. The pace flags terribly during the search through an abandoned house here and only eventually picks up with an increasingly-loud heartbeat on the soundtrack.

A year before the full-length *Children of the Corn*, a shorter, low-budget version appeared – *Disciple of the Crow* (John Woodward, 1983). It uses several techniques picked up by its successor, such as point-of-view shots from within the field at the accident, high

angles of deserted streets and a church scene picked up in the first sequel with the boy-leader signalling to his accomplices. The acting is clearly poorer, the budget lower and the editing more amateurish. However, it also has a few touches missing from the longer version, which are arguably more effective. Early close-ups of the crow, focuses on a known pagan symbol rather than an invented supernatural entity. We see a girl feeding a 'Dippy-Duck' toy with a blood-like red liquid, which remains unexplained but oddly effective. Vicky seems strangely attracted to the crow's head on the dagger found on the dead boy, which she proceeds to lick and kiss. The glimpses of children taking up positions in the background, the rapid cutting in the attack on Vicky in the car, and in particular her killing of an attacker (thereby motivating a revenge attack), are all elements found in the initial part of *Assault on Precinct 13* (John Carpenter, 1976) and in particular, the ending is left slightly open. The couple drive away but a cob of corn has been rammed into their radiator and an overheating sign starts to flash – the implication being that they will not get far. Burt also raises an enduring problem for the concept (how no one in the wider world knows about this) but also supplies a partial answer (unless the pagan god being worshipped approved matters).

Children of the Corn II: The Final Sacrifice (David F. Price, 1993)

What is all this shit about corn?

(Reporter to cameraman after trying to interview survivors about the massacre, in *Children of the Corn II: The Final Sacrifice*)

Although it took nine years for the first sequel to appear, they have been produced at regular two-year intervals ever since. Here, one of the main plot-holes of the first film (the reaction of the outside world) appears to be answered as the film opens with the discovery of mass murder in Gatlin. However, the media storm passes unbelievably quickly and it is left to a no-hoper John Garrett (Terence Knox) to investigate what we are told is one of the biggest massacres in American history.

Reprising the plot premise from *A Return to Salem's Lot*, an estranged father-son pairing are thrown together, the son full of foul-mouthed resentment, the father under pressure professionally (he tells of his former glory at *Newsweek* but now we see him mocked by rival journalists in a TV van) and seeking to make up for being a neglectful father in the past when his marriage broke down. Knox in this role looks like one of the Baldwin brothers but his acting is less impressive. His ridiculously-deadpan delivery into his handheld recorder notes there are 50 dead and 'lots of corn'. The preacher role is taken by Micah (Ryan Bollman), possibly for the sole reason that he has black hair and a slightly mean smirk, which he uses a lot in the film. Angela Casual, the landlady (Rosalind Allen), sporting the hair and overall style of Demi Moore in *Ghost* (Jerry Zucker, 1990), lives up to her name by providing token love interest, as well as a place for John and Danny (Paul Scherrer) to stay.

There are a few effective sequences. The badly-acted, poorly-delivered, waspish doom-mongering of former teacher Mrs Burke (Marty Terry) is redeemed by her slow crushing under her own house, causing her legs to stick out rather comically, in an effective horror parody of *The Wizard of Oz* (Victor Fleming, 1939). The repeated device whereby a character opens a blind only to find the window full of staring children is used a couple of times (at the town hall and the surgery) and is quite unsettling, not just in the sense of being watched but also we do not know how long they have been there. Stylistically similar devices are used for romance and horror. When Danny chases Lacey (Christie Clark) through the corn, alternating point-of-view tracking shots take us into a disorientated space but the upbeat music allows us not to fear for the characters. Their literal rolling about in the hay is romantic as long as they and we do not know they are surrounded by body parts. It is only when she complains of something underneath her and they pick out a dismembered hand that the music changes and the tone of the scene shifts. The shot of a group of children, fronted by Micah, who stand watching Mrs Burke's house, could be quite eerie but the tableau effect is held in static shot far too long. A sense of strangeness is often created more by simple, possibly unintended combinations. Danny walks through the fields at night after making an unsuccessful attempt to leave and as he walks towards the camera, a group of children emerge from the corn behind him but walk away in the opposite direction, without looking at him. It is an odd event for the character and the viewer too who might expect characters who share the same frame in this context to meet one another.

Methods of despatching include corn cutting the throat of one journalist and a stalk flying, javelin-style through the windscreen of a van to impale another in the neck. The town hall is surrounded and those meeting inside (including the Sheriff complicit in what is going on) are burned alive and the doctor meets a suitable end, stabbed by syringes and given a sarcastic lollipop (as he had given each child at the beginning). Reverend Hollings (John Bennes) is given a nose-bleed that becomes a fatal deluge thanks to Micah, sitting on the back pew, whittling away at a voodoo-style wooden doll. Mrs Burke's sister, a vocal critic of the youngsters is stalked by a group, headed by Micah who uses a remote control device to direct the woman's wheelchair into the path of an oncoming juggernaut. However, what could be horrific is rendered ridiculous by the *Thunderbirds*-style cutting to studio close-ups for hand motions, the clear dummy shot in slow-motion as the 'woman' supposedly crashes through a day-centre window and the final pay-off line, as an old guy murmurs 'Bingo?' Ultimately, Micah meets his poetically-just end dragged into the combine, thereby becoming a victim of the machinery against which he railed but also fertilizing the land. However, like the original film, there is the sight of an unexplained monster in his brief transformation into a monstrous creature just prior to death.

All the 'Corn' films express a distrust of the next generation, with whom the adults seem to have no connection. At the town meeting, one mother states that 'something evil has gotten hold of our children' articulating a sense of moral outrage at the taboos being questioned. However, as in the next sequel, there is a major leap between the preacher being mildly persuasive and apparently having everyone around him in thrall. Danny goes from mildly

disgruntled teenager to virtual sacrificer of his girlfriend (who, for no particular reason is immune to the cult despite having grown up around such kids). Similarly, in Part III, the speed with which Eli (Daniel Cerny) wins over a group of street-wise kids, is unbelievable.

An environmental subplot is crow-barred in with the gnomic utterances of Redbear (Ned Romero), a Native American Anthropology expert, who opines that the corn is being deliberately mixed with toxic mould. He describes a 'higher power' who 'seeks revenge for all the wrongs done to the earth', casting He Who Walks Behind the Rows as a pagan response to pollution and environmental damage. On the one hand he uses the language of mysticism that 'life is out of balance' but frankly his more down-to-earth explanation is more convincing: 'the kids went apeshit and killed everybody'. Via voiceover, he delivers the final words of the film as his ghost, in full tribal garb, fades away into the landscape and New Age spirituality blends with Indian mythology: 'the spirit will part the corn and let through one who finds truth about himself', which could refer to the next preacher-figure incarnation or Danny and John who make up at the end of the film. Originally, Knox was to be sucked under the earth whilst in a phone booth but budget restrictions prevented this. Instead the closure is professional (he has suffered but 'found' his story), romantic (he has paired up with Angela and Danny with Lacey) and familial (he and his son both saved each other's life in the final battle and John intones 'Let the healing begin').

Children of the Corn III: Urban Harvest (James D.R. Hickox, 1995)

> You reap what you sow.
>
> (Eli preaching at school, in *Children*
> *of the Corn III: Urban Harvest*)

Director James D.R. Hickox takes the basic Gatlin plotline as a backstory and moves the rural characters to the city. *Crocodile Dundee II*-style, the protagonists, half-brothers Eli and Joshua, are initially taken out of their element and placed with an adoptive family, Amanda and William Porter (Nancy Lee Grahn and Jim Metzler). Whereas Josh (Ron Melendez) tries to integrate, making friends and playing basketball (exactly where he played before is not clear), Eli uses the opportunity to preach to his fellow school pupils and to plant a new crop in the abandoned factory next door. Rather than producing illicit marijuana, this urban harvest produces an amazing crop of demonic corn in a matter of weeks. A coda on Hamburg docks, evoking the importation of disease in Stoker's *Dracula* and its many film versions, shows two businessmen agreeing an export deal on Eli's corn.

Eli's diminutive size and pre-pubescent looks means he seems more sweet in the preacher role than demonically possessed, as when he walks off down the aisle with his hands behind his back and a smug look on his face after humiliating Father Nolan (Michael Ensign) in church or hypocritically hugging William after effectively murdering his wife. At the same time, Eli's putting his tongue in Amanda's ear when she kisses him goodbye to go to school

has no real motive other than to 'creep her out' which it certainly does. The look of the brothers is overtly Amish (Josh is called 'Amish boy' several times), and Eli regains the wide hat sported by Isaac in the first film. Although it remains unexplored, there is a pseudo-sexual tension in their relationship (they prefer to sleep in the same bed and Eli sees Josh's interest in others especially Maria as a betrayal).

The idea of the hole in the hedge through which Isaac passes into the factory seems like a cross between Narnia and Clive Barker's urban nightmares, in which a character discovers some kind of gateway into another dimension. The 'mole' effect from both previous films appears early on here as Eli tosses seeds into the earth. The amount of light in the factory is unnaturally high from the outset and as the corn grows, the walls seem to disappear and there is even brilliant sunshine – these scenes are clearly shot in open fields. A long-bearded derelict wanders into the cornfield and more than just wrapping round his limbs as in the first two films, shoots fly directly into his eyes. Amanda, escapes shears falling in slow-motion but then falls backwards over some piping and lands on an upturned valve (reminiscent of the prison guard's death in *Midnight Express* [Alan Parker, 1978]), with her head lolling straight at the camera and initially water and then blood, coming out of her mouth. Eli draws a strangely childish drawing of Amanda and the inter-cutting suggests his drawing causes her 'accident', especially since after crossing her out, he asks to go for a drink of water.

The nature of Eli's powers seems quite protean. In the opening sequence, Eli using a magic book (whose origin is never explained), exacts revenge on Josh's abusive father, causing a cross to rise from the earth and corn to strap him to it. As the man's eyes and mouth are sown up, he replaces the existing scarecrow and effectively disappears. Eli later makes Amanda think his case is teeming with bugs, before moving on to persecuting Father Nolan (also with bugs at first) and then sending him nightmares. These are constructed from sepia-tinted clips of the cafe attack from the first film and the murder of the doctor from its sequel. A third nightmare follows in which children with bags over their heads, pin a couple in their bed with scythes and then burn them, the dream cutting to a cornfield and the ringleader identifying himself as Eli, before Nolan wakes. The style of the previous dreams and the oblique framing here allow us to identify this as a dream rather than reality but whether this is a specific prophecy remains unclear. Nolan sits up, calls out 'Enough' and then Isaac steps through the bedroom doorway and says 'I agree' before flying at him, arms outstretched. The 'double dream' device works well here.

There are a few redeeming features. Thematically, small elements of Part II are picked up as William (a commodity broker) plans to exploit the strain-resistant corn for maximum profit. The adults seem less principled than the children – William's lying to his wife via his secretary and his blunt 'Fuck ethics' seems to suggest that Eli's railing against the abuse of the land by grown-ups, may contain a grain (!) of truth. Nolan's attempts to deal with Eli in church make him seem patronising and he foolishly invites Eli to come and continue the sermon, which he duly does. Eli's Maths teacher is shown in extreme close up from the blackboard's point-of-view but filling only half the frame (a similar shot of Johnny Depp

appears in *Secret Window*), creating the impression of a threatening, unbalanced individual, underlined by the man's tired sarcasm. Ironically, Eli's ascendance creates order in the school – a colleague of Nolan states 'Things are finally shaping up' to which he replies, 'Into what?'

Stylistically, there are some effective shots too. The film opens and closes with credits using a scythe as a wipe, although this does have the slight look of windscreen wipers. Hickox blends a freeze-frame of Eli and a three-stage zoom with a dramatic thudding sound on each movement to convey how Nolan seems to be able to hear Eli's words ringing in his ears, especially the word 'Traitor'. Shots of Josh and Malcolm breaking into the church to save Nolan use the 'Kubrick' position from *The Shining* – an extreme low angle from someone lying on the ground with their head against the door. Eli influences Maria (Mari Morrow) to poison her parents with corn and as the camera tilts up to Maria, Eli's voice starts to distort. During an apparently-friendly meal, an overhead shot shows her mother choking and then she falls, her head splitting open in close-up and bugs crawl out.

However, effective shots often alternate with very poor ones and parts of the plot do not cohere. We are only told some way in to the film that Josh and Eli do not share the same father but little is made of this apart from emphasizing the difference between the two. For no specific reason, Josh starts to have doubts about what Eli did to his father and he and Malcom (Jon Clair) go back to Gatlin to investigate. While Josh is digging up Eli's book (with no indication of how he knows where to find it), the scarecrow wakes. Despite obvious use of blue screen , the sound effect of eye-stitches snapping open works well but this is followed by a ridiculous fight with a figure who is clearly a man wearing a straw-mask. Also, the idea that they would walk off, forget the book and then have to return for it is unbelievable, and yet the way that Malcolm is not just grabbed by the corn, but *penetrated* by it, produces a powerful image of his neck elongating and rising up, like Rob Bottin's effects in *The Thing* (John Carpenter, 1982) or even the impaled head at the end of *Macbeth* (Roman Polanski, 1969). After Eli's death, T-Loc (Garvin Funches), reaches down for his flick-knife and he is grabbed by an alien hand, not just *Carrie*-style but so that his whole body disappears head first into the ground.

In the final climactic battle, Josh stabs Eli through the book and after a bit of an electrical firestorm, dies rather anti-climactically. There are some truly awful special effects, including a shot of the monster supposedly picking up a victim that is clearly a model and some shaky handheld shots like the original series of *Star Trek* (Gene Roddenberry, NBC, 1966–69). The spider-like thing that emerges, with fleeing, screaming kids, looks like a very amateurish animation from a 1950s B-movie. Close shots of the creature's digestive tract, from which Josh cuts Maria, work quite well but wider shots seem laughable. Instead of a higher entity we have a gloopy, mechanical toy monster. After the 'dragon' is slain by Josh as the gallant knight, and even though we have seen several of their number garrotted, stabbed and hung, most of the children (including Josh and Maria) pick themselves up and amble off, quite happily. Even Charlize Theron getting an early acting break as one of the children in church and later running from the monster, does not fully excuse this.

Children of the Corn IV: The Gathering (Greg Spence, 1996)

Unlike the first three films, there is no real grounding of a religious community here; no He Who Walks Behind the Rows. The source of threat is a poorly-conceived monster, whose existence is 'explained' in retrospect in religious terms. Clumsy plot exposition is put in the dialogue of the Nock sisters, recalling the sacrifice of the unnatural boy-priest Josiah (Brandon Kleyla), not to palliate a pagan god but who was poisoned and burned just because the community was afraid of him. Without a clearly-motivated agent of evil, the film struggles to generate a sense of threat. June Rhodes (Karen Black) is grabbed by tendrils and dragged towards farm implements but just as the opening murder of a drifter, the nature and extent of Josiah's powers are completely inexplicable. It seems that actions occur to generate the most bloody method of execution rather than follow any kind of logic. The first victim is reaching for a whisky bottle (in a thinly-veiled punishment for excessive drinking) but this is placed so obviously under the jaws of some threshing equipment that his demise generates no suspense. If the normal laws of physics are suspended without explanation, if agricultural tools can just fly and impale people, in short if anything can happen, there can be no suspense.

The film is also highly derivative but without any wit or sense of irony. It is all very well for Mary Anne (Samaria Graham) to declare later that she does not want to be around 'when their heads start doing 360s and they're hurling pea-soup' or burn-like marks appear on the neck of Margaret (Jamie Renee Smith), but the film can only echo *The Exorcist* (William Friedkin, 1973), it shows no ambition to generate its own tension. Josiah crawling up the well echoes the ghost in the 2002 remake of *The Ring* (Gore Verbinski) (which also features Watts in the lead role) but there is no reason why he would be confined by such a 'prison' since we see him disappear at will. Apparently drawn by Josiah, Margaret is seen rising bolt upright from her bed, Dracula-like but this effect is taken directly from *Nosferatu* (F.W. Murnau, 1922). The ice-baths that are prepared for the children could be dramatic, like that for the eponymous hero in *Jacob's Ladder* (Arian Lyne,1991), but the power of Josiah to induce fever is overcome relatively easily. There is also something of the nightmare sequences from this film in June's opening vision with rapid cutting, dark, partially-obscured images, flapping sound effects, and suggestions of some devilish entity transforming in front of the viewer but whereas confusion and ambiguity is purposeful in Lyne's film, here it is not. The death of the patrolman, propelled backwards in the cornfield and then stabbed in the stomach from behind, evokes similar deaths in the last three of the *Alien* quartet: *Aliens* (James Cameron, 1986), *Alien3* (David Fincher, 1992) and *Alien Resurrection* (Jean-Pierre Jeunet, 1997), especially with the serrated edge of the blade but again nothing is made of this. The scene in the clinic reflects this, relying on the slightly uncanny nature of the appearance of identical twin boys, who can inexplicably appear and disappear at will and who equally inexplicably produce a trolley with a huge blade at one end to slice Doctor Larson (William Windom) in half. When Grace (Naomi Watts) sees a child in her rear window, riding a bike, this hardly creates the same sense of unease that Carpenter does in early scenes of *Assault on*

Precinct 13, when the same car appears to draw up parallel to Officer Ethan Bishop (Austin Stoker). The general sickness amongst the children seems to presage a *Children/Village of the Damned*-style possession under the guise of a medical condition, but the needless repetition of a second wave of fever and the loss of teeth (reminiscent of *The Tommyknockers* [see Chapter 3]) lacking explanation, fails to develop coherently.

Like the incoherent editing of the sequences featuring Josiah-as-monster, the film clumsily overuses standard horror tropes. An unsignalled dream sequence opens the film but another follows when Grace is in the clinic, featuring Josiah sitting by Margaret's bed but then appearing with a satanic bottom half (although the effect is undermined by actor Christopher Wheatley as Josiah's demonic double, anticipating his cue and clearly being visible before he should appear in shot).Yet another dream follows when Grace is at home, that becomes a double-dream as Margaret buries what seems like a trowel in her back. However, like *Secret Window*, overused unsignalled dream sequences demonstrate very clearly the law of diminishing returns. Events play out exactly as June's dream with Josiah coming to her house (admittedly in the guise of a girl) asking for help, she drops a glass in slow-motion and then is attacked. However, rather than creating a sense of dread, viewers are left wondering *why* or how she has this precognitive dream. There is a later flash-cut of a girl drowning, who we subsequently realize is Margaret, but whose dream this is supposed to be, remains unclear. The kills themselves oscillate between the extremely graphic (the sadistic pinning-down and decapitation of the unnamed drifter, with a crude side-on dummy shot, and the later flying scythe that thuds through the head of Mary Anne (Samaria Graham) to the more decorous (Donald's wife's demise is signalled by blood sprayed on the walls and windows of Marcus' bedroom).

The children at the end seem under the hypnotic spell of a vague demonic entity, so that when that is destroyed, their evil instantly vanishes. With a rootless premise and without coherent character action, the attack on Grace's mother is typical. Flash-cuts to the monster in the fields could suggest the presence making things happen but unlike the images of Randall Flagg in the cornfield outside Mother Abigail's house in *The Stand*, this has the stronger impression of threatening images rapidly edited together without coherent purpose. Despite being a supposedly-serious agoraphobic, June manages to get in her car and drive away, just coincidentally passing the barn where her son, James (Mark Salling) has been drawn and where Josiah was killed. As in other films in the series, the outside world is kept at arm's length. Grace requests a toxicology team but the fact that bodies remain undiscovered, deaths go unreported, and the absence of children goes unnoticed, is hard to accept.

In the clinic, Mary Anne unbelievably makes the penicillin-style discovery of how the infected blood reacts to a mercury-based filling agent, repeated shortly later by scapegoated father, Donald Atkins (Brent Jennings). The potentially-chilling effect of the scythe cutting through the pool of blood on the floor, suggests a more visceral, mechanical effect, paralleling the CGI of *Terminator II: Judgement Day* (James Cameron, 1991) or the animatronix of *Hellraiser* (Clive Barker, 1987). However, sadly the crucifixion of Mary Anne using syringes and the sudden kill via a flying scythe, only superficially reference *Carrie* and lacks any

credibility in the plot. Wes Craven's *Nightmare on Elm Street* (1984) also uses several images of blades pushing against a restraining fabric, and the sight of the scythe breaking through the pool of blood or through Grace's mother's door, could carry a similar sense of permeating a membrane to a darker dimension, but here the cut conveys the feeling of a director without a vision (or, to be fair, a large enough budget) to visualize what might happen next. The vat around which the children chant and pour their own blood at the end, feels like a throwback to classic Universal horror or even Hammer films, but there is no climactic effect to meet our expectations, only a glimpse of Josiah flying up into the rafters.

Like *Cujo*, a child is endangered but miraculously saved by mouth-to-mouth resuscitation (in the girl's case after several minutes). Despite the similar scenario with characters trapped in the a vehicle, this time by a mob of crazed children, what is completely different here is the unmotivated character action, lack of visual tension and consequent lack of viewer involvement. Donald, after suddenly rationalizing where the threat is and how to combat it with mercury-tipped bullets, sees Marcus, his son, a haemophiliac, collapse from blood-loss and comments without emotion, 'There's Marcus'. Grace suddenly turns into an action hero- knocked to the floor, she rolls, cocks the gun and fires at Josiah, hitting him in the shoulder and then fails to show a credible emotional reaction upon spotting the bodies of her mother and Doc Larson. Even Josiah fails to convince – as a monster, he is only seen in flash-cuts or shadowy cropped images (often out of context of the scene in which they appear), making the extent of his injuries, his power or indeed his very nature, unclear. Sudden flash-cuts to the girl, apparently drowning in slow-motion, could evoke the opening of *Don`t Look Now* (Nic Roeg, 1973) but there really is no sense of jeopardy created – the girl allows herself to be pulled under and then we largely forget about her for the duration of the gunfight around the vat.

Overall, a few images might remain with viewers. Grace driving through the town, past apparently zombified children, one in particular impassively bouncing a basketball, might echo a very conservative view of an alienated generation of apparently lethargic and yet paradoxically threatening young people. The opening sequence with the boy in close-up, pale and impassive at June's front door, taps into fears of letting strangers into one's home, even children, who apparently need help, but this is not part of a coherent aesthetic. There is a brief mention on an early radio broadcast of the decay of family life in declining rural economies but a political subtext remains undeveloped. There is both a sense of closure and openness about the ending. At the graveside of her mother, James lays down his 'serial killer trading cards' (with which he had earlier teased Margaret), declaring 'I don't think those are so funny any more', which makes Grace strangely happy, reinforcing a strongly conservative moral.

The performance of Naomi Watts adds dramatic weight to the role of Grace Rhodes, which is in itself fairly limited. The plot twist that her 'sister' Margaret is really her daughter does explain partly why she is reluctant to come back to the small-town but little is made of this revelation, which should in theory make her attempted rescue of the girl, more personal and dramatic. The way is left open for the next sequel as James is momentarily entranced by

a locust, which had been used initially as a symbol for Josiah's evil, particularly in an early cutaway shot, crawling out of the corn and in the first kill but is then largely forgotten. The creature lands on the car's wing-mirror before James mashes it with his fist and his family drive away.

Children of the Corn V: Fields of Terror (Ethan Wiley, 1998)

The initial sequence of Ezekiel (Adam Wylie) coming upon a mysterious fire, which leaps out at him, like the electrical current in Sometimes They Come Back Again, seems to be a retrograde step but unlike the previous sequel, which regularly descends into supernatural incoherence, there is then a return to a grounding in a religious, child-driven sect worshipping an unseen He Who Walks Behind the Rows.

The basic narrative structure takes six college students and reduces that number to one. Alison (Stacy Galina), Greg (Alexis Arquette), Kir (Eva Mendez) and Tyrus (Greg Vaughan) lose their friends, Charlotte (Angela Jones) and Lazlo (Ahmet Zappa) and seek shelter in an abandoned house. Character motivation is wafer-thin. As three of the surviving four wait for a lift to take them out of town, their reason for staying becomes their sole defining feature – Greg has 'a thing for her' (Alison), Tyrus 'has no one to go home to' and Kir says nothing. She is there purely to be looked at and judges others in a similarly superficial way, dismissing Tyrus as just a one-night stand (she virtually sleepwalks into this gratuitous sex scene) and is drawn wordlessly to a blond boy, Zane (Aaron Jackson), one assumes on the grounds of looks alone. There is the vaguest of implications that she is vulnerable to cult doctrine after losing her boyfriend but nothing is really made of this.

The nagging problem with the Corn series, the apparent impotence of the outside world, is implicitly referred to in the Sheriff's declaration to Luke (David Carradine) that 'I've been trying to nail your ass for a long time'. However, the death scene with Luke, who has only occupied one previous scene, seems strangely out of place. Under the apparent influence of Ezekiel, Luke's head splits open in a Rob-Bottin style effect that would seem more at home in science fiction like Carpenter's The Thing and a blazing light pours out, blasting a hole in the cop's head seen from behind (a little like the suicide scene in Eureka (Nic Roeg, 1984). Luke describes himself earlier as a 'saviour' and Ezekiel states that 'he's been dead for years' but neither statement is explained – either metaphorically or that he is some kind of vampiric or supernatural figure.

The remaining protagonists are systematically removed from the narrative, Tyrus by a sickle blow to his neck, Greg trapped under a car by Jared with a blow-torch on one side and a girl with a drill on the other. There are a few seconds of suspense as we see events unfold from Greg's point-of-view under the car, looking at feet walking back and forth before stopping and the weapons coming into view. There is an effective sense of panic and a close-up of a drill going into Greg's leg. Alison manages to throw both Ezekiel and a sack or two of fertilizer into the silo, which strangely causes no explosion of any great note. Greg's

previous lighting of a fuel cable under the car in the barn produces a more spectacular explosion, shown in repeat edits from different angles. The silo itself is problematic. Low angles of a piece of standard farm architecture do not create demonic, totemic iconography. The inexplicable fire inside, produces no smoke, burns like an Olympic torch at times, and later seems to burn only right at the bottom. Like the fire in the silo, the life goes out of the narrative with unexpected ease. The children, who moments before had been a murderous mob, now meekly ask Alison if they will ever get to join He Who Walks Behind the Rows, before being led away. In a final flash-forwards, Alison takes the baby of Lily (Olivia Burnette) as her own. The eyes of the baby flash with green fire, strangely unseen by Alison, and are held in a fairly clumsy final freeze-frame, showing the demonic possession continues.

There are some low spots, like Jacob's ridiculously slow running when fleeing for his life, allowing some smaller, karate-kicking girls to bring him down, Kir volunteering to die, claiming 'I've read the book' when we have not seen her do any such thing and Jacob's acrostic 'Help' message more likely to be missed than noticed. Ezekiel stabs Jacob, strung-up, as punishment for refusing to sacrifice himself but unbelievably makes such a poor job of this that Jacob manages to somehow break free and kick away his captor to escape. Most of the effects used to try and create tension, such as oblique framing when the bodies of their friends are discovered, somewhat miraculously, in the combine machinery, the hooting owl to denote nightfall, and the thunder and lightening to accompany the initial kill, are mostly clumsy and obvious. Adam Wylie as Ezekiel, has the requisite protruding ears but struggles to convey the ridiculous Biblical cadences with any sense of menace. In conjunction with his main henchman, Jared (Matthew Tait), an over-sized boy shown in ridiculous low angles next to Greg, there is the slight sense of an inbred freakshow. There are some unintentionally funny situations. Jacob refuses to climb the silo ladder (can his name be purely coincidental here?) and as Kir ascends instead in a short skirt, Ezekiel and Zane look straight up (the object of their attention being very obvious) but we only cut to a more decorous side-on shot.

It is a feature of the sequels to use bigger names in minor roles, who usually only appear in a small number of scenes, contributing little to the narrative (Carradine here; Stacey Keach in 6; Michael Ironside in 7). Here we also have extratextual references – Ahmet and Diva Zappa (children of Frank) who are dispatched quite early, and metatextual features – Kane Hodder (Jason Vorhees in *Friday the 13th, Part VII* (John Carl Buechler, 1988) and *Jason X* (James Isaac, 2001) for horror aficionados to spot as the bartender, and the barn scene, chainsaw fight and deaths falling on spiked equipment here echo scenes in *Friday the 13th, Part III* (Steve Miner, 1982) and *V* (Danny Steinmann, 1985).

There are also a few effective features. The initial kill features Lazlo backing into a girl wielding a scythe that appears through his stomach, to which he comments, 'This doesn't look right'. As Alison reads Jacob's book, the fixed camera position, above her rocking chair and on the book itself, creates a nice claustrophobic effect. Tyrus' reluctance to stay and look for Alison's brother, comically juxtaposes his adamant, 'Not over my dead body' with a jump-cut to a point-of-view shot looking down at his feet walking towards the cult's house. However, ultimately, the working subtitle, 'Field of Screams', is probably the best thing about this film.

Children of the Corn VI: Isaac's Return (Kari Skogland, 1999)

The extremely short running time (76 minutes), suggests there is little new to add to the franchise. As the subtitle suggests, it is the return of Isaac (John Franklin), which marks this film as distinct. Franklin, whose own career has been largely defined by the first film, co-wrote the script. He reappears here, some 15 years after the first film, in which he died by being burned, without any visible scaring and without any explanation about his coma.

The plot attempts to pick up the thread of what has happened to children from the original cult but much of the narrative does not really cohere. The film opens and closes with close-ups of sunrise and sunset but without the sense of menace engendered by *The Exorcist*, which uses similar imagery. A small example illustrates the film's clumsiness. Hannah (Natalie Ramsey), returning to Gatlin to find her real mother, picks up a hitch-hiker and quickly hides a piece of paper, entitled 'Boy preacher admitted to Gatlin County Hospital' above a grainy picture. However, this is not a newspaper or a website, it is just a clumsy case of on-screen 'info-dumping', narrative information just written on a piece of paper. Later when we first meet Dr Michaels (Stacy Keach), there is a bizarre ellipsis, omitting any introductions, jumping straight into dialogue about the back-story of the town. Hannah mentions that Gatlin is known on the Internet but we do not see any other outside interest. The script piles up coincidences ridiculously, so that the following day just happens to be Halloween and Hannah's birthday.

Like Part IV, incoherent flash-cuts and events are used to apparently create a sense of menace and tension, where none exists. The hitch-hiker that Hannah picks up, after instructing her to name her future son Samuel (as Hannah did in the Bible), strangely disappears and we have flash-cuts of a boy in a hat and sound of the man laughing. Hannah's keys disappear and Cora (Alix Koromzay), a female cop, suddenly appears out of nowhere to take her to hospital. If such events were deliberate attempts to create the impression of nightmarish events, it might work but here, they just seem a mess. Later, slow-motion shots of Hannah driving around are inter-cut with flash-cuts of the boy walking with a frame, long corridor shots and shaky, handheld camerawork, without any clear purpose. Her hallucinations, such as a maggot-ridden crow in the boot of her car, are unexplained and the later series of rapidly-edited images of a figure in a leather coat reaching out for her in bed, may motivate her sudden waking and a gratuitous shot of her in panties, but serves no clear, character-related purpose.

By contrast, the scenes in the hospital, do largely work. We see obscured shots of children scurrying in the extreme foreground across corridors, wheelchairs and other equipment covered in cobwebs, and shots from Hannah's slow-motion point-of-view; passing children who all turn to stare at her. The use of long-shots down apparently-deserted, unstaffed corridors evokes Wes Craven's *Elm Street* series, accompanied by music that sounds like a music-box winding down. It feels like a more realistic *Kingdom Hospital* (Craig Baxley, 2003), minus the anteater. As she leaves later, there is a conventional high angle of her getting into her battered open-top car (as used earlier) but then we have the unsettling reverse low-

angle shot up the side of the building to see Cora, her disturbed brother, Jake (William Prael), and the doctor all standing, looking down, watching (evocative of a sequence, scenes 69–77, storyboarded but never shot in *The Shawshank Redemption* [Frank Darabont, 1994] in which Bogs [Mark Rolston] 'falls' from a walkway and Andy [Tim Robbins] looks up to see Hadley [Clancy Brown] and other guards looking down; and also of *Kika* [Pedro Almodovar, 1993], where Andrea [Victoria Abril] looks up and we see a drop of semen fall, tear-like on her cheek, from a masturbating rapist several storeys up).[6]

Like the shot of Isaac in the mirrors above his bed, distorting his image, the hospital seems to attract the most creative thinking in the film. A hospital whose sole purpose is the mysterious boy in a coma, is an uncanny premise that might have opened the film more powerfully. After touching Isaac's hand, causing the shaking to stop and his eyes to open, Hannah is ushered out by worker Gabriel (Paul Popowich), with the enigmatic comment that she has to 'find out for herself' about the prophecy. There are several mentions of 'the prophecy' (by Cora), which is only clarified near the end, so that the son of Isaac's first-born and Hannah's first-born, are branded to begin a new generation of followers of the cult.

The inconsistency of the truck driver, later identified as Hannah's mother, Rachel (Nancy Allen), who tries to run her off the road but does not pursue her into the motel, remains unexplained. Later at the graveyard, Rachel looks directly at where Hannah is watching her but whether this is deliberate, is also unclear. Hannah's whole character, including the fact that she appears to be living with the doctor, is fragmented and not thought through. Drawn back to the hospital, Hannah breaks into records but is interrupted by Jake wielding an axe. Absolutely unbelievably, after such an attempted murder, Gabriel *just leads him away*.

Keach's potentially-interesting but largely undeveloped character is killed off by Isaac, electrocuting him in the showers. There are some gratuitous kills of Morgan (Sydney Bennett), a lone dissenting voice, who is chased through the corn, and eventually cut down by Isaac's scythe; and Matt (John Patrick White), Morgan's partner and Isaac's first-born who kills himself by falling on a strategically placed scythe, both shown in repeat edits from different angles. A gratuitous sex scene with Hannah and Gabriel, is accompanied by a *Miami Vice*-style music montage, which climaxes with clocks chiming (in a virtual parody of orgasm displacement) and reminding us about Hannah's birthday.

The final sequence in the basement, promises a dramatic climax but descends into sheer nonsense, with Gabriel claiming to be the original first-born son, (thereby fulfilling the prophecy) and actually He Who Walks Behind the Rows. The sequence of Gabriel levitating and delivering his dialogue in the style of a game-show host before pinning Isaac with nails and finally impaling him with a pole, works but why he then appears to *help* Rachel who tries to stab him with a scythe, is unclear. He gets up, complimenting himself on a 'damn fine performance' and then the hospital blows up for no apparent reason. The film ends with Hannah pregnant, contemplating how the evil 'now lives in me' but unlike the clear parallels with *Alien*, there is no threat to her own health if she chooses to terminate the pregnancy.

Children of the Corn 7: Revelation (Guy Magar, 2001)

The plot is relocated to Omaha, Nebraska and mostly takes place in and around the single setting of a run-down condominium, the Hampton Arms, where the grandmother of heroine Jamie (Claudette Mink), looking like a young Belinda Carlisle, used to live. Corn really only impacts on the plot as an adjunct to the house and overall, the film feels like a less imaginative version of Part III in the series, subtitled 'Urban Harvest'. The basic premise, that Jamie's grandmother survived a group suicide from years ago, hardly explains why all the other tenants are killed one-by-one. Blanket motivation, that all adults are evil and must be destroyed, just reduces the film to a series of kills. As elsewhere in this book, the extent of supernatural powers is vague – children appear and disappear at will and yet can apparently be destroyed by fire.

Michael Ironside's role as the Preacher, like Keach's in the previous film, is largely as a conveyor of plot information, and his enigmatic appearance (initially appearing *Exorcist*-like in a dark, steam-filled street, backlit in a black hat, producing a silent silhouette before looking up to reveal his scarred face), remains completely empty of meaning. The supposed focus of evil, Abel (Sean Smith), has little on-screen charisma and few lines to speak of (this is perhaps why) and he just appears ridiculous in an oversize suit. Neighbour Tiffany (Crystal Lowe) has a couple of gratuitous shots of her changing from her lap-dancing outfits but no amount of slow-motion of her demise in the bath (trying and failing to echo the bath scene in *A Nightmare on Elm Street* [Wes Craven, 1984]), thrashing about, supposedly strangled by tendrils of corn, can prevent it from seeming ridiculous.

Inconsistencies in the plot abound. An aggressive, wheelchair-bound neighbour is noisily pushed through a banister and down a stairwell with plenty of screaming but Jamie apparently hears nothing. The corn the children grow spills blood when bitten for no apparent reason. Despite the extremely limited number of settings, these are still not clearly established. Although cropped shots of the building surrounded by corn, give it a rural feel, from the rooftop we suddenly see an unexpected cityscape and only after twenty minutes is it clear that a railway actually runs right past the building. Equally, we have absolutely no idea what lies between the building and the store, although Jamie walks there. Typically, in a scene that could be straight out of *Scary Movie* (Keenan Ivory Wayans, 2000), Jamie goes down heavily-cobwebbed stairs and enters (with remarkable ease) a room signed 'Do not enter'.

There are a few interesting shots, mostly with a macabre element, such as the store-owner's head visible to us in the chiller cabinet but unseen by Jamie; the boy and girl playing pat-a-cake with a human hand; and the death of Stan (Michael Rogers), the paranoid neighbour with the night-vision goggles whose apparent heart attack and removal by the children is recorded through his own visor, a boy strangely stopping to look momentarily straight at the camera. The rotating shot round Tiffany's bath to reveal a ghost boy, just standing there, works quite well but as elsewhere, his lack of dialogue limits what he can do. The children's main power is in their pale, sullen, impassive tableau-quality, more at home perhaps in a pop video than a dynamic fictional narrative. The girl shouting 'kill' at Jamie outside the

store takes us a moment to realize she wants more change to play the violent video games inside, picking up the knee-jerk conservative view of young people as emotionally-stunted and aggressive in Part IV, here fuelled by violent computer games.

The opening sight of the girl, playing hopscotch on a pentangle, could be threatening but the shot is from Jamie's point-of-view and whilst rapid cutting in on the axis may be a cinematic device, to jump from long- to mid-shot to close-up is not physically possible for the human eye. At the beginning, the long corridors with a blurred figure, shuffling through the foreground, evoke the hospital setting of the previous sequel. However, flickering shadows visible under the door or the echoing sound of children's laughter, in themselves cannot paper over the absence of narrative tension. The lack of real movement and threat cannot be hidden by tilted camera angles or bathing the scene in red light as used later. These are not the corridors of the Nostromo and Jamie is certainly not Lieutenant Ripley, as she suddenly descends at the end into a virtual parody of a screaming female victim. Peering round the corner at the group of children who are just standing still, the compressed, distorted image suggests a loss of sanity but there has been no sign of this up to now.

Multiple explosions leads to a ridiculous handful of debris being thrown on the car of forgettable cop Armbrister (Kyle Cassie) and ghostly faces rise up from the cornfield, suggesting along with the melodic choral music that the children's souls are now at peace. Here we have a basic problem with the horror genre – how do you kill the undead? Vampire and zombie movies solve the problem by developing their own lore but here it is not clear why fire should hurt or kill the children when they survived intact before (without any visible scarring).

The pacing is fairly flat and this in large part is due to virtually non-existent characterization (after twenty minutes in, we still only really know about Jamie). In this, there is a strange evocation of early silent film with a lack of differentiation between characters, (sometimes even played by the same actors). The fact that only one character, Jamie's grandmother Hattie Soames, who has a relatively minor role, has a surname, is telling. There is a sketchiness throughout the plot and the characterization, so that the ghostly boy and girl who appear sporadically throughout the film, are still termed Girl #1 and Boy #1, even though they rank number six and seven on the end credits. Most characters are merely functions ('Preacher', 'store owner', 'cranky man') and our reaction to the latest in a very tired franchise is likely to be similarly perfunctory. This tendency is not new however as even in the first sequel, Marty Terry plays both Mrs Burke and her sister.

Children of the Corn (Donald P. Borchers, 2009)

This TV version, directed by the producer of the original 1984 version, who also has a writing credit alongside with King, seems like an attempt to restore the 'Kingness' of the text. Vicky is played by Kandyse McClure, best known for Anastasia Dualla in *Battlestar Gallactica* (Sci-fi Channel, 2004–09) with David Anders as Burton, best known as Julian Sark in *Alias*

and Adam Monroe in *Heroes* (NBC, 2006–present), i.e. both leads are famous for roles on the small screen. The fact that McClure also played Sue Snell in the TV movie *Carrie II: The Rage* (David Carson, MGM, 2002) might have provided opportunities for some kind of intertextual reference and South African-born McClure brings a different ethnic dimension to the cast and implicitly raises the question of racial intermarriage in the 1970s but her character spends much of the second half of the narrative screaming, either at or on behalf of, her husband and is extremely difficult to like.

Anders' attempt at portraying a bruised Vietnam veteran seems a sloppy way of introducing an empathetic element but it never rises beyond clichéd flashbacks of wartime gun-battles and makes the supposed fights with children lack credibility. As discussed in *Stephen King on the Big Screen*, one of the first strategies in nearly all King adaptations is to strip out the political subtext, partly for length, partly to control costs. This shows what happens when it is retained – unconvincing cliché. Malachai (Daniel Newman) lacks the viciousness of the original (played by Courtney Gains) without anything more interesting to replace it, beyond a certain solicitousness for some children like Nahum, which is both out of character and dramatically less engaging. Isaac (Preston Bailey) struggles to exude a sense of evil beyond his oversized hat and without this – and the impression that he understands only fragments of his own dialogue – the notion of a town enslaved to a demagogue, does not really work.

The addition of a pair of teenagers having sex on the altar in the church as a fertility rite, while being watched by a congregation of nine-year-olds, might seem the ultimate transgressive act, worthy of an Argento horror movie but here it just seems like an exercise in cross-cutting. Actors Jake White and Zita Vass were also clearly well over the age of consent. *Kids* (Larry Clark, 1995) is more disturbing for holding in-the-scene viewer and under-age couple in the same shot. Further additions seem to be motivated by adding spectacle with an exploding car and an epilogue of Ruth dreaming about going into the corn with fire. Deletions include the fight between Malachai and Isaac, the final sight of He Who Walks Behind The Rows and the diner scene (a shame as that established a sense of slow-burn horror in the original and made the transgression across the generations credible).

Conclusion

All of the films have been shot by different directors, none of whom have made a name for themselves as major players on a global scale, and none (with the possible exception of Linda Hamilton) have drawn on A-list star talent, suggesting that genre, rather than auteurism or star theory, is a more relevant mechanism to consider the films. Some of the films have been the first rung on the film ladder for future talent such as Eva Mendes (*Children of the Corn V*) or Charlize Theron (*Children of the Corn III*) but the fact is that the films in this chapter are intrinsically linked by using the exact same setting, title, and basic narrative premise. Sequels are inevitably going to carry some features from previous work or they would not be recognizable as such. Therefore the same tensions that exist in generic studies, how to introduce novelty

within a series of recognizable features, apply in a heightened form in a series of sequels. However, unlike some sequels such as *Texas Chainsaw Massacre II* (Tobe Hooper, 1986), there seems little attempt here to play against events in a deliberately ironic fashion. Like the 'forgetfulness' of an on-going TV series, characters appear to learn little from film to film and operate in a perpetual present.

The first film in the *Corn* series does just fall within the era that Dika identifies (late seventies and early eighties) and initially received similar strong criticism, especially on the grounds of its violent content. However, there is no iconic killer as anti-hero with which to identify. Some of the appeal of the films might be attributed to similar generic roots (the pleasures of viewing violence as a cathartic release from fears about bodily harm) but others, which Dika argues are part of the subgenre's dynamic, do not work here.[7] There is no great visceral pleasure available in the kills on display, social and political tensions are displaced into the religious realm and the sense of kills as the punishment for transgressive sexual behaviour (a favoured reading of *Halloween*, for example), do not readily apply here. Indeed, sexuality is largely absent (in the sense of visibly on screen – we see hardly any male or female flesh) until the 2009 TV remake, where the libidinous element (in the altar scene) seems a gratuitous import, not present in the original short story. Since this only occurs after seven previous films, it suggests that it is not central to the sub-genre. The fact that the community are children and that even the leaders seem stunted or asexual (part of John Franklin's particular sense of chilling threat in the part of as Isaac), adds to the difficulty in reading the narratives as expressions of displaced sexuality. It might be said that sexuality is sublimated into the cycle of violence and sacrifice but it is, for the most part, an element of the narrative that is steadfastly ignored – are the teens having sex to 'replenish' their numbers or are we just rewinding the narrative each time? It is an awkwardness in the franchise as the first sequel clearly occurs after the first film, so this issue should be raised but it is copiously shelved. The reappearance of Franklin as Isaac (now many years older) can only occur after the first film but exact chronology seems unimportant. It seems to be an example of where audiences seem willing to engage in a collective act of Sartrean bad faith, winking at an awkward truth they do not want to think about.

There is certainly repetition but unlike the ritualistic elements of *Prom Night* (Paul Lynch, 1979) or *Graduation Day* (Herb Freed, 1981), there is little sense of knowledge acquired and acted upon. The narratives of the *Corn* films are nearly always accumulative rather than sequential and episodic rather than climactic – once the danger is discovered, the films become an ongoing battle for escape and survival. There is little sense of suspense – we usually know little more than the victims and do not see enough of them to empathize with their fate. The dominant narrative questions about the kills are not 'who' (the victims are clearly signalled by their status as adults, outsiders, or betrayers of the dominant group) or 'where' (given the limited sense of locale) but 'when' and 'how'. With the lack of a specific killer-as-antihero, stylistic tropes like the killer's point-of-view, with which we might identify, as in the *Halloween* series, or a 'floating' camera (as in the early shots of the interior of the Nostromo in *Alien*), problematizing exactly where the killer is, are also largely absent.

John McCarty's definition of 'splatter movies' suffers from a very broad acceptance of films that include quite significant differences and does not seem to apply easily here either. The kills are not 'gleefully extended' and the intended effect on the audience does not seem to be to mortify them, although there is, certainly in the later sequels, a sense that the deaths are the only substance to the films, which can include illogicalities (although this may be more part of a diminution of creativity and a franchise running down).[8] There are some parodic, light-hearted kills but again, this does not seem coherent enough to constitute a pattern. Robin Wood's consideration of the slasher subgenre, also quite broad in scope, identifies two sub-strands – the 'violence-against-women' film and the 'teenie-kill-pic'.[9] The former is not present in the *Corn* series, except perhaps the stalking of Vicky in the first film but there is no sense that this is related to her gender but *her age*. These are not really 'youth in jeopardy' films; the youth *are* the jeopardy. In the *Corn* series we have teenage characters but they are killers; the violence is performed *by* the teens, mostly upon adults. Wood's notion of an un-killable killer, appears here as a projection of religious mania, He Who Walks Behind the Rows, rather than a specific human character.

As stated in the introduction, I have explored elsewhere weaknesses in psychological approaches to analyzing horror films and would wish to avoid repeating myself here. Even so, without a male stalker, a surviving female heroine or first person point-of-view camera positioning, consideration of the male gaze, particularly in a psychological context, seems redundant here. Unlike *Halloween*, *Friday the 13th* or the *Elm Street* series, there is no prologue, establishing a traumatic event in the past, which then could be said to cast the body of the film as an eruption of a previously-suppressed episode. Indeed, apart from the first film in the series, which provides a little by way of back-story, the *Corn* films are set in a perpetual present.

Will Wright's (1977[1975]) study of the western (*Sixguns and Society*) links the commercial popularity of films with the emergence of appealing underlying sociological and possibly political subtexts. The difficulty here is that the *Corn* franchise has spawned a large number of sequels spread over a period of at least 25 years and possibly beyond. Their appeal is apparently not limited to the narrow era discussed by Dika (1978–81). If it does have a sociological significance, then it is one tied to a broader time span, rather than one particular political administration. Dika's general correlations between horror films and America post-Vietnam and post-Watergate, alongside economic anxiety in being a declining world power, all seem to hold less sway in a film resolutely isolated from politics, economics or the wider world (except for a brief reference in the fourth film).[10] The *Corn* films show us a lost civilization, adrift from its actual chronological setting, in which Biblical language and literal belief in scripture and the rights of the individual are taken to a logical, if murderous extreme. It could be said that there is an elision of Christian and pagan ideology manipulated by a dictatorial figure to gain supremacy but exactly what Isaac and Malachai do with their power is unclear. We do not see them indulging in sinful excess at the expense of their congregation. Perhaps power becomes an end in itself but it seems that although selective in his use and citation of scripture, Isaac may actually believe in the need to expiate

the spiritual entity in their midst. In this, there is something of the filmic version of pagan worship of the creature motif as seen in films like *King Kong* (Merian C. Cooper and Ernest B. Schoedsack, 1933), in which victims are tied in a prone position as sacrifices to some creature beyond the norm. However, we do not have lingering shots of a sexualized Fay Wray-like victim, or a sexualized monster, whom we do not see at all.

John Cawelti's (1975) *The Six-Gun Mystique* also studies the western, insisting that for that particular genre, setting is a primary feature. In this characteristic, the *Corn* cycle might be seen as a form of western too, but lacks most of the other stock characters, structures, and thematic tensions associated with it. There is some element of suspicion of outsiders, who are repelled by a tight-knit community but the role of the church is completely inverted from, for example, the sense of celebratory worship in *My Darling Clementine* (John Ford, 1946). There is little of the iconography of a western – guns are replaced by anachronistic knives and scythes, heroic adults by un-heroic children and conflict resolution by open-ended lack of resolution. If anything, the *Corn* series is partly an anti-western, refusing to give us an active hero to defeat the forces of evil and replacing adult workers on the land with a cast of children. We have an inverted version of Robin Wood's notion of 'normality threatened by the monster', in which it is the perverted normality of Gatlin that represents the dominant value system and which is disturbed by outsiders, who must be repelled or destroyed. The *Corn* films blend Thomas Schatz's notions of 'determinate' and 'indeterminate space', in dramatizing a battle for a particular territory but on ideological grounds.[11]

Following John Cawelti in looking for an allegorical reading of the genre as articulating a dream of the collective unconscious, is also problematic. Rather than fears about bodily change or ultimate corruption in death (arguably underlying concerns in horror generally, including the stalk and slash subgenre), the *Corn* films might be seen to articulate a sense of wish fulfilment about liberation from adult control and a rejection of the necessity of assuming adult responsibility. However, this is still fairly limited as victims are also children. If Noel Carroll sees horror films of this slasher era as representing feelings of 'paralysis, helplessness and vulnerability', it is less a nightmare of children and perhaps more convincing as an adult nightmare *about* children and the ultimate consequences of allowing isolated communities to cut themselves off from mainstream America, especially when fuelled by religious mania.[12] We are not in a generic school or summer camp, or even the existential generic space of dreams, we are in a very particular part of the American mid-west. Gatlin may look like other fairly non-descript towns but its horrors could be avoided by simply driving past – Burt and Vicky in the first film are only ensnared initially by an accident. Even though the *Corn* films do not use the relentless killer's point-of-view creating a dramatically active sense of involvement, this still taps into a societal version of J.P. Telotte's idea of slasher films like *Halloween* as a morality play, requiring us to be vigilant for manifestations of evil and punishing those who are not.[13] Whether these children are seen as personifications of a generation, unwilling to grow up, is possible but we see very little sign of parent-child relationships, only children acting as demagogues to one another. Furthermore, exactly what has led to this one town of Gatlin developing in this way we do not see and are not told, it is simply presented as fact.

So where are the pleasures in viewing such films? In this sense, it is not the viewer's *involvement* in the on-screen action, in which the identification with a killer's point-of-view acts as a catalyst, but its opposite – a sense of detachment, allowing us to feel superior and possibly aloof from events. As Dika notes, 'the low budget methods and the less-than-professional actors, dialogue, and image [...] encourages participation from a position of emotional distance'.[14] Once the template has been established, the extinguishing of evil seems unlikely. There is no consistent hero or heroine to 'root' for (other than the anti-hero in the person of the returning villain Isaac). There are no catch-phrases for audiences to call out; no costume cues that would encourage cultish mimicry. The main difference is in the nature and creativity of the kills. Ultimately what we have are the pleasures of serial TV drama – little or no character change, no challenging elements of film form, just a familiar milieu in which to pass some time, possibly as a date-movie, which might offer the sound of something transgressive but actually will not be too unsettling or shocking to spoil the atmosphere.

The significance and endurance of the premise over so many sequels may baffle some viewers but it represents a coming together of a number of factors – low production costs, a simple and known premise (carried in the four-word title), the lack of A-list stars needed and perhaps most of all, its distinctive setting. It may be part of the stalk-and-slash genre but its location and source of evil do make it sufficiently different from its generic parentage to see the films in this chapter as representing a subgenre of their own. The notion of possessed children as Other is found elsewhere, but usually attributed to satanic possession (*The Exorcist*) or alien influence (*The Village of the Damned*).[15] Perhaps the reason the single film has evolved into a franchise is because rather than externalizing evil as deriving from some outside force, its source is firmly located in human society and is still with us – religious mania in mid United States. Globalization and the spread of mobile communications may erode the viewer's credibility of any community's ability to remain undetected for years but the persistent existence of Amish communities and Christian militias underscores its possibility. Repeatedly denied the potential consolation of a survivor, Clover's 'Final Girl', we are faced with a bleaker vision. In talking of the children in *Salem's Lot* (Tobe Hooper, 1979), who are not only the vampire's first victims but subsequently its most willing servants, Nina Auerbach's comments also apply here: 'They are not, like other demon children of the 70s, occult invaders of a benevolent adult society; they are the essence of that society'.[16]

Notes

1. Joe Bob Briggs, 'Gary Hart Is Strange and So Is This Movie About Cornflake Kids', in George Beahm (1991), *The Stephen King Companion*, op. cit., p. 376.
2. See Michael Collings, *The Films of Stephen King* (Washington: Starmont House, 1986), p. 135.
3. Ibid., p. 29 and Tony Magistrale, *The Hollywood Stephen King* (New York: Palgrave Macmillan, 2003). Magistrale, op. cit., p. *xi* and *xiii*.

4. See Stephen Jones, *Creepshow: The Illustrated Stephen King Movie Guide* (New York: Billboard Books, 2002), p. 36.
5. Don Herron (ed.), *Reign of Fear: The Fiction and the Films of Stephen King* (Novato, California: Underwood-Miller, 1988), p. 3.
6. See Frank Darabont, *The Shawshank Redemption: The Shooting Script* (New York: Newmarket Press, 1996), p. 179.
7. Vera Dika, *Games of Terror: Halloween, Friday the 13th and the Films of the Stalker Cycle* (Rutherford, NJ: Fairleigh Dickinson University Press, 1990), p. 10.
8. John McCarty, *Splatter Movies* (New York: St. Martin's Press, 1981), p. 1.
9. Robin Wood (1983), 'Beauty Bests the Beast', *American Film*, 8:10, pp. 63–65.
10. Dika, op. cit., p. 131.
11. Thomas Schatz cited in ibid., p. 27.
12. Noel Carroll cited in ibid., p. 24.
13. Ibid.
14. Ibid., p. 129.
15. Robin Wood, 'An Introduction to the American Horror Film', op. cit., p. 10.
16. Nina Auerbach, *Our Vampires, Ourselves* (Chicago: University of Chicago, 1995), p. 158.

Chapter 3

Monsters vs Aliens

T he invasion narratives in *Stephen King on the Big Screen* were discussed in relation to 1950s science fiction. Some of this persists here but on a distinctly smaller stage with notions of infiltration, mind control, and a power struggle for the soul of America (and by implication the free world) played out in the microcosm of small-town America. Andrew Tudor discusses what he terms 'invasion narratives' in which 'the monster appears out of the blue, goes on the rampage, is faced with the customary combination of expertise and coercion and, perhaps, is finally returned to the unknown'.[1] King's narratives offer fairly good examples of 'closed' versions of this, in which even when there is some element of infiltration, it remains clear who is the alien. Their basic structure involves the appearance of an alien entity, a demonstration of powers, a revelation of purpose (largely absent in *The Tommyknockers*), an element of temptation, at least one character siding with powers offered by alien, a series of battles and a final resolution.

The Tommyknockers (John Power, 1993)

The basic plot premise, alien-spacecraft-crashed-in-the-backwoods, draws on a long tradition from H.P. Lovecraft's short story 'The Colour Out of Space' (1927) to films like *It Came From Outer Space* (Jack Arnold, 1953) and *Quatermass and the Pit* (Nigel Kneale, 1958) in which first contact between human and alien takes place on earth and leads to questions about the course of human evolution and the likelihood of benevolent extraterrestrials. Like King's Jim Gardener, the character of Roney (Cec Linder) in *Quatermass* is resistant to the influence

of the alien craft and eventually sacrifices himself to destroy it. Lovecraft's idea of a meteor causing bodily change to those who come into contact with it (particularly those seeking to exploit extraterrestrial power) had already been used by King in 'The Lonesome Death of Jordy Verrill', the second section of *Creepshow*, which he also scripted. The idea of an alien outsider acting as a catalyst for corruption in small-town America clearly holds some attraction for him, appearing again in *Storm of the Century*, *Needful Things* and the more recent *Dreamcatcher* (Lawrence Kasdan, 2003). The most obvious precursor however is H.G. Welles' novel *War of the Worlds* (1898) and its infamous 1938 radio dramatization (alluded to slightly in the opening jazz theme in *The Mist* [Frank Darabont, 2007]). In his introduction to *Everything's Eventual* (King 2002), in commenting on playwriting as a lost art form, King describes his failed attempt to produce a radio play like Orson Welles' *War of the Worlds* (1938), in which an alien landing interrupts a radio programme (he had hoped to use his own WKIT-FM channel).

The derivative nature of the plot can be seen in the guarding of the town limits by a force-field, the destruction of the means of communication and the mass following one figure, whose mind they cannot read and who ultimately sacrifices himself to destroy them – all features reminiscent of *The Village of the Damned*. The taking over of bodies in rural America smacks of *Invasion of the Body Snatchers* (Don Siegel, 1956), although the bodies held in tanks look more like they are covered in bubble bath, rather than any terrifying loss of humanity. Unlike the novel, where the unlikeliness, the unfashionability, the harking back to classic science fiction of the 1950s, is all recognized, the plot in the film seems hackneyed and predictable. A spacecraft is discovered in woods, locals think they can tame its power, the alien force somehow takes them over and there is a final confrontation in which the aliens are defeated and those most suckered by them destroyed. It is a plotline straight out of BBC's *Dr Who* or even Gerry Anderson products like *Thunderbirds* (ATV, 1965–66) or *UFO* (ITV, 1970–71), which shares the premise of a parasitical force seeking to abduct humans for their own benefit. This all creates the sense that this is more entertainment for a child audience than an adult one.

Lawrence D. Cohen's script manages to cut through some of the bloated, over-writing of the novel (the meandering back-story about the local history of the town of Haven for example). Originally broadcast as a two-part mini-series, the regular breaks paper over some of King's dramatic rambling. However problems remain. Cutting Jim's first view of the craft means he never really credibly carries the viewer's sympathy and Nancy's deadly lipstick seems more like a light sabre parody. The speed with which the town is won over is unconvincing (virtually the whole town appears at the dig site) as is the meeting witnessed by Jim, heavily using oblique angles, shaky handheld camera and the ubiquitous green light. Those affected by the light exhibit zombie-like movement but in this one scene alone. In the climax, there is the hackneyed 'battle for the protagonist's soul' scene where Jim miraculously manages to regain sufficient humanity in Bobbi (Marg Helgenberger) to help her break free from alien influence and inexplicably understands their motives and methods. Just how Jim knows how to operate the alien machine, fly the ship and destroy his enemies by force of will, however all remains unclear.

The effects, particularly the aliens, are reasonable for a limited TV budget. The interior of the spacecraft, although using blue screen effects for the lift sequences, are sufficiently Giger-like, to avoid looking like a cheap *Alien* parody. That said, the novel describes the unearthing of a sizeable spacecraft but here we see blocks resembling a children's adventure playground. The visualization of the aliens uses the conventional 'greys' humanoid form and the final explosion clumsily juxtaposes model work with extras having twigs thrown on them.

The 'monster theory' of Andrew Tudor describes a model of narrative structure in which the monster is kept back until the end but this creates the possibility that any visualization of monster likely to be different to what viewers had imagined and therefore disappointing, as in *It*. As an example of a higher intelligence, it seems incongruous that their means of combat is to throw their human adversaries around and Jim's opponent seems to allow himself to be decapitated rather easily (possibly explaining why they have virtually died out).

Tension is rare. The opening credits with its rapid low angle Steadicam through woods could suggest hunter or hunted but neither is really followed up in the film. The slow motion running, oblique framing, and green eye effect, feels more like an impressionistic trailer than a coherent credit sequence. King repeats the green eye effect for Flagg in *The Stand* and Harlan in *Golden Years* but in combination with the glowing green light in the woods, this feels more like an effect to scare an audience of children rather than adults. The intercutting of the love scene between Bobbi and Jim or the adulterous liaison with Joe (Cliff De Young) and Nancy (Traci Lords) with the bathing of woodland in green light, implies tension but there is none there. Jimmy Smits lacks the charisma to carry the main role and delivers a particularly unconvincing drunk, stumbling around the town bandstand. The one-dimensional breathless delivery of Traci Lords makes her character little more than a porn stereotype, reminiscent of Sheryl Fenn (also attempting a crossover from porn to mainstream film) in *Of Mice and Men* (Gary Sinise, 1992) (but whose character in that film, only being able to relate to men via sexuality, makes sense, whereas Nancy's here does not).

There are some unsettling moments. The reaction of Davy (Paul McIver) to policewoman Ruth Merrill (Joanna Cassidy) showing him the bizarre collection of dolls in a police station, uses a close-up of a sock scarecrow puppet, whose sewn-up mouth appears to move and growl. Rapid cutting, threatening music and the fact that nothing is seen by the adults, makes the scene eerie but without a coherent link to the rest of the plot (the aliens bring a source of electrical power, they do not animate inanimate objects). However, much of the effectiveness is later undone as Merrill is 'attacked' by the dolls, some clearly moved on wires. The magic trick, that goes wrong so that a child really disappears, could have acted as a powerful image of the Todorovian fantastic – something inexplicable enters the narrative, which could have caused viewers to question the nature of reality. However, all 'unexplained' phenomena are easily-attributed to the presence of the aliens. The TV dating show host addressing Becka Paulson (Allyce Beasley) directly works well, with all the contestants advising her to kill her adulterous husband, Joe. After Becka rewires the TV, the host's dialogue ('That's it, goodnight') provides an ironic commentary on the subsequent demise of her spouse. The

ending of the film has Bobbi survive, ameliorating the novel's irreversible mutation, but this at least is consistent through the plot with her talking of becoming but displaying fewer signs of physical mutation. Indeed her peeling skin and lifeless pallor (linked to the loss of teeth) make her look more like the victim of a wasting disease, possibly increasing sympathy for her rather than her selling her soul to an alien intelligence. The final image of Bobbi and her dog wandering off into the woods and the camera tilting up to the sky with Jim's love poem on the voiceover, is a fairly downbeat comment on his sacrifice.

Needful Things (Fraser C. Heston, 1994)

> What do you mean, 'He's a monster?' [...] he looks like my uncle.
>
> (Pangborn in *Needful Things*)

Director Fraser Clarke Heston, son of Charlton, dramatizes King's last Castle Rock novel in which the devilish Leland Gaunt (Max von Sydow) uses his position of proprietor of Needful Things, an antique store, to set neighbour against neighbour, husband against wife and to dissolve any bonds that binds the community together. All are granted a talismanic object, which emits an electrical charge when touched, throwing the holder into a flashback or fantasy reverie. A young boy's baseball card prompts him to live out a destructive fantasy in pitching apples at the window of a neighbour, Wilma Jerzyk (Valri Bromfield), a statue forms a link with a long-dead husband for Nettie Cobb (Amanda Plummer), a jacket allows Hugh Priest (Duncan Fraser) to relive his lost youth and an amulet apparently cures Polly Chalmers (Bonnie Bedelia) of her arthritis, as well as carrying an erotic charge, suggesting a certain lack of satisfaction with what her lover, Alan Pangborn (Ed Harris) has to offer. King's lengthy novel is inevitably shortened and characters cut (Ace Merrill) or simplified – Danforth 'Buster' Keeton (J.T. Walsh) is less resistant to Gaunt's manipulation than in the book and wired up in every sense, and completes his character trajectory by destroying the shop with a suicide bomb.

Fairy tale elements, such as the source of evil luring individuals by granting them a wish for which there is a price to pay, work quite well but just as effective are more subtle filmic references. The shot composition of Brian (Shane Meier) and Gaunt negotiating the price of the baseball card over a shiny table with strong central lighting from a window and swirling mist in the background inside the room, evokes the chess game in *The Seventh Seal* (Ingmar Bergman, 1957), since Gaunt is playing for the soul of the boy. Reminiscent of his own silhouetted figure in *The Exorcist* and the T-1000 in the underpass chase sequence in *Terminator II*, Gaunt emerges, not just uninjured but unscathed from the final explosion, clearly underlining that he is not human. He promises Pangborn that he will return to plague his descendants and then calmly walks to his car, also unmarked, and drives off, disappearing as he crosses the town boundary. Like *The Witches of Eastwick* (George Miller, 1987), a charismatic stranger appears in a small town, corrupts its citizens one-by-one

before being driven out. However, unlike the impassive Linoge in *Storm of the Century*, which also follows this pattern, Gaunt is avuncular, charming and stylish. Max von Sydow's performance invites comparisons with fellow antiques dealer, James Mason's Barlow in Hooper's *Salem's Lot*. Gaunt is held in frame with a gold raven in the bottom right corner, paralleling Barlow's skull shot. Unlike Linoge, who is written as an enigma but just comes across as tedious, Gaunt and Barlow act for *pleasure* – for them, evil is a playful way of passing the time. Gaunt claims 'I'm not the father, the son and the Holy Ghost. I'm just a lonely guy,' sounding more like a misunderstood high school shooter. The newspaper collection, which Pangborn finds, suggesting a link between the presence of the narrative's source of evil and events in the wider world, is also found in Mick Garris' *The Shining* but this is not pursued in either narrative. Here, ambiguities surrounding Gaunt's status, aims, and even the extent of his powers (typical ambiguities in this chapter) are overcome here by the engaging performance of Von Sydow.

There are predictable horror elements, such as Pangborn suddenly appearing at the window of the coffee shop, Gaunt standing right next to Hugh when he goes into the shop, and Gaunt dropping a hand on Dan's shoulder in the churchyard. The labelling of Gaunt's packages in his basement with 'explosives' seems cartoonish and the pseudo-vampiric scene between Gaunt and Polly, complete with lightning flashes, neck kissing, and the semi-orgasmic response from the woman, in thrall to a dominant lover who bears down on her, is all fairly clichéd and the exact extent of the sexual bargain with Gaunt is left ambiguous.

However, some sequences do work. His sudden appearances in Polly's shop and later in her bedroom, seem more unsettling as they suggest supernatural abilities more effectively than placing an actor just out of the frame. Sound is used effectively in places. Nettie's discovery of her beloved dog, involves a slow search through her house, in which we hear a creaking noise and the buzz of flies before, skinned and hanging, it swings into her face, looming into the camera as she pushes open a door. Dan's instability and the speed with which he becomes obsessed with the racing game, is conveyed by the drumming of the horses' hooves and race commentary, which is inter-cut with a different, quiet sound perspective when his wife tries to listen at the door. By contrast the 'Ave Maria' that Gaunt listens to, in a fireside armchair after entwining his long, *Nosferatu*-style fingers and kissing his book of names, runs on into the following scene, showing the consequences of his machinations, in the less than peaceful confrontation between Nettie and Wilma. There is a lengthy and brutal fight sequence, with knife and cleaver and a final slow-motion crash through a window, producing a tableau with both weapons impaled in the object of hatred. The blend of track and zoom in the close ups of the barman and Hugh (also in an oblique angle), conveys the unreality of the scene, moments before blasting each other with shotguns. The single shots of Brian framed against the rocks by the rising sun and particularly the extreme low angles used twice for Gaunt standing next to the lighthouse, do suggest more of an epic Faustian struggle for the soul of the town and a graphic match links the scarecrow that Brian passes, cycling away from his apple attack to Gaunt closing the door of his shop. The 'talking down' of a suicide is clichéd with Brian holding a gun to his head, while Pangborn's edges closer and then launches a

slow-motion dive but the cutting away at this point to the Reverend slashing tyres, denying us immediate knowledge about the outcome of the scene, does create some tension.

Amanda Plummer has made a career of quirky roles and here as Nettie Cobb she exudes instability, reflected in the ubiquitous stickers she plants all over Dan's house, her manic point-of-view showing accusations (ranging from the formal 'Misappropriation of town funds' to the more colloquial 'Horse-fucking') and the speed of her malicious action picks up, making the stickers into improvised decorations to the sound of Grieg's 'Peer Gynt: The Hall of the Mountain King' (1876). Her absurd escape weaving through the rooms, including a comic trip behind a sofa, is shown via Steadicam as Dan tracks her.

Like Arthur Miller's *The Crucible* (1953), small-town rivalries surface (often superficially based around religion) and there is a drive to find scapegoats for perceived 'wrongs' under the direction of a charismatic individual. Here, it is ironic that this role is taken by the devil himself. The rivalry between the two rival priests, Reverend Rose (Don S. Davis) and Father Meehan (William Morgan Sheppard), escalates through the course of the film. Rose is seen scurrying away with a package after Gaunt has interested him in some erotic statues and Meehan gains a prize exhibit from the shop window. The two men use overlapping dialogue, both delivering last rites to Nettie and Wilma at the same time, conveying petty bickering over prospective souls. The ubiquitous stormy weather which accompanies the final third of the film, rather heavy-handedly showing the town's descent into hellish chaos, motivates the lightening strike on the steeple, providing a fairly crude allusion to Father Brennan (Patrick Troughton) in *The Omen* (Richard Donner, 1976). Here the priest, Father Meehan, is not impaled on the falling crucifix but organized religion is shown as corruptible as the rest of the town – ironically, the Reverend is examining the goblet from Gaunt's shop window (the reward we assume for damaging Hugh's tyres) when Pangborn appears to ask for spiritual guidance. The Reverend subsequently defends Gaunt with his arms outstretched, crucifix-style, before the explosives planted outside by Dan Keeton under Gaunt's influence, blow the windows in.

At the climax, a reverse tracking Steadicam shot shows Pangborn, the only one to stand up for law and order, fetch his shotgun from his patrol car and march up the road, loading the gun one-handed, action-hero-style. On the streets of Castle Rock looting and random acts of violence break out like the opening of King's *Cell* (2006), symbolized by Meehan frozen in tableau about to kill Reverend Rose. Pangborn draws his handgun but fires the entire clip into the air, miraculously bringing everyone to their senses. The sheriff cannot easily articulate what he feels about Gaunt, who is eagerly watching the scene, goading him with 'Yes, we're waiting'. Pangborn's impassioned speech unbelievably brings all the disorder to a halt, almost reminiscent of the *Top Gun*-parody *Hot Shots* (Jim Abrahams, 1991), when after a similar speech, characters all stop fighting and hug one another. Here, characters start to offer confessions and fall into line with their Sheriff, even starting a call-and-response before Pangborn is suddenly hit in slow-motion by a sniper. The scene feels like Piggy's final speech in William Golding's *Lord of the Flies* (1954), which leads to the death of the unwanted messenger, not a wishful voluntary laying down of arms.

The Langoliers (Tom Holland, 1996)

Make it stop. Please make it stop.

(Bethany in *The Langoliers*)

I couldn't sleep last night and there was this old Stephen King movie on channel 62 in which almost everyone vanishes in mid-flight except for these six people who were asleep [...]. But this is total crap. What *would* be left behind if everything that was you vanished? The only thing that's truly *you* is cells containing your DNA [...] so there'd also be dental fillings, breast implants, hair weaves, false eyelashes, porcelain veneers, makeup, contact lenses [...] (Bethany, depressed Staples employee in *The Gum Thief*)[2]

Coupland's Bethany (who must be named after King's character) goes on to list undigested food, quite a number of unpleasant bodily secretions and gallons of water, which may seem fussy but it does blow a sizeable hole in King's basic plot premise. *The Langoliers* blends a number of typical King features – an everyday situation (an aircraft flight), a contingency premise (what if a group of passengers woke up to find themselves alone?), and a group who must work together to defeat an other-worldly entity.

The premise itself is not original. *The Outer Limits* episode 'The Premonition' (Gerd Oswald, MGM, 1965) features a plane which enters a frozen, timeless zone and is threatened by a creature, which will prevent its return to the present. The protagonists are thrown slightly into the future and must battle to return to the present as time gradually catches them up. Certainly, the experience of aircraft flight, can seem disembodying and disorientating but one might expect more of Tom Holland, a director with some influential genre work in his back catalogue, such as *Fright Night* (1985) and *Child's Play* (1988), who is working from his own script here (including a cameo as Harker at the beginning). However many of the acting performances are really quite weak. Despite being British, the accent of Nick Hopewell (Mark Lindsay Chapman) sounds very like a poor impression of one, punctuating every other word with 'bloody' and 'mate' (a flaw in the writing as much as the performance) and the back-story of the Captain and especially Nick does not feature until the final approach to the 'time-rip' (as in the novella).

The emotional range of Captain Engle (David Morse) does not extend beyond stoic calm, Dinah Bellman (Kate Maberly) has little chance to overcome the mawkishness of her role, the romance between Laurel (Patricia Wettig) and Nick seems perfunctory, and the theorizing of Bob Jenkins (Dean Stockwell) is just plain annoying. King's placing of a mystery writer amongst his ensemble cast, seems a very overt narrative device, so that he acts as a King-proxy figure, asking and answering useful questions to promote plot development. The mysterious disappearance of a large number of passengers is explained step-by-step via a group of characters, nearly all of whom miraculously learn something about themselves. The reserved child prodigy who dreams of being a western-style hero gains some courage, the little blind girl (with crushingly-obvious irony) gains some vision, the shy middle-aged woman learns to risk her heart and trust in men (although she finds love a bit late in the

character who must sacrifice himself). Even Toomey (Bronson Pinchot), the pressured businessman who has had lifelong nightmares about the Langolier monsters who come and eat lazy individuals who are 'laying down on the job' in the capitalist world, learns some self-sacrifice in drawing the ire of the monsters at the crucial moment. Pinchot does what he can with the role he has but beyond the wish fulfilment of putting a nose-hold on obnoxious passengers, there is little the actor can do. His back-story is compressed into a couple of repetitive flashbacks, and the therapeutic ripping of paper remains unexplained. In short, we have nearly all the clichés of the TV disaster movie but with a slight supernatural twist and some unconvincing monsters.

Opportunities for unsettling shots are wasted. For example when Dinah wakes, we see her stumble from her seat, calling for help but the potential shock of the empty plane is given to us in a wider shot almost immediately. Similarly, the idea that Captain Engle, a trained pilot, would rush up to her and only then note the lack of other passengers, seems ridiculous. Furthermore, he and the other passengers only display curiosity, rather than shock, confusion or fear – far more believable emotions. There is also an intrinsic problem with Dinah's character, since without a voiceover, the film struggles to convey her inner thoughts and yet also cannot give us her point-of-view shot. It is only when Bob starts to look around that we start to feel directly involved, looking at the uncanny remnants left on the seats.

Holland wastes the chance to create suspense in Toomey's 'revival' in the fight with Albert (Christopher Collet), showing him sitting up in full shot. There is often a strange contradiction between dialogue and action, like Albert and Gaffney (Frankie Faison) instantly trying the visitors' centre when looking for Toomey for no apparent reason and later Bob declares 'They're coming out', referring to the remaining characters emerging from the airport building but we can see they are already halfway across the runway.

The special effects, even given the mid 90s state of computer graphics, are not that special. The Langoliers sound like crunchy cereal and are about as scary, having a combined look of Pacman, Critters ('monsters' not designed to be frightening) and the Chattery Teeth from *Quicksilver Highway* (Mick Garris, 1997). However, this misses the point. The weakness in the Langoliers is not in their surface appearance but their conception, in both book and film. There is a central contradiction in that we are supposed to accept that all the other characters can see, hear and are acted upon by projections of a third party. Elsewhere in King's work, such as *Secret Window*, exactly the opposite is presented as a given. This is even underlined in this film. Led on by a vision of Dinah, surrounded by dry ice, and her words on voiceover, Toomey makes a report to King's obligatory cameo on the tarmac as Tom Holby, Chairman of the Board. This is effective in that we see his subjective vision, crawling on the table, inter-cut with the long shot point-of-view of Nick and the Captain, who just see him crawling eccentrically on the tarmac. However, like Wendy bewildered by Jack in the ballroom in *The Shining* (1997), we are made aware that we do *not* share the subjective visions of others. Equally unlikely is that characters would just accept and start using the term 'Langoliers' without question. The recurrent King weakness of spurious-fiction-presented-as-fact, resurfaces here.

However, Garris' treatment lacks credibility and plot-holes abound. Toomey describes the creatures as 'hairy' and 'running' and yet they appear more like walnuts and clearly have no legs. If they represent a metaphysical concept, why are they land-bound and do not, since they can apparently fly, pursue the plane into the air? If they are supposed to personify 'purpose', why do they appear to move around apparently at random? Why did the plane initially fly into the 'time rip' if their was no force-field pulling them in? How did Capt. Engle manage to get home on less than a third of the fuel he said he needed including a second approach at the 'time rip'?

Notions, such as the creatures eating the past and time slips would be less flawed if the cast did not spend so much time debating them, precisely underlining their questionable status. As elsewhere in a King mini-series, the central problem is narrative pace. No sooner has a dramatic obstacle been discovered than several characters spend time staring enigmatically into space (especially unbelievably when the Langoliers are eating up the airport itself), delivering portentous dialogue or pontificating about their latest theory, Bob especially. Despite the warnings from Dinah of something evil getting ever closer, they decide to go and eat something, whereupon they start discussing the relative merits of sandwiches and beer and allow Toomey to escape, going on to kill Gaffney and mortally wound Dinah. If a subject can be talked about, it is. On a desert island with time to kill, this might work. Apparently being the last survivors on earth and facing imminent extinction, should create a more urgent dramatic dynamic. The question 'What happened to everyone?' is asked so many times, it loses any dramatic weight. With nothing happening to them, the experience of being on the flight is entirely soporific, replaced on the ground by characters looking towards the direction from which, for a considerable time, nothing appears. Dinah's slow-motion walk towards Toomey with the knife, her stilted dialogue and lack of reaction to being stabbed casts her as unsympathetic martyr (whose status is rendered less absurd in the film by not seeing her disappear on the return trip through the time rip as she is not asleep). Even the appearance of the Langoliers, which could be potentially frightening, is completely dissipated by the time it takes them to appear. Although they cut through the airport quickly enough, their approach is marked by a cutting down of pylons at a fairly pedestrian rate. Given the slow pace, continuity errors, like cars moving in the background shots of the supposedly-deserted Bangor airport, seem more obvious.

There is an attempt to inject some drama in the landing at Bangor and the final approach to the 'time-rip' but the *Star Trek*-like shaky, handheld, camera, oblique framing and cast members throwing themselves around, do not make this convincing. In the first example, there is no suggestion of anything mechanically wrong with the plane or hijackers- in short, no imminent threat. Similarly, the later refuelling section seems ridiculous as characters suddenly start rushing around after 90 minutes of doing very little. Both landings at Bangor and Los Angeles use screeching sound effects, speeded-up stock footage or sudden pans, underlining the lack of drama rather than creating any. The survivors' final child-like dancing around at the beauty of 'now' that catches up with them, could have been engaging at the end of an hour-long *Twilight Zone* or *The Outer Limits* (Leslie Stephens, ABC, 1963–65) but after three times this length, the idea of these six being the 'new people' is just depressing.

The Mist (Frank Darabont, 2007)

The universe is not only queerer than we suppose, but it is queerer than we *can* suppose.

(J.B. S. Haldane)[3]

In theory, *The Mist* could be classed as an apocalyptic narrative, except the exact spread of the mist and its properties remain unknown, i.e. whether it can be fought at all. Several typical King elements resurface here – it derives from a short story and features small-town America and the eruption of the fantastical in the everyday. As in King's sole foray into directing, *Maximum Overdrive* (1986), a group of characters are trapped in an everyday place of commerce by inexplicable malevolent creatures. Explanations about the source of the threat are less important than how the characters react to it. It is also similar, strangely enough, to director Frank Darabont's previous two King adaptations, *The Shawshank Redemption* and *The Green Mile* (1999), in that this too is a narrative involving a sense of incarceration. What is different here is the precise locale – a supermarket. The film is interesting primarily for its relation to the source novella, the nature of the creatures and the ending. The novella, published as part of *Skeleton Crew* (1985), leaves several elements open, such as the precise nature of the creatures and what happens to the survivors in the car, whereas the film moves towards a greater sense of closure.

The short story (and the film to a degree) explores an aspect of horror theory most commonly exemplified by *Alien*, namely that it is more horrific to see a monster step-by-step, piecemeal rather than in its entirety straight away. In Scott's film, we actually do see the monster as a newborn bursting from John Hurt's chest, held in shot for a few seconds but the creature grows and shows new capabilities each time we see it. One of the disappointments of the end of *It* is that you have a visualization of something that has only been suggested up to that point and the film in particular suffers badly as a result with a rather ridiculous unconvincing spider-like creature. The otherness of fog is not a new element in horror narratives. In 1979, John Carpenter's *The Fog*, an adaptation of James Herbert's 1975 novel by the same name, uses a rolling cloud to mask the appearance of murderous ghost-pirates. King and Darabont use a cloudform with slightly better visibility to reveal fantastical creatures (apparently produced by an accident in a government research lab – the pseudo-scientific explanation linking the plot to classic 1950s sci-fi).

The dream

We are experiencing some kind of disaster. I don't know if it's manmade or natural but I do know that it's not *super*natural. Or Biblical.

(Norton in *The Mist*)

A key omission from the novella is the dream experienced by David (Thomas Jane). Rather than a sudden experience of monstrosity, the novella keeps eddying back to David's dream and the sense of unease that it creates, more evocative of a trauma breaking through piecemeal

into everyday consciousness as in *Jacob's Ladder* (Adrian Lyne, 1990), which incidentally also uses fleeting images of a flapping pterodactyl-like creature. In the novella, David has 'one of those terrible visions' about harm coming to his family of the picture window blowing in. Darabont transposes this hypothetical fear into a real event but takes out the glass which the literary David 'sees' embedded in his wife's stomach and his son's face.[4] Later asleep, David has a dream of God walking 'on the far side of the lake, a God so gigantic that above the waist He was lost in a clear blue sky' and the destruction that he inflicts causes smoke to cover everything 'like a mist'.[5] The mist, its source, a cruel God and an elision with the monsters, especially the final one, are all present in the dream which resurfaces in his mind on first spotting the mist the next day. In the source text, this carries the weight of a premonition, something perhaps Darabont felt viewers would find hard to accept without giving his protagonist some kind of psychic powers and explanation for such capability, all of which would take time from getting his hero to the store, the centre of the narrative. However, the omission also loses something. The dream passage is rare example in King's writing where an unexplained fantasy becomes genuinely unsettling and for a while we inhabit a strange fictional space, which we cannot fully explain or externalize as just a monster story.

The category ambiguity in the statement by Norton (Andre Braugher) lies at the heart of the evocation of the fantastic as described by theorist Tzvetan Todorov and although it is explicitly raised later in discussions at the store in connection to whether the monsters are 'real', the cutting of the dream loses the chance to feed into this ambiguity. Without the initial dream episode, the statement by Amanda (Laurie Holden) to Billy (Nathan Gamble) that 'It's just a bad dream' when he cannot sleep, remains at purely face value rather than the more interesting possibility that the body of the film represents his fantasy or greatest fear – loss of his parents and a father who would turn against him. David's mention to Norton that during the storm, 'I thought we were gonna take off and head for Oz' might remind us that the body of that film, *The Wizard of Oz*, is really a dream. There is a link between Billy and Carmody (Marcia Gay Harden) too, in the relish that the boy takes in reporting tragedy – as David says, 'Having spoken, the doomsayer departs'. Strangely, there remain oblique references to a precognitive dream even though none exists in the film. David blames himself for the damage to their house but his wife states 'You couldn't know a tree would come flying through the window'.

As an artist, apparently for film studios, David would be familiar with how movies work and how single framed images can inform and intrigue the viewer – the basic business of a film director. There are a couple of allusions to John Carpenter's *The Thing*. In the opening shot we track through David's work-room and one of the finished pieces of framed art in the background is a male figure with a blinding light instead of a face, which was used as the main publicity image for Carpenter's film on posters and DVD covers and Irene (Frances Sternhagen) shows the presence of mind to burn a spider creature with a lighter and aerosol combination, so that it falls to the ground still writhing about like the scene with Stan Winston's spider-head (still an incredible effect nearly 30 years later).

There are several further layers of intertextuality here with the poster David is working on having been painted by Drew Struzan, an eminent poster artist and other artwork we see

are further examples of Struzan's work, particularly collaborations with King on *The Green Mile* and *The Shawshank Redemption*. There is even a glimpse of *Pan's Labyrinth* (Guillermo del Toro, 2006), which shares some of the same special effects technology (using CaféFX), helmed by Nicotero and Everett Burrell. All of these intertextual references feed into a sense of an artist, possibly King himself, influenced by a range of sources and creating, whether consciously or not, dream-like narratives. As discussed in *Stephen King on the Big Screen*, they also provide markers of authorship for an elite group of dedicated fans, attuned to such signs, a device David Bordwell links to European art film.[6] Perhaps a literary dream is replaced by a cinematic one. The setting of the morning after the storm and especially the extreme long-shot with the lake, a single dominant tree, and a father and son who run through the frame, all evoke the opening of *Sacrifice* (Sergei Tarkovsky, 1986), which also tells the tale of an apparent apocalypse, that may or may not have engulfed the whole world. The tree is often taken to be a symbol of divine beauty in the face of corrupt and fallible humankind – the consequences of which in King's narrative are heading towards the house across the lake.

The monsters

> It appears we may have a problem of some magnitude here.
>
> (Bud in *The Mist*)

Designer Greg Nicotero claims his brief was to find some original on-screen monsters but what we see actually have some clear antecedents in the filmic and natural world. One issue with the adaptation is the lack of specific description in the novella, leaving Lovecraftian gaps in overt description which readers must fill for themselves. This is one factor why some viewers may feel some disappointment with Darabont's visualization.

It is true that first of all, King describes 'a grey shadow in all that white' and the tentacles that take Norm (Chris Owen) are fairly close to what we see in the film, except the novella dwells upon the gory consumption of the boy rather than his abduction.[7] However, the creatures that hit the front window and the later spider creatures *are* described and in some detail. At first, using impressions from painting (logical for an artist), David says 'It looked like one of the minor creatures in a Bosch painting – one of his hellacious murals'.[8] The following pages describe in some anatomical detail, the bugs on the window and the flying creatures that follow in after them:

> It was maybe two feet long, segmented, the pinkish colour of burned flesh that was healed all over. Bulbous eyes peered in two different directions at once from the ends of short, limber stalks. It clung to the window on fat sucker pads. From the opposite end there protruded something that was either a sexual organ or a stinger. [9]

In the novella, David impales a spider on a sharp stick and learns 'they were no Lovecraftian horrors with immortal life but only organic creatures with their own vulnerabilities'.[10]

However, in the film, this action is transferred to Dan (Jeffrey DeMunn) and along with Amanda's throwing of a tin being transposed to Irene, the filmic protagonists seem more passive than their literary counterparts and the spider effect is used purely for a pseudo-3D effect, invading the camera's focal distance with a blur.

According to King, talking about the novella, 'you're supposed to see this one in black-and-white, with your arm round your girl's shoulders (or your guy's), and a big speaker stuck in the window. *You* make up the second feature'.[11] However, although Darabont's experience as co-writer on the remake of *The Blob* (Chuck Russell, 1988) would have provided useful background in pseudo-1950s sci-fi and although such allusions are hinted at in the consequences of scientific hubris and the consequent unleashing of monsters, in both novella and film, we have only hints of what the 'Arrowhead Project' actually is and are denied a scientist-as-hero who might help to employ science in the battle against the creatures or re-accommodate our feelings towards science. All we have is the slightly anachronistic feel to the old-fashioned uniforms of the MPs, their jeeps, whipping past David on his way into town and Jessup's gabbled comments about a 'window' into another dimension. Knowledge here provides no help in trying to survive. The story was actually written in 1976 but it took the intervening 30 years for special effects technology to develop before it was a viable possibility. The novella mentions that The Arrowhead project is concerned with 'atomic things', further linking it to a common trope of 1950s sci-fi, although the film steers clear of scientific explanations or precise geographical markers.[12]

Part of the power of the shots of the mist enveloping the cars and then the store itself is how they are strongly evocative of the images surrounding 9/11 and the cloud of dust rolling past New York shop-fronts, filmed on mobile phones and subsequently used on news broadcasts (also clearly drawn upon in *Cloverfield* (Matt Reeves, 2008). We have similar shots of people transfixed, looking up with panic close to the surface. There is the same sense of a fantastical disorientation, in which the familiar is rendered strange, that civilized society is under some form of attack and that the world has changed irrevocably. Generically, the use of an improvised barricade and a single dominant setting in which a group of characters fight for survival against incalculable superior numbers, evoke a mixture of war film (dog-food for sandbags) and westerns like *The Alamo* (John Wayne, 1960), where we might expect the narrative to be punctuated by moments of heroic sacrifice. King recounts being struck by the basic premise whilst in a real supermarket and envisages it as 'what *The Alamo* would have been like if directed by Bert I. Gordon'.[13] Such genres need dialogue-based breaks to punctuate the attacks but there is such pressure to focus on the main threat that there is usually little time for serious romantic interludes. The exchange between Sally (Alexa Davalos) and Jessup (Samuel Witwer) seems contrived and needing more narrative space to be either interesting or fully convincing but is pared down from the novella, which features a sexual relationship between David and Amanda despite both being married. King seems a little squeamish himself about this and in the film it struggles to be credible in the timeframe of the narrative. Darabont also probably wanted to avoid morally compromising his supposedly empathetic hero.

The squid-like tentacles that grab Norm evoke the battles with monsters from *20,000 Leagues Under the Sea* (Richard Fleischer, 1954) or the monsters of standard 1950s sci-fi, whose parts are glimpsed but due to limits of budgets and technology, are rarely seen in their entirety. CGI allows the tentacles to be a little more active, ripping skin from Norm's leg and chest with some sucker-like element, akin to the 'shit weasels' in *Dreamcatcher*. Mark Pilkington, rather uncharitably, describes the effects as 'a poorly-rendered CGI mess'.[14] The first appearance of creatures at the window is more effective because from behind the barricade we see something straight ahead in the distance and track its progress as it flies at the window before hitting it with a splat, which is both shocking but for which we are partially prepared. Looking through the window constitutes a screen-within-a-screen, creating a depth of field and suggesting that the cinema screen might also be penetrated. This is reminiscent of the shot in the prologue where we track back from a window until we pass David, Billy and his mother all looking out at the storm. Like David, Darabont puts characters in a frame for a living and here the tableau looks strangely separate from the fictional world in which they supposedly live. It is as though they inhabit a transitional medium, also looking out on the world of the film, reminiscent of the main menu sequence on a DVD.

The pace picks up as the creatures break into the store and we cut between Ollie trying to shoot one of the flying bat-like creatures, fires being set off accidentally and individual victims being attacked. The flapping creature in the store seems credible in its continual movement and effect on the environment of the store, although seen in closer shots, it does resemble Gonzo from *The Muppets* (Jim Henson) with wings. The flying beetle-like creatures also seem to be played more for laughs than horror by being given literally bug-eyed, human-like faces, so that when one crawls up Carmody's chest, there is more absurdity than horror. The choice to spare her goes unexplained too. Carmody takes this as a sign of divine will and that she is spared to prophesy a message of doom-mongering and the need for expiation but literally there is no reason why the creature does so. It is an action that only works at the level of metaphor – she is such a monstrous human being, even the bug does not want to eat her.

There is a link to the Dark Tower series with the monsters deriving from a between-world state and the way in which the chopped tentacle still appears to flinch when poked with a stick but immediately disintegrates into dusk evokes the monsters in *From a Buick 8* (King 2002a) (also linked to this same transitional state).

The fictional construct of the mist allows Darabont to play upon primal fears about the unknown at the same time as allowing tension to be built up by very small-scale actions. A good example of this is the rope which is paid out to an unnamed volunteer (Buck Taylor) who disappears after just a few seconds of walking away from the store. All eyes are on the rope as it goes slowly, rapidly, stops, bizarrely rises up to the top of the door like trying to land a shark and then comes back blood-stained, before revealing it is only attached to a pair of legs without a torso (this final element not in the novella). Although in part this works, extending the expectation of what these creatures might look like, the opportunity for suspense is lost by seeing the severed legs in full and the extended tug-of-war seen from one side only does become ridiculous after a while. This reflects the novella where David

remembers his father taking him to see *Moby Dick* and 'smiled a little' at the memory.[15] Close-ups of hands grabbing the rope, feet slipping and the bank of faces looking, can only really be effective once we know what is outside and at this point we do not. Although laughter is a common reaction to scenes of the unexpected or unbelievable, if viewers are given the encouragement to laugh (as with the snuffling sounds that accompany the dragging away of the severed legs), it largely precludes feelings of fear.

The break-out to the pharmacy works in some ways as it underlines the loss of the day/night distinction now – the survivors are simply wondering around in the near darkness, illuminated only by flash-lights, like a murder scene in *Seven* (David Fincher, 1995). The lengthy shot of the pharmacy allows us to track the progress of the emergent army of tiny spiders over and around a body in parallel to the larger spider along the bar. Rather than something unpleasant coming towards us, the examples of monstrosity are quietly moving further away but this is strangely more unsettling due to the sense of inexorable movement.

The cocoons discovered in the pharmacy, strongly evoking the alien use of human victims in *Aliens* (James Cameron, 1986), especially their position above the characters, the gradual emergence of baby parasites, and the sense that the characters have walked into a trap from which only a few will survive. The overt similarity between the creatures' ability to emit an acidic web and the xenomorph's acid for blood, the nature of the victims (soldiers) and the cocooning of victims begging to be killed, all make the nature of the scene seem more narrowly derivative than intertextually allusive. The emergence of spiders from a near corpse draws on the widespread fear of spiders and more specifically its expression in the aptly-named *Arachnophobia* (Frank Marshall, 1990).

A human drama?

> You scare people badly enough, you can get them to do anything.
> (David in *The Mist*)

Part of its televisual aesthetic is also related to its static nature. The limited location and tendency to talk in the first half of the film at least rather than action, as well as the cast largely drawn from experienced TV performers, feels closer to armchair theatre. There is an element of low-budget limitation in the setting – for the most part, the film's action is entirely set in the store and even the supposed nearby pharmacy could be filmed anywhere as the mist prevents wide or establishing shots. Darabont does well to insist from the outset of the store element of the plot that there are many people in the building and we see in high angle 20–30 individuals looking out and to be fair, he is overtly concerned less with dwelling on the source of the monsters than with the human dynamic that develops in response to them. However, ambiguities about causes raise questions about their effects. The narrative does dramatize the circumstances in which religious bigotry can flourish but the disproportionate space given to Carmody makes her character more tiresome than persuasive. The speed with

which she whips up and radicalizes the group in the store stretches credibility to breaking point. As Amanda notes, 'It's not even two days'. Even before Carmody is established as an extreme presence in the narrative, an emotional appeal by a mother (Melissa McBride) for someone to accompany her is far too overwrought and sounds an oddly melodramatic note out of synch with the emotion of the scene.

Norton places his faith in rationality but also has his fair share of petty grudges towards his fellow townsfolk who he feels are out to humiliate him. The exact back-story of a property dispute with David is only really lightly touched upon but there is the sense of existing divisions between regular citizens and so-called 'out-of-towners' such that it does not take much for petty resentments and jealousies to rise to the surface. However, none of these are either particularly interesting or spelled out in clear detail. Amanda's branding as a 'whore' by Carmody (which does not really work with the sexual episode removed), the alcoholism of Jim Grondin (William Sadler), or Carmody's reputation as unstable, are all presented as givens. We see the attempt by David to persuade Norton from a distance, without dialogue, as from the point of view of a minor onlooker, representing also Darabont's approximation of King's shift to reported speech.[16]

The dominant style adopted by Darabont is resolutely concerned with the small rather than the big screen and in a search for a slightly more documentary style, he discussed camera technique with the crew of The Shield (Shawn Ryan, FX Networks, 2002–08). In a limited range of locations, especially once in the store, the camera movement is restless, often via handheld shots and dominated by positioning that is obscured or often rotates around characters and focus that is suddenly pulled for little apparent reason. It is the style associated particularly with TV crime series like CSI (Anthony A. Zuiker, CBS, 2000–present) in all its various incarnations and locations and feels like a desperate attempt to inject drama and movement where little really exists. Emergency vehicles suddenly loom into close-up during a long shot of David driving Norton to the store and whip-pans are used with a point-of-view from within the car to give us a sense of the eye-catching nature of a line of military vehicles passing in the opposite direction. This restless style is present from the outset with the camera circling or moving up to the Drayton family as they survey the damage. The later exterior shot up to the window as the survivors start to erect barricades for example, winds around parked cars and suggests the presence or approach of something but is a red herring, at this point.

King is interested in the Jonestown phenomenon, suspicious of charismatic religious leaders and Carmody is described as 'our very own Jim Jones'. Casting herself a seer, she prophesizes that some will die and the creatures will come at night – predictable guesses that, upon being proven correct, boost her credibility amongst the impressionable survivors. As the bug crawls up her, she utters the mantra 'My life for you', evocative of the role of Renfield in Dracula and an exact 'borrowing' of dialogue from Trashcan Man in The Stand. However, Darabont also gives the (relatively) rare sight of a character in a film at prayer, so that we can see her point of view as well intentioned, hoping to save people from eternal damnation, rather than just reject her as mad.

There are a few actors here who have worked with Darabont before, also on his King adaptations, such as William Sadler and Jeffrey DeMunn , who both have key roles in an ensemble cast in *Shawshank* and *The Green Mile* respectively. This does not signify the creation of a King-Darabont branded look but certainly helps the director in using familiar co-workers and both actors have proven in previous work that they can create credible minor roles. Sadler in particular here, has a harder time with fewer lines but his transition from under-achieving drinker to fervent supporter of Carmody makes some sense after he experiences the mind-altering trauma of being confronted by a large spider creature in the pharmacy, shown in a crash-zoomed close-up. Frances Sternhagen (Irene) was also a central part of *Golden Years* and can credibly play an older woman with steely courage beyond her years.

Ending

Amanda: My God, David. We're a civilised society.

David: As long as the machines are working and you can dial 911. But you take those things away, you throw people in the dark, you scare the shit out of them, no more rules. You'll see how primitive they can get.

One reason for the length of time in bringing *The Mist* to the screen was Studio pressure for a more satisfying resolution. As King notes, 'No-one is looking for a sugary ending, but they need a sense of closure'.[17] However, although much touted as original in marketing material and by Darabont and King in interviews, the potential for the film ending is there in the novella as King describes having four bullets 'but if push came right down to shove, I'd find some other way out for myself'.[18]

King's novella addresses the reader directly, warning that 'you mustn't expect some neat conclusion', dismissing the dispersal of the mist or the arrival of soldiers or 'that great old standby: It was all a dream'.[19] However, we do have some elements of this with the arrival of the soldiers and the lingering possibility of a hallucinatory explanation. If there is no effect of breathing the mist (and we see no direct effect upon all the characters who do so), then why do the soldiers at the end (who presumably know as much as anyone about its nature) wear gas masks? The implication is that the mist *does* have an effect on people and possibly a key effect is the sudden experience of monstrous hallucinations. The choice of 'Requiem For a Dream' has both the elegiac element of a lost dream (the future of mankind) but perhaps also suggests the loss is caused by nothing more than a fantasy. Casting the monsters as subjective visions goes some way to explain why they are all apparent mutations or hybrids of existing terrestrial creatures (ants, bats, spiders), rather than something truly otherworldly. This does not however explain the direct effect these creatures have on the survivors (Norm being snatched away or Ollie being sliced in two) or the environment of the shop being affected (as when the flapping creature crashes around the store, smashing into shelves), unless these too are hallucinations.

There are certainly Lovecraftian overtones in the huge behemoth that lumbers past the survivors in the car at the end and their upward gazes of awe and wonder suggest a moment of supernatural otherworldliness. In the novella, David states 'there are certain things that your brain simply disallows' and the behemoth is described as 'something so big that it defied the imagination.' However he also describes six legs, grey wrinkled skin, and the fact that it is host to hundreds of bug creatures. Pilkington even suggests that the scene 'captures the spirit of Lovecraft's awesome cosmic horror more thrillingly than perhaps anything yet put on film'.[20] However, the entity is amazing more for its scale than its physical form, blending overtones of the known world (elephant and mammoth) with the artistic world (evoking Francis Bacon's use of figures with distorted necks like Three Studies For Figures at the *Base of a Crucifixion* [1944] and Dali's series of elephantine pictures, all with extended limbs, from the 1930s onwards, such as *The Temptation of St Anthony* [1946]). There is even an intertextual allusion to George Lucas' 'Imperial Walkers' from *The Empire Strikes Back* (1980) in terms of scale and movement, drawing attention to their construction rather than their fictional reality.

The irony, that when David steps out to meet his expected end, what approaches is not a murderous creature but a column of vehicles with soldiers, is compounded by the sheer numbers of survivors and that chief amongst them is the woman who walked out first of all, now with her children. Had they all walked out as bravely from the outset, and showed some solidarity with her when she asked for help, more might have survived. The irony over the sheer number of people and their nature (the soldiers may not pose a direct threat but they caused the monsters to be released), is compounded by the timing. Had he waiting a few seconds longer, the column would have passed him (and do we not feel that he should have heard such a large body of people moving so close by?). He has slaughtered his fellow survivors and especially his son, for nothing. It evokes Carmody's Old Testament reference to Abraham, except here the father has gone through with the deeds but any spiritual director of events seems malevolent, vindictive and cruel. In *Storm of the Century*, the son is given away to placate a source of evil but here the sacrifice is literal.

The hero trying to kill himself is perhaps the faintest of echoes of Romeo but there is little Shakespearean depth here. Romeo is stymied by circumstances (Juliet has drunk all the poison), whereas we have to believe that David's mind has been lost since he apparently cannot count beyond four (the number of bullets he has). Furthermore, their situation is not as hopeless as Romeo's emotional cul-de-sac. David is not a lone survivor, there is food and petrol available (if they can get to it) and not all the creatures are murderous (unlike the *Alien* franchise) – some are simply curious. The outlook is certainly bleak and dangerous but after 90 minutes of fighting, far from hopeless.

In effect, David's dialogue about taking away the familiar societal supports, describes the work of a horror film director but it is debatable how much at ease Darabont actually is in this environment. There are some cheap horror clichés, especially the sudden appearance of a good character into the frame, designed to make viewers jump, such as Jim popping up at the front window of the store after the pharmacy raid as well as the sudden appearance of

creatures out of the mist, such as Jessup's sudden abduction. In the prologue, we have a few seconds of silence to lull our senses before the tree suddenly crashes through the window, shown from side angle and then head-on, so that it almost seems to fill the screen in an attempted 3D effect. The fact that this room, the so-called 'picture room' is where he was working and the window through which we see the family looking out at the storm makes it feel almost as if there is a sentient, malevolent element to the tree.

Darabont claims that 'It's *Lord of the Flies* that happens to have some cool monsters in it', but as a basis of comparison, it falls some way short.[21] Clearly, the notion of humans being at each other's throats once the veneer of civilization is removed is there in the body of the film but the presence of monsters complicates the significance of this. In Golding's novel, the belief in a 'beast' is clearly a projection based on fear, whereas here the battle with an external force, shifts the emphasis away from human evil. Pilkington reads the ending as 'a stark warning that we should not give up hope, even in the darkest of times' and we do see the extent to which tribal loyalties surface, how quickly people revert to primitive behaviour and the externalization of fear by offering up a sacrifice to expatiate an angry god (Jessup rather than Simon in Golding's narrative).[22] However, here David is not wailing at the end about the darkness of human nature, rather the apparently godless universe which allows such things to take place.

The sheer bleakness of the ending is shocking but also struggles to be credible. We have just witnessed the protagonists struggle for over two hours to stay alive and fight, risking death just to go to fetch supplies from the pharmacy and yet now, even though their lives are not directly threatened, they all somehow meekly give up. Furthermore, David has seemed resourceful up to now but suddenly allows the car to run out of petrol, despite the presence of other cars and gas stations. Would a father, who has done everything to protect his son, suddenly turn into a mercy killer? Suicidal impulses in the face of such experience is believable as we see Hattie (Susan Malerstein) and two soldiers take their own life (echoed in *The Stand* and *Storm of the Century*) However, like the character development in the store (the shift to religious fanaticism especially), what might happen over days and weeks is telescoped into hours, with the corresponding lack of credibility. What might be the starting point for a further car-based battle for survival, as is the case in *Cujo*, is just surrendered. To assume that the entire country or even world is doomed, after driving the distance gained by a single (and probably not even full) tank of petrol, seems a big assumption. The novella has a more open ending with a pause at a gas station, the faint words 'Hartford' and 'Hope' on a radio broadcast and the driving away into the unknown but with some purpose. Here, it almost feels as if Darabont wishes to eschew the Hollywood sentiment with which *The Shawshank Redemption* and *The Green Mile* are often associated, to such an extent that it is more important to deny the viewer hope against Darabont's own instincts. It becomes a kind of anti-*Shawshank* statement, an explicit denial of hope (the key element and indeed final word of that film and the final word of King's novella), with which Darabont seems far less comfortable.

Conclusion

While King adaptations appear to offer us aliens, really what we are being offered is something more crude- monsters. We learn very little about the alien entities and they are nearly always just a narrative construct to threaten our own normality, which is mostly restored intact by the end. As Tudor states, 'the "threat" is the central feature of horror movie narrative', or 'the nub of the horror-movie, then, is the threatening creature'.[23] Problematically, for King, his creation of credible and disturbing monsters is one of the weakest parts of his fiction and this transfers to his on-screen adaptations. *It* provides a rare example of an original and disturbing monster in the guise of Pennywise, but also a useful contrast with something closer to the norm – the disappointing final spider creature, which cannot support the weight of dread that leads up to its revelation. The meatball-like creatures in *The Langoliers*, the aliens in *The Tommyknockers*, even the creature with tentacles in the first attack in *The Mist* – they all lack dramatic, visual credibility.

Kingsley Amis described science-fiction as 'that class of prose narrative treating of a situation that could not arise in the world we know'.[24] King's fiction and visual adaptations are at pains to suggest that precisely the opposite is true – they can and do. The adaptations rarely raise particularly profound philosophical questions about identity and the nature of human reality, artificial intelligence, the possibilities of time travel or the unreliability of memory and selfhood – in short, in the universe of a King adaptation as a viewer, you usually know where you are, who you are, and what might happen to you. Even given the breadth of the term 'science fiction', if the label were to be applied to such narratives, they would seem quite conservative elements of the genre. None of the adaptations discussed in this book happen away from Earth, are set at any other chronological period than the present, and only *It* features brief flashbacks. The pleasures of spectacle of which Christian Metz speaks seem to be largely absent here.[25] In terms of production, none are particularly effects-driven. Indeed, that may be seen as a disappointing feature of them, especially in portraying climactic confrontations with an alien other (as in *Children of the Corn*, *The Stand* or *It*).

These narratives are not the catalyst for a consideration of how humankind, with its own aggressive history, might treat peace-loving visitors from another planet, such as *The Day The Earth Stood Still* (Robert Wise, 1951). It is not about emotional bonds that might form with life from another planet, like *E.T.* (Steven Spielberg, 1982), or about humankind being taken over (except in *The Tommyknockers*). King's narratives do not identify the monstrous in the human, implicating us all in the present but instead feel like a step back in time. As Tudor points out, 'the threats of the fifties come from "beyond" to assail us in our everyday lives'.[26] All of the alien narratives in this chapter could be set in the 1950s with minimal difficulty and there is certainly nothing exclusively contemporary about the environment into which the alien enters. Threats remain external, rather than leading to altered or broken psychological states. Therefore as Tudor expresses this, 'the fear articulated here is focused upon a threat to our "way of life" as much as to our persons'.[27] Whilst marketed to offer supernatural thrills, King adaptations routinely offer comfort to audiences who sees characters tempted

by a pseudo-devil figure but also sees this entity overcome, often by communal action, to reinforce the societal (and by implication, religious) norms that existed before.

Following Tudor, what we have here is a repeated recourse to a very specific form of horror narrative, most commonly found in the first thirty/early years of the genre's development, particularly in the 1940s and 1950s. In this, the threat is external and alien, rather than originating from within. It does not prompt questioning about the nature of human psychology (there is no metamorphosis or demonic possession), allowing the threat to be seen exclusively in external terms, as a force to be battled with and eventually, after a series of episodic encounters, to eventually be vanquished, allowing the status quo to prevail.

There is little or no attempt to explain where the threat comes from, clearly define its powers, or seek to give it a coherent psychology by which we might understand or even sympathize with it. The delay in attributing motives to his aliens suggests a desire to avoid clear generic motivation – are these creatures out to take over the world, take something from it, or destroy it? By delaying such decisions or making them ambiguous, King tries 'to have his cake and eat it too' implying his supernatural threat is a threat to both local community and the wider world but this is often not spelled out.

The disruption of everyday life from the appearance of some entity beyond the human world appears large-scale but actually the main disruption is social. This might take a number of forms (a supermarket in *The Mist*, an ordinary airplane flight in *The Langoliers*, a small-town community in *Needful Things*). However, it is snobbery that sets people apart in *Needful Things* and *The Mist*, not crises of personal identity. Threats of infiltration are activated not by political allegiances but petty jealousies – the creatures in *The Tommyknockers* manage to 'bribe' the local population by offering them one-by-one an unlimited power source. There is even something of a moral lesson in this latter example of not being fooled by salesmen offering a 'something-for-nothing' product in a commercial version of the spiritual temptation motif seen in narratives such as *Needful Things*.

It seems as if King finds it hard to break away from those genres that dominated his own televisual viewing as a child. Where the antagonist is human, such as Gaunt, Linoge or Randall Flagg, the basis of threat is often spiritual, casting the central figure as tempter, winning over a few converts but ultimately defeated by the mass of a community acting together (or at least brought to their senses in *Needful Things*). At the same time, those who adopt a more devout form of religion, such as Carmody in *The Mist* or the children in *The Children of the Corn* series, are seen as extreme elements and often constitute the role of antagonist for the hero. In this, King narratives offer something quite at odds with the impression left by trailers, emphasizing shocks, thrills and scares. What we actually have is spiritually-comforting entertainment, in which closure is nearly always total (evil may not be destroyed completely but it is repelled) and notions of individual and societal goodness fundamentally unchanged. Moments of Todorovian suspension, when viewers are genuinely challenged to rethink what is possible in the world, are almost non-existent here. In this, it could be said that these narratives are inherently suitable to relatively conservative entertainment platforms, i.e. American network television. For Samuel R. Delany,

In the s-f tale, a series of possible objects, possible actions, possible incidents (whose possibility is limited, finally, only by what is sayable, rather than what is societal) fixes a more or less probable range of contexts for a new lexicon.[28]

Although plausibility is central to narratives, which introduce the apparently-impossible, in a sense, King ducks the potential difficulty of creating alternative worlds and universes by locating most of his fiction firmly in the world he knows well, a particular part of the United States and have the unlikely events come to him. If he does create a new lexicon, it is one with which we are already familiar.

Notes

1. Andrew Tudor, *Monsters and Mad Scientists: A Cultural History of the Horror Movie* (Oxford: Blackwell, 1989), p. 91.
2. Douglas Coupland, *The Gum Thief* (London: Bloomsbury, 2008), pp. 230–231.
3. J.B. S. Haldane, *Possible Worlds and Others Essays* (London: Chatto & Windus, 1927), p. 286.
4. Stephen King, *Skeleton Crew* (London: Futura Publications, 1985), p. 12.
5. Ibid., p. 15.
6. See Browning, op. cit., p. 230.
7. Ibid., p. 48.
8. Ibid., p. 98. For a precise description of the spiders, see p. 129.
9. Ibid.
10. Ibid., p. 138.
11. Ibid., 'Notes', p. 607.
12. Ibid., p. 28.
13. Ibid.
14. Mark Pilkington, 'The Mist', *Sight and Sound*, 18:7 (2008), p. 64.
15. Stephen King, op. cit., p. 93.
16. Ibid., p. 71.
17. Jones, op. cit., p. 141.
18. Stephen King, op. cit., p. 145.
19. Ibid., p. 151.
20. Pilkington, op. cit., p. 64.
21. See Frank Darabont (2007), 'Chatting in *The Mist* – Darabont and the cast on the Stephen King adaptation', http://en.wikipedia.org/wiki/#cite_note-sdcc-2. Accessed 28 August 2010.
22. Pilkington, op. cit., p. 64.
23. Tudor, op. cit., p. 8 and p. 19.
24. Kingsley Amis, cited in Vivian Sobchack, *Screening Space* (London: Rutgers University Press, 1997), p. 19.
25. See Christian Metz, 'Trucage and the Film' (trans. Françoise Meltzer), *Critical Inquiry*, 4:3 (1977), pp. 657–75.
26. Tudor, op. cit., p. 47.
27. Ibid., p. 44.
28. Samuel R. Delany, cited in Jan Johnson-Smith, *American Science Fiction TV: Star Trek, Stargate and Beyond* (New York; London: I.B. Taurus & Co Ltd, 2004), pp. 19–20.

Chapter 4

Sometimes They Come Back

I hold to the main idea which is that we survive death in some fashion or other.

(Stephen King)[1]

G hosts appear in some of the earliest examples of primitive film narratives (such as *The Haunted Castle* [George Albert Smith, 1897]) and traditionally they have proved useful cinematic symbols of fears over death and what might lie beyond the grave. The appearance of ghosts have been used to carry important messages (such as Hamlet's father) and represents a staple part of gothic fiction and the introduction of the uncanny but for a twenty-first century viewer, it is debatable whether this still carries the sense of a valid source of fear. This chapter considers films where death is apparently more of a permeable membrane than an absolute state and from which it is possible to return.

Sometimes They Come Back (Tom McLoughlin, 1991)

Teacher Jim Norman (Tim Matheson) secures a new job in his hometown after problems with temper in his last job. However, the stick which he snaps in anger at his noisy senior class, may work as a symbol of his fragile temper but we do not really see that threatened instability anywhere else. There is a focus on the family (a boy is added to King's narrative) and many of the early scenes are domestic and aspirational in tone – this is a fresh start for Jim professionally and personally. Jim's profession, the casting of his wife Sally (Brooke Adams), the slight similarity of name to Johnny Smith and his Everyman function, are all

slight echoes of *The Dead Zone* but there is little of the earlier film's complexity or artistry. Adams' character is flatter and not much more than a one-dimensional, loyal wife.

Stylistically, there are occasional similarities with *Dolores Claiborne*. Jim hears a child crying and whilst exploring the house, the lights suddenly come up and the room is transformed into a subjective vision of his childhood (this is their family home). In his dressing gown, he sees his parents in the kitchen and his younger self sitting outside on the step and after watching his brother Wayne (Chris Demetral) pass by (neither boy can see him), he follows the pair to the railway tunnel where he witnesses the confrontation with the bullies and Wayne's death. After the younger Jim runs back, we cut to the adult Jim copying his doppelganger's body positioning and crying too, when Sally finds him. As in *Dolores*, a threshold location (both within the house and at the main door), is the site of an on-screen convergence of past and present selves, suggesting the importance of the past for the present character and potential future action. In a possibly unwitting echo of William Burroughs or a memory from his own childhood in Fort Wayne, Indiana (a fact glossed over in most biographical summaries), the sound of a steam-whistle is used from the outset to motivate flashbacks but also is part of Jim's subjective universe and we are not always sure if he has actually heard something or not.

The conception of the ghosts is confused. The devilish, black car with flames pouring from the back used to chase down two of Jim's students Billy (Matt Nolan) and Chip (Chadd Nyerges), his own wife and later their son Scott (Robert Hy Gorman), feels like an unsubtle version of *Christine*. It shows why Carpenter was right not to have kept the ghostly Roland LeBay character. Unfortunately for Jim, only *his* van is seen by witnesses of Billy's death. However, this is later contradicted by Sally and Scott who both see the car (as they saw the ghostly sneakers hung from a lamp post at the parade earlier). The same inconsistency is true with the ghost characters themselves who appear one-by-one to replace murdered students in Jim's class. They are clearly seen by other staff and students and have a corporeal reality (one assumes they attend other lessons) and yet they cast no reflection in the mirrors in the toilets (drawing ad hoc on vampire lore). The ghosts uncover their true faces to Chip in the car and then proceed to supposedly dismember him piece-by-piece with just a flick knife. Tellingly, Sally later swaps a small for a big kitchen knife when she hears noises outside the house. The exact nature of their powers is unclear since they seem to need a means of access, and yet the reason for adopting the physical form they do, is unclear (other than providing filmic spectacle). Although there are four in the gang, with high-pitched, girlish laughter and given to much smirking and preening in their small time on-screen, they seem more like extras from *West Side Story* (Robert Wise and Jerome Robbins, 1961) than credible sources of fear. Jim manages to shoot Lawson (Robert Rusler) but although he gets up apparently unharmed, they all run off without any reason why.

There are some notable shots, such as the silent, long shot of Scott walking home and the black car suddenly flying over the brow of the hill behind him. Earlier, we dissolve from Jim watching *King Kong* the remake (John Guillermin, 1976) to a composite of video images of himself and Wayne playing together, as a rather clichéd and sentimental metaphor of memory

but one that is also oddly effective. The sequence with Sally inside the house seems poorly paced with several minutes devoted to making a cup of tea but does raise tension slightly prior to the demons smashing their way into the house through the windows, *Cujo*-style.

The ending is ameliorated from King's story. The past is replayed, now with the fourth member of the gang, Mueller (Don Ruffin), who is stabbed but Jim uses a key-fob luckily kept all these years, which somehow magically (and inexplicably), allows him to despatch the demons. In a sentimental farewell full of quasi-religious consolation, Jim frees Wayne from his limbo-like existence and promises 'one day, we'll be together' at which Wayne just ambles off into the mist. The family, at last united (including Sally who survives here), walk away down the tunnel together. King's original short story was a financial lifesaver for him back in 1974. Unfortunately, the body of his work was resuscitated twice more rather than letting it rest in peace.

Sometimes They Come Back... Again (Adam Grossman, 1995)

> Does it *have* to be the same story repeated over again? I mean, can't we change anything?
> (Billy in *Sometimes They Come Back*)

Like the first film, the hero (here Jon Porter, played by Michael Grossman), moves back to his hometown and is pursued by demons from his past involving the death of a sibling (seen in black and white flashbacks), for which he blames himself and as present-day characters are killed, another creature from the past is reincarnated. The first film is essentially a ghost story but the second and third deviate into satanic ritual and deliberate attempts to raise the dead, involving the severing of a finger, present in the King source story but absent from the first film with the protagonist from the first film, Jim Norman, briefly referenced as an off-screen kill.

The opening accident with an old woman falling from a ladder, attempting to reach a plaster which mysteriously moves, feels a little bit like a public information film about avoiding domestic accidents. The momentary cut to an underground pool with some sort of figure emerging could be an interesting blend of *Hellraiser* visceral effects with *Terminator II*-style CGI animation but unfortunately, the scene never progresses beyond tiny suggestions, no doubt limited by the film's modest budget. The first and final deaths of the three aspiring demons uses the kind of mixture of live action and animated power sources seen in the *Back to the Future* series (Robert Zemekis, 1985; 1989 and 1990), i.e. more akin to a family film than horror. Some glimpses, such as the red protrusion from Tony's back seen by Jules (Jennifer Elise Cox) when he takes his jacket off in the diner, are unsettling but taken as a whole, the film is disappointing.

There is little real tension and never a credible sense of threat in the film. Tony Reno (Alexis Arquette, looking like a young Jerry Seinfeld) and his friends spend much of their time giggling, which is more pre-pubescent than scary (although the casting of Arquette

and Hilary Swank as Jon's daughter, Michelle, does mean they strangely mirror each other 'teethwise'). Coloured contact lenses and a distorted voice or even the mix of zoom and tracking-shots later in the diner (which bizarrely makes him look like he is being wheeled through), are not enough to make his character threatening. Therefore Jon's investigation of noises in the kitchen (which he fears are caused by Tony), culminating in the discovery of a pig, seems contrived. Jon's dream of Michelle (not her dream of him as Jones states) riding a devilish creature could tap into darker Freudian insecurities but the conception of Tony's monstrosity is so muddled with snake-like limbs, big ears and later long, vampire-like fingernails, that he seems more a composite monster rather than a credible single entity.[2] Most of Tony's supposed wisecracks fall very flat ('D'you mind giving me a hand?' after severing Steve's hand), although his twist on subjective idealism ('If a gardener with a big mouth is being tortured in a field with no-one to hear him scream, does it still hurt?') is quite witty.

Coherent character motivation is in short supply. Any explanation for Jules' psychic power is neither sought nor given or why Maria (Jennifer Aspen) and Jules (Jennifer Elise Cox) are so desperate to befriend Michelle. The role of 'crazed man of religion trying to warn the hero' is a staple of *The Omen* cycle, taken here by Father Archer Roberts (William Morgan Sheppard), who unbelievably has a large room, decorated with pagan symbols just beneath his church, where he pontificates endlessly about the occult. It could be said that Maria is punished for illicit drinking (we see her pouring vodka into her Coke), promiscuity (she strips off for Vince, played by Bojesse Christopher, who had 'saved' her from Tony, only for him to transform into a snarling *Sleepwalker*-like monster) and perhaps gossiping (her ears, which he complements as 'nice to nibble' are later sent to Michelle in a box). However, the deaths of Jules and Steve are completely unwarranted. Tony produces his own Tarot pack, which he magically turns into death-star-type weapons, cutting her hand, head, and then launching several at her. The scene is relatively effective, although the reason for the location at the top of a dam, seems purely to motivate the vertiginous top-shot of her body. Steve (Gabriel Dell Jnr) plays a *Lawnmower Man*-type simpleton, who meets an attempted-ironic end, pulled underground by stop-motion tendrils, suggestive of the body horror of *Tetsuo* (Shinya Tsukamoto,1989) (without any justification in the plot) and chewed up by his own mower, drawing on the demise of the patrolman in King's novel *Misery* (1987), cut from the film version (Rob Reiner, 1990).

The paper and print quality of the satanic texts Jon studies, is both ridiculously modern and in pristine condition. At the end, his escape from being tied up is ludicrously easy and he manages to entice the three demons to step back into the pool in which they were electrocuted before so he can do the same again, this time with an added spell and his own thumb so that they are duly despatched to a place from which supposedly they cannot return. The ending with Jon disconcerted by a client appearing like Tony, causing him to knock over a pair of binoculars (used before as an obvious symbol of looking back into his past), is clumsy. The momentary vision may intone that the hardest part is 'to admit that something exists which makes you frightened', but you will not see it in this film. Like bonus tracks in the dead space of CDs, the brief shot of Tony, post-credits, delivering 'I'm back

again' while laughing is more a knowing reference for horror fans (like the glimpse in Jon's desk drawer earlier, of King's Dark Tower novel *The Drawing of the Three* [1987]), than an effective final fright.

Sometimes They Come Back… For More (Daniel Berk, 1999)

The film, co-written by Adam Grossman, director of the previous instalment, is a thinly-veiled version of *The Thing*, whose critical stock has gradually risen from virtual unanimous dismissal on its initial release, but in almost every point of comparison, it seems weaker. The setting (an Antarctic base cut off by extreme weather conditions) and plot (something mysterious found in the ice) is similar, although the realization is very different. Here we are denied Carpenter's broad panoramic vision (and possibly his budget) so that beyond some brief helicopter shots at the opening (from stock footage), all supposed exteriors are either close shots taken in a studio (like the opening helicopter drop) or clearly models with very unconvincing snow.

Carpenter's visual style is literally and metaphorically dark. Here, investigator Capt. Sam Cage (Clayton Rohner) complains early on about how dark it is but actually it is unbelievably light everywhere, even the underground mine sections, despite the fact that Medical Officer Jennifer Wells (Faith Ford) reminds us of the need to conserve power. The basic interior set looks very similar to Carpenter's with plenty of top-lighting but there is so much aimless rushing around that the precise geography of the base is never established. Equally unbelievable is the apparent warmth of all interior settings so that, unlike Carpenter's film, we never see a character's breath. Unlike Carpenter's powerful narrative concerned with questions of human identity, there is no real mystery to solve here, just a lot of chasing half-seen figures and a battle with zombie-like creatures at the end. Events repeatedly happen off-camera and we see a broken radio, the absence of a body, a door left open *after* the fact – a device which could create tension if used sparingly but which soon becomes just tedious.

Carpenter's film creates a credible group of at least seven characters – here we have just three (the others remain mere bodies or shadowy figures glimpsed scuttling around the base), who are still less complex than Carpenter's. The hero, Cage, is a pale echo of MacReady (Kurt Russell). He too is a rough-shaven hero but ridiculously reveals himself as a half-brother to the devil-worshipper in the mine, who is not even seen (except in flashback) until the end. A completely unmotivated romance suddenly appears between Cage and Wells and we are told everything about Cage's back-story in clunky dialogue. The tech officer, Shebanski (Max Perlich), moans constantly and sweats despite the supposed cold. When his cap falls off later and a pentangle sign is revealed on his forehead, that only explains why he did not fix the radio, not why he has been pretending to be normal from the beginning. The sudden adoption of a distorted voice, does not present a threat to the hero and heroine. Crucially, in plot terms, we are never told exactly what has been discovered in the mine. Carpenter's other-wordly explanation for the source of the madness is credible, even without Rob Bottin/

Stan Winston's effects, but its satanic replacement here, just seems feeble and unconvincing. Unlike Carpenter's film, or an even stronger subcurrent in *Alien*, the political aspect of the illegality of the mining operation here goes completely unexplored.

The security camera technology allows for some grainy point-of-view shots of characters' movements and later a motorized camera explores the mine but this adds little more than we had via the video tape in Carpenter's film. Instead of ratcheting up tension, the mobile camera just shows us the cabalistic pentangle and Schilling (Damian Chapa) tying up the captured Callie O'Grady (Chase Masterson). Wells screams that it is a trap, even though it is unclear how Schilling could know about the camera and later she has a bizarre, hysterical outburst, only serving to underline the incoherence of the film in terms of characterization and theme. There is also a potentially-interesting tracking shot along one of the interior corridors *above* the lights, which suggests along with a sound effect of crunching footsteps that someone is on the roof (Cage and others look up as they track the sound). However, the sound just stops and the explanation that Cage gives – the wind blew over an antenna – is wholly unconvincing. Symptomatic of the difference is the incidental music. Carpenter's self-composed theme is a two stage, heart beat motif (x-xx), creating the sense of possible change of pace but here we just have a more double timpani note (x-x), which suggests slow lumbering movement.

Confusingly, at the beginning there is a tiny glimpse of a bloodied face at a window on the base before we cut to Cage at a bar, apparently drowning his sorrows. It remains unclear whether this is a flashback, undermining the supposed happy ending, or a flash-forwards, which is not explained in terms of his character. It is typical of the incoherence in the script. Cage's later flashbacks could be interesting but are initially misplaced (he sees Indian dancing girls within the base for no apparent reason) or too obvious (his vision of a romance with a nurse is clearly set in the distant past, judging from their uniforms). We are therefore prepared for some kind of revelation but that he is the half-brother of some kind of eternal demon, for whom he kills over thousands of years, does not match the character we see, (even though he becomes jumpy and unstable after Callie's death), who shows no supernatural features whatsoever until the climax by the pool. Perhaps, most strange of all, we *see* the flashbacks whereas Wells does not and yet she does not react in horror or even disbelief at Cage's verbal account.

When Cage and his partner Callie (Chase Masterson) first arrive, they propose to search the mine with only twenty minutes of daylight remaining and without gas-masks or a map, which they only ask for on struggling back. The mine itself, although the setting for supposed tense chase sequences, looks less like a labyrinth and more like a tunnel, i.e. there are very few branching tunnels, which should make pursuit of a quarry relatively simple (reflected in the ease with which they suddenly find their way back). Gradually more outlandish plot elements intrude upon the semi-realistic setting, such as Schilling being a closet satanist with a large book of demonic lore in his room (which rather handily has some sections translated), Reynolds (Michael Stadvec) babbling in pseudo-religious language that 'The dead will walk', or why stabbing these creatures through the heart should necessarily kill them any more than shooting them (importing a piece of pseudo vampire lore for no apparent reason).

Suddenly, the film switches into *Assault on Precinct 13*-mode, when Cage and the others barricade themselves against attackers trying to break in through the back. After an other-worldly roaring sound (borrowed from Carpenter) is heard outside, the former dead crew, lumber forward slowly (hands reaching through glass like Romero's zombies) but also bring guns even though they do not fire them and although they cannot be killed by bullets, they still flee. The final confrontation down in the mine moves at a funereal pace, with Cage's eyes turning black after killing Shebanski, supposedly sharing the pleasure of killing. In his unsubtle Jekyll-and-Hyde battle, he rejects his evil self, kills his half-brother with a pick-axe and blows the place up with some handily-placed dynamite. In the helicopter, we cut from a flashback of Mary, the love of Cage's life, to Wells sitting beside him and unbelievably he offers her the same ring, as a clear substitute. As the pair are miraculously airlifted away, unlike Carpenter's nihilistic ending, Wells asks, 'Will I ever understand?' and with all the plot weaknesses, one would have to answer truthfully, 'No'.

Ghosts (Stan Winston, 1997)

The six minute credit sequence, relative to the modest running time of the film (39 minutes), reflects the fact that this is really a special effects movie, underlined in the background of director Stan Winston, credited with the ground-breaking effects in films such as *The Thing*. The plot is a thinly-veiled attempt by Jackson to hit back at his critics. The mob that storms his mansion, is led by the mayor who demands that he leave and calls him a freak. Any vaguely expressionist motifs however are overwhelmed by the sheer unoriginality of the project. The ghosts who appear to walk up the walls and onto the ceiling are reminiscent of Lionel Richie's 'Dancing on the Ceiling' (Stanley Donen, 1985). The dance routines, still featuring body-popping and moonwalking, seem a pale echo of the ground-breaking make-up and choreography of John Landis' *Thriller* ten years earlier and unlike that film, there is really no plot momentum here, just three songs juxtaposed. The CGI stretching of his mouth and Jackson playing several parts, most notably that of his antagonist the mayor, undergoing several hours of latex prosthetics, reflects the antics of Eddie Murphy in *The Nutty Professor* (Tom Shadyac, 1996), but not to the same comic effect. The question he asks at several points 'Are you scared now?' unlike the on-screen admiration of the children (perhaps worryingly, all young boys), is likely to be answered by a clear 'No' and explicitly also echoes another part of *Thriller* when he taunts his girlfriend, 'You were scared, weren't you?'

There are a couple of interesting effects, most notably Jackson smashing his own body into the ground (echoing the end of a previous Winston project, *Terminator II*) and a hand holding a mirror bursting out of his chest, showing his face becoming monstrous. This second example is slightly reminiscent of Pennywise's hand reaching out from a picture but the opportunity for the philosophical comment about personal identity is lost. Furthermore, the 'normal' look of Jackson after so much plastic surgery, makes the challenge 'Who's the freak now?' seem hollow. He may assert 'I'm not like other guys', which perhaps rings true as

an individual and a performer but not as a film-maker. King's involvement may seem distant (Jackson's possessory credit reflects his input as dancer, singer, and main star of what is really an extended pop video) but King is credited with the story and overall concept. Along with Garris (co-script and story) and Mikael Salomon (creative consultant), it has the sense of a gathering of familiar personnel around a King project.

Rose Red (Craig R. Baxley, 2002)

A house is a place of shelter. The body we put on over our own body [...] Our bodies may sicken and so do our houses [...] We say haunted but we mean the house has gone insane.
(Professor Joyce Reardon in Rose Red)

The film opens in Seattle, (actually used for the street scenes and some of the flashback Rimbauer material). The major exterior shots of the house were taken in Tacoma and the interiors mostly on giant, hanger-like sound stages. What seems to have been missed by critics, who might have been alerted to the Carrie-like figure of Annie Wheaton (Kimberly J. Brown), a young, female outsider with psychic abilities who calls upon them when she is angry or frustrated), is that the opening dramatizes the original first scene deleted by De Palma from Carrie. Perhaps this reflects a poverty of the imagination on the part of King, an understandable desire not to waste material once created or a writer in thrall to his inspiration, Shirley Jackson's The Haunting of Hill House (1959), which also features such an episode. Robert Wise's version of The Haunting (1963) and Jan de Bont's The Haunting (1999) carefully chose to avoid such a scene. Here, family strife leads to Annie causing a hail of stones to rain down on her neighbours' house, after being bitten by their dog. Despite director Craig Baxley's waxing lyrical on the DVD about the technical complexity of the sequence, we can clearly see why De Palma made the right choice 26 years earlier. Even with the development of technology, the special effects of miniatures expert Mike Joyce and his team still do not really work, the boulders bouncing and failing to fall like credible heavy rocks. The film ends with Annie's dominoes running into the model house, supposedly sending 'real' boulders crashing through doorways of the actual house but like the opening sequence, this does not work, tell-tale slow motion highlighting the destruction of miniatures and here looking more like a parody of Raiders of the Lost Ark (Steven Spielberg, 1981).

King's avowed intent was to make 'the Moby Dick of haunted house stories', meaning 'something big, scary, that sticks in people's minds'. However, despite his enthusiasm for this horror subgenre, of his three aims, King really only achieves the first one. The plot is incredibly bloated. To run for 240 minutes with commercial breaks every ten minutes or so, effectively flattens out any potential tension and just like the characters themselves in the house, their motivation becomes lost in the mechanics of a spooky house. As with Storm of the Century, King may find that the mini-series offers him a closer approximation of the novel in visual form, as he says on the DVD, he is more of a 'putter-inner than a taker-outer'

but that in itself is not necessarily a good thing. Judicious editing is something that both of these mini-series desperately call for. Problematically, the plot premise of both mini-series basically involves a group of characters waiting for a time to pass during which something might (or might not) happen. King's comment that if viewers 'believe they know how things are going to turn out, they're going to be very surprised', turns out to be slightly hopeful. You do not need to be a psychic yourself to see where the plot is heading. The fact that 'not all the good people make it through' is hardly a major claim for any horror film, even on network TV.

When the group first approach the house, Cathy (Judith Ivey) says 'it seems to be looking at us' but the problem is it does not, any more than any house does. The extensive use of cutaways of both interiors and exteriors of the house, do not in themselves generate tension. The final shots of *Halloween* are eerie because the domestic space has been made strange and what was known and comforting has been seen as a source of threat. Here, there is no such challenge to our expectations. What we have is a stereotypical creepy, haunted house with gothic architecture, statues, fountains and some grounds, the exact geography of which is never established properly. Despite having a large budget as far as TV drama is concerned, the house as a setting is no more convincing than the set for *Edward Scissorhands* (Tim Burton, 1990), but at least Burton's film is supposed to be fantastical and a highly stylized exploration of the power of storytelling. When Karl Miller (David Dukes) and Mrs Waterman (Laura Kenny) drive up to Rose Red, its immediate proximity to an urban area which apparently is oblivious to its presence, seems unbelievable. In *Salem's Lot*, the Marsten House has a clear influence on, and link to, life in the town below and also by apparently imbedding the house in an urban area, King removes one of the basic tenets of the haunted house genre – its isolation.

In terms of generating tension, Baxley uses plenty of crane shots, up and over the gates of Rose Red, particularly as the opening shot of sequences but through overuse it rapidly loses its ability to suggest a creepy, voyeuristic peeking into the unknown. Similarly, the repeated track across the model of the house over its rooftops and across the supposed skyline of Seattle only serves to underline its unreality. When we first enter the house, we begin a tour with Reardon (Nancy Travis) still in lecture mode. Even with flashbacks mixed in, it makes the pacing sedate, almost leisurely and there is little sense of narrative momentum created. We have gone into a house with a group of characters, who like us, are waiting for something to happen and have a whole weekend for it to start. Reardon tells the group about a previous death from bee stings at which point we cut to an image of a body lying in the glasshouse (known as the solarium), i.e. all verbal clues are instantly converted into visuals, leaving little to the viewer's imagination. In the lounge, the characters sit around and talk and we are told by Reardon first about Petrie and then about Douglas Posey, Rimbauer's business partner but not via engaging and involving stories. Miller and Mrs Waterman's minor car collision takes up an interminable amount of screen-time as they flail through the undergrowth of the garden, really does not work. Numerous close ups, shots obscured by plants and extreme low angles cannot disguise the dramatic redundancy of such sequences. Miller in particular,

having been enticed into the solarium, seems to be attacked less by a ghost and more by a wind machine. Mrs Waterman's panicked progress outside is paralleled inside as Emery (Matt Ross), hopelessly lost, starts running aimlessly through the house.

There are a few effective moments. In her bedroom, Annie twice hears whispering for her to 'Come' and spies, reflected in her flickering wind-chime the face of an evil-looking gargoyle, which we have already seen perched above the house. This same figure is shown in a high-angle over-the-shoulder shot as the group first draw up at the house but without more powerful incidental music and dramatic momentum (something *The Exorcist* clearly has), this fails to unsettle the viewer. When Annie uncovers a secret panel and looks through, only she can see into the dolls' house visible there. However, even she does not get the fuller shot from the other side of how this is suspended in the middle of the wall. Levels of knowledge and understanding are hinted at, with the opportunity for dramatic irony, but again nothing really comes of this. The model itself, reminiscent of the one of the maze in Kubrick's *The Shining*, remains literally what it is and develops no greater symbolic significance. Similarly, the dolls she plays with are dubbed Adam and April but no coherent connection is really made with the dolls possessed by Ellen (Julia Campbell). The appearance under beds and April's point-of-view out from a closet references earlier King short stories such as 'The Boogeyman' but are updated slightly as Annie clarifies 'No boogeyman, boogey*lady*'.[3]

Some transitions work well. The sudden cutting from Annie creating havoc in the house to the bar where the psychics are discussing the expedition occurs unusually right in mid-dialogue, creating a strong sense of panic. Later we cut via a graphic match from Emery holding up blueprints for the Perspective Hall to plans lowered revealing Sukeena (Tsidii Leloka), the apparent architect of the feature. Baxley uses an unsignalled dream sequence which does effectively disorientate us for a moment or two. We follow Pam (Emily Deschanel) going to the fridge at night and as we see her face in close-up she senses something out of the corner of her eye, turns and sees the ghost of Bollinger (Jimmi Simpson) lurch towards her at which point we cut to her waking up screaming.

There are some interesting shots, which are not developed. Baxley uses a bird's-eye view that rotates and descends as the group climb the staircase, making it feel like an Escher painting. It is a favoured camera movement of his (also present in *Storm of the Century*) and occurs again when Steven (Matt Keeslar) is in bed and later when Annie is playing dominoes. The upside-down room is first introduced the wrong way up and then inverted 180 degrees and the idea of the rope leading back to a solid wall is a quirky effect, but the resolution of the obstacle, Nick (Julian Sands) and Annie 'pushing' the wall back, is less so. When we see more of Ellen as a ghost, actress Julia Campbell walks with the same stiff body positioning as Sissy Spacek at the climax of *Carrie* but we do not know exactly why. The shot of Annie and Steven dancing several inches in mid-air, unnoticed by the others (and possibly even themselves) is interesting but not developed. The sequence in which Cathy discovers Bollinger hanging in the mirror library and then tries to walk away only to find that instead of walking on a solid floor, she is wading through ever-deepening mercury-like liquid is promising but then *she just steps out of it*.

The flashback scenes in Seattle and the building of the house are drained of colour but are not made completely monochrome. One or two colours are allowed to remain to draw attention to particular features in the shot. Like the little girl's coat in the Warsaw ghetto scene in *Schindler's List* (Steven Spielberg, 1993), a single colour object remains in shot, such as the blue shirt of the teamster who shoots his foreman, the green of the neon at the bar where he goes next and most clearly in the later scenes the red of John's mistresses' jackets, the lanterns at the house, and most especially Sukeena's headscarf. As the equipment is unloaded, a low angle shot from the back of the van suggests colour is starting to drain from the group too apart from Annie's blue cardigan and red hat. This idea however is not developed further.

There are some scenes which are more effective because of their restraint (also due to self-imposed censorship, no doubt). The decapitation of a workman is shown via his point-of-view looking up at a sheet of falling glass and the demise of the last 'victim' of the house (an old woman wandering away from a tour party), is conveyed by a cop holding up a ripped, blood-stained purse. The rippling carpet effect (a more highly-computerized version of the creatures in *The Thing* or *Tremors* [Ron Underwood, 1990]) works quite well, and in transferring to Cathy's bed and heading up between her legs, the scene clearly references Nancy's bath scene in *Nightmare on Elm Street*. Here though, the covers are whipped back to reveal nothing. There is some witty dialogue. When Miller emerges from his office, his face blood-stained, he shouts in the face of a passing student 'What are you looking at? Well go and look at it somewhere else'. Seduced by the corpse-like ghosts of Pam and Petrie (Yvonne Sciò), Emery declares 'I'm hard up but not quite that hard up' and earlier Reardon queries why Steven wants to knock the house down, to which he replies 'It eats my relatives'. The basic premise is ludicrous but in context, it is quite funny.

However, other parts of the film do not work so well. The scenes with Annie showing her telekinetic anger, so that TV channels change, the phone moves, draws fly in and out, and the whole house shakes by rather unconvincing shaky camerawork, feel straight out of *Poltergeist* (Tobe Hooper, 1982). The exchange between Sis (Melanie Lynsky) and Steven in the solarium is fairly typical of rather clumsy 'info dumping'. All dramatic momentum grinds to a halt as we are given a solid lump of narrative exposition about Annie. When Nick peers behind some boards at some miraculous new building work, he is met by an extreme close up of a ridiculous rat puppet before we cut to a shot of a real animal scurrying away.

The appearances of the ghosts themselves do not always convince. Annie banishing the first spirit simply by screaming 'No!' or a flash-bulb being enough to dispense with the ghost of April, does not make their threat seem very great. The animated suit of armour that Annie calls upon to protect herself from Emery and which disintegrates when its job is done, seems no more effective than the final prophecy sequences in Roman Polanski's *Macbeth* (1971). Generally there is a lack of fluidity between relatively smooth CGI work and mechanical effects with the animatronics tending to detract rather than add to the effectiveness of the ghosts. The skeletal woman that appears in Emery's bed, has the red eyes and machine-like hand of the first generation of Terminators. The jerkiness of movement in these corpse-

creatures, especially of the bony hands, such as the one that abducts Mrs Waterman, do not really show any development from Ben Hanscom's vision of his father in *It* twelve years earlier.

Annie sees Vic (Kevin Tighe) flirting outside although there is no one there (one might imagine someone with her supposed psychic gifts would see the ghost) and then we cut to his point-of-view which sees an enticing Pam leading him out to the statue by the fountain, whose eyes unseen by him glow red (rather like The Hood in Gerry Anderson's *Thunderbirds*). Increasingly panicked, he wades into the fountain, seeing what he believes to be the body of Pam but only lifts an empty dress from the water. A cutaway of the statue in low angle framed against the sun, creates the kind of threatening silhouette used to telling effect in *The Exorcist* (and quite unsettling here). The best part of the sequence though occurs as Vic moves away from the fountain and in the background in the same shot but unseen by him, the arm of the statue starts to move and pulls away the front of its face as if wearing a mask. He turns at this point and sees the eyes open on the mask-like façade, prompting a fatal heart attack. However, although effective in part, the sequence misses the chance of the more frightening (but also more difficult effect) of showing the 'face' move *whilst* being held out in the statue's hand – what we see is a 'cheat' cut, an extreme close up of the face, allowing Baxley to use a standard shot edited into the sequence. Perhaps the sequence also gains from the restraint shown here but it could have been more powerful to show what lies beneath the mask, an effect that works so well in *Westworld* (Michael Crichton, 1973).

There is very little consistency in King's conception of the ghosts, appropriating ad hoc features from werewolves, vampires or zombies. Cathy has a momentary glimpse of Sukeena and Ellen via a whip-pan to a reflection in a mirror before the vision is shattered by a crow banging loudly into the window. The ghosts that Cathy sees in the photoframe in the attic and some of the other ghosts at various times have snarling, werewolf-like features for no apparent reason and in the tower when Steven rugby tackles the ghost they assume is Ellen but turns out to be April, she vanishes like a vampire in the daylight. The creatures that surround Reardon at the end shuffle and reach out for her with zombie-like movements and yet the screaming ghost of Mrs Waterman, stretching out to grab her son from the mirror, may seem more believable than she was as a living human.

Gary Chang's incidental music echoes what he produced for *Storm of the Century* but his simple piano theme of three falling notes as Bollinger wanders through the house for example, does not really create an atmosphere of dread. We cut between a reverse tracking shot of his face and shaky handheld shots from his point of the solarium. The music is cut as he discovers what looks like Sukeena's scarf covered with beetles and then is framed next to a very-clearly-computerized wasps' nest (like the flapping crow later). A drop of liquid falls on his shoulder, causing him to look up and he is then hauled up out of shot, strangely the only victim we see to be taken in this way.

Characterization is also problematic. Nancy Travis, as Professor Joyce Reardon, is largely unable to generate much sympathy as her single point of characterization (not being taken seriously as an academic by her peers) is not enough to flesh out her central role.

Despite sleeping with the last member of the Rimbauer family apparently to gain access to the house, she is neither Machiavellian enough nor charming enough, to be interesting. She floats through most of the film with a permanently fixed grin that makes her relatively sudden lurch into instability, neither credible nor interesting. The first time we see her, she is lecturing and asserting that 'the investigation of psychic phenomena is an honourable pursuit'. While we might not sympathize with the underhand tactics of her academic rivals, personified by her Department Head Karl Miller (planting a reporter to ask awkward questions and manoeuvring to have her tenure removed), that does not actually make her assertion true. Credibility aside, no one at any stage makes a particularly compelling argument why humanity would be greatly improved by uncovering spirits at Rose Red. The motley group of psychics accompany Reardon for money, very clearly in the case of Emery, not from any philanthropic motives.

Although Galvani is not mentioned by name, there is an unattributed allusion to the inspiration behind *Frankenstein* (Mary Shelley, 1817) in Reardon's reference to experiments passing electric current through dead frogs to animate them. All she is hoping for is 'one single twitch' in which the psychics function as her electricity. Similarly her fascination with what she terms 'the blood under the skin' in seeking to repel Miller, paraphrases T. S. Eliot's description of John Webster's ability to see 'the skull beneath the skin' from *Whispers of Immortality* (1920) but this also does not tally with the slightly squeamish character she displays elsewhere. Joyce claims that Rose Red is 'a dead cell', whilst knowing that is not the case and hopes that their presence will wake it up again. She claims that psychic powers 'have no moral gradient. They are neither good nor bad', but anyone who has read any King novel or seen any adaptation based upon one, however loosely, is unlikely to be persuaded by this. The naivety of a so-called expert in the subject unable (or unwilling) to see any potential danger in the project, makes her character seem laughable. One of the strangest inconsistencies about her character is the extent of her ecstatic reaction to a door slamming, denoting it as 'a phantom draft' and then after seeing at least three examples of more substantial ghostly behaviour, her complete lack of reaction afterwards in the lounge, showing no desire to talk about the experiences, which represent the very point of her expedition. It is one thing to be an ambitious and scorned academic but she shows no concern with the fate of Bollinger, Miller, Pam or Mrs Waterman. Later, after Steven banishes the ghost of April, rather bizarrely, by throwing a glass at it, Reardon again shows neither anger nor excitement, merely neutrally observing 'I advise none of you to go wandering' (which of course, according to *Scary Movie* lore, is the first thing they start doing).

An interest in or ability to channel psychic phenomena seems incompatible with an ability to form stable relationships, for as far as it is possible to judge, all the psychics seem fairly dysfunctional in terms of relationships. Annie as the most powerful psychic (telekinetic and telepathic, a 'searchlight' to the others as mere 'candles' according to Joyce), like King's Carrie White and Charlie McGee in *Firestarter* (Mark L. Lester, 1984), has few lines to play with. In the opening, an elderly neighbour claims that their dog 'sensed something in her', implying an element of evil or demonic possession (there is a slight *Exorcist* feel to Gary Chang's piano

theme here) but this ambiguity about her character is not picked up in the film that follows. Although she controls the doors in the house later, there is no implication of malevolence on her part. Supposedly fifteen years old and autistic, she gazes doe-eyed at Nick and Steve and inexplicably improves her speech, eye contact and interpersonal communication, through the course of the film and apparently no longer needing telepathy by the end. Her father's attitude to her, which initially might seem blinkered and over-protective, actually turns out to be fairly accurate as does his description of Reardon as a 'crazy lady'.

Most of the rest of the characterization remains sketchy. Annie's sister, tellingly denoted as Sis, is defined by her function in relation to Annie alone, and her main job seems to be to parrot 'Oh, Steve' repeatedly. Julian Sands as Nick, the verbose Englishman, (who ludicrously describes himself on the DVD as 'a James Bond character') does have one or two vaguely witty lines. He asks a deranged Mrs Waterman who leaps out of the dark and begins to strangle Cathy, 'Would you mind awfully letting her go?' and later 'The truth is, right now, I'm rather scared'. He does at least stand up for Annie, who Emery tries to bully but he states that Reardon is prepared for people to die in order to secure her proof in an entirely neutral tone and yet does nothing about it. Cathy, the automatic writer, disappears from the plot until she gets lost on the way to the kitchen and later tries to communicate with Annie and make her open the doors via her psychic gift which has been all but forgotten about. Pam, the psychometrist, demonstrates her ability on touching the front door-knob and yet nothing is made of her sense of unease neither here nor later, when she disappears almost unnoticed by the others, only to pop up again as a zombie-like ghost.

Steven Rimbauer rather conveniently discovers some telepathic ability once in the house. Like that of Ben Mears in Solomon's version of *Salem's Lot*, his flashback as a little boy, meeting a ghost-like figure in a house reputed to be haunted and which he initially denies having taken place, is given to us incrementally and piecemeal through the film. Although he eventually accepts his experiences as a child, the film still ends with him not only planning to demolish the house but build on the site, which might suggest he has learnt nothing (as well as leaving open the possibility of a sequel). There is the near-obligatory King cameo, here as a 'pizza delivery guy' who 'asks too many stupid questions' like 'is the house haunted?' but the script as a whole, in conception and delivery, is not knowing enough for this self-referentiality to be funny or challenging.

The only character that could be described as different enough to be interesting is Emery, whose gift is retrocognition, and whose open-mouthed, greasy-haired geek-like appearance hides a credibly-unpleasant personality. Still living at home, he has an overweight, overbearing and overspending mother who dominates his every move ('Run along and get my bags and then you can have your pie'). Driven to comfort eating, it seems reasonable that he could call Annie a 'retard' on their first meeting, finding someone at last weaker than himself, who he can bully. Similarly, he points out later, quite logically, that if they are trapped in the house due to her and that if they are being killed one-by-one, would it not be the sensible thing to attack her? This is also understandable since the slamming of the doors, which she has caused, has sliced off several of his fingers. Apart from Annie, he is the

only one of the group we see being 'recruited', giving him a context outside the basic haunted house, *Scooby-Doo* premise.

There are several similarities with the film version of *It*. In both films we clearly see the building of a team of seven to take on a supernatural adversary. We may not have Bev's vision of a basin of blood in an attempt to face-down the group but here we have Emery's fridge used in the same way for the same purpose. A hand shoots out from the fridge, which we see momentarily at first side-on (like the ghost of Ellen bursting out of the photo frame later) and then head-on, reminiscent of Pennywise's hand stretching out from Mike's Hanlon's scrapbook. Like the manifestations of the clown, Emery can wish these apparitions away by making his disbelief clear, later chanting 'Not there' repeatedly to the ghost corpses in his bed. As Vic says to Pam later, 'Be not afraid, only believe'. The Losers Club ultimately defeat It, the monster, by declaring their lack of belief in it. An artwork gallery on the DVD also shows a draft of several fridge effects for the scene with Emery, and Version B shows a head in the fridge, which could talk, like Stan in the earlier film. The effect of black and white photos coming to life is rather over-used, appearing again during Reardon's orientation meeting about Seattle's past and in her later description of celebrity parties featuring Deanna Petrie, again echoing the scrapbook sequence. At the end of the meeting, she calls for the group to hold hands, reminiscent of *It*'s 'Lucky Seven' before and after undergoing their challenge. As they meet informally in a bar afterwards, just like Ritchie in *It*, Vic ducks out of the social interaction and hides in the toilets, taking some pills to calm him down. In contrast to *It*, although running much longer, this mini-series manages much less by way of character development. Pam and Cathy 'disappear' from the plot and only really exist as one-dimensional figures, whose basic back-story is still being unpacked in Part III.

There are some interesting ideas (the Perspective Hall, the mirror library, and the upside-down room) but these settings mostly feel no more disturbing than squares on a Cluedo board. The attraction of the idea of a self-building house is one thing – the same principle of a disparate group trying to find its way out of a structure that self-generates is also the basis of *The Cube* (Vincenzo Natali, 1997), *Cube 2: Hypercube* (Andrzej Sekula, 2002) and *Cube Zero* (Ernie Barbarash, 2004). However exactly why Ellen believes the fraudulent spiritualist Madam Stravinsky, that she will never die until the house is finished, is unclear. Pam may say, 'It's like living in a funhouse' but the dramatic possibilities of these rooms are never really explored. Despite features like hidden doors, there is not even the kind of playful, surreal quality of an *Alice in Wonderland*-style setting that is present in the corridor sequences of *Being John Malkovitch* (Spike Jonze, 1999). King may have wanted warm colours rather than the sense of a mausoleum but it does appear ridiculously clean for a so-called abandoned house. Magistrale (2003) does have a point about the corrosive impact of continued interruption by commercials but bearing in mind, the script was written explicitly for the TV medium alone, as writer and executive producer, this would not be a surprise to King who must bear a major responsibility for all this.

Reardon overtly refers to Shirley Jackson that 'some houses are born bad' and there are hints that the house itself is diseased – Miller calls the whole expedition 'a virus' and Pam

murmurs 'It's metastasis' – but where a director like David Cronenberg would have made more of this, Baxley allows such references to surface and then disappear. At the end, there is the feeling that like a Bond set, everything is likely to explode and so windows blow out, bulbs explode, and fleets of wind machines go into overdrive. Like some eccentric Bond villain, Reardon will not leave and so is destroyed by her own 'creation' in a sense, the spirits she has awoken. In contrast to examples of the genre like the BBC's *Ghostwatch* programme (Lesley Manning, 1992), which effectively mixes documentary and fiction, thereby unsettling viewers and causing the kind of panic reminiscent of Orson Welles' *War of the Worlds* radio broadcast from 1938, there is nothing to fear here. In *Alien*, detection equipment creates tension but here with literal gadgets like Reardon's 'People Proximity Counter', the main part of the programme feels like *Ghostbusters* (Ivan Reitman, 1984) trying to be taken seriously as art (and failing).

The DVD extra 'The Diary of Ellen Rimbauer' forms quite a clumsy piece of marketing, which was shown prior to the film's first airing on television, setting up expectations of the three-part series. As a 'teaser-trailer', it trails more than it teases. Purporting to be a documentary on the 'real' events behind the film, this is a blatant half hour promotional package. It tries to emulate the myth-making that underpinned the success of films like *The Blair Witch Project* (Daniel Myrick and Eduardo Sánchez, 1999), which worked much more subtly and effectively, especially via the Internet. Actors appear as expert witnesses, alongside clips from the film and fake newspaper footage. An actress, purporting to be Reardon, is inter-cut with a female voiceover supposedly of Ellen (Lisa Brenner) reading from the diary as we see newly-shot sequences of the pen writing the document itself. A deep-voiced male voiceover assertively tells us about how the diary has recently been discovered and an archaeological expert even mentions that the house is built on an ancient burial ground in a fairly cheap reference to *The Amityville Horror* (Stuart Rosenberg, 1979). There is new footage of the house, in slow motion and black and white, the original blueprints of the house and even sceptical psychic witnesses who scoff at the notion of the house regenerating. We learn that Reardon's academic predecessor supposedly disappeared in the house on an ill-fated previous expedition and on-screen titles tell us that Ellen went missing shortly after her last diary entry. There is mention of Ellen collecting works of art on her yearlong honeymoon, underlining the implied links between the house and the Xanadu complex in *Citizen Kane* (Orson Welles, 1939) and of a huge fortune corrupting its owner. The extracts that we hear from the actual diary itself focus on contentious issues – there is an extreme close up on the words 'unspeakable acts' which Ellen is supposed to have witnessed and the confession that 'I don't know if Sukeena suggested it or perhaps it was I but it was time to get rid of John' – the fairly unbelievable assertion that you would forget plotting to murder your own husband. The clumsy book tie-in emphasizes salacious details – the publisher from Hyperion mentioning the 'frank sexual situations' and evidence of psychic phenomena.

King says on the DVD that we should watch the *Rose Red* mini-series because 'if it fails, I won't get to do another one'. To date, there have been no more prime time adaptations of this kind. *Kingdom Hospital* (Craig R. Baxley, 2004), which follows, was made around the same time and definitely for a late-night audience.

Kingdom Hospital (Craig R. Baxley, 2004)

> The dead are always with us. They move just beneath the surface.
>
> (Surgeon, Henry Havens in *Kingdom Hospital*)

Kingdom Hospital occupies a unique position in this study as it is the only King project inspired directly by a film source – the eight-part Danish mini-series *Riget/The Kingdom* (1994), co-written and directed by Lars Von Trier. The linkage between the two is both greater and lesser than at first it seems. Some features are kept, some changed and some added. The title, the basic premise, the quirky black humour, many of the main characters and Von Trier himself as executive producer, are all retained. The basic setting of a large city hospital, Copenhagen, is transferred to Lewiston, Maine and a host girl, a psychic, and Down Syndrome characters (here orderlies rather than dishwashers) reappear. The pink-uniformed pair, Abel (Brandon Bauer) and Christa (Jennifer Cunningham), who comment on the action in poetry, prose and often in unison could be said to be empowering minorities or exploiting them, a charge levelled at the 'spassing' characters in previous Von Trier work, *The Idiots* (1998). Some names are anglicized – Sigrid Drusse becomes Sally Druse (Diane Ladd) and neurosurgeon Dr Stig Helmer becomes Stegman (Bruce Davison), whose final act and declaration from the top of the building parallels Helmer's oft-repeated 'Danish scum' delivered misanthropically from the roof. However, stylistically the Dogme 95 influence, the development of which Von Trier has been so central, is less in evidence. The credit sequence of the later film follows the sepia tones of the original but less so elsewhere, except in the washed out tones of the parallel ghostworld. Largely gone are the more eccentric jump cutting, the predominance of shaky, handheld camerawork (more a feature of *ER* [Michael Crichton, NBC, 1994–2009]) and Von Trier himself offering a comment over the closing titles. The anteater creature, the headless corpse and the earthquake appear in the later series alone.

The credit 'developed for US television' is fairly vague, although King is explicitly credited with the scripts for 8 of the 13 episodes, including the finale. Parallels might be drawn with *Twin Peaks* (David Lynch, ABC, 1990–91) but more particularly, there is a stylistic influence from *Six Feet Under* (Alan Ball, HBO, 2001–05). The opening credits have a similar feel – Ivy's theme 'I worry about you' with a dreamy female vocal, has both an elegiac and a whimsical quality, shared by the concept of Ball's show. An earthy colour palette, stark images of trees, and a focus on images of separation creates a sequence that is more like a car commercial or a pop video, except that it focuses on the relationship between the dead and the living.

Some ideas work. Like *The Shining* (in Garris' version at least), the film dramatizes the concept that buildings retain a residue of the souls who lived in them, producing the slight 'breathing' effect of the lift walls. Slow tracking shots in the library, shelving, or walls blocking our vision only to suddenly reveal it, show the ghost boy playing tricks with Elmer (Jamie Harrold), also reference Kubrick's lugubrious tracking shots in the kitchen in the same film. The 'cut' that Peter (Jack Coleman) makes with his hand in the fabric of the screen, giving us a glimpse of a possible future with Stegman firing his gun at random, acts as a teaser-trailer

for the final episode. The concept of another dimension just below the one we inhabit could be interesting, although there is confusion in places between a psychological basement and an actual one. Writers like Clive Barker have other dimensions erupting into the everyday and although King's earthquakes and ghosts passing through walls would seem to offer the same process, here it seems more benign. The vision of Hook (Andrew McCarthy) in the operating theatre of his own mortality in which graves are marked by lolly-sticks in takeaway cartons, effectively conveys the scale of human existence but ghosts appear curious rather than threatening and the much-vaunted earthquake takes 13 episodes to transpire, dissipating any sense of jeopardy.

There are some examples of effective black humour in the dialogue and action. Asked his opinion about the worshippers of the miracle, Stegman suggests they should be 'sterilized and sent to the gulags of Siberia as slave labour' and later 'Hand goes here' appears written on the stump of Stegman's wrist. Indeed, the stylized sense of realism and quick-fire dialogue makes some scenes, like the junior doctors 'borrowing' a head, feel more like *Scrubs* (Bill Lawrence, ABC, 2001–07). When Hook discovers Fleischer (Michael Lerner) is a lawyer, he starts rapping out commands *ER*-style but these directorial orders for camera positions and 'Clear' does not precede resuscitation but the stamping of a legal document.

King has some fun with character names – we have a head lawyer called Overdick (reflecting King's view of the legal profession), Andrew McCarthy's Dr Hook (evoking the camp 1970s MOR band and the Peter Pan character – the librarian calls him 'Captain') and Jesse James (Ed Begley Jr.), who is not a gritty hero and parodying his role as Dr Victor Ehrlich (German for 'honest') in *St Elsewhere* (NBC, 1982–88), only concerned about his 'Project Morning Air' initiative. However, as with Dickensian names, this can also be limiting as characters come to represent a single quality or action and cannot easily change or develop. Antubis supposedly has the form he does because Mary (Jodelle Micah Ferland) mispronounces Anubis, Egyptian god of the afterlife.

However, there is a limited quality to King's conception. The headless corpse is basically a 'character' based around one visual gag, effective though that is in the short term when it washes its own hair in the shower, blinking soap out of its eyes or gossiping whilst under a drier. This is *Re-Animator* (Stuart Gordon, 1985) for a mainstream audience, who want their 'horror' bloodless and played mostly for laughs. Crash McGreery's Antubis creature is quite an achievement technically to convey a believable, slow-moving large animal (shown several times in full shot) that can lick up ants or bare rows of razor-sharp teeth. The problem with it is its function is not clear. With a telltale growl, it cannot easily be fun in a quirky sense (declaring 'Mmm, delicious' on voiceover) at the same time as being truly frightening.

It soon becomes apparent that the wafer-thin characters exist only as ciphers for eccentricities, as in the minor character name 'Janice McManus' (Kathryn Kirkpatrick) or Otto (Julian Richings), the rather skinny, insecure security guard whose job in surveillance is undermined by the fact that he cannot see without goldfish-bowl glasses or Stegman's mistress Brenda, who wants a romantic break in Salem and concocts a witch-like aphrodisiac with a stereotypical mad scientist's bubbling green liquids). *Alice*-style

surrealism (such as the sporadic appearance of Mary, the ghost girl and her anteater) does not dove-tale comfortably with psychological realism. Episode 10 ('The Passion of Reverend Jimmy') is a good example. Although the episode was written by King himself and the story provided by his wife, the notion of a Christ figure appearing in downtown Lewiston, needs more time devoted to it to make it believable. The miracles of wine, loaves and fishes and apparently rising from the dead are all accomplished (very literally, especially the holding up of a bloodied, Turin Shroud-like sheet) and massive crowds form outside the hospital singing rhapsodic hymns but then, bizarrely, this rather major series of events just fades from view without any resolution whatsoever and the supposed 'rescue' from a quake burying several staff has no dramatic impact or urgency at all. Havens' reference to 'the profound intimacies of the dead' suggests a weightiness which the rest of the quirky plot just cannot support. Stegman's attempt to bury an incriminating report, especially where three different characters try to obtain copies of medical records, descends into unfunny farce.

The coherence of some episodes is stretched to the limit. The identity of the figure in the green tank in Episode 9, is unclear as is the reasoning behind the ability of Paul (Kett Turton) to go back in time and effectively rewrite history with Candleton (Callum Keith Rennie) making the catch and the mill fire and the injury to Peter never happening. Like *The Langoliers* (and its possible inspiration 'The Premonition'), it conveniently avoids many theories about time travel and opts for a simple wish-fulfilment model. Unlike Ray Bradbury's short story, 'The Sound of Thunder', where time travel tinkering leads to disaster, here everything turns out for the best with Mary surviving to found the very hospital where they now stand. The drawing of a fire extinguisher, which then miraculously comes to life via a mechanical blow-up effect and then a CGI finishing touch, is an impressive special effect but the underlying rationale for this is murky to say the least. The final shot of Stegman, and the ghost boy and Klaus (Bill Meilen) looking down is reminiscent of the close of another Craig Baxley-directed King adaptation, *Rose Red*, suggesting evil is not cancelled as the survivors assume. Although Stegman's final lines ('I'm gonna get them') feels more like a baddie in a Batman movie, if Sally Druse (Diane Ladd) is willing to 'stake my considerable reputation as a medium' on having solved the problem, then her whole status elsewhere in the series is questionable.

There is a certain clunkiness in some parts. Those with head injuries, such as Earl and those with lucid dreaming ability like Traff, have access to this other ghost realm but why Dr Massingale (Sherry Miller, bearing an uncanny resemblance to Lena Olin), his love interest, shares this ability too as they are transported to the parallel morgue, remains unexplained. The exact logic of why 'ghost' characters like Antubis can have a bearing on the real world, biting Stegman's hand off, and yet it does work the other way round, also seems inconsistent. King may be a fan of the surreal hospital-based drama, *The Singing Detective* (Dennis Potter, BBC, 1986) but that does not explain why the love scene between Elmer and Massingale is suddenly accompanied by 1940s big band music. Mary moving Pete's head so that it appears he is nodding in answer to questions, seems ridiculous and the woods in which she sleeps

after the fire look strangely like the set of Dagobah for *The Empire Strikes Back* (George Lucas, 1980), minus Yoda.

There is self-aware game-playing elsewhere in the dialogue, which feels cloyingly self-indulgent. Both the radio commentary and the later on-the-spot reporter use an overt comparison between a dramatic situation and King's own work ('in a repeat of a Stephen King-like horror story' and 'in a scene out of a Stephen King novel').There is plenty of King product placement (Peter's wife is reading *Misery* and a man in a waiting room is reading *Bag of Bones* [1998]) and the knowing references extend to the van, which hits Peter (clearly paralleling King's own accident) driven by a stoned-out guy with a record of driving offences, who is distracted by his dog. Even the name of the absent anaesthetist who can confirm the truth of Stegman's negligence is Dooling (that of the producer and co-writer), whose book *White Man's Grave* (Richard Dooling, 1995) is also held momentarily in close up by a stand-in security guard. King writes the baseball episode, 'Butterfingers', reflecting his own personal Red Sox obsession. The pitcher, with 'King' clearly on his shirt, acts as an alter ego, to dramatize a life forever marked by a single moment (reminiscent of Jonesy's section for 'Sporting humiliations' in his Memory Warehouse in *Dreamcatcher*). The inescapability of public infamy extends to bars, ambulance crews, and even surgeons operating on him. Like *The Tommyknockers*' juxtaposition of dialogue on TV with Becka and later Joe Paulson, so here the radio commentary on a game 'You'd think somebody died' gains ironic resonance after we have just seen the humiliated catcher, Earl Candleton, shoot himself.

In typical King style, the plot becomes a battle between Peter, Sally, Elmer, Mary and Antubis against the evil doctor who had performed torturous experiments on the children at the mill on the original hospital site, which supposedly will prevent a major earthquake. The half-baked nature of the *Scooby-Doo*-like plot, is reflected in Elmer's incredulity: 'What am I supposed to do? Dream it away?' Where one might expect the pace to pick up, it actually slows down. The final mill episode features some painful repetition, not just of the mill shots (possibly to justify the set budget), the setting of the fire (shown through twice), or sententious descriptions of child labour conditions but of Druse's wittering repetition about 'Swedenborgian space' which as usual in King, not only goes unquestioned but other characters, such as Hook, start to use the term as well. Her verbose, self-dramatic speeches beginning 'I'll tell you'), which lead up to the final episode in which she explains things that she has no clear way of knowing, are extremely annoying. Although there should be tension in an approaching deadline (three hours until the quake), the finale itself is very strung out and even before it starts, Abel and Christa warn us that 'some will live, some will die'.

Like the pace in the final episode, the ratings for *Kingdom Hospital* initially promised much but dropped away badly. Taken out of context, there are points of interest in most episodes but like *Twin Peaks*, this style of heightened realism based on caricature and single role characters, ultimately cannot support extended narratives. Running gags like the attacks on Stegman's car, the headless corpse, and the ludicrous character names (such as 'Jesse James'), are played for laughs rather than realism and quickly become tiresome.

Although the inclusion of *House* (Steve Miner, 1986) in Stephen Jones' book on King is easy to criticize, there is a sense that King's prime horror influences are locked into a pre-1990s mode. The inclusion in *Kingdom Hospital* of séances, ghosts and spirits feels closer to the era of *Poltergeist* and *The Amityville Horror*. As a promotional tool, Hyperion Publishing tried the false mythology technique (as they did with *Red Rose*) again here with 'The Journals of Eleanor Druse' authored by writer/producer Rick Dooling. There is even a website for a fictional Kingdom Hospital describing in some detail the medical care it offers (www.kingdomhospitalofmaine.com).

A reliance on some knowledge of the narrative, the characters, and even stock phrases is a suggestion of genres like sketch shows, which are inherently episodic. At the same time, the use of quirky, knowing references is a nod towards the European post war arthouse cinema and the more cultish TV associated with figures like David Lynch. However, this may exemplify cultural differences in what constitutes 'amusing eccentricity'. Generically, it does not seem brave or clear enough to succeed. It seems neither witty enough to be funny in a sustained fashion, not hip enough to be deemed 'cult-worthy', and not frightening enough to be seen as horror – Klaus's DIY brain surgery never reaches the dramatic pitch of Hannibal Lector (Anthony Hopkins) in the climactic scene of *Hannibal* (Ridley Scott, 2001).

Riding the Bullet (Mick Garris, 2004)

Based on a longish, short story, originally available as an e-book but now appearing in *Everything's Eventual*, the narrative is set in 1969. It is Halloween in Maine and student Alan Parker seems drawn to committing suicide as a grand gesture worthy of the English Romantic poets. Even though the trailer might boldly claim the film derives 'from the mind of Stephen King', this is very much a Mick Garris project, acting here as producer, director and screenwriter in his sixth King adaptation.

The opening is reminiscent of *Salem's Lot* (2004) both in its full moon in close-up and the speeded-up motion of the hitchhiker. The grainy home movie, which protagonist Alan Parker is watching alone, might suggest it is the key to a mystery in the narrative but as it turns out it is really just to stress the importance of the mother figure in his life. The extreme close up of Alan's eyeball upon which the home movie is reflected, references the opening of *Blade Runner* and the notion of memory as a film and vice versa that runs in one's head, although there is not the challenge of Scott's film to watch closely – what we see is pretty much what we get here. In the view of his Art teacher, Alan is wasting what talent he has failing to appreciate the beauty around him, such as the posing nude woman in his life drawing class and instead is fixated on 'adolescent monster movie images'. The teacher asks 'Why don't you draw what you see?' to which he replies 'I do'. Superficially this would seem to link him to characters like *Salem Lot*'s Mark Petrie but it is ambiguous whether Alan is adopting a morbid, self-indulgent pose or whether he really is in a moribund state and needs to be reawakened to the possibilities of life. His girlfriend, Jessica (Erika Christensen),

certainly feels there is an element of the former as she jokingly tells him to 'quit playing the Prince of Darkness'.

There are a number of actions foreshadowing those of George Staub (David Arquette), some more subtle than others. In a small, apparently unimportant action, he is nearly run down outside the university by a pink *Christine*-style car (possibly actually containing the dead man). His first lift is run off the road by a similar car too. Later Alan witnesses a crow picking at some roadkill (shown blurrily at first in the extreme foreground of the shot) before being ironically struck by an ambulance screaming through the scene. His second lift confesses that on long journeys, he sees his dead wife sitting right where Alan is now and talks to her.

The short story is a first person narrative and Garris tries to be vaguely inventive with how to transpose Alan's thoughts and fears to a visual medium. Alone, an identical figure walks up to Alan (played by the same actor via CGI) and wishes him a happy birthday before walking through him and disintegrating. It is the first of several appearances of Alan's thoughts as expressed by an alter ego but it is really only partially successful. In a sense, it is brave to try something slightly different but apart from paranoid schizophrenics most of us do not experience thought in this objectified, projected way. It seems later almost cartoonish to have a character whispering advice in his ear. Later in the hospital, his doppelganger is the voice of Alan's conscience, pointing out that he cannot go to the concert while his mother might be dying.

The second appearance of his alter ego sits on his hospital bed when Jessica is there and tells him, 'You know, you are a whiney. And being a bit of a creep, to tell you the truth'. He has a point since we do not see this level of self-obsession in the protagonist of the short story. The fact that he alone can see and hear this figure, creates a *Randall and Hopkirk Deceased*-feel but the comic potential of the device is not really exploited. Alan mentions to his first lift that his mother is in hospital and the man asks if she is sick to which the doppelganger figure, sitting behind Alan, chips in 'No she hangs out there [...] it's kind of a hobby' and is sarcastic when the driver shares the story of losing his mother through cancer. His second lift, an unnamed crotch-grabbing farmer (Cliff Robertson) is viewed with repulsion and suspicion by his alter ego. When he offers to take Alan all the way, the figure whispers from the back seat, 'Don't let him, there's something wrong with him'. Excessive sentiment is effectively punctured – after Alan wishes on the harvest moon, that his mother will recognise him, his doppelganger advises him, 'I wouldn't fuck with wishes if I were you. Remember *The Monkey's Paw*'.

Later, his alter ego comments on the smell in George's car and then cites 'the dead travel fast' from *Dracula* (another link with *Salem's Lot*). He appears to act on a third party for the first time in taking off George's cap to reveal the top part of his still-pulsating brain (much like Ray Liotta in *Hannibal* [Ridley Scott, 2001]) but then we cut back a few seconds and the sequence is just cast as fantasy (yet again). Alan panics and lies about his identity but his alter ego prompts that George knows who he is with lines like 'he knows you know he's dead', illustrating the (unnecessarily) convoluted nature of the plot. Even Alan's father (an addition

to the plot from the original story) appears as a back-seat driver in this same role, encouraging him to 'paint the walls like I did' before shooting himself again. When presented with the so-called dilemma by George, Alan wonders via voiceover (incongruously introduced here for the first time in the film) 'I'm only 21...' to be countered by his doppelganger putting the case in favour of his mother. In *Tom & Jerry* (William Hanna and Joseph Barbera, MGM, 1943–present) this might work but in films for a more adult audience, it is less convincing and its effect is contradictory, since positive and negative, good and evil thoughts are expressed through the same figure, prompting George to turn to him and address him directly (which no character has done up to now), telling him (and possibly articulating our wishes too) to 'shut the fuck up'.

There is some witty dialogue. Jessica asks him who loves him, to which he replies 'My mum...baby Jesus...you?' His sarcasm is undercut by her gift of John Lennon tickets, making him look quite small. His friends Archie and Hector (Robin Nielsen and Chris Gauthier) suddenly wonder how the world will look 'when all the rock and roll icons get old' and conclude 'It'd be a world, I don't wanna live in', ironically foreshadowing their demise in a car crash. When Alan admits he knows George is a ghost, George is almost offended – 'C'mon, you can do better than that. Casper's a fucking ghost'. Later there is a small allusion to dance group Snap!'s terrible rhyme in 'Rhythm is a Dancer' (1992), when he claims that he is 'serious as cancer'. A few moments into the final credits, we see George come and offer an older Alan a ride, which he refuses saying he is going to walk.

Garris creates some elements of tension. Alan's first lift is from a stereotypical hippy called Ferris (played by Nicky Katt), talking about Woodstock, Vietnam, and offering him a joint but there is the suggestion of something more sinister here – when the van crashes, the man's wig slips, and there appear to be stolen goods in the van and he starts to shout 'I'm one of you' (echoing the ensemble call at the end of *Freaks* (Tod Browning, 1932). The dissolves used to cut between Alan standing, sitting and then drawing, whilst waiting for a lift, compress the time well and motivate the fantasy sequence through the hospital in which we follow him through the wards until he reaches his mother (Barbara Hershey) and rolls her over only to be confronted by a face without features, reminiscent of work by Dali or Magritte. It is an effective, nightmarish vision, in part because we have been drawn into it, rather than 'tricked' by an unsignalled dream sequence. There is a second fantasy hospital visit, which is unsignalled but is motivated as it follows his second lift's account of his former wife's battle with Alzheimer's. Alan's mother looks up at him, gives a beatific smile and then emits a bizarre squawking noise as the doctor calmly explains how this will mean giving up any idea of a life of his own to care for her.

There are some effective shots/sequences. A bus passing-by in slow-motion, the faces of children at the window dressed in Halloween masks, is surreal and strangely out of place in the woods. The use of speeded-up film to shot-cut narrative time in repetitive action, such as when Alan is walking along the road at night, can work but at times it is simply thrown into the editing mix to try and inject a sense of kinetic energy, such as the approach to the bathroom door. About to slice his wrists, a mysterious figure in a cloak walks in, sits down

on the toilet and starts to talk to him, encouraging him to go on with it. The problem is, that ironically without interruption he would have done exactly that. The animation of the veiled women on the walls of the bathroom could be scary (and is motivated by Alan smoking pot) but the chorus of 'Cut' unfortunately just reminds this viewer at least of the scene in the pilot episode of *Friends* (David Crane and Karta Kauffman, NBC, 1994) when Rachel is encouraged in unison by the Café Perk entourage to cut up her credit cards.

The weirdness and slightly threatening element in the second driver's offer to take him all the way, are effectively conveyed by the jump cuts as he repeats 'Whaddya say?' and the jump cuts linked by dissolves as Alan walks away from his first lift are effective but then immediately repeated down a railway track – it almost feels like once Garris finds a technique that works, he over-uses it with progressively less powerful effects. Alan turns to see what looks like an old woman in the car talking with his second lift but after a truck passes like a wipe, she has gone. In George's car, Alan's fear and disorientation are conveyed by the relatively simple device of three close ups of him taken with a rotating camera at different speeds, superimposed over each other with overlapping dialogue. Again, however this also feels more like an MTV aesthetic, seeking kinetic movement on screen whether motivated by character or not.

The use of fade-to-white rather than black at the end of the bathroom scene links with the sterility of the following hospital scene but there is something strange here. The light is brighter than usual and the focus slightly soft so that by the time Jessica apologizes, stoops to kiss him and sprouts wings, we should be clear that we are in a dream sequence, signalled by features within the scene rather than by transition devices like a wobbly screen. The scene then replays and the girl announces rather less romantically that 'that was a fucking stupid thing to do'. The unsignalled fantasy sequence is used again shortly afterwards when the phone rings and Alan hears Jessica declaring her love and suggesting they run away before the scene replays and he hears about his mother's stroke. Garris then cuts to a rapidly-descending top shot via a crane at a funeral with clichéd organ music, which is abruptly cut off as Alan hears that his mother is stable in hospital. In fairly quick succession we have had three examples of unsignalled fantasy scenes. Sometimes they can be effective but over-use weakens this as we half expect all scenes to be revealed as fantasy, i.e. there has to be time enough given for viewers to suspend their disbelief again.

Thumbing a lift, Alan has a flashback (via 'flashbulb' cut) to when he was a boy, bringing a picture home to show his parents. We track through the house with him and zoom in on his face as he is told about the death of his father. We dissolve to a funeral and the camera tracks over the gravestone and *through* some standing mourners to a second graveside with Alan putting flowers on a grave, identified by the headstone to be that of his mother. Then via a cheat cut over the second gravestone we track to a third grave in which Alan lies in an open coffin and which slams shut as we pass over it, reaching the gravestone and the happy epitaph 'Who gives a shit?' We then end with a tilt shot up to Alan himself standing by his own grave and Jessica who arrives distraught and weeping at his tragic death. The sequence neatly combines his mother's current illness, prompting a memory of his earlier

parent's death, a vision of the present and possible near-future in his mother's death and then consideration of the inevitable future and his own mortality.

At the accident scene, there is a shot of Alan looking down for several seconds before we cut to a petrol can (which we assume is what he was looking at). It is only during the following flashback, introduced by a literal 'wipe' as Alan's mother pulls a sheet down to hand to her son standing behind her, that we are told about the death of Alan's father, whose body was found still holding that same object. This feels more like a moment from a film by David Cronenberg or David Lynch as an object is invested with a symbolic weight that is explained gradually and with some restraint. This is followed by the strange sequence of Alan apparently being followed by a mysterious figure in a long coat and hat, who he eventually turns to confront, only for the figure to be revealed as his father, claiming that Alan's mother lied to him. At this point we are not entirely sure whether we are in a fantasy sequence or not, just as Alan is momentarily disorientated by his awareness that all that he has thought about his parents, may be based on a lie.

After his second lift in particular, the film descends into fragmentary episodes. Rednecks with rifles chase him for no good reason and he hides in a fridge in a junkyard. The scene shows some promise, shot from inside only so we see and hear only what Alan does – little muffled sounds and his own heartbeat before a shotgun blasts a hole in the door and a ray of light falls on his face. However, then in a big anti-climax, apart from jumping at a spider, *he just gets out*. Then we have a section where he starts to hear howling and we have a point-of-view through woods as if something is stalking him. A rabbit suddenly emerges, only then to be pounced upon and ripped to pieces by a dog, which then stalks Alan. The dog attacks, appears to rip his throat out and then is hit by a truck at which point we cut back to the scene on the road a few minutes earlier. Alan looks round, dazed and confused and so might we by this time, unsure what is real and what is not and what has happened and what has not. Over-use of this technique makes it virtually impossible to engage with characters and their situations as we just wait for the scene to be revealed as a fantasy.

Then we hear a tinkling noise before seeing a second walking figure, this time his mother, shuffling along connected to an IV drip. She asks him why he keeps turning down rides (something we have not really seen him do), implying that he does not really want to see her. She delivers the enigmatic 'Fun is fun and done is done' line and then is gone. He sees a sign for a theme park where you can 'Ride the Bullet', prompting a dissolve and a flashback to being in a queue for a scary ride and a foot-level shot of change falling at his feet from the pockets of those on the roller-coaster. A flashbulb cut takes us to the ride itself, during which a figure of death (the old man from the bathroom scene) appears and throws him off, using the same technique as John Rimbauer's fall from Tower Folly in *Rose Red*, falling headlong into the camera. With a double jump cut, we realize we are in a dream-within-a-dream as his mother slaps him to a thunderclap sound effect and we cut via a dissolve back to the rainy road at night.

He comes to some cemetery gates, through which the camera tracks and *past* him to the grave of George Staub, which miraculously appears to have the epitaph just recited

by his mother. The shock motivates a flashbulb cut back to his funeral scene, where his alter ego bursts from the ground and declares that 'We're saving a place for you'. Scared and disorientated, he turns and bumping into Staub, who has been stalking him since the accident scene, falls and bangs his head. This, we learn later, motivates a longer fantasy sequence, including most of the ride with George, whose face is initially obscured by smoke but we should be alerted that all is not well by the extreme low camera angle. His smoking-through-a-tracheotomy-effect has appeared before in *Dead Again* (Kenneth Brannagh, 1991) and more recently *Thank You For Smoking* (Jason Reitman, 2005). After choosing his mother to die, Alan is pushed out of the car and there is a ridiculous shot of him flying *ET*-style across the moon before a slow dissolve mixes the moon with a shot of his face as he comes round.

After the experience with George, the final ride to the hospital is covered with almost-perfunctory speed, where the use of the unsignalled dream sequence reaches truly ridiculous proportions. Firstly a doctor (played by Garris himself) puts his arm round him and tells him his mother is dead then we cut to the same scene with a different doctor declaring, 'I'm not gonna lie to you. Your mother's a vegetable… a banana squash. She's fucked and so are you'. In theory, this could be funny but with the constant alienation device of casting scenes as fantasies, Garris forfeits any viewer empathy there might be with characters by this stage. Alan sees a badge from the theme park, implying his experience with the ghost was real and reasonably wonders (as indeed we might) 'then why isn't she dead?' Then he spots George entering a lift (not in King's story) and we begin what we assume will be a dramatic race to his mother's bedside but George *just disappears*, vanishing form the narrative. If his work is done, exactly what that work is, remains unclear. Alan was going to see his mother anyway, he hardly speeded up the journey, he has not 'taken' either soul, so what is his purpose? What had promised to be a race peters out to nothing. Alan approaches his mother only for her to turn and say 'I know what you did' before cutting to the 'real' scene of a tearful reunion with soft piano music where he makes peace with his mother. After so many 'false-starts', the power of this final scene has drained away completely, robbing the moralizing voiceover ('There's nothing like a brush with mortality to teach you to appreciate life') to carry any dramatic weight.

A sentimental flash-forwards shows us the remaining years of his mother's life, laughing and smoking and painting a scene featuring George's car, suggesting he has told her about it. Even here, however Garris cannot resist further fantasy sequences so that we dissolve from an image of his mother painting to what we assume is her funeral, but as Alan bends to put the badge from the roller-coaster on her coffin, it flies open and George pulls him in. In *Carrie*, this would be shocking; here it is just tedious. The flash-forwards to Alan's own life as a home movie shows how the experience 'unlocked my heart', hugging his girlfriend and finally we dissolve from Alan painting (paralleling his mother) to the roller-coaster. The concept of taking a roller-coaster ride, voluntarily waiting in a queue for a near-death experience, as a test in life, accepting that you need to risk things, perhaps even death, in order to really know yourself, could be interesting but it is not strikingly original.

The film contains several examples of 'nested narratives', such as George's story about a teenager buying a car, only to discover the wife of the previous owner killed herself in it. We see the husband coming home and finding his wife, who has been dead for several days. When Alan quibbles about the kind of car, he snaps 'what's the difference, it's a *story*'. The exact purpose of the story however is not entirely clear. Alan asks 'why didn't he call home?' which would link it perhaps with his own relationship with his mother but the type of question and George's dismissive reaction ('It's a story. Fiction'), make Alan seem like Vern, asking an irrelevant, pedantic question in *Stand By Me*. George's following anecdote opens with a tracking shot into a cinema, displaying '*Riding the Bullet* starring George Staub' on the billboard. Inside we track up to the screen showing a trailer for the film. In daylight, we have a standard point-of-view shot through the windscreen of a car and then cut to an accident, which we track up to slowly. A decapitated body is slumped over the wheel and George's head rests on the back-seat. Suddenly his eyes flick open and we have the warning 'Every Halloween when the moon is full up on Old Ridge Road you might see old George Staub looking for souls like yours' before 'The End' and a question mark appears across the screen. Narrative exposition is cast as a movie trailer.

In talking to his two, distinctly unfunny friends, Hector and Archie, Alan confesses that he wishes Jessica would dump him if that is really what she wants. He claims 'I'm just trying to evolve here', which in theory is echoed in his gradual realization of how important his mother has been in his life. His second lift says that he must be a 'pretty good kid' to drop everything to see her and he has given up his Lennon tickets but the meeting with Staub forces him to confront his real feelings and whether he would be prepared to sacrifice her if he had to. We flashback to his mother being charming to a charity representative but making faces behind his back, showing a strongly protective nature and a capacity for fun and yet the picture is mixed. There is the sentiment of her graveside, 'Just you and me now, baby' but also the less flattering reality when he rolls her over to find her drunk on the floor. Like *Storm of the Century*, there is some cod psychology going on here and what at first appears to be a dilemma (designate someone else to die or everyone does), is really nothing of the kind. George implies that Alan's father committed suicide (shown in a *Christmas Carol*-style flashback) and therefore that his mother lied but whether this is true, or even if she did whether she did so for honourable motives, we do not know.

In his introduction, King terms it 'Simple but fun' but the plot is problematic.[4] Alan is told by a traffic cop to 'Move along' as if he has suddenly come upon the traffic accident but he is on a long, straight road and the whole scene would have been visible for several minutes to someone approaching slowly on foot. Alan rather unbelievably struggles away from George's car and just happens to be just right by the theme park they have been discussing. George calls Alan 'one of the walking dead' but exactly why George should have a claim over either Alan or his mother is not clear and indeed neither is why there needs to be 'a kind of messenger. Fucking Western Union from beyond the grave' and what is the nature of the message anyway? Has Alan or his mother 'forgotten' to die? Why does Garris add a father figure not in King's story, which only obscures Alan's motivation further? The dead may

travel fast but the fragmented plot, turning in on itself repeatedly but without a great ability to carry viewer engagement with it, definitely does not.

Some of the inconsistencies of the film derive from King's short story. In the book, King rather self-defeatingly, has Alan declare that 'I came to understand that there are things underneath [...] and no book can explain what they are.'[5] Has Alan neglected his mother and is guilt prompting the speed of his response? Was it a 'cruel practical joke on Staub's part?'[6] Alan, and we, expect to find his mother dead ('wasn't that the way stories like this were supposed to end?'[7] However, it does not make the reader or viewer into Teddy Duchamp from *Stand By Me* to see the ending here as a complete anti-climax. Tellingly, Alan asks at the end 'what was the goddamn point?' and admits 'There ought to be more to it, but there's really not.'[8]

Conclusion

> Edgar [...] I don't think ghosts can hurt people.
> (Wireman in *Duma Key*)[9]

Rose Red's missed chance of a the uncanny shot of a moving inanimate object is symptomatic of a lack of ambition in the films in this chapter, which seem mostly content to operate firmly within generic boundaries. It seems contradictory that King lauds Wise's subtlety and restraint in *The Haunting* (Robert Wise, 1963), such as the shot of a door which bulges outwards but which remains closed to the viewer (also present in the cracked mirror shot in the adaptation of *Carrie*) and yet the TV adaptations in this chapter seem to lack precisely this quality. Even in terms of special effects, *Rose Red* is not that original, not only in the opening unattributed 'borrowing' Shirley Jackson by way of De Palma but even *Scrooge, or, Marley's Ghost* (1901), credited to Walter Booth, including visual tricks by R.W. Paul, features a door knocker that is superimposed with Marley's face, some back-projection to show flashbacks and some dissolves as a transitional device.

The weakness in the cinematic presentation of ghosts derives in large part from King's own ambiguous and inconsistent use of them in his fiction. There is little consistency over what ghosts look like or what they can do. King's ghosts generally seem to lack a purpose. As Jack says in *Duma Key*, 'in *Scooby Doo*, it would turn out to be the crazy librarian', but such self-aware references do not necessarily forestall criticisms of similarly facile plotting.[10]

Although much parodied, at least the 'ghosts' that appear in *Scooby-Doo* usually attempt to scare someone away from a place. In King's fiction, ghosts do not bear messages but just represent a force that can apparently kill. Entities are both designated as projections and yet seem to be shared at times. They seem to be above the laws of physics, appearing or disappearing at will and yet seem able to act upon the physical world when it suits them. In *Duma Key*, the narrator, Edgar Freemantle, states 'the truth is in the details' and then proceeds to deny the reader such details.[11]

The short ghost story 'Willa' in *Just After Sunset* (2008), although much trumpeted by King as heralding a new burst of creativity in this short form, actually contains few surprises. The narrative deals with ghosts who know that they are dead – they may be in some form of denial about it but they are dead: their status is clear. There is none of the genre mixing of *From Dusk till Dawn* (Robert Rodriguez, 1996), the dark, even morbid humour of *Beetlejuice* (Tim Burton, 1988) or narrative unreliability as in *The Sixth Sense* (M. Night Shayamalan, 1999). If anything, King's tale naturalizes and even humanizes the supernatural. It even confuses its own generic references, having ghosts cast no reflection in mirrors (in *Sometimes They Come Back* too), like vampires and states, rather than shows us, that ghosts do not get tired or hungry. The 'ghosts' of the *Sometimes* series display few consistent characteristics in terms of motivation or otherworldly powers, often picking up and then dropping motif actions from vampire and zombie narratives, making empathy with them very difficult, if not impossible.

King seems drawn to genres of his youth that are now exhausted as sources of fear for contemporary viewers. The 'old dark house' movie of Roger Corman's version of Poe, such as *The Fall of the House of Usher* (1960) or *The House on Haunted Hill* (William Castle, 1959), seem light-years away from contemporary horror. William Malone's 1999 remake of the latter narrative, with state-of-the-art special effects and a clear shift towards a slasher narrative with an open ending, reflects changing tastes in the subgenre. At the same time, the ghost ship in *Duma Key* (close in conception to *The Fog* [John Carpenter, 1980]), is now sanitized for teen viewing via The Black Pearl in Gore Verbinski's *Pirates of the Caribbean* series (2003, 2006 and 2007). The appearance of ghosts on TV has been focused on psychic powers in detective genres (*The Ghost Whisperer*, ABC/CBS, 2005–present) or pseudo-documentaries to investigate paranormal manifestations, usually in houses (*Ghost Hunters*, Syfy, 2004–present).

As a literary form dating back hundreds of years (with an oral tradition before that), the ghost story may seem linked to a bygone era and certainly with *Salem's Lot* as an updated version of *Dracula* and the basic notion of survival after death in a dark house as in *Rose Red* or even *Kingdom Hospital*, looks back to the tales of writers like Edgar Allen Poe. However, in an age of supposed-rationality and advanced science, it is debatable whether the portrayal of ghosts is still credible. However, whereas *The Blair Witch Project* uses handheld camerawork, limited viewpoint and deliberately-low production values or *The Ring* series (in both Hideo Nakata's 1998 version and Gore Verbinski's 2002 remakes) and *Paranormal Activity* (Oren Peli, 2007–09) foreground the notion of surveillance footage, within a dramatic context, the adaptations here often fail to blend the narrative drive of an investigation with suitably creative filmic form. In the *Sometimes They Come Back* series, ghosts are shown as 'real' characters, only with the proviso that they have supposedly been killed, à la Banquo's ghost and *Rose Red*, although based around the premise of a scientific exploration, takes so long to discover anything that it largely forfeits viewer engagement.

Kingdom Hospital, and to a lesser extent *Riding the Bullet*, present a different problem – it is extremely difficult to evoke simultaneously the self-aware comedy of parody and then

expect it to be frightening. A parody without a 'control' is like an impression of someone you have never met – it is unclear whether viewers who have not seen *Riget* find *Kingdom Hospital* interesting, funny or even comprehensible. Its repackaging and scheduling as late-night cultish fare suggests parody only really works if you know the generic codes that are being copied or subverted.

Ultimately, what the narratives in this chapter do not do (or attempt to do) is disturb. There is no real problematizing of the boundary between life and death and no element of sympathy for the not-completely-dead, which are just monsters, which we can combat and ultimately overcome in bizarrely physical terms (bearing in mind we are supposed to be dealing with spirits). The programmes indulge viewers' superstitions about the possibility of some kind of life after death in a way, which is ultimately consoling. Monsters can be dealt with, narratives closed and wider philosophical questions (such as 'Do we all become ghosts?'), conveniently ignored.

Notes

1. Stephen King, *Just After Sunset* (New York; London: Pocket Books, 2008), p. 530n.
2. Stephen Jones, *Creepshows: The Illustrated Stephen King Movie Guide* (New York: Billboard Books, 2002), p. 105.
3. See Stephen King, 'The thing under my bed waiting to grab my ankle isn't real. I know that, and I also know that if I'm careful to keep my foot under the covers, it will never be able to grab my ankle', in *Night Shift* (New York: Doubleday, 1978), p. 6.
4. Stephen King, *Everything's Eventual* (London: Hodder and Stoughton, 2002), p. *xviii*.
5. Ibid., p. 476.
6. Ibid., p. 513.
7. Ibid., p. 517.
8. Ibid., p. 522.
9. Stephen King, *Duma Key* (London, Hodder and Stoughton, 2008), p. 328.
10. Ibid., p. 484.
11. Ibid., p. 36.

Chapter 5

Apocalypse Now

There seems to be an enduring appetite for apocalyptic narratives, especially when they articulate anxieties about life-threatening forces, most obviously nuclear-related, such as TV films like *The Day After* (Nicholas Meyer, 1983) or BBC TV film *Threads* (Mick Jackson, 1984). The spread of viral infection, such as *28 Days Later* (Danny Boyle, 2002), often wrongly described as a zombie film, and more recently, an overwhelming environmental catastrophe, as in Roland Emmerich's *The Day After Tomorrow* (2004) and *2012* (2009), express fears beyond the threat of nuclear Armageddon. More recently, even the cause of catastrophe remains unspecified, as in John Hillcoat's *The Road* (2009) or *The Book of Eli* (Albert and Allen Hughes, 2010) so that the prime focus is purely on human survival and what values are worth keeping. The scope and scale of the narratives usually make them a vehicle for spectacular special effects, opening such films, Emmerich's in particular, to criticism as so-called 'disaster porn', where viewing pleasure is often couched within a context of mass destruction.

Apocalyptic narratives are often inherently religious in terms of action, language or character types. This is perhaps unsurprising since when characters are faced with apparently insurmountable odds, it is logical that some will turn to religion for comfort, support, and possibly divine aid. King goes a stage further by making his antagonists (Randall Flagg, Linoge and Gaunt) explicitly devilish and thereby the central conflict, one between good and evil in explicitly Christian terms. *The Stand*, *Needful Things* and *Storm of the Century* are all battles for the soul of America. Notions of the apocalyptic are usually approached via the small-scale, the macro – via the microcosm. In *Needful Things*, Gaunt as the devil seems

to be intent on corrupting one small town, (presumably as a first step) rather than trying to destroy the world in one go.

Notions of apocalypse occur elsewhere in King's adaptations, such as in *Dreamcatcher* (Lawrence Kasdan, 2003), where humanity threatens to be enslaved by an alien race and the most pessimistic of all, 'The End of the Whole Mess' from *Nightmares and Dreamscapes* (see the following chapter), where well-intentioned science has unforeseen consequences and humanity is seen as ultimately dispensable. Although the possibility of nuclear conflict remains, its likelihood in a post-Cold War world seems to have receded, which means that King's vision of a nuclear strike in 'Graduation Day', collected in *Just After Sunset*, although still with us as a possibility, seems a throwback to the 1980s, a literary version of the Armageddon scene in *Terminator II*, now nearly 20 years old.

The Stand (Mick Garris, 1994)

> A virus is only doing its job.
> (David Cronenberg)[1]

Perhaps the main achievement of *The Stand*, is that it was made at all. As King's longest novel, which he had to fight hard to persuade publishers to eventually release it its original form, it presents considerable problems of compression. At the same time, its content, Armageddon, does not make it the natural choice as prime-time family entertainment – a reservation shared by King himself. Post-nuclear Armageddon has certainly been fictionalized but viral infections centred initially on North America, is not a common subject for network TV (the cult BBC series *Survivors* [Terry Nation, 1975–77] has a specifically-English focus). On the big screen, Richard Matheson's seminal novel *I Am Legend* (1954), using a similar scenario, has been the basis of *The Last Man on Earth* (Ubaldo Ragona and Sidney Salkow, 1964), *The Omega Man* (Boris Sagal, 1971) and Robert Wise's low-key *The Andromeda Strain* (1973) but more recently Francis Lawrence's version of *I am Legend* (2007), suggests survival as a visceral fight to the death with crazed monsters, often prompting comparisons with George A. Romero (who may at some point direct King's own *Cell*). The fact that *The Stand* was a considerable ratings success for ABC and often quoted by fans as one of their favourite King adaptations, is perhaps a mark of achievement for King (who also wrote the script) and second-time King director, Mick Garris.

Although *The Stand* was marketed as an original and groundbreaking television 'event' with its 95 locations, 100 day-shoot, and $28 million budget, there is also a derivative element running through it. The twanging slide-guitar of W.G. Snuffy Walden is very reminiscent of Ry Cooder's score in *Paris, Texas* (Wim Wenders, 1984). The crow (a nod to the hawk in Wenders' film as well as the sense of threat demonstrated ever since Hitchcock's *The Birds* [1963]) appears as a traditional harbinger of death, an emissary of Flagg (reverse shots from the bird's point-of-view pepper the film) and a naturally-occurring species in desert areas.

Death from the virus is extremely rapid and we only see a few actual deaths on screen. More common is the grotesque tableau of corpses that litter streets, progressively decomposing through the narrative and losing their shock value as such scenes become normalized. Like *Maximum Overdrive*, we see a few streets of chaos as emblematic of a nation falling apart and despite the large budget and number of locations, radio reports and expository gossip stands for a national picture, too broad to encompass. In the government research facility at the centre of the outbreak and later at the disease centre in Vermont, the one place where we might have hope of a cure, we cut between black and white shots of such scenes on surveillance monitors and tracking shots through the scenes in colour, as if recording the last moments of mankind, which give little dignity to those who perish. Garris manages to secure a 15 certificate for the video release by toning down gore, such as when the car crashes into the gas station near the beginning, bodies are recovered in darkness, close-ups focus on figures facing away from the camera and we quickly cut to reaction shots.

King clearly had an input in the soundtrack. The Blue Oyster Cult's 'Don't Fear the Reaper' (1976) or Crowded House's 'Don't Dream it's Over' (1987) gain an ironic resonance in a post-apocalyptic vision, where from the outset, those entrusted with protecting the public desert their posts or, like the Arnet cop, lie about their movements (and thereby spread the disease) or treat victims with a callous disregard for their humanity ('This is interesting, now watch this' mutters a doctor as a victim undergoes his final death spasms). The cowardice of the chief doctor assigned to treat Stu (Gary Sinise) is exposed by Stu's threatening to infect him and a fake coughing fit, which prompts near-panic. Even the apparently friendly small-town doctor that Nick (Rob Lowe) finds, resolves to leave his patients and try and wait it out in an isolated cabin. Civil liberties and free-speech are soon casualties, reflected in the interruption of a talk-show and the emblematic cutting off of a critical commentary by the host, Rae Flowers (an uncredited Kathy Bates) by gunfire. The military, as seen by General Starkey (an uncredited Ed Harris) can do nothing but quote Y.B. Yeats' observation that 'Things fall apart' ('The Second Coming', 1920), as does his sanity quite rapidly.

In structural terms, like *It* we are introduced to separate characters, whose destinies gradually entwine and due to the size of the ensemble cast, characterization is limited. Rob Lowe as Nick Andros does what he can with a part requiring him to be deaf and dumb. Lloyd (Miguel Ferrer) also has little to do and is ironically introduced by ZZ Top's 'Sharp Dressed Man' as he is a slovenly drunk and a hopeless rather than a smooth criminal. The simpleton, Tom Cullen (Bill Fagerbakke) peoples his deserted town with dummies, creating a rather surreal impression for Nick on entering the town. The concept of a deaf and dumb man falling into the company of an illiterate simpleton, creates some interesting ironies of communication since Nick usually expresses himself through a small notepad. Strangely, it is not until they meet Ralph (Peter Van Norden) sometime later on the road, that Nick can actually introduce himself. Julie (Shawnee Smith) appears as no more than a stereotypical nymphomaniac with no clue given as to why she is so unstable. Even Trashcan Man (Matt Frewer), although presented along with teasing voices on voiceover and sudden head movements (shown in close-up with a wide angle lens), seems little more than an

insane arsonist. The notion that a satanic figure would exploit the dispossessed and offer them temptation to rise above their lowly status as 'losers' is fair enough but in fictional terms, there is not much that can be done with Trashcan's character other his mantra 'My life for you' and acts of destruction, which gain cartoonish rather than tragic force. Abigail (Ruby Dee) is given sententious and sentimental dialogue (accompanied by piano), often delivered in a laboured and theatrical style. Given the panoramic view of the novel, some compression is inevitable but in the film, characters also appear at the beginning of Part III virtually unannounced (Dana and Judge Ferris) and the narrative struggles to be stretched in so many different directions.

The representation of evil is always going to be problematic. It could be said that here is a brave attempt at representing the Devil (or one doing his work) as charismatic, plausible and therefore highly dangerous. For Randall Flagg we have Jamey Sheridan, in boots, jeans and a Billy-Ray Cyrus hair-style. If Sheridan does not exude sufficient menace, the supposedly epic battle in *The Stand* does not really work. His eyes glow red and later in the narrative he morphs into two different devilish facial incarnations but as in He Who Walks Behind the Rows in *Children of the Corn*, the sense of threat is greater when it is suggested than realized. As elsewhere in King's work, vampiric features (his sudden revelation of fang-like teeth when he is in Abigail's cornfield) are introduced as an ad hoc sign of monstrosity and evil without logic within the narrative. However, there is also a lightness to his character – when he quotes some apparent scripture at Nadine (Laura San Giacomo) about brides coming to bridegrooms 'as the flame cometh to the lamp', she asks if it from the Bible, at which he admits that is Danielle Steele.

Las Vegas, a city built on greed and superficial materialism, might seem the natural choice for King to place Flagg and his disciples, as a gang of mobsters. Later, the Chief of Police challenges Nick whether they have been as successful in rooting out drug crime in the Freezone. With the logos on Flagg's trucks, gun-toting, bully-boy tactics and a mass rally at the end, Riefenstahl-style searchlights strafing the sky, there are suggestions of a neo-fascist cult of personality (Flagg underling, Whitney, played by Sam Anderson, considers fleeing to South America – a stereotypical Nazi sanctuary). Indeed, there is quite a strongly conservative undertow to painting this morality tale in overtly Christian terms. Some of the later works of King (*The Shining* and *Desperation* in particular) do feature a fairly uncritical Christian agenda. The crane shot sweeping across the hall, showing the singing of the national anthem at the beginning of the town meeting and the shot of the painting featuring pioneers, suggests a binding of nationalism and religious faith. Later Abigail tells Fran (Molly Ringwald) in a dream that it is 'God's will' that they travel west, expressing the notion of *translatio impereii*, the divine duty to travel and in effect colonize westwards with nothing but faith to guide them, a concept which underpins American westward expansion historically. There is a slight nod not just to *Stand By Me* as the four men are shown walking through the iconic Utah landscape but also John Ford westerns – they are demonstrating the spirit that formed America. As elsewhere too, the exact extent of Flagg's powers are unclear. If he can walk through fire, 'zap' dissenters with bolts of electricity and senselessly

kill a deer just by pointing his finger, why does he need human agents, like Trash Can Man and Harold (Corin Nemec) to do his destructive bidding? If he knows about two of the three spies, why is it so important to detain them without head injuries? This proves their identities of course but for an all-powerful spiritual enemy, he seems to work very much like a low-grade dictator.

Plot problems remain but in part they derive from King's novel – Abigail's sudden disappearance and then re-appearance, weakens her credibility and even if she is supposed to be suffering spiritual doubts and punishes herself for the sin of pride, it weakens her status.

Fran assures Harold Lauder that he will meet someone his own age but there is no real clear age gap between the two here. There is a slight reliance on coincidence. As Harold himself notes, the chances of those resistant to the infection being friends and neighbours, are highly unlikely. The meeting of Glen (Ray Walston) and Stu with Fran and Harold who calmly ride up on their bikes, seems unbelievable. It may have been a pure coincidence of casting but to juxtapose Ray Walston next to Gary Sinise, in terms of character appearance, role and accent, strongly echoes *Of Mice and Men* (1992), which Sinise had just finished directing and starring that same year opposite Ray, cast as an old-timer with an old dog who wants to share a dream. There is brief mention of the battle to restore power but a bigger 'black hole' appears in the lack of a sense of struggle for food, fuel, and the basics of *survival*. Quite why or how Larry (Adam Storke) carries his guitar for the whole period of his 'walkabout' only for it to be smashed in Vegas, is never raised. The fortuitous arrival of Tom to help Stu crawl out of the ravine, supposedly told by Abigail in a dream where to go and the appearance of Nick in a dream to show Tom where to get drugs for Stu, stretch credibility to the limit.

King has talked in interviews about *The Stand* as his version of a Tolkien epic but his narrative really lacks the mythic grandeur and truly epic sweep of such work. Characterization tends to work at a one-dimensional level, designated by appearances. With her bright red lipstick, dress and scarf, Nadine is presented as a scarlet woman and from the outset as we see her dream of giving herself sexually to Flagg, marking her as a Mary Magdalene-like temptress and betrayer (her hair turning visibly grey, suggesting a price is being paid for her spiritual weakness). Harold acts as a doubting Thomas or Judas-figure and there are a few contenders for Christ-figure in Nick, Larry, Glen and Stu who are willing to sacrifice themselves. Indeed the first three do so, for (a clearly Christian) Good, although Stu is willing to consider suicide, a sinful act in some eyes. Abigail commands that four of their number go out (as Jesus did) for 40 days and nights into the wilderness without food and be tested and the final sacrifice of Larry and Ralph are pseudo-crucifixions before a baying mob.

A problem with the film (also in the novel) is that one of the first actions of the Mother Abigail group is to wonder what Flagg is doing without any clear need (they can do nothing about it anyway). It seems that when presented with the chance to construct a new society, they revert to the behaviour that caused Captain Tripps to be developed in the first place. Harold and Nadine are clearly traitors but the subtitle for Part III, 'The Betrayal', might equally apply to the idea of sending out spies to infiltrate Flagg's camp.

The Judge's expectation that the group's first priority should be 'information' smacks of the McCarthyite insecurities of the Cold War era. This is certainly how Larry sees it and although the other characters give him short shrift, this may seem so to the viewer too, making the term 'Free Zone' ironic. Echoing Abigail, Stu talks about a passive belief in the will of God, to which Larry replies 'Do you know how crazy that sounds?', with which many viewers will tend to agree, especially after witnessing the literal *deus ex machina* of The Hand of God, which triggers Trashcan Man's bomb. The explosion that kills several members, including Nick, and makes Fran lose her baby, seems to be explained as a reminder that virtue should be active (if so, it seems quite a harsh punishment from a less-than-benevolent God). Similarly, there is the sense that nuclear weapons are needed to keep them safe from a perceived (but actually quite unreal) threat – a basic right wing political agenda.

Stylistically, there is little that is really innovative in the film. Garris is still early in his TV career and perhaps with such a large project (and budget) at stake, elected to mostly 'play safe'. There are some effective shots. The dreams of Mother Abigail, which the survivors all share, are shot in slow-motion on a studio set with unnatural light. For visions, this works well but seems odd when used for the actual collision of dream and reality when characters arrive there later in the plot. The tall, black character (Kareem Abdul-Jabbar) prophesying the end of the world, looms into the camera, shot with a wide angle lens, distorting his features and exaggerating the movement into the frame, so that Larry Underwood recoils in shock. The iconic power of Larry singing 'Eve of Destruction' at the head of a line of dead cars stretching into the distance, works well. Fran singing 'Amazing Grace' while sewing up her father's body-bag, is powerful. The advert for 'Flu Buddy' (seen in passing on a TV ad) can ironically be seen behind Tom on a bench and the long shot of Nick and Tom cycling over the brow of a hill framed by billowing clouds, strives for an epic iconic quality, a viral *Stand By Me*. We see Harold walking through the debris of Los Angeles and it is only from the inappropriateness of the fact that he is wearing pyjamas, rather than any direct editing clues, that we might deduce we are being shown a dream, confirmed when a corpse turns and talks to him. However, there are also some poor shots – the clear dummy falling that is supposedly Nadine, the childish whooping as the men stumble down a hillside (and then cannot get the injured Stu up the relatively small slope opposite), and the final God-like appearance of Abigail over the cots (like Mary at the end of *Kingdom Hospital*) as well as her 'impossible' point-of-view shot as Glen closes her eyes after death.

The film ends with a *Wizard of Oz*-like return 'home', and the final drama of Fran's baby, which miraculously survives infection, symbolizing hope for the future. Stu is still advocating blind faith in God but Fran's question resonates more strongly – 'What do we do all this for?' and her answer to whether people can change, 'I don't know'. Good has defeated evil but only through many unlikely coincidences, much sacrifice (the montage of dissolves feels like a war film credit sequence), and a blind faith in a God who often seems indifferent to human suffering.

Storm of the Century (Craig R. Baxley, 1999)

Storm of the Century, is King's first attempt at an original mini-series (*Golden Years* was planned as a full series and *The Stand* and *It* were based on his novels). His involvement includes roles as executive producer, scriptwriter and the obligatory cameo (featured as a money-grabbing lawyer in a TV commercial). It represents a watershed in the expense of a mini-series and represented the height of King's stock as a key part of ABC's production and scheduling. Like *Dolores Claiborne*, the action is set in the same claustrophobic island community, like *The Mist*, the store is the centre of community, here held hostage by something that manages to infiltrate them, and as in the novel *Under the Dome* (Stephen King, 2009), the appearance of a supernatural element is the catalyst for a power battle for the will of a community, played out in human and religious terms, rather than understanding the nature of what the Other is and really wants.

The plot fails to cohere in places. The choice of the island as a target because the inhabitants 'know how to keeps secrets' is not very convincing as this would only make sense if the source of evil, Linoge (Colm Feore), seriously had to worry about concealment. The pseudo-Biblical nature of his gnomic utterances, such as 'Born in lust, turn to dust / Born in sin, come on in', obscures their non-sensical nature, since, for example, Martha (Rita Tuckett) the first victim, does not seem guilty of anything. The TV is promoting a video of extreme weather, under the title 'Punishments from God', which works as a Balladian comment on catastrophe-as-entertainment, but if the events of the film are some kind of divine judgement, it is not clear for what. The ones who suffer most are the most blameless. When one of the locals assures Michael that 'God takes care of his own', it is not entirely clear that this is so. Later Michael paraphrases God's explanation to Job about suffering: 'I guess there's just something about you that pisses me off'. A first person voiceover by Michael Anderson (Tim Daly) intones the moral at the beginning ('in this world, you have to pay as you go, sometimes it's a little, sometimes it's a lot and sometimes it's all you have') based on an event from nine years ago, the full significance of which has only just become apparent to him. The full meaning of this frame story is only clear at the end as Michael catches a brief glimpse of his son in the company of his master (perhaps a tad unlikely if they have the complete universe to range over).

The motivation for the opening murder (to get the attention of the townsfolk), is not very credible and smacks more of King's desire for a dramatic opening to the narrative. In the opening sequence around the house of Martha Clarendon, there is an attempt to create suspense by a slow track up to an armchair and fragmented close-ups of tea on a table, an old hand and milky blue eyes. A mysterious figure outside is shot from behind or cropped (we only see feet walking up to the front door) or backlit from the woman's point-of-view when she opens the door. After her walker is flung away and we see the cane used to brutally beat her, Linoge assumes her place in the chair, shot with a blend of the slow tracking shot used for her and the cropped shots used for him. The disparity of a barbaric and apparently motiveless murder with the calm removal of gloves whilst humming of 'I'm a little teapot' or later eating a biscuit as he is handcuffed, is unnerving but is typical of the mini-series in

how its potential effectiveness is undercut by slow pace – he can only be an enigmatic, man of mystery for so long before such behaviour becomes simply tedious. It is only when the self-important town manager, Beals (Jeffrey DeMunn), later enters the house that we have a full face shot of Linoge. After slow tracking shots up to the house and up to his chair are repeated, eventually we have a close-up of the man's face and his eyes opening to reveal jet-black pupils, before the screen fades to black. As with a typical King mini-series, this device which normally conveys a passage of time, does not do so here, just another commercial break, emphasizing further the snail's pace of the plot even after half an hour. We have plenty of repeated low angles of the house, which seems more like a desperate attempt to instil a sense of unease, when none really is generated by the drama. Davey Hopewell (Adam Zolotin), passing the house, sees the open door and we share his slow point-of-view through the house, down the corridor, looking down at a puddle of blood, before reversing to see his shocked expression at finding the woman's body.

Linoge knows things about the boy's basketball ambitions, Beals' dalliance with a prostitute rather than seeing his dying mother, and can make the ball come towards him and turn the TV on by pointing at it (telekinesis) but the exact nature of his powers is never made clear. He can make Pete (Ron Perkins) write, pass a crossword clue to him telepathically, and make Beals 'see' his mother. He can induce suicide (which he does with Pete, one of his guards in his cell; Lloyd Wishman [David Ferry], who performs an axe-version of Frank Dodds technique in *The Dead Zone* and Cora Stanhope [Myra Carter], who drowns herself in a basin of water. There are some similarities with *Sleepwalkers* [Mick Garris, 1992] [a long-lived, creature, with some vampiric elements, looks to continue its line] and a similar lack of explanation about matters of origin and how new initiates become monstrous – we are never told exactly how Ralph (Dyllan Christopher) becomes like Linoge. Like Neo (Keanu Reeves) in *The Matrix* (Wachowski Brothers, 1999), one is forced to wonder why a character does not use his powers from the outset, take what he wants (a child) and leave, which he eventually does anyway. What is crucially different however is that unlike *The Matrix*, punctuated with state-of-the-art action sequences, here we can *only* dwell on plot holes, so ponderous is the pacing.

The steady progress of the storm is shown by progressive penetration through a storefront, repeated shots of the lighthouse, which bears the brunt of the waves as well as several shots of swinging traffic lights (itself a nod to David Lynch's *Twin Peaks*), all of which combine to make the metaphor of urban chaos under 'attack' from the elements, crushingly obvious. If 'Hell is repetition', as Linoge remarks, then watching this mini-series can feel like a hellish experience. There are *six* repetitions of the tracking shot up to Linoge in his chair – from the point-of-view of the omniscient camera, the boy, Beals, and finally Hatch (Casey Siemaszko) and Mike (who also revisits the scene again later). The unseen snarl that Linoge gives in the back of the police van, reveals to us a perfect set of CGI-generated vampiric teeth (top and bottom sets). Later in the cell, the same gesture, using prosthetics, works better but a further example later still looks like he just has bad false teeth. When Mike and Hatch are trying to put Linoge in the backroom of the store and Hatch is momentarily left alone with him,

there are plenty of low angles used for Linoge but a sense of things being odd or off-kilter does not necessarily make them frightening. Like the plot, Linoge himself has no emotional range. Mike loses his temper with him and starts to rough Linoge up a little after searching him and finding nothing. Some of that is the slightly threatening way in which he touched Ralph but it expresses frustration quite possibly shared with the viewer – we too may wish by this time to provoke some kind of drama, some kind of reaction. For this pacing to work we would need a villain who could offer the threat level of Anthony Hopkins as Hannibal Lector. Linoge's tone is nearly always glacial and emotionally uninvolved. When he picks up Ralph, there is little real sense that he will harm the boy. Like John Carpenter's *The Fog* and *The Thing*, we have a community cut off from the outside by apparently-natural but extreme weather phenomenon at the coast but there is absolutely no *dread* evoked here. The only pace change is actually slower. Symptomatic of the difference, Carpenter uses simple note sequences in his scores but whereas his three-note motif is a single note followed by a double, mimicking a heartbeat, Gary Chang here uses just the repeated four-note motif of steadily rising notes. As in *Rose Red*, Chang's work suffers by comparison with Carpenter.

There are a few effective shots. The image that King has mentioned as the inspiration behind the narrative (Linoge sitting serenely in his cell) has some potential to chill as the power goes out and his eyes momentarily glow red, Randall Flagg-style, only seen by Pete. The expectation that the point-of-view that we are sharing during the attack on the house is the boy's, is broken as he unexpectedly walks into shot in the lounge. In Martha's darkened house, Mike takes photos of words scrawled in blood and a bloodied cane, which subsequently both disappear but the attempts at suspense (stumbling around a house in the dark or windows suddenly blowing in) are fairly heavy-handed. Gradually, what the island is facing becomes apocalyptic, in the group's Linoge-induced dreams of mass suicide, posited as the explanation for the disappearances at Roanoke mystery. However, what might be seen as an exploration of Jonestown-style hysteria is fatally undercut by the very obvious blue screen for both the dream sequences and shots of Linoge flying, holding hands with the children, seems more Disneyesque, like a parody of Raymond Briggs' book *The Snowman* (Diane Jackson, 1982) or *Superman* (Richard Donner, 1978).

There are plenty of shots of the wind rising, the snow deepening and references to the coming storm but as an adjunct to the unfolding enigma of Linoge, it does not really crank up the tension as in *The Shining* because here nothing happens and it happens *very slowly*. It beggars belief that it takes several *hours* on screen before Linoge articulates what he wants. Affecting Hatch's computer crossword and getting people to write on walls, is all very well but it does not really show a higher intelligence. When Mike 'interrogates' Linoge at the beginning of part two all he can do is list questions. Where is his cane? How did he get to the island? And most of all, what does he want? None of these are answered. The idea of a prisoner being in control of his captors ('Who's holding who prisoner here?' as Hatch asks) could be interesting but we need to see a purpose in his actions for our curiosity to be engaged and sustained. The idea that Michael understands Linoge is the Biblical devil 'Legion' only through seeing the name spelled out in blocks, strains credibility. The mothers

undergo the choosing of lots with all the certainty of a heavily-rehearsed game show format and the idea that they would not look down at the point of picking a stone or that the black stone is the very last one, is a laboured dramatic construct.

When Linoge says and then writes, 'Give me what I want and I'll go away', this is the language and basic threat of racketeers, not extra-terrestrials. The acquiescence to evil that lurks beneath the surface in Molly Anderson, played by Debrah Farentino (family), Robbie (politician) and even the local Reverend, played by John Innes (organized religion), does suggest the concept of 'evil flourishing when good men do nothing' but the film does not really explore this. Mike asserts 'We don't give our children to thugs' but billed as a dilemma, the decision of whether to offer Ralph up as part of the casting of lots, is actually no dilemma at all. There are some limits to Linoge's power, in the refusal of Cat (Julianne Nicholson) to hurt Billy (Jeremy Jordan), which so infuriates Linoge, he makes her return and kill him but this is not really followed up and by contrast his destructive capacity is clear. Despite Mike's histrionics, to lose one or lose them all, is no real choice. There is more interest in what kind of knowledge Linoge has. Michael asserts 'You only see the bad, none of the good', to which Linoge replies, 'By and large, the good's an illusion, little fables folk tell themselves so they can get through their days without screaming'. Michael can only state 'I don't believe that'. The problem is that Linoge can list endless examples to back up his pessimistic view, which he keeps doing even at the final meeting, revealing closet gay bashers, gamblers and thieves. Small-town law enforcement has few resources, including only a rudimentary cell for prisoners. Mike is the face of local law enforcement and the scapegoat when things go wrong. Several characters at various points note 'that's what we pay him for'. He acts as a convenient focus for community disavowal of the evil within them.

As the name suggests, Little Tall Island is a place of contradictions. There is a claustrophobic sense of a community, which takes an unhealthy interest in the business of others. Mike's saving of a girl whose head is trapped in banisters spreads at amazing speed, concerned locals press up against the glass of Mike's office and there is a lynch mob mentality just beneath the surface of the locals who part to let Linoge be led through the store. Linoge's supernatural knowledge reveals Billy's affair with Jenna (Nicky Guadagni), Cat's pregnancy and abortion, the act of arson by Kirk (Denis Forest) after losing his job at a local mill, Pete's growing of marijuana and Mike's exam cheating. Very strangely, characters only lethargically react to these disclosures, if at all. Similarly, they accept Cat back into their midst with only minor reservations and allow her to take responsibility for the children, even though she has just bludgeoned her boyfriend to death. Robbie Beals, is a representative of a self-aggrandizing small-town politician, but with an amoral undertone as he suggests murdering Linoge. At the meeting called at the climax, he suggests that they will get through this, 'if we stick together like we always have on the island'. However this is really only a veneer of solidarity as the stampede to reach the sleeping children earlier, is still fresh in our memory. Robbie displays casuistry in justifying giving up a child as this is more like 'an adoption' than a 'human sacrifice', as Linoge issues vampire-like promises to

somehow endow the child with a lengthy and varied life. Hatch and his wife agree that if their daughter is taken, they will say she died in childbirth, i.e. they are prepared to create a fiction and believe it to be true.

The mini-series is not totally devoid of tension. In the opening sequence, the long takes and depth of field in both Linoge's approach to the door and the woman's slow walk to answer the bell, are effective. Later, the pan of the room as the adults all sleeping restlessly is quite creepy: 'look at them, all dreaming' as is the kids singing 'I'm a little tea-pot'. The simple effect of suddenly pulling minor characters out of the frame with a whooshing noise one-by-one as if by some unseen force, while watching the lighthouse falling into the sea, works too.

The warning delivered by the vision of Beals' mother, on two separate occasions, that she will 'see you in Hell and when you get there, I'm going to eat your eyes over and over' is quite powerful for network television. There are some little touches of humour too, such as Linoge's dialogue where as he commentates on his throwing of the basketball into the TV screen ('He shoots… he scores'). As Billy is stacking shelves, we can see briefly from his point of view a can in close up, right in front of him labelled 'Grade A Bitchy' with a snake's head logo.

Overall however, the mini-series feels like an *X-Files* (Chris Carter, 1993–2002) episode stretched to six times its natural length. The fault-lines exposed in the marriage of Mike and Molly by her suggestion they kill Linoge and later that they acquiesce to a lottery, including their son, is much more obvious than the similar plotline in *The Dark Half* and there seems a slight nervousness on King's part to wrap up anything resembling a loose end. The consequences for those left is disturbing, not so much because of the child taken but they have shown each other (and themselves) what they are really capable of. Suicides of Robbie's wife and Jack (Steve Rankin), the homophobic attacker, follow but the final moral, repeated from the beginning does not really tally with the film we have spent many hours watching. Hatch and his new wife Molly, do not have to 'pay as you go', the life that Ralph enjoys could be richer than growing up on the island and Mike is left to suffer for a decision he did not make. This is a universe of random suffering, not a coherent philosophy of good and evil.

King talks of 'a mental snapshot' as the genesis for this particular narrative and calls such events 'the true creative mysteries: stories that have no real antecedents'.[2] This is incredibly disingenuous however, as most of his narratives, particularly televisual ones, are often highly derivative. Moreover, as discussed in *Stephen King on the Big Screen*, single static images are not the best starting points for dynamic narratives (as with the abandoned plane situation in *The Langoliers*). Also discussed in the earlier book, a strong vein of literalism runs through visual adaptations from King and this continues here – most of the running time of *Storm of the Century*, is completely dominated by a massively over-extended and crushingly-obvious use of pathetic fallacy. A force is evil is present so a huge storm rages throughout the body of the film, replaced by the calmer epilogue, when Linoge has left the island.

Desperation (Mick Garris, 2006)

There are really two main points of interest in this Mick Garris-directed film: the show-stealing performance of Ron Perlman and the unusual retention of a specific political-religious subtext in the narrative. Perlman, whose massive facial features have been their own special effect in a diverse career from *The Name of the Rose* (Jean-Jacques Annaud, 1986) to *Hellboy* (Guillermo del Toro, 2004), dominates the first half of the film as psychotic cop, Collie Entragian. Unfortunately, when his character then leaves the narrative, so in large part does the viewer's interest. There is some elision between writer, John Edward Marinville (Tom Skerritt) and King himself – like King in 1994, when he first thought of the plot premise, Marinville is crossing the country by motorbike and passing through apparently-empty towns.

Perlman's face, which gradually shows more graphic lesions as the demon Tak sucks the life out of its parasitic host, is often shown in close up using a distorting wide angle lens and held in shot longer than usual. When he first approaches the Jackson's car and then stares into it, an extremely low angle makes his appearance more monstrous still, prompting Mary Jackson (Annabeth Gish) to declare, 'Oh my God, it's Sasquatch'. Garris conveys the sense of a world out of kilter by lingering shot lengths, oblique extreme camera angles and a sense of drift, like the patrol car sliding into the verge and dissonant sound effects like the whisper of helicopter rotor blades as Entragian questions the couple. Instability and unpredictability dominate Entragian's character, from his erratic and aggressive driving, to his facial tic, to killing Peter (Henry Thomas) for no apparent reason. His apparent enthusiasm for meeting Marinville soon tips over into madness, as he pumps the author's hand, strangely shot suddenly from below, stands slightly too close and cites scripture at him. On sneezing blood onto the windscreen, he turns in mock disgust, asking 'Aren't you at least going to say gesundheit?' There is some over-the-top histrionics in the Lugosi allusion to his 'children of the desert [...] what music they make' but there also is some wonderful humour in his manic patter. On learning the name of the husband, he starts to wax rhapsodic, 'Hey, wait a minute. Peter Jackson. I loved *Lord of the Rings*'. In the middle of reading the Jacksons their rights, he interpolates 'I'm gonna kill you', making the characters and the viewer wonder if they heard correctly, like Patrick Bateman in *American Psycho* (Mary Harron, 2000).

The plot is clearly not wholly original, even drawing on King's own works. There are other Stephen King works referenced in *The Shining*'s 'Redrum Dog' message, 'Murder God' in reverse. It has elements of travellers attacked by madmen while passing through a desert area (*The Hills Have Eyes* [Wes Craven, 1977]), an apparently abandoned town is dominated by a demonic god (*Children of the Corn*) and a vampiric creature in a western town (*From Dusk Till Dawn*), the final shot of which is similar to the Mayan-style stepped excavation in the huge pit next to the road. Moreover, there is an underlying problem with the basic plot (one shared with *Storm of the Century*). If anything can happen anywhere at any time, it is hard to create and sustain any sense of jeopardy. We know little of what Tak can do, or why

he is doing it. The initial weirdness of the opening half-hour needs some kind of pay-off or explanation, which never really comes.

The boy, David Carver (Shane Haboucha), is not so much a symbolic Christ figure, as an actual talismanic presence. However, unfortunately Haboucha struggles to convey the charisma of a spiritual leader. We see him praying, preaching and talking about God. He performs minor miracles, sliding through the bars of his prison cell using some glowing, magical soap provided by his dead sister, who he sees in several visions, and later in the theatre, creating enough food for the group 'loaves-and-fishes-style'. However, his knowledge and ability to explain what is going on around Tak and the other characters' willingness to fall into line with what he wants almost immediately, stretches credibility to the limit. Like *It* and *Red Rose*, we have a group coming together to fight a supernatural entity, whose efforts focus on a boy-leader but here groups hugs are manifested in explicitly Christian prayer. After a childhood experience where he prayed for a friend to recover from a car accident, David feels like he has a spiritual debt to repay. However, the boy's sense of a redemptive destiny is misplaced as it is the older writer who must expatiate for his Vietnam guilt in failing to warn of a bomber's imminent attack, and sacrifices himself in an explosion to bury Tak in the mine (in a strange echo of *A Prayer for Owen Meaney* [John Irving, 1989]), which also closes with a sacrificial death, apparently dictated by divine destiny, caused by an explosion and in part to palliate a sense of guilt). The photo album left in their car with pictures of Marinville, David's sister, and a Biblical reference, ('God is love') is a fairly clumsy plot device showing the existence of an afterlife and implying Marinville's sacifice was worthwhile. David's dialogue reaches the heights of sentimentality with 'I guess God thought of everything. That's what makes him God', as if this physical manifestation were needed to prove the existence of a spiritual entity, who should exist by faith alone. Similarly, Mary asked what Tak wants, to which David answers that it does not matter, 'It matters what God wants'. *Desperation* is not a complex examination of Christianity but it does suggest that God is no less cruel or random than Tak. There is a strange blend of a surprising level of gore for network TV (such as a lingering close-up on a dead cop with pencils stuck in his eyes, Mary crawling out of a window onto a pile of dead bodies, and dead bodies in a store crawling with spiders and snakes) and overt Christianity.

There are a few effective shots. As Steve (Steven Weber) and Cynthia (Kelly Overton) look around the mine works, a health and safety sign is held in shot, 'Be careful! Watch Your step. Think!' The media of film itself is highlighted at times to convey narrative information and personal, often subjective experience. So David sees a black and white, silent film (with unmotivated piano accompaniment) about the mine and the accident (with intertitles but smoothly running film) and Marinville sees a feature film of his life (*Viet Cong Lookout*) with its own poster, and theatrical showing in a local cinema. The film-within-a-film motif has been used before by King in *It* but here it is made slightly more ambiguous by the appearance of the little girl before the projection room scene, and her citing of John Ford's advice to 'print the legend', which would suggest the films we see may be only partially accurate.The idea of including the treatment of Chinese immigrants is interesting and does link with Marinville's Vietnam experience, arguably another US exercise in exploitation of

the Far East. However, the film really only does touch upon this in the scapegoating and lynching of the only two survivors from the mine explosion and the opportunity for a more thoughtful examination of the issue is lost.

There are some typical Garris-stylistic signatures – a low-flying helicopter shot across open landscape that crosses a road with a vehicle carrying the protagonists, crane shots up when we approach residences and when roadside scenes end (all used in *Quicksilver Highway*). When the patrol car approaches the town, the helicopter shot shifts to reveal a huge mineworks right next to the road, dwarfing the car and creating a sudden vertiginous perspective. A similar, computer-generated, extremely high, birds-eye view of a vehicle approaching the mine at night, is also used on two further occasions. Tension is rarely generated, symbolized by the characters in the theatre who literally sit around on stage and exchange information. Garris is content to represent the desert with clichéd shots of cactus and punctuate the action with the howls of coyotes. There is never any doubt that David will shoot the dog guarding the jail and even the race for the car between Mary and a zombie-like Ellie Carver (Sylva Kelegian) is highly derivative of a similar scene in *Terminator II*, when the T-1000 momentarily hangs onto the back of the car but is thrown off.

There are some truly ridiculous moments. The lines of animals stretch down the road but most of these creatures look closer to domestic pets than active killers. In the mine offices, Cynthia becomes amorous upon touching the piece of statue, stops when the computer screens blow, and neither character ever makes any reference to these events. The vulture 'attacks' on Mary and even Mr Carver (Matt Frewer), seem ludicrous (as does the fact than no one reacts to his death at all). If Tak has the power to control animals, so that spiders collect around a picture of the cinema to show where the escapees have gone, one might expect something more than an attack by one puma. The ease with which Mary escapes from the shack, having miraculously realized that the venomous animals inside would not hurt her (and unbelievably squashing a tarantula-style spider in her open palm), all weaken this section of the story. The so-called 'Well of the World' looks more like the set from a Sinbad film and like the rest of the underground sequences the condition of the mineshaft, especially the lights, are exactly as they were when it was a working pit. Hilariously, the spirit of Tak cannot enter Marinville as he puts a crash helmet on, which he luckily brought with him. Marinville falls down the well, which appears to have a gradient gentle enough to roll down fairly slowly. As the mine explodes, a minor rock fall of computer-generated images and actual polystyrene à la *Carrie* and *Rose Red*, fails to convince. The film ends with a real sense of anti-climax. After seeing an image of Tak's face drift away in the clouds above the mine, the survivors drive off towards the horizon.

Conclusion

Several of these narratives suffer the same kind of problem that plagues King's film adaptations – the difficulty of manifesting evil, which really is most effective when it is left to the fears of the viewer to visualize. In the case of Entragian in *Desperation* or Pennywise in *It*, it is quite

easy to forget that they are not actually the major focus of evil in these narratives, but merely doing their bidding, as they are more charismatic than the final 'monster' that is revealed (Tak or the unnamed spider creature). Linoge and Flagg both display vampiric fangs for no apparent reason, suggesting King's residual difficulty in visualizing evil that is free of genre stereotypes. Perhaps it is only when evil is humanized, especially when given some wit and charm as well, that viewers can identify more closely with such entities. To attempt to see *Needful Things* as a satire on consumerism or *Desperation* as an exploration of Christ's 40 days in the Wilderness contrives to see profundity in texts that just yield too little substance to support such readings. The clichéd nature of characters designated purely as evil, allows audiences to externalize them as pure otherness and dismiss or ridicule them, rather than feel implicated in their actions.

Notes

1. David Cronenberg, Interview with Linda Ruth Williams, *Sight & Sound*, 3:5 (1993), pp. 30–32.
2. Stephen King, *Storm of the Century* (New York; London: Pocket Books, 1999), p. *vii*.

Chapter 6

Tales of the Unexpected

The imitation lives we see on TV and in the movies whisper the idea that human existence consists of revelations and abrupt changes of heart [...] Such things may happen from time to time, but I think for the most part it's a lie. (*From a Buick 8*)[1]

Stephen King on the Big Screen devoted a chapter to the much-neglected portmanteau films, such as George A Romero's *Creepshow*. Implicit in such films is the recognition that King's short stories have a 'natural' duration when it comes to their visual adaptation, i.e. 30–45 minutes. Where such boundaries are exceeded, narratives tend to resort to action effects or chase sequences (as in *Graveyard Shift* [Ralph S. Singleton, 1990]) or struggle to maintain the pace needed to carry a narrative to 90 minutes. King sees the linkage between his short story work and the TV he remembers from his youth, such as 'Mute': 'reminds me of the poison bon-bons I used to sample weekly on *Alfred Hitchcock Presents*.'[2] However, he seems to miss the correlative of this, i.e. that if a short story equates well to a half-hour or hour length telecast, then adapting longer novels either needs radical cutting or risk losing a sense of momentum. King notes himself, 'The idea always dictates the form,'[3] but ironically seems oblivious to how this relates to the dangers of over-writing.

Quicksilver Highway (Mick Garris, 1997)

If you can't see the black heart of America, you're either blind or a fool [...] I have visited its deepest, darkest areas up close and personal.

(Aaron Quicksilver in *Quicksilver Highway*)

Quicksilver Highway is made up of two separate but vaguely related narratives. Raphael Sbarge plays protagonists in both films (Kerry Parker and Bill Hogan), which is confusing as Kerry only appears for a few minutes at the start of the film and it may seem unclear which character is the victim of the accident at the end of the film, i.e. how far fantasy has bled into reality if the chattery teeth have turned up. Similarly Matt Frewer is both Charlie and Dr George. Whereas in the visions in *The Dead Zone*, this device raises some interesting questions, here it is merely confusing.

The two introductions, which preface the tales, are also a little uneven. The relevance of the 'cautionary tale', 'Chattery Teeth' is not clear, nor the potted version of 'the hook' at the beginning to the bride, Olivia (Missy Crider). If this is a warning about their future happiness, then the 'sin' of the husband is ambiguous. He nearly hits a hitch-hiker but this is due to poor visibility rather then negligence and unlike Annie in the third part of *Creepshow II*, he is not guilty of a hit-and-run. Failing to pick up a hitch-hiker is not a crime and as it turns out, would have been a prudent action. At worst, the giving of a dime could be said to be patronizing and certainly the hitcher refers to Hogan trying to buy off his 'guilt' at the earlier near-miss.

The sense of discontinuity is reflected in the blend of 1965 Rolls-Royce Silver Cloud pulling the Airstream trailer of Aaron Quicksilver (Christopher Lloyd). The trailer, modest on the outside, palatial and apparently Tardis-like, i.e. much larger on the inside, is an interesting place for a tale to be told and allows Lloyd to deliver his explanatory speech while eating strawberries in a grandiose manner. However, the second introduction, in a carnival freak show tent, is more appropriate to a self-styled collector of things and tales. Christopher Lloyd is well cast as the eccentric figure Quicksilver, effectively conveying, like Tim Curry's Pennywise in *It*, an unsettling blend of camp theatricality and underlying threat.

The film opens with Ry Cooder-style twanging guitar and a pan from desert scrub to a roadside breakdown. Garris' credit notes that the script was 'written for television', which partially explains its limited scope and ambition. Garris' tendency to use a slow crane shot, up or down, as the opening shot in a sequence, can be effective but often it looks like an attempt to bring some energy to a scene, which is dramatically inert. He shows us nothing happening by showing us nothing happening. The tale proper begins with Kerry trying to tell his wife that the bad weather means he will not be able to make it home for his son's birthday. The rather obvious wind machine and sound effect, unconvincing though they are as effects, do at least show that he is being honest to his family. The photos and kid's pictures on the dashboard suggest he genuinely misses them.

The strange menagerie of 'Scooter's Grocery and Roadside Zoo' is a reflection of the cancerous proprietor and his menopausal, nagging wife. Hogan is literally caught in mid-shot between the husband wheeling a new animal in at the door and the wife at the counter.

Hogan leaves, walking past an ominous-looking vulture on a perch, stretched out as if crucified. There is some tension as the hitcher threatens Hogan but the knife is tiny and Hogan's counter threat to crash the van would only make sense if he had no family ties or love of life. His willingness to risk death seems unlikely. The subsequent fight in the upside-

down van could have been dramatic but after the opening boot in the face, the pace slows with the hitcher pretending to be bitten, which weakens the potential horror of the actual attack, now seen as just comic and absurd. We do not empathize with the ungrateful hitcher who has smoked when asked not to, stubbed his cigarette out on a child's drawing, riled Hogan by calling him 'label dude', before pulling the knife. We are not really surprised or upset by the teeth's response to his challenge to 'Bite me'.

As the teeth march towards Hogan (seen from his point-of-view) we fade to black and then cut to a tracking shot up the van after the attack, so like Hogan we are deprived of a full view of events. He realizes his belt has been gnawed through and scrambles out. In the distance he can see the hitcher's body being pulled away from him and it is only we who get a closer overhead shot as the teeth drag the body through the frame (like the race with the slick in *Creepshow II*). It is quite a powerfully-horrific moment but more for us than the character who can only imagine what we see. He starts to back off but realizes he has nowhere to run and with the sound of a coyote howl, Garris tilts up to a black sky.

Nine months later, the truck stop is cleaner, the animals (all bar a guard dog outside) are gone, and we see a smartly-dressed Hogan filling up a new van. In clumsy expository dialogue, we learn how he survived and the new owner describes the accident and how supposedly 'animals worked him (the hitcher) over pretty good'. Hogan laughs rather inappropriately, displaying his own prominent teeth, perhaps prompting her memory that the chattery teeth have been found and returning them to him. Myra (Veronica Cartwright) follows him round the counter and gives a very wide grin as well, which could be friendly or fake. Hogan holds them up to his face, like Hamlet addressing Yorick's skull, and with the teeth clear in the foreground and the woman blurred in the light background, it is still not clear whether the teeth are his saviour or a threat. This time when the husband calls home, he promises that he will definitely be home for bath-time and with a saccharine 'I love you, cookie-face', the tale ends. Olivia's immediate question, 'Is there a moral or a point?' may well be echoed by most viewers and Quicksilver's supposedly-enigmatic advice to 'Add your own context' is symptomatic of sloppy writing rather than experimental openness or ironic postmodernism.

The coda of the accident with Olivia's husband being dragged away by the teeth just like the Hitcher was, shows the fiction spilling over into real life, or the prediction coming true, whichever it was. Quicksilver's musing as he watches the teeth waddle away, 'a mountain of dreams and an ounce of regret' is equally unclear. The nature of those dreams, to whom they belong, who feels regret and about what – none of this is resolved satisfactorily. Garris ends again with a tilt up to the black sky in a metaphorical shrug of the shoulders before tilting back down for the second tale.

Pickpocket Charlie (Matt Frewer) is followed via Steadicam as he swiftly steals a range of valuables at a fairground. After some verbal sparring with Quicksilver, he is drawn to the 'Hand of Glory', shot in blurry foreground with flames coming from each finger, which motivates the following tale. We see Dr Charles George in a low angle, rapid reverse tracking shot, conveying a powerful, successful and confident persona, next to which an attractive

female assistant with an unfeasibly short skirt is scurrying to keep up. The furnishings of the interiors of this clinic are closer to a 5-star hotel and reflect the wealth of the clients and the medical staff. Despite advising a client against a sixth facelift, he is bullied into agreeing until his thumb appears to act independently, involuntarily striking the woman's face. In the operating theatre, (also staffed by Garris and fellow director John Landis in cameo roles) he flings a scalpel across the room, provoking an anaesthetist (Clive Barker) to remove his mask, and remark, 'What have I ever done to you?' Ludicrously, no one else reacts.

His hands take on more and more a life of their own, flicking the steering wheel, slapping his wife's backside and later drumming in the foreground in the bath and at a therapy session. Arriving home, his wife addresses him from a sweeping staircase, that 'You'd better leave, my husband's going to be here any minute' an odd joke/seduction line, followed by a parody of *The Shining*, 'Honey, you're home'. Lying asleep, his fingers start to communicate over his chest, with their 'dialogue' on voiceover. This may seem odd but is not really scary (unlike Danny's finger dialogue in *The Shining*).

Garris' camera rises up, making Dr George appear small and powerless but the philosophical power of the idea, the body at war with itself, is never really fully articulated. Dr George is also aware of what is happening, unconvincingly interpreted by his therapist as 'symbols of parental power' but whereas *The Fly* (David Cronenberg, 1986), which also explores the bodily dissolution of an individual who is acutely aware of the process, seems moving and tragic, here the lack of depth of Dr George's character and warmth in Frewer's betrayal, means we just do not feel this as a lived, existential dilemma. The basic idea is not original – a hand with a life of its own is a horror subgenre all its own, as seen in *The Hands of Orlac* (Robert Wiene, 1924), remade by Edmond T. Greville in 1960, and as *Mad Love* (Karl Freund, 1935), *Body Parts* (Eric Red, 1991), *Severed Ties* (Damon Santostefano, 1992) and *Idle Hands* (Rodman Flender, 1999). However, Clive Barker's conception in his short story 'The Body Politic' (1985) is quite different to previous uses of the trope. He is not interested in reattached hands of killers but of the body at war with itself. The logical extension of viruses and immune systems could be that entire limbs long for separation and independent life. True monstrosity, in this version of body horror, is not some strange 'other' external to ourselves but our relationships with our own bodies. Rather than expressing some pure libidinous, destructive impulse, Barker's hands work *together*; they organize and rebel against their masters.

After George strangles his wife, the narrative speeds up and there is an effective (and bizarrely comic) scene, where he tries to use the phone and his hands will not allow him. However, such set-pieces are closer to a mime act, which cannot be sustained over several scenes. En route to the kitchen, Frewer is clearly *pulling himself* along on a little trolley. In chopping off a hand, the film irrevocably changes into absurd slapstick rather than the surreal parable of Barker's short story. The computer effects lack the visceral credibility of high-quality stop-motion animation. What is horrific on the page – the climactic vision of a tree full of hands, appears just a mundane CGI image. There are some small touches of humour which do work, like the hand scurrying out of the cat-flap or the shot of a security

guard being dragged by a hand down a corridor, shown on his own surveillance camera and particularly the low angle of Frewer standing up over his remaining hand and threatening it, 'And besides I'm bigger than you'. However others, such as the 'conversation' between Dr George's remaining hand and the severed one running about on the driveway unnoticed by emergency vehicles, just seem laughable.

Using the language of an ungrateful spouse, Dr George asks his remaining hand 'What could you possibly want that I don't give you?' to which it answers (and can now apparently be heard) 'Freedom'. The 'chase' up to the rooftop has no real dramatic tension and the Pied Piper motif of the hands launching themselves off the roof in long shot like lemmings, seems ridiculous. The cutting of the falling hands breaks continuity rules like the divers in *Olympia* (Leni Riefenstahl, 1938) but to what end is not clear. There is a kind of surreal beauty to the view from the top of the building of the body surrounded by hands and the foley 'squelching' sound may work for the falling body but the hands just look like what they are – rubber. The closing image of the girl cutting off her rebellious twitching nose just does not work – we all may feel our hands as strangely independent at times, used intrinsically in all face-to-face communication but our nose just does not function in the same way. Again, Quicksilver sidesteps the question about the point of the tale, implicitly recognizing its inherent weakness. Charlie walks out only to be arrested as his hands act apparently on their own attempting to steal from a cop. Again, Garris tracks back and tilts up to the black night sky, in a very low-key ending, which feels plain weak rather than purposely open or anti-climactic to be thought-provoking.

On several occasions, King declared the future of horror fiction to be Clive Barker.[4] Barker's 'The Body Politic' is certainly one of his most resonant short stories from the *Books of Blood* collection (1985) but without the written narrative's political/metaphysical dimension, what was creepy and uncanny and genuinely disturbing, becomes purely ridiculous and special effects-driven. More than removing unwieldy background matter (as in the case of *Salem's Lot*), literally, shorn of its politics, the title would be just 'the body', which is what we have here.

Nightmares & Dreamscapes (2006)

Umney: What are you, a horror movie guy?
Landry: I'm a literary guy.

The opening credit sequence of *Nightmares and Dreamscapes*, suggests that each tale takes place in a room in a house, giving them a sense of coherence but these images are contrived, pasted into the setting. However, despite the title, not all the eight tales featured come from this volume of King short stories. 'Autopsy Room 4' and 'The Road Virus Heads North' appear in *Everything's Eventual*. 'Battleground' was first published in 1972 and features in the *Night Shift* collection but perhaps it is only more recently that special effects technology

(for example, for *Toy Story* [John Lasseter, 1995]) and particularly *Small Soldiers* [Joe Dante, 1998]), has made a visual realization credible. There are six different directors (Rob Bowman and Mikael Salomon, who previously worked on *Salem's Lot* [2004], both direct two) and although there some common elements like Jeff Beal's music, there are few similarities between tales, which vary in quality (as indeed do their written sources). All episodes are shot on location in Australia, which mostly works fine except for the light and the accents when it is supposed to stand for Britain in *Crouch End* but that episode is so flawed in other ways, few viewers probably notice.

Battleground (Brian Henson)

The script, by Richard Christian Matheson (son of the author of the seminal *I am Legend*), is a very carefully-crafted piece of work. It is a real *tour de force* for William Hurt, who as Jason Renshaw is virtually the only human character, occupies screen-space for most of the running time and yet is given absolutely *no* dialogue. The film presents a series of scenes where he might say something but then has a reason not to, such as the unsettling cutting between a close-up of Hurt and a grinning toy poking out from a rucksack, which realistically seems to invade his personal space on a rising elevator. This extends to the few other characters – The toy designer, Morris (Bruce Spence), who appears to live above his factory, in an apartment peopled with his own creations, like a more homely J.F. Sebastian, has tears in his eyes in looking at a favourite doll and later appears to be meeting his fate with fortitude until his composure breaks and he begins to blubber. There are direct references to Matheson's senior's short story 'Prey' (Trilogy of Terror, 1975) in the basic premise of toys hunting a character who is trapped in an apartment and more precisely, the fetish doll that is momentarily glimpsed in Renshaw's glass case.

On the DVD extras, Hurt mentions recording animal movement as preparation for the role, which may seem excessive but in the climax we see elements of a cat-like body positioning as he leaps down from the ledge, an apish roll in his gait and a primal roar he gives at destroying the jeep. The concept of sliding down the evolutionary ladder as he fights for his very survival, is pertinent, if not immediately obvious on first viewing. He manages to maintain a solid, bullish-looking jaw throughout and has to use other facial expressions and body language to carry the narrative. In an ostensibly special effects story, his face is the main effect. On the plane after the 'hit', a woman mouths 'gum' to him. At her touch on his arm, a piano chord signals shock and then his initial glare is like an unexploded bomb. The woman tears up at the brief sight of the doll in his bag, ironically suggesting hidden sensitivity for a child, and then after holding the gum for a few moments, he passes it to her and delivers a long 'don't-bother-me-again' stare. He even outstares the green Morris toy on the lobby desk, which seems to offer a reproach in its cheerful look.

Moments such as when he is charmed by the ballerina figure or when he later puts it in his case ambivalently shift between suggestions of a man with hidden sensitivities and a

psychopath collecting trophies from the scenes of his crime. His later off-camera chopping up of the remaining soldiers, spearing one on a kitchen knife and sadistically watching it wriggle or the use of the lift doors to decapitate the final commando suggests the latter.

In Cronenberg's *A History of Violence* (2005), released the same year, Hurt also plays a killer but with dialogue that facilitates irony, wit, and an impressive Philadelphian accent. Here, back-story and character is conveyed by action, gesture and *mise-en-scène*. Renshaw's ordered, glacial bachelor-pad with its indoor and outdoor pool, oozes a distinctively male sense of control and perfection also reflected in his own clothes in stylish, dark material. The entrance security system, which shows a girl holding up a parcel for him, is suggestive of a Howard Hughes-style recluse.

As soon as the 'Jungle army footlocker' hits the ground, the film shifts into an updated blend of 'The Ledge' and 'The General' from *Cat's Eye*. As in the latter, Hurt makes his way out onto the balcony and must contend with wind, side and top shots showing the cityscape and the vertiginous height respectively, and third parties trying to make him lose his balance. The gunfire may crackle like indoor fireworks but after some *Critters*-like searching of curtains, the remainder of the episode becomes a pursuit and a fight to the death. Rapidly he starts to use realistic combat tactics (using the shaving mirror to see round corners) and the strafing of the sofa and the stomp on fleeing soldiers shows him as a ruthless killer but even his hard-bitten character just stares at the approaching helicopters in disbelief until one buzzes his head, cutting it.

The onboard point-of-view from the helicopter, alongside the gunner or through the windscreen or outside shots pulling back into the helicopter, adds to the sense of a real battle, juxtaposed with more surreal elements, like Hurt's bundling of one helicopter into a towel, which he then proceeds to stamp on (evocative of Gulliver's fight with giant wasps), flush down the toilet and drop a hairdryer upon. The closer shots of the soldiers, when played by real actors in masks and surrounded by 'rubberized' props, look like a1950s monster movie with only the mid-ground in focus, and still lack a sense of reality. Ironically, the slow-motion crashing helicopter and particularly the jeep, are models, literally. The close ups of the final commando make him look Hulk-like and means the battle, especially his march up Hurt's chest, seems more cartoonish than earlier (perhaps natural from director Brian Henson, co-CEO of the Jim Henson Company). That said, for the most part there is not the reliance on scuttling movement that we find in the *Puppetmaster* (David Schmoeller, 1989) or the clumsy puppetry of *Cat's Eye's* troll.

To paraphrase the Dirty Harry line, in all the excitement we might forget the exact number of combatants and weapons that Renshaw is up against. However, the final revelation of the 'bonus surprises', as the sticker peels back to reveal an extra commando and a 'thermo nuclear weapon' (to scale), provides a satisfying twist (in both original story and here). Clearly, there is a moral tale here – the killer of a toymaker is himself killed by some of the man's own creations, mysteriously sent by the victim's mother. How she knows who is responsible is unclear and why she is visualized as a tongue-in-cheek Elizabeth II-look-a-like, is also left unresolved.

Crouch End (Mark Haber)

It is no wonder there are no endnotes for this in King's collection. It is hard to find any redeeming features of this episode. It is like an English *Children of the Corn* – without the children or the corn. Lonnie and Doris Freeman (Eion Bailey and Claire Forlani) are newlyweds, taking a London honeymoon, and manage to get lost trying to find the mysterious village Crouch End. Where Barker *shows* the underbelly of urban decay (as in the 1985 story 'The Forbidden'), King only talks about and around it. English stereotypes are juxtaposed with completely implausible characterization (taxi drivers offering spontaneous explanations that this village is supposedly a 'thin spot' between our world and a parallel dimension), non-existent narrative momentum and truly ridiculous attempts to make the plot a horror story, such as Lonnie's consumption by a three-headed monster, that appears out of nowhere. *Deliverance* (John Boorman, 1972) or *Last House on the Left* (Wes Craven, 1972), this is not.

In the credit sequence, a chocolate-like substance drips from the eyes of a statue but this plays no apparent part in the tale that follows (unless this is the 'monster'). It is rather optimistic to expect viewers to be scared (or even interested) by a character who goes through a hedge after hearing groaning sounds and glimpsing a hole in the ground, even if this sequence does feature the single interesting shot, (a top-shot of the hedge) in the entire episode. However, this is not Narnia. The setting simply does not support the metaphorical weight heaped upon it. The swirling effect of an apparent vortex in a railway tunnel evokes the 'Day of the Daleks' series of *Dr Who* (Paul Bernard, 1972), which was genuinely unsettling, and the idea that beneath an apparently benign village green lurks something darker has also appeared before, in an earlier *Dr Who* series, 'The Daemons' (Christopher Barry, 1971). Shooting sequences that derive from, or have some association with, this other dimension in sepia tones (apart from the obvious red phone- and pillar-boxes) and using a constantly roving camera, oblique angles, wide angle lenses, crash zooms, an expanding iris as the taxi first pulls up in Crouch End – all of this only serves to highlight the complete redundancy of plot or tension. A couple are lost – that is all. They stand, bickering at a crossroads, for what seems like an eternity. Doris' glimpse of some bikers, who momentarily appear to have sprouted some werewolf-like whiskers or a newsstand proclaiming '60 Lost in Underground Horror', is neither involving nor unsettling.

By the time we have the narrative spoon-fed to us by the taxi-driver about the Druid town of 'Slaughter', we have already reached a state of parody. Lonnie's cringingly unfunny routine as 'Lonnie the Creepslayer' (which is actually no more ridiculous than the film that surrounds it), the implausibility that they never consider knocking on anyone's door and the completely out-of-place incidental Indian music, only leads to the end of the frame story, where Lonnie's soul supposedly turns up in a cat with a CGI-enhanced glowing red eye.

Umney's Last Case (**Rob Bowman**)

This is the real jewel in this collection, blending April Smith's intelligent script with a show-stealing central performance by William H-Macy. As in King's original story, the first act is deliberate pastiche. The opening shots (featuring a breathless femme fatale, in hat, furs and heels, in silhouette) looks initially like we are in a classic film noir, especially with *The Maltese Falcon*-style shadow showing Umney's name and profession. However quick-fire, Chandleresque, staccato dialogue is soon complemented by a visual style, which is not aspiring for a complete noirish look but something a little brighter as seen by the décor of Blondie's, shot through with a hazy sunshine and dominant colours are light browns rather than out-and-out chiaroscuro shadows. The ambitious wide shot across the street scene with precisely-crafted mattes provides a fake backdrop above the roofline. Clive Umney (Macy) is surrounded by the visual icons of noir but his character is much more upbeat, such as declaring that bad guys do not always win 'because there's love'.

Macy is extremely good at playing little guys with large-scale, heroic impulses, such as Bernie Lootz in *The Cooler* (Wayne Cramer, 2003), defusing the opening overdramatic threat of suicide with a blend of razor-sharp charm, Holmes-like deductive genius and Bond-like cool, holding up his hand to catch unseen, trousers thrown from behind him. Like a standard noir hero, he goes home, walking into a darkened room before putting on a table lamp, fixing himself a drink and staring moodily out of the window. However, we also first see him literally with his pants down, chasing his secretary around the desk and then we see him sleep alone in his vest after looking longing at the dancing couple next door, accompanied by a melancholic modern flute score. As a literary creation, he reflects the mores of his creator, Landry who blends noirish surface features with a later twentieth century sensibility closer to that of his own character. This sense of a fractured character projection is glimpsed in the shots of Umney looking at his neighbours through a window made of opaque and patterned panels, distorting his features momentarily like the reflection of Richard Dees in *The Night Flier*.

The clichés do not only appear in language ('Run away to Mexico with me. We belong together') but in actions too. In the lift, Vernon (Harold Hopkins) shouts a warning, 'Look out, he's got a gun', that seems as literal and unlikely as the imminent arrival on the scene by the police to haul the bad guy away, allowing the hero to stroll off unhindered. Later, in Blondie's, where he is trying to protect the waitress from a 'hophead' called Dillinger, Umney is peppered with machine-gun fire but hits the bad guys with two single shots.

However, there is a growing self awareness of the plot's own absurdity, from Vernon's picture of Jesus next to his wife dressed up for the rodeo to Macy's command to the girl to stay under the table during the shootout, which is also 'obeyed' by the camera as the gunfight is played out in sound only. The kid's cynical and abusive reaction to Macy's sunny optimism marks a change in the fabric of this world and gradually with the 'cancellation' of a setting, (Blondie's, now clearly all boarded up, where we saw him the day before), we should be aware that the narrative is beginning to show things which are, as Macy murmurs

'impossible'. The cartoonish dialogue works from Macey's absolutely straight delivery, which makes his dawning awareness of his precarious existence both credible and tragic.

Like Truman Burbank (Jim Carrey) in *The Truman Show* (Peter Weir, 1998), he slowly becomes aware of something not right in the predictable fabric of his life; that he is part of a fiction. More than Truman however, like Rachel in *Blade Runner* (Ridley Scott, 1982), he realizes credibly quickly (since we have seen he is a good detective) that he personally is also a fiction. The awareness of the fragility of existence and that what characters had believed was theirs and unique, to be shown as owned by someone other and mass-produced, produces a sense of tragic pathos. The *Blade Runner* example is particularly pertinent since Sam throws quick-fire questions at Umney, particularly about his parents in a Chandleresque version of the Voight-Kampff test (which itself is ironically administered in surroundings more darkly noirish than this film), especially in the light of Vernon's upcoming 'retirement'.

Whereas in *Misery*, where a crazed fan does not want a character cancelled and *The Dark Half* where the pseudonym does not want to be erased, here there is more coherent dialogue between creator and created. In particular, the scenes with the two men together shows Sam, the author, thinking aloud and Umney, having been established as a rounded character (in his world at least) can respond in a more interesting way than George Stark. The morphing of Sam through his different characters is the only, and in some ways the weakest, point in the story, which is generally subtle enough to avoid such literalism. There is humour in Umney's assessment of Sam's appearance, based on his sneakers that make him look like Boris Karloff and carrying his brains around in a case (his laptop), that he must be a 'horror movie guy'. The convergence of Sam and Umney grows closer as Sam starts to type the dialogue, actions and feelings of Umney at that very moment, making his legs sag beneath him. Sam claims the lottery win of the news-seller, the lack of a dog barking next door and Blondie's closing, were all 'clues' to let him down gently. In an obvious pathetic fallacy, a storm is raging as Umney goes home, only to find his neighbour dead, killed off by Sam, who appears again as an initially shadowy figure in a chair in the corner. He admits using a Chandler influence (the lawyer in *Playback* [1958], Chandler's last novel) but calls it a 'homage'.

We see in flashback the drowning of Sam's son, filmed mainly in slow-motion reaction shots and Linda, his wife suggesting he swap places with Umney as a way of avoiding having to face up to the loss. The death of his son does create some empathy for Sam but he also seems pretty heartless, writing the torture of his younger sister to force Umney to accept the swap idea. His wish to be a private detective seems more like a naïve childhood dream, 'to live in a world I could understand. A world where sweet boys don't drown and husbands and wives don't stop loving each other'.

Perhaps unwittingly, King is drawing on the same technique used by Vladimir Nabokov in novels like *Invitation to a Beheading* (1938), where the hero becomes aware that he is only playing a part (Umney declares to Vernon, 'you're supposed to be here, right here, on this stool') and is are simply 'cancelled' by an author apparently bored with him. In

cinematic terms, the concept of a character discovering he is inhabiting a fictional world has been realized before, as in John Carpenter's *In the Mouth of Madness* (1995) and the notion of subjective fantasy having a concrete reality can work if not pushed too far, like *Solaris* (Andrei Tarkovsky, 1972), which *closes* with the image of a floating island of the protagonist's imagination. Either bravely, or foolishly, King's narrative goes beyond this point and considers what might happen next. The role reversal is only partly successful. Clearly the noirish man of action is more at home in the brutality of late twentieth century America than the more sensitive Sam, dealing with predictable adultery cases. The problem is in the mechanics of the switch. Pastiche character he may be but we might expect Umney to show some shock at being met by his doppelganger, whom he recognizes straight away. In *Big* (Penny Marshall, 1988), supernatural intervention and the generic flexibility of a family comedy film, allow some suspension of disbelief. Here, establishing the seriousness of the idea from the outset only underlines the leap of faith that accompanies the switch of identities. We cut from a close-up of an Enter key to Macy appearing in a green-coloured pool and with green eyes to match until both turn blue.

Umney-as-Sam, still sporting the same moustache, uses the same speech patterns as before which seem oddly out of place yet welcome to Linda (Jacqueline McKenzie), who shows no shock or concern at her new husband. She, rather patronizingly, assumes that he did not have irony in his world, to which he replies 'Talking uppity in order to sound smart? Yeah, we had it'. Whereas Umney-as-Sam adapts, sporting a Hawaiian shirt and peering curiously at the microwave, Sam-as-Umney has to practice his tough guy pose, rehearsing his macho phone technique, shown in small jump cuts. The two worlds converge as Linda dresses as a femme fatale in a vampish, red outfit and Umney-as-Sam begins to wears jeans, trainers and shows an interest in Sam's laptop. Despite Umney's womanizing, chasing the pool-girl around like the secretary earlier, Linda still prefers him, mainly for his decisiveness, although this still does not prevent her from suicide (shown with more subtle restraint, cutting to shattered glass on the ground, than the same method and the same low-angle windscreen shot in *Carrie II*). Unapologetically, he explains that his nature is 'Never going to change [...] this is how it's written'. A fictional character can apparently accept his fate better than an introspective writer, given to indulge naive fantasies, who finds that two-dimensional motivation of his clients may not be quite as fulfilling as he thought. Umney starts to use the laptop, vowing to pursue Sam, creating a sense of potential eternal return, a little reminiscent of the ending of 'Something to Tide You Over' in *Creepshow*.

The End of the Whole Mess (Mikael Salomon)

King's fairly brief and apocalyptic story is fleshed out through the lives of brothers, Howard and Robert Fornoy (Ron Livingston and Henry Thomas). The whole concept of the hour-long story shot in real-time as the final hour of Howard's life in a piece direct to camera, recording Horatio-style how the end happened, works well, especially with the occasional

loss of composure (nerves at the beginning, correcting himself; the effects of the self-administered drugs at the end). Howard's video record becomes a virtual real-time piece, with a *DOA* element as he implies he only has about an hour to live.

Lawrence D. Cohen's script works at ways to make a fairly short written account, fuller and more visual. As a contemporary means to record family experiences, as a motivated tool for his character and a way of cropping the sight of Robert, just off-camera, until the denouement, the home-made video provides the logical means for Howard to tell the story. We have captured images on-screen, some pasted scrapbook-style of Howard's mother at Brown's University and computer screen-style of his father's place of work. The montage sequences of Robert's prodigious development contain some humour such as the birth itself with a mad father shining a light in the woman's eyes, Robert's Da Vinci-style plane and his mathematical ability (even if someone else's arm is writing on the whiteboard for him). Additional Twin Towers references (better for the lack of direct images, which sadly have lost some of their ability to shock), also update the plot from the original short story. Howard admits halfway through that he killed his brother but we do not know how or why until nearer the close.

Rather like *Dreamcatcher* in reverse, Robert's idea is to use water to save mankind. The ironic, and indeed tragic, twist here is that the technology that escapes control is developed for purely philanthropic motives. The idea of global catastrophe is really a premise requiring more time, as in *The Stand*, but here it is told in strictly personal terms. This metonymic idea, using the part for the whole, mostly works well. So we see Robert several times from low angle, receiving the cheers of a ticker tape parade, the concentric circles spreading outwards from a map and a reporter starting to slur her words, as symptomatic of the wider world. The final cliché of your life flashing before eyes is literally a summary of the previous hour and although the concluding 'flying' image hand-in-hand with his brother is overly sentimental, the final bleak shot of a video camera with its battery running out, is still powerful for mainstream US TV.

The Road Virus Heads North (Sergio Mimica-Gezzan)

This story, which is a fairly workmanlike adaptation, with little to either enthuse about or dislike, suffers from being preceded by the more persuasive *Umney's Last Case*. Here, it is impressed upon us by Kinnell's doctor (Chris Haywood), shot in slightly sinister, backlit two-shot, reducing both men to silhouettes, that 'writers control what they do' but 'medicine's different – we're accustomed to a significant degree of chaos'.

There are flaws, in both King's story and this version, such as the concept of a metaphorical pursuit (his likely colonic cancer) being reflected in a physical one – both why an idea should assume physical form and why this should then act murderously on third parties unrelated to his disease, is just not convincing. The dialogue supposedly clarifying that Bobby Hastings represents 'your fear, I'm what you don't know', does not explain why he should grow vampiric teeth and even Kinnell's attraction to a picture, which appears so

overtly sinister from the outset, seems unlikely too. Furthermore, there is the feeling, that as his Aunt Trudy (Marsha Mason) advises him, in the words of *Shawshank*'s Andy Defresne, he should 'get busy living'. The top shot, showing a group of rabid fans swarming round Richard Kinnell (Tom Berenger), rising up through the stairwell of a luxury hotel, suggests the confinement and encirclement he feels in his professional life but linking his situation (as a famous, successful writer, albeit possibly with an illness) with a troubled youngster's artistic failure and suicide, seems self-indulgent. The concept of a picture changing and moving (also used in a photo in King's short stories 'The Sun Dog' [1990] and 'Stationary Bike' [2003]) but not when looked at directly has the same weakness as the hedge creatures in *The Shining* (1997) and highlights the strength of the moving picture effect in *It*. The film descends into low-budget slasher with dry ice, shots of feet moving through a house in darkness, and the anti-climax of Kinnell announcing a little like Captain Oates that 'I'm going outside, I think'. This may be from the original story but viewers might well feel left wanting a greater sense of resolution.

The Fifth Quarter (Rob Bowman)

In updating a pirate movie motif, Willy and Karen Evans (Jeremy Sisto and Samantha Mathis) pursue pieces of a map, showing where 'treasure' is buried, ultimately discovering it (somewhat unbelievably) in a literal treasure chest in a theme park. There is some subtlety in the relationship of Willy and Karen, who do not speak immediately after sex, exchanging almost a hand-shake rather than anything more intimate. Willy projects this unease onto their trailer-trash surroundings but a hollowness lies at the core of their relationship, which he is prepared to jeopardize without any thought. The idea that he is actually not such a nice guy and is not as forgiving about Karen's arrangement with Barney (Christopher Morris) as it seems, could be interesting but beyond shooting his adversaries, often rather fortuitously (Willy accidentally shoots him right in the face), little is made of this. There is the suggestion that Willy shares more with Barney than just a cell (Karen queries earlier how he managed through a seven year stretch), a potential allusion to a gay relationship, which she understands and forgives.

There are stylistic inconsistencies. The interaction between criminals seems rather unlikely, Kenyon crying after being shot and Willy, supposedly worldly-wise, allowing Keenan (Peter O'Brien) and Sarge (Christopher Kirby) to stand at 180 from each other when he is 'covering' them with the gun, seems unlikely. The in-car sequence with Willy and Sarge, looks exactly like what it is – a mock-up in a studio being gently rocked. There is a dramatic high-angle shot with a distorting wide angle lens, as Willy draws up to Sarge's house, with house, trees and full moon in the background, bathed all in green but like the occasional use of jump cuts that only advance the action by a microsecond, the intention of such devices is not really clear, other than drawing our eye to a director's presence rather than following Willy's pursuit of the map. We are left expecting more from an ending which

just ends. The 'treasure' would allow Karen to break away from financial dependence on her weak husband. In a sense, she is the fifth quarter, having demonstrated more strength in 'standing by her man' despite repeated disappointments over many years but beyond trying to explain why she briefly 'sought comfort' with Barney, we do not really learn much more about her and why she stays with Willy.

Autopsy Room Four (Mikael Salomon)

This episode opens with a shot of a cloudless, blue sky, which then becomes framed by a body-bag as we realize that we are inhabiting the point-of-view of a corpse. As a metaphor of a fairly bleak world-view, emphasizing our ever-present mortality, this could work but the problem is, this plays more for laughs. The same shot, in reverse-angle, appears in *Hot Shots* (Jim Abrahams, 1991) as Jim 'Wash Out' Pfaffenbach (Jon Cryer) asks if he will make it, is given a consoling reply from a doctor, at which point we cut to him being zipped up. This episode is a good example of one of the fundamental problems of adapting literature to film. King's story is told exclusively from the point of view of Howard Cottrell (Richard Thomas), an autopsy patient unable to show any signs of life. As such, he is able to create a growing sense of panic and dread as we are only allowed one point of view, which is both personal and powerless. On screen, we have objective shots of the morgue, the golf scenes and a few love scenes with his wife/girlfriend (added from the original story) inter-cut with occasional point-of-view shots from Howard (not actually possible, since his eyes do not register any images). Film's only recourse in this situation is voiceover and here the full weakness of that is illustrated by Thomas' lack of emotional range. His constant wittering and incredibly literal rhetorical questions ('What's happening to me?'), may actually seem unintentionally funny, so that we might well empathize with the disrespectful Rusty (Eddie Ifft) rather than the humourless Dr Peter Jennings (Robert Mammone). Moving pictures require the one thing he cannot do – move. Far from the short story's claustrophobic point of view, which we are forced to share, here we too are looking at a body on the slab.

As a very short film, this might work – over an hour, it rapidly becomes tedious. The series of obstacles in King's narrative, which create tension, raising the hope that life will be visible (checking the wound, measuring temperature, signs of bleeding) happen in an impersonal, serial manner and become simply ridiculous, such as Dr Katie Arlen (Torri Higginson) and Peter pausing to kiss just before an incision is made. The idea that a professional pathologist would spend the best part of an hour prevaricating before beginning a post mortem or the speed of Cottrell's recovery, sitting up and talking at the end, both beggar belief.

On the DVD extras, Thomas mentions a similarity with Poe in terms of a relentless single view of a situation, which is fair but it is the intensity bordering on mania of his delivery which makes this particularly telling. He mentions *The Pit and the Pendulum* (1842) and *The Black Cat* (1845) but not the clearest precedent, *The Premature Burial* (1844).There is some

quirky humour in the old doctor on the golf course, who is so frail himself that he has to be carried to Cottrell's body and then puts a wad of bills under his nose with a metal clip to see if he is breathing, asking whether it would make any difference if he 'made it a hundred'. The humour climaxes in the epitome of social embarrassment – an unwanted erection, actually saving Cottrell's life (and possibly his marriage).

However, the only scene of any cinematic tension is the additional scene of Rusty being accosted by a CGI snake in the lift – the perpetrator of Cottrell's now-not-so-mysterious condition. Even here, the full possibilities of being in a broken-down lift with a poisonous snake *in the dark*, are not taken up. The lights come back on almost immediately and the scene only seems to be added for reasons of exposition about the snake – a lost opportunity dramatically.

They've Got One Hell of a Band (Mike Robe)

The problem with this narrative is that, like *Crouch End*, really nothing happens. There is some social commentary about masculine pride in stopping to ask directions and the common experience of getting lost whilst driving and disorientation, leading to mutual recriminations and rows but basically, a couple, Mary and Clark Rivingham (Kim Delaney and Steven Weber) get lost, drive into a town and cannot leave.

Like *Crouch End*, most of the so-called 'tension' is extremely contrived and ultimately empty. A truck grille appears in extreme close-up at the beginning but this is not Steven Spielberg's *Duel* (1971), a boy jumps past them suddenly at the diner on a skateboard but without any real sense of threat and Mary's momentary glimpse of herself and her husband looking like their parents, is not a perception special enough to be interesting. Despite the budget spent on creating a fake town, which does have a look of unreality (this really should not be difficult with a stage set), the script simply does not have enough jeopardy or substance to make it interesting. It may look like a town from *The Twilight Zone*, as Mary notes, but that is really the only similarity. The presence of a series of look-a-likes, in US culture especially, the land that gave the world the theme restaurant, is not in itself scary (any more than Jack Rabbit Slim's in *Pulp Fiction* [Quentin Tarantino, 1994]). A town with only a tiny number of inhabitants, whose eyes bleed for no apparent reason, may seems threatening but bearing in mind King's own musical taste, there is the distinct feeling that he would not mind living in a place called Rock and Roll Heaven and probably share Clark's speedy resignation to his fate. The ending at the supposedly climactic concert, rather than revealing anything, simply fizzles out. The central premise here is flawed – even if they stay, there is no suggestion they will become rock and roll icons themselves; some people must stay as audience members. What they are being 'threatened' with is a life of limited musical choices, not becoming one of the zombie undead.

Golden Years (1991)

Like *Thinner* (Tom Holland, 1996), *Golden Years* takes a basic human process and posits what might happen if it could be reversed. This was King's first attempt at a TV mini-series, a format he was to come back to repeatedly in later years, often with the same inherent weaknesses. One could say the multiplicity of directors and the fact that the last two episodes were not written by King, contributes to a fragmented whole but the flaws are present all the way through. Unlike the advice he gives in *On Writing* (2000), talking about using a single telling detail, the main problem here (as with much of his serial work) is one of sheer overwriting and lack of pace.

In terms of character, Terry Spann (Felicity Huffmann), Head of Security at Falco Plains, is an interesting precursor of Dana Scully (Gillian Anderson) from the Fox series *X-Files* (1993–2002), for which King wrote an episode, 'Chinga' in 1998 and in which Huffmann starred herself in an episode entitled 'Ice' in 1993. She is an armed special agent (who keeps her gun inside a teddy bear), sceptical by nature and concerned with uncovering 'the truth' of a situation. Like Scully's Walter Skinner (Mitch Pileggi), she has a tough-talking, hard-drinking but ultimately indulgent boss, General Crewes, (Ed Lauter) to whom she reports personally and she must endure conspiracies and agents working against her (Crewes stays at 'The Watergate Hotel'), who are prepared to kill to stop her revealing the truth. Their appearances are also similar – a noirish femme fatale look, pale skin, straight shoulder-length hair with a curl at the end, and especially in the opening episodes a preference for tailored suits (Andrews notes she is 'still dressed for success') and in Episode 2, she is framed in a morgue, a typical Scully setting. From the outset, when we first see a decontextualized shot of her legs emerging from a car, to her perching unnecessarily on the edge of Dr Ackerman's desk to the gratuitous underwear scene in Episode 6, we are encouraged to look at Spann as more of an object than a credible character. Crewes' lecherous expression as he watches Spann's legs on his black and white monitor adds to this impression, except Spann looks up, knowing she is being watched, problematizing who is in control of the gaze. Later she stands behind Crewes and flirts with him, putting her hands over his face and eyes, so she can see but he cannot. However, like the gypsy girl in *Thinner*, there is not enough of such actions to claim her as a heroine for Laura Mulvey, reclaiming the female ownership of the gaze.

Jude Andrews (R.D. Call) is a cross between the villain of Victorian melodrama and British pantomime in his moustache-twirling histrionics. He goes around killing characters, apparently at will, none of whom we have any empathy for, thereby lending their deaths no emotional weight. In the flashback where he allows a suspect to be tortured, he seems like a virtual parody of Burt Reynolds and much of the dialogue around him, is pure cliché – 'Just like old times, Terry'. There are tiny glimpses of what his character might have been, in the Tarantino-like banality of giving his underling Burton a dressing down about the tastelessness of leaving up Christmas lights all year round and plastic Christmas trees, both of which 'offend' him. However the effectiveness of his chilling description of torture to

Ackerman or his mantra 'Perfect paranoia is perfect awareness' are undercut by his one-dimensionality elsewhere.

Professor Todhunter (Bill Raymond) – whose unsubtle name uses a German allusion rather than the French in *Mort* Rainey in *Secret Window* – seeks to defy death and reverse time. The under-lighting, his receding hairline, spiked-up hair, round glasses and imperious, eccentric manner, cast him instantly in the role of mad professor, making any attempt at humour or profundity, redundant. A quirky version of the main theme with plucked strings fails dismally to make him a comic character – he is clearly dangerous from the outset. The ranting that the experiment is 'Mine', the dialogue with his father's grave upon which he curls up to sleep and his attempt to speak to his workers as a great leader, all mark him as a caricature. His last experiment, in which an old-style mantle-piece clock is bathed in green light until the hands start to move backwards, is ridiculously literal. As usual in King, the science is not explained but much is made of the terminology – in the first couple of episodes, the fact that Todhunter ignored a red light leading to 'Secondary delta overload' is given incredible amounts of screen-time and then promptly forgotten.

In the initial episodes, the paraphernalia of security (blast-proof doors, voice recognition, even Spann's baseball codes), suggest the possibility of unpredictable events but actually only serve to underline that we are witnessing ritualistic behaviour, not real conflict. Like the motiveless adjournment of the inquest into Todhunter's actions, events which could be telescoped into a single one-hour drama are stretched out, sometimes interminably, and dialogue kills any forward narrative momentum. Characters talk rather than do (such as Crewes talking to his fish, Andrews updating an unseen superior by phone, or the two calls between Spann and Crewes in Episode 3, which seem to drag on forever). In Episode 1 especially there is also an almost porn-style percussion track, which strangely seems to complement the dialogue that goes nowhere. Stylistically, the combined effect in the early episodes is of a porn film without sex scenes.

There are tiny glimpses of what could have been. The relationship between Harlan (Keith Szarabajka) and Gina Williams (Frances Sternhagen), whom he touchingly, or disturbingly, depending on your point of view, calls 'mother' is given some space to breathe and in particular, we see in the opening and closing episodes, sexual activity between older characters – a considerable on-screen rarity. It has the proviso of that this may only happen because of Harlan's rejuvenation and is alluded to rather than shown too explicitly. Perhaps more interestingly than Frances Sternhagen's lengthy wailing about the process separating them, is the simple fact that she recognizes the process whereas he does not. A long-term marriage gives both partners an intimate knowledge of the other's corporeal presence, more so than they know themselves.

Single shots, like the blood dripping down the eye poster in the optician's, have some potential. The race between Moreland and Burton, in effect between Spann and Andrews in Episode 5 to reach Williams' computer file, one seeking to access it, the other to delete it, does work and shows there could have been some tension created. We see Todhunter in Episode 4 talking to his mice, who are visible in close-up on the other half of the frame,

in a pale echo of Roy Batty's poetry in his death scene in *Blade Runner*. There are a few melancholic xylophone notes but the 'Time is short [...] but time is all we have' moral, does not reach the depth of poetic or dramatic emotion of Ridley Scott's film. The green eye-glow is a fairly crude special effect but the real problem here, is that unlike films like *The Man with the X-Ray Eyes* (Roger Corman, 1963), this effect *means* nothing, it is purely a passive glow. King, who knows Corman's film well (he discusses it in *Danse Macabre*) alludes to Corman's protagonist Xavier in Todhunter's middle name.[5] However in King's narrative there is no idea of what increased vision/power this provides – there is no indication of how or why the earthquakes occur (making Harlan's harnessing of his power at the end unbelievable).

The plot is lengthy, paradoxically without having much in the way of incident and drifts badly, especially in the latter stages. Apart from some truly toe-curling group singing in the car journey to Chicago, the idea that they could purposely get themselves arrested as a way of supposedly remaining safe, is scarcely credible. Even the most retarded police force would hardly be held at bay by three crude dummies in a car *in daylight* (as in Episode 5). The idea that Spann would agree to go to the Williams' only daughter in Chicago and that Andrews and the whole law enforcement apparatus, cannot guess this, seems ridiculous as does the concept of escaping not only in a hearse but one that you then *choose* to spray bright red. The scene in which the blind daughter helps them escape in a darkened car-park could work, if only it were not perfectly light enough to see. A major CIA stake-out seems rather excessive to arrest an old couple, their blind daughter, one agent, and an elderly general. The final cutting between some tunnel referred to but not seen in the basement of the refuge safehouse, set in suburban Chicago and a huge waste pipe emptying onto a lake and large open space, also stretches credibility. At the end of the original TV series, Gina dies and Harlan is captured but the DVD version tries to create a little more closure by having the pair disappear in front of Andrews' eyes. Harlan is miraculously able to control the effects of his exposure to the green dust, something he has not been able to do up to this point and Spann and Crewes head off arm-in-arm as a fairly unlikely couple. Aping the use of B.B. King's 'Stand By Me' for Rob Reiner's film, it is tempting to wonder whether the title would have remained 'Golden Years', had permission to use the Bowie titletrack been denied.

Thinner (Tom Holland, 1996)

Thinner is a more malevolent version of *The Green Mile* or *The Dead Zone*, where a spiritual connection is also achieved through a sense of touch. Sociological (and arguably stereotypical elements of American society), such as the wish to improve oneself, especially concerned with physical appearance – lose weight and gain the fiction of a perfect body, rarely appear in King adaptations, and certainly not as its central metaphor. The sedentary nature of American society is also suggested with ubiquitous televisions in many rooms of Billy's house.

The use of the marginalized Native American group, links with *Pet Semetary II* (Mary Lambert, 1992) and *Children of the Corn III* in portraying the ethnic other as a source of fear and supernatural power (here the giving or removal of curses). The transgression of Indian ritual and disrespect of its culture is also a small, and largely sublimated, part of The Overlook Hotel's haunted nature in *The Shining*, where the building was constructed on ancient burial grounds. However, any consideration of the treatment of an actual minority group on the margins of society is bypassed in favour of using the groups as shorthand for superstitious evil. The notion of a disease leading to an inexorable process of weight loss does evoke cancer or AIDS but the film does not have the substance to support a sustained reading of this kind and the local corruption in covering up the true cause of Billy's accident is more a plot device than a focus of examination. The nature of the curse itself seems rather contrived. There seems little logical reason why the elder, Tadzu Lempke (Michael Constantine) cannot lift the curse, nor why it can only be removed by transferring it onto someone else, like a chain letter.

There is a certain 'sexing-up' of King's source material in the pre-accident exchange between Billy (Robert John Burke) and his wife with oral sex in transit clearly the cause here. The young gypsy woman (Kari Wührer) is used as a titillating distraction by Billy who gazes out of his office window via his point-of-view, cutting in on the axis as she dances around her caravan. On the other hand, in his defence, it could be said that he does not act on his desires, that other colleagues also look at the girl in this way and that perhaps (and at the risk of not being terribly fair or politically correct) the girl bears some responsibility for flaunting her sexuality knowing its effect on others. He sublimates his desire for the girl into a sex act whilst driving (for which his skeletal wife, who initiates this, also bears some blame). Clearly, the lack of concentration causing the death of another by reckless driving – none of this is praiseworthy but in relation to the sin, there seems to be a disproportionate and sadistic punishment. Billy did not hit the gypsy woman with intent, whereas the curse is purposely placed upon him. Furthermore, the nature of the fair itself is a little ambiguous, looking like the fair in *Quicksilver Highway*, i.e. an opportunity to dupe the paying customer. When Billy visits, the dolls he can win as a prize all look like him, suggesting perhaps that he is the target of a seduction on the part of Gina as temptress as much as victim of his own weaknesses.

The casting of Robert John Burke in the main role seems a poor choice. Even given the restraints of the prosthetics and make-up, he exudes a limited range of eye-rolling in terms of facial expression. It is a good example of the broader difficulty of physically manifesting an appearance only described in literary terms in its source material but whereas *Battleground* is credible, the low-budget *Thinner* is not. Burke looks like what he is – a man in a fat-suit. The notion of a curse, in itself a largely-redundant horror cliché, is largely an abstract one, unless its consequences are made visible.

The main plot of both *The Dead Zone* and *Pet Semetary* is also initiated by a car accident but both films are also driven by more complex characterization and greater artistry in their telling. Where *The Dead Zone* has milk splattered on the windscreen, here the director,

169

Holland, opts for the more obvious choice of blood. Characterization here hardly extends beyond types with Richie Ginelli (Joe Mantegna) as a swarthy mafia-style cliché used to solve Billy's problem (a much less subtle version of David Cronenberg's unnamed assassin in *To Die For* [Gus Van Sant, 1995]) and Billy appears very much as he is described by the old man as 'White Man from Town'.

Unfortunately, once we see the direction in which the narrative is going, there seems to be little sense of momentum, until the twist right at the end. There is the gratuitous introduction of special effects in near accidents caused by the disfigured elder, the giver of the curse, but Billy essentially needs a dramatic antagonist for the narrative to have more pace but he suffers alone. The fleeting shot of Billy looking through a hole in his hand, caused by the girl's sling-shot, could be an interesting and original consideration of the strangeness of one's body, apparently at war with itself, *if* it had not been done already in a much more dramatically-compelling manner in the hand-to-hand fight between the terminators in *Terminator II*.

There is a strange and unmotivated leap in the level of violence – a boy given a message to pass on, is tortured and murdered and yet the unnamed criminal enlisted by Billy to help who strafes the Indian camp with gunfire, *A-Team*-style, causes no injuries or bloodshed at all. Ironically, where the effects are restrained, rather than excessive or cartoonish, such as the final shot of the pie 'bubbling' as Billy's blood is dripped onto it, the effect is proportionately more powerful.

The end is fitting, at the kitchen table, emblem of the American family, which could be said to have been threatened by Billy lusting after the gypsy girl, an outsider. The wife is punished by eating the pie as an adulterer (as is her partner in crime, the doctor, who calls round) but by his daughter also falling victim to the curse, it seems as if revenge is arbitrary and unfair. It implies a female culpability, that she is somehow guilty, in league with her mother who initiated the sex act before the accident. However, as with her husband, the exact nature of her crime (expressing sexual desire?) and its relation to any potential punishment seems excessively punitive in nature. The suggestion that the sins of the parents are visited on the children might work if this was clearer but the ending is quite confused. When Billy wakes up next to a corpse, far from being repulsed, he actually kisses it. There is no sign that Billy is either repentant or that he has learnt his lesson and perhaps that is why his daughter is punished but there is also the feeling of the narrative being left open purposely for commercial rather than artistic reasons, i.e. for a potential sequel.

'Chinga' (Kim Manners, 1998)

Not one of the strongest episodes of *The X Files*, King predictably selects Maine as the setting for a series of suspicious deaths, in association with accusations of Salem-like witchcraft and possession, linked to a mysterious doll. Whilst on vacation, Scully (Gillian Anderson) stumbles across a store where all the customers have tried to claw their eyes out, except

for Melissa Turner (Susannah Hoffmann) and her daughter Polly (Jenny-Lynn Hutcheson), who seem strangely unaffected. The threat of Polly's doll is mostly restricted to its eyes flicking open and the refrain 'Let's have fun'. The Chucky comparison seems obvious and is jokingly mentioned by Mulder (David Duchovny) explicitly, but independent movement is suggested via shadows (on sheets and on a boat later) rather than shown explicitly. In the climax, the doll's dialogue changes to warnings not to play with matches or knives and an invitation to play with the hammer instead. Scully's sudden last-minute rescue and the apparent destruction of the doll in a microwave are undercut by the denouement's discovery of the doll, only slightly charred, by another fisherman (the reasoning behind the location of the discovery as unexplained as the first).

The narrative has some slight interest as a satire of a generation of self-centred, brattish kids who put the hex on you if they do not get their way (a waitress gets her hair caught in a machine when she does not give Polly more ice cream), although the basic premise of a doll acting out the id-related wishes of its 'owner' is not original. However the plot is confused (reflected by Chris Carter needing to come in as a co-writer). Melissa denies witchcraft and yet she has three visions of future victims of the doll (the teacher, Buddy the cop and herself). There are mentions in passing of *Crucible*-like 'joojoo' dolls but the back-story of the father's death is told rather predictably in a flashback by a fisherman and the visual discontinuity between the isolated lobster trawler and the large doll, discovered in fairly good condition, looks more unconvincing than uncanny.

There are some small touches of irony in the 'Hokey-Pokey' song, which is playing whilst the doll induces Polly's former teacher to slash her own jugular with pieces from a broken record. King attempts to inject some quirky humour into the Scully-Mulder relationship (here conducted exclusively over the phone) in Mulder's eccentric way of passing the time while they are apart, apparently watching porn, bouncing a basketball, and throwing carefully-sharpened pencils so they stick in the ceiling. However, apart from an extreme low-angle 'Kubrick-shot' of Melissa in a trance banging nails into a window frame to keep Scully out, visual artistry is generally in short supply.

Conclusion

The production quality of *Nightmares and Dreamscapes* is relatively high and in terms of budget and screen-time, it is an original attempt to realize a series of stand-alone dramas based on the short stories of one writer. It attracts a number of A-list stars in both main and supporting roles (such as Berenger, Hurt and Macy), which helps the project as several narratives focus on one central character alone (and probably part of what drew the interest of such acting talent). Noticeable perhaps is that of the eight stories, four focus on married couples and a further two on ex-relationships rekindled – in a way, this literally is *family* entertainment. That is the institution placed under most pressure. The other two feature brothers, who are distant professionally but personally close, and in the case of Hurt's

hitman, his explicit lack of family, is a defining feature of his coldness. However, little is really made of this – the early frostiness that creeps into the exchange between Clark and Mary in *They've Got One Hell of a Band* (on her description of him as a computer programmer, he replies tartly 'It's what I do. It's not what I am'), goes nowhere. In each case, the fractures in the relationships are established and then just left hanging.

Furthermore, as discussed in *Stephen King on the Big Screen*, we have a number of writers-as-heroes (Sam Landry, Richard Kinnell, Howard Fornoy – documentary maker). Kinnell, a successful novelist from Maine, functions as a King surrogate, who is first greeted by a valet who describes himself not as a 'fan' but the full term 'fanatic' with all its negative connotations. The constant 'Where do you get your ideas?' and the freakish hero worship of a crazed fan tattooing himself, represent extreme versions of an oppressive reading public. The pile of books that he trips over at the top of the stairs includes *Pet Semetary* and *The Tommyknockers*, suggests King causes the downfall of his own characters, albeit not as overtly as Sam Landry.

The adaptations in this chapter represent quite an uneven collection. There are clear links between the basic plot premise of *Autopsy Room Four* and *Alfred Hitchcock Presents* (Alfred Hitchcock, CBS, 1955–65), and direct dialogue riffs from *The Twilight Zone*'s credit sequence at the beginning of *Desperation* and *They've Got One Hell of a Band*.[6] Where allusions prompt self-reflexive jokes and consideration of the boundaries between fiction and 'reality', we have some engaging and thought-provoking drama (as in *Umney's Last Case* and *Battleground*). Where the references are purely derivative (*Golden Years*), these adaptations are closer to unwitting parody. A sociological aspect can be glimpsed in *Thinner* but perhaps less obviously, the power of particular acting performances (in the case of Macy and Hurt here) help to obscure narratives which are no less implausible.

Notes

1. Stephen King, *From a Buick 8* (New York: Scribner, 2002), p. 419.
2. Stephen King, *Just After Sunset*, op. cit., p. 537n.
3. Stephen King, *Storm of the Century* (New York; London: Pocket Books, 1999), p. x.
4. See George Beahm (ed.), *The Stephen King Companion* (London; Sydney: Futura Publications, 1991), p. 144.
5. See Stephen King, *Danse Macabre*, op. cit., p. 220.
6. See Stephen King, *Everything's Eventual*, op. cit., pp. 30–31n.

Conclusion

It is like all the finest food in the world put into a bucket and stirred with a stick.
(Kitty on American television in Zadie Smith's *The Autograph Man*)[1]

Authorship

I don't try to maintain quality control. Except I try to get good people involved. The thing is, when you put together a script, a director, and all the other variables, you never really know what's going to come out.

(Stephen King)[2]

Produced by so many different directors, crews and writers, it appears there is little that binds the films in this book together as an oeuvre. Generically, they are more disparate than at first sight, often on closer examination denying their apparent horror label. However, the presence of Mick Garris as King's director of choice, does suggest an element of artistic coherence. The fact that he is the director of six so far (with *Bag of Bones* in gestation), suggests that he understands King's aesthetic and that King seems happy for him to helm repeated projects. However, the fact that Garris' own CV is so replete with television and only sequelized films, suggests that his particular strength is in delivering narratives that match genre expectations closely. Viewers are likely to approach a movie directed by Kubrick (who never produced fiction for television), hoping to see something they have never seen before. A viewer of either Garris' *Critters II: The Main Course* (1988) or *Psycho IV: The Beginning* (1990), is unlikely to be looking for any significant generic innovation.

Comparing film and TV adaptations of the same text, suggests the shift between media allows a greater claim of authorship with the use of King's possessory credit in *Stephen King's Salem's Lot* (2004) and *Stephen King's The Shining* (1997). The reinstating of previously-cut material is central to emphasizing the 'Kingness' of the product in its promotion (like the fleshing out of the Father Callaghan role and use of hedge creatures in the two examples mentioned). Unfortunately, in the case of these examples, this inevitably means a longer running time with a resulting tendency towards narrative drift. There seems to be greater

involvement from King himself, adding his voice to promotional material (certainly on DVD extras). However, as suggested in *Stephen King on the Big Screen*, this is more a case of marketing a known brand than indicating any greater creative responsibility. Greater involvement is stated as a given in marketing material, rather than objectively demonstrated. An Executive Producer credit, for example on *Storm of the Century*, may in effect mean no more than a veto on a script or cast, of which he disapproves. The 'no more' is not meant dismissively here, this certainly, represents a powerful position but it is one that he has held since the early 1990s. What King does give is literal 'authorization', permission to tackle his words and adapt them for the screen, both large and small. This has consequences for assumed notions of auteurism, which then become part of the marketing of the programme and texts used in voiceover trailers ('from the mind of Stephen King…'). As Timothy Corrigan has discussed however, such material can be part of the marketing of a narrative and the persona of a director, as much as any actual notion of 'authoring'.[3] There is a strange link here between authorship and Williams' notion of 'flow'. King initially found it hard to accept *The Stand* being shown on commercial television, with dramatic engagement periodically interrupted by a parade of consumer items and yet that very feature appears *in his own fiction*. It is a well-established criticism of his work that he enumerates lists of branded goods as part of his descriptions of twentieth-century America. The feature to which he objects is already there in his own writing.

As noted in *Stephen King on the Big Screen*, King's appearances in cameo roles, especially in TV adaptations, suggests some level of involvement and therefore an attempt at authorship, even if only in the sense of conferring a level of approval. His cameos also fulfil a meta-textual, ludic role, tending to fall into specific categories and this is also true of his TV work. This includes 'fetchers-and-carriers' (Bus Driver in *Golden Years*, Hoagie Man in *Knightriders*, and Pizza Delivery Man in *Stephen King's Rose Red*); 'bearers-of-information' (Teddy Weizak in *The Stand*); and satirical figures of authority (Tom Holby, Chairman of the Board in *The Langoliers*, Lawyer on TV in *Stephen King's Storm of the Century*, and Pharmacist in *Thinner*). There is even an extended form of game-playing with his audience, who are by now well-accustomed to these appearances. In *The Stand*, King's cameo seems like *Creepshow*'s Jordy Verrill's more sophisticated older brother. He gives Nadine a lift and imparts of expository information about how close they are to Boulder and how the rival groups are shaping up. He appears later in the town meeting (next to Mick Garris, also in a cameo) and at the end manning a roadblock with a few more lines, next to another guard is played by director John Landis. In *Kingdom Hospital*, his rock n roll alter ego, Jonathan B. Goode, is held back until the denouement, by a series of excuses, including jury duty and vacation. King's choice of cameo as a Minister in *Pet Semetary*, played without irony, might suggest that he finds some comfort in organized religion, delivering a standard litany by the grave of Missy (committing a sin in some religions by committing suicide). However, elsewhere, his portrayal of Ruth White in *Carrie*, the zealots in *The Stand*, or indeed naming the zombified cat 'Church' for short in *Pet Semetary* (Mary Lambert, 1990), all suggest that he is no enthusiast for extremist beliefs of any kind. Ultimately, the cameos provide a further

branding tool. As producer, Jeff Hayes notes on the DVD extras package for *Nightmares and Dreamscapes*, with King's name attached to a project, 'you don't have to sell too hard'.

King himself declares that 'I think my novels are better suited for mini-series presentations', but this is not always true.[4] The TV mini series, King's format of choice since the mid 90s, may offer the closest visual format to the notion of the page-turning bestseller. However, to keep the viewer interested, in competition with distractions in the home, the zapping of a TV remote and gaps for adverts, regular cliff-hanging turning points and some repetition, is needed. It works best when there is a clear, memorable log-line- convoluted and subtle plots lose their way. Budgetary considerations also do not apply quite so harshly to the novel-writing process as they do for television or film. Extending a 90-page novel to one of 120 would not increase the production budget by an equivalent proportion but once you start to go towards the two hour mark in film terms, you begin to lose viewer loyalty as well as requiring millions more dollars to complete the project.

King appears to share the view of the narrator in *Duma Key*: 'all art, no matter how strange, starts in the humble everyday'.[5] Especially in his short stories, King often focuses on domestic fears, which might be dubbed 'the terror of everyday life', for example dentures in 'Chattery Teeth' (dramatized in *Quicksilver Highway*) or toy soldiers in 'Battleground'. This may work better on the smaller-scale of TV, beamed directly into our own living-rooms than on a movie screen, which tends to show scenes outside the home and seems better suited to larger, special event entertainment, for which viewers are prepared to pay more. King's narratives in print and on screen (big and small) routinely show the extraordinary breaking into the everyday lives of, usually, a group of characters. In this respect, one might see an attempt at following a tradition of televisual tale-telling that stretches at least back to *The Twilight Zone*. However, a key difference exists between the two – duration. The anthology armchair theatre of *The Twilight Zone* (CBS, 1959–64) and *The Outer Limits* (ABC, 1963–65; 1995–2002) and were usually around fifty minutes (all but the fourth season of the former coming in around 25 minutes). Furthermore, his televisual narratives often have a blend of 'amnesia' in terms of character development and yet lack the pace of single episode drama. King may be inspired by the anthology series of the 1950s, sometimes falsely portrayed as sometime of a golden age of broadcasting, but what we actually have is closer to what that rapidly became – the episodic telefilm, shifting the dominant narrative structure from the episodic to the cumulative. Theoretically, television offers the opportunity to get to know characters in a different way than film, not necessarily more deeply but *over time*. The fact that this opportunity rarely occurs is primarily due to the pressure on writers to build minimal character progression into serial dramas. Therefore, what the mini-series appears to offer is very rarely delivered.

In a sense, parody represents the death of a genre. Certainly, it reflects a cultural exhaustion or saturation with particular genres, so that dramatic engagement is no longer possible, making laughter a primary audience response. In the short term, it can be difficult for genres to recover from this, such as the disaster movie (particularly the subgenre of aircraft-based narratives) in the light of *Airplane!* (Jim Abrahams, David and Jerry Zucker,

1980). However, given time, even these can recover, especially with cultural changes and generic hybridity, such as the action film and Wesley Snipes vehicle *Passenger 57* (Kevin Hooks, 1992) the docudrama *United 93* (Paul Greengrass, 2006), and the conspiracy thriller *Flightplan* (Robert Schwentke, 2005). Developments in special effects have made large-scale destruction a spectacular possibility once more.

Some genres have found it harder to recover, such as tales based around possessed dolls (outside David Schmoeller's *Puppetmaster* films [1989 and 1991]), which King persists with (in 'Chinga' and more recently in *Duma Key*). Arguably just as redundant is the much-mimicked vampire subgenre. As Wireman says in *Duma Key*, 'I think almost everybody believes there could be ghosts – but there's no such things as vampires'.[6] Unfortunately, vampire features, apparently unwittingly, creep into King's visions of monstrosity, not just in overtly vampiric narratives like *The Night Flier* but also Flagg in *The Stand* and Linoge in *Storm of the Century*. It seems as if King draws on vampire lore almost at random. The awkward racial reversal, which is rapidly tedious rather than liberating, in *Vampire in Brooklyn* (Wes Craven, 1995) and the focus on mechanical gadgetry in *Vampires* (John Carpenter, 1998) suggest a horror genre that has largely lost its ability to shock or scare. From the children in the seminal *Night of the Living Dead*, prepared to transgress not just boundaries of cannibalism but that their victims should be their own family, through George A. Romero's apparently-innocent *Martin* (1977) to the more recent *Let the Right One In* (Tomas Alfredson, 2008), it may be that the subgenre retains its greatest power where the vampires are humanized most and thereby appear least culpable for their actions, particularly in the figures of children, creating a distinctive elegiac and melancholic tone.

In this respect, King's narratives in print and on-screen seem anachronistic within the subgenre itself, relying on versions of this monster that are closer to the work of Bela Lugosi or Christopher Lee than the adversaries of Buffy. *Martin* parodies this precise gulf, in the playground scene (the exact status of which is unclear as to whether it is a dream or not) where Martin (John Amplas) taunts the older more superstitious figure of Tada Cuda (Lincoln Maazel) for believing in vampires. Cuda believes in the older traditions, linked in Martin's mind to the clichés of Hollywood. Romero's film is particularly powerful because he does not allow this to be a simple dichotomy, with Martin brutally staked and buried at the close by Tada, who believes he is doing what is morally right. King's vampire narratives never reach this level of empathy – his vampires remain monsters, encumbered with the filmic iconography of Lugosi. Where there are attempts to deepen the portrayal of the vampire, as in *The Night Flier*, it is at the level of metaphorical significance in relation to tabloid journalism, not a more existential exploration of identity, and in Pennywise, although there are some vampiric features (particularly in his teeth and some references to the moon), he appears in daylight, preys primarily on children, and is as much linked to the underground troll/bogeyman figure as used in traditional stories as a moral lesson not to talk to strangers (he lures children with corny jokes and balloons) as with contemporary paranoia about paedophiles.

Less prominent perhaps but still anachronistic are climactic images of monstrosity that morph unaccountably into zombie iconography, such as in *Salem's Lot* and *The Night Flier*. A key problem in classic zombie narratives (discussed in *Stephen King on the Big Screen*) is the lack of mobility of the source of threat. Following Danny Boyle's influential *28 Days Later*, this has been altered so that all of the more recent remakes of George A. Romero's 'Living Dead' series now use creatures that can move at incredible speed, translating them into snarling nightmares rather than plodding sources of ridicule. King does not seem to have realized this (at least up until *Duma Key* in 2008 where his undead start to show some pace) and the majority of his narratives retain the earlier zombie incarnation, forfeiting credibility at the same time as including a closed ending, positing rescue and escape for the protagonist as possible (something Romero's films are at great pains to deny). Similarly, the moving severed hand in *Pirates of the Caribbean* (Gore Verbinski, 2003), certificate PG13 in the United States, historically indicative of a whole subgenre in itself, now feels more like a symbol of the movement of horror devices into the mainstream and making hand-based narratives like *Quicksilver Highway* seem closer to a bygone era.

As mentioned in *Stephen King on the Big Screen*, once evil is visualized, it can often be externalized and laughed at, placed in a known category and synthesized with the world as known previously. Evil is nearly always vanquished, except as a means to facilitate sequelization (*Children of the Corn*). Visualizing evil, especially in the last century that historically produced an unsurpassed parade of almost incomprehensible evil, is certainly difficult. In his realization of Randall Flagg, it could be said that there is a brave attempt at representing the Devil as charismatic, plausible and therefore highly dangerous. However, in adaptations like *The Stand*, Dayna expects (and possibly the viewer as well), 'Charles Manson at the very least'. To non-Americans (and perhaps to millions of them as well), Flagg's 'Billy Ray Cyrus' hair and especially scene where he sings, 'Baby Can You Dig Your Man', looks completely ridiculous and not worthy of the apotheosis of evil (except in fashion terms).

Many of the adaptations for television operate so firmly within generic boundaries, that the results are often quite forgettable. There are some rare examples of originality, when narratives push up against generic boundaries or even exceed them, occasionally charting new generic territory, such as the conception of Pennywise in *It* (arguably King's only truly original 'monster'), the duality of the vampire in *The Night Flier* and the basic premise around the *Children of the Corn* franchise. However, as with his otherworldly entities, if viewers do not really know how a creature lives, it is equally specious how it might be destroyed, making climactic scenes unconvincing. There is perhaps a particular debt to Shirley Jackson in King's conception of unseen supernatural entities. As the final words of *The Haunting of Hill House* state, 'whatever walked there walked alone'.[7] This is not only cited knowingly by Edgar and Wireman in *Duma Key* but informs the naming of He Who Walks Behind the Rows in *The Corn* series and even the final creature in *The Mist*, akin to 'the walkers' of George Lucas.[8]

The sprawling, diffuse plots, particularly of King's later works (but present even in *Salem's Lot*) can be accommodated within the running time of a mini-series, whereas

feature length running time of around 90 minutes often struggles to do this. With so many rival entertainment platforms, the one thing a televisual narrative cannot afford is 'bloat'; a tendency to drift and lose narrative momentum – a feature with which many King adaptations are afflicted. Literally, one obvious difference between big and small screen is in matters of scale. The big screen exaggerates and blows up physical blemishes 40 feet high and the same can also be true of holes in the plot. King is attracted to the speed with which decisions can be made in television but the lack of 'creative dithering' which King praises in the speed that *Storm of the Century* went into production, might equally be seen as a lack of editorial discipline.[9] It seems as if ABC did not want to kill the goose that laid this particular kind of golden ratings egg.

Where there is pace (*It*), deficiencies can be overlooked; where this is lacking, this only serves to draw attention to weaknesses in plot and character motivation (*The Langoliers* and *Storm of the Century*). Pace seems to be a central problem of King adaptations, particularly where there is too much narrative information, condensed too quickly (such as *The Stand*), often from a literary source or its opposite – not enough narrative incident, stretched too thin, leaving audiences desperately waiting for something, anything, to actually happen (such as *Storm of the Century* or *Rose Red*). In both these latter cases, these narratives were written explicitly for the medium of television, suggesting that there was not a problem in adaptation but in the writing itself (in both cases scripted by King himself). As was noted in *Stephen King on the Big Screen*, the closer King's involvement, the weaker the end product seems to be.

When finances are stretched (or just in a desire to increase productivity) there is greater pressure to cut those costly elements from narratives which audiences associate with pace or more attractive still, commission those dramas, which do not include so many to start with. Extremely expensive activity, such as elaborate stunt work or extremely elaborate post-production effects, occurs hardly at all (*The Stand* being an exception). In place of numerous global locations we have a limited number of American locales, especially around Maine. King rarely creates fictional worlds – he sets his story in the known world (especially for American audiences) and has his forces of disruption break in from outside. Rather than physical movement, requiring frequent camera set-ups, rehearsal and lengthy shooting, we have longer, slower-paced dialogue scenes, where characters tend to stand and talk (especially in narratives like *The Langoliers*). Dialogue predominates over action, and if possible, slow, repetitive dialogue. Thus, the prohibitive costs of bringing more expensive elements (which we might associate with film) into television, appears to have a 'flattening' or deadening effect on narrative pace.

However, that is not always true. Even where considerable sums have been spent, apparently on features, which might convey a sense of pace, this still cannot replace/disguise a lack of character development. The budgets of *The Stand* and particularly *Storm of the Century* (with its 80-day shoot and a budget of $33 million; $2 million just for snow effects), are many times that of *It* but the earlier film still seems more powerful due to a more charismatic monster, an extended but still limited cast (rather than a drifting ensemble

piece), and a stronger overall narrative through-line. As Wireman notes in *Duma Key*, 'Art is memory, Edgar. There is no simpler way to say it. The clearer the memory, the better the art'.[10] If you deny characters a past tense in print or in a visual medium, they will struggle to live fully in the imagination of a reader or viewer. *It* is the only film in the book with a credible sense of the past informing the present (via a carefully-balanced flashback structure) but it is the tightly-written seven-act structure as well as Tommy Lee Wallace's inventive direction, which dictates the presence of some pace.

The relative absence of A-list movie stars is both a reflection of the budgetary constraints of television but it might be said that such a term as 'A-list' is fairly protean and subjective, that there are plenty of big names sprinkled through the films discussed in this book (Donald Sutherland in the 1997 version of *Salem's Lot* and James Mason in the original film, William Hurt in *Battleground* and Max von Sydow in *Needful Things*) and even if the majority of parts are taken by full-time TV actors, that in itself is not a sign of poor quality. One might argues in fact the opposite – that it makes the best use of individuals used to working in this medium.

The Incredible Shrinking King

Mick Garris' forthcoming version of *Bag of Bones* has been shifted from a feature with a cinematic release to a TV mini-series. It is tempting to see this as the likely model for the future of King adaptations. Some might 'slip under the radar', such as *Dolan's Cadillac* (Jeff Beesley, 2009) given a premiere in Sweden and subsequently only a limited global release but television seems King's natural home. An increasing number of King narratives have been converted into comics and graphic novels, particularly *The Dark Tower* series, certainly suggesting also a suitability for visualization but on a small-scale with repeated reframing, rather than the larger canvas of film. Even in terms of Darabont's involvement with King, a shrinking of scale can be seen, from the epic sweep of *Shawshank*'s helicopter shot across the prison ground to one set of cells in *The Green Mile* to *The Mist* where we spend most of the narrative inside a supermarket.

King's *Full Dark, No Stars* (2010), comprising of a collection of previously-unpublished novellas, suggests an eddying backwards creatively, a looking back rather than forward. There is a certain backward-looking tendency in King's recent fiction, which cynics might attribute to a lack of creative inspiration or a tendency to recycle derivative plots. The premise of *Under the Dome* looks suspiciously like John Wyndham's *The Midwich Cuckoos* (1957), filmed in 1960 as *Village of the Damned* by Wolf Rilla, and even borrowing character names like Jim Rennie from Micheal Rennie in *The Day The Earth Stood Still* (Robert Wise, 1951). There is also the sense of collecting previously-written material. *Blaze* (2007) is overtly a revamped 'trunk' novel, *Just Under Sunset*, although presented in its introduction as representing King's newfound interest in the short story, features 'Cat From Hell' (now more than thirty years old) and 'Rest Stop' replays the Jekyll-and-Hyde dichotomy of civilized writer and

brutal literary creation from *The Dark Half*. In fact, 'N' is the only previously unpublished story in this whole collection.

Many of King's more recent work features a growing use of incremental repetition – characters typically find themselves in a difficult position, often a constricted space, and gradually work themselves free or are inexplicably drawn to repeat an action even though they know they should not (see 'A Very Tight Place', 'N', 'The Gingerbread Girl' or 'Stationary Bike' in *Just Before Sunset*). This may not be wholly new in King's work (*Misery* is based on just this principle) but there is a growing sense of narrative atrophy, (reflected in a tendency also to divide all narratives, even short stories, into sections) which makes translation to a visual medium, less likely to occur on the big screen (and possibly not the small one either). There seems to be a growing dependence on similar narrative blueprints, such as *The Monkey's Paw* (W.W. Jacobs, 1902), discussed in *Stephen King on the Big Screen*, appearing in *Thinner*, *Riding the Bullet* and *Kingdom Hospital* (where Fleischer asks Antubis for the heart of a recent suicide victim as soon as possible, unaware that Blondie, the Alsatian, has just chewed it up).

There is a growing tendency in King's fiction too towards narratives involving some kind of 'rip' or 'hole in reality', as often favoured by *The Twilight Zone* (as in 'The Langoliers', 'Stationary Bike', or 'N'). At the same time, the adaptation problems identified in *Stephen King on the Big Screen* persist, such as the tendency to literalize metaphors, in particular to make mental projections 'real' and expect readers to accept them as such (as in 'Stationary Bike', which itself is a more benign version of his own 'The Road Virus Heads North'). Narratives are still being based on a static tableaux rather than a dynamic situation. King overtly likes 'suspense stories that turn on crucial little details', but this is the literary equivalent of Chekhovian 'gun on the mantelpiece' cliché (i.e. that once an element is mentioned early on in a narrative, it is only a matter of time before it is activated).[11]

This reduction in scale has reached its natural point in 'N', which appears to represent the future of King adaptations, wedding as it does two media – the relatively-new graphic novel with the rapidly-developing creation of narratives released primarily for cell-phone or online customers. With the explosion in mobile phone applications, it literally is, 'Stephen King on the small screen'. Artwork, in the style of those graphic novels already released, by Alex Maleev and coloured by José Villarrubia, is used in a fairly primitive cut-out animation format, but with professionally-voiced actors it represents relatively high production values. However, although much touted as representing a new generic blend (bringing Marvel, CBS and Simon and Schuster together) between comic book, flash animation and television programme, and although it does contain an original score and sound effects, the actual form of 'N' is less innovative than it might at first appear. In terms of harsh line drawing and sharp patches of colour, contrasting with a dark overall aesthetic, it may evoke the *Creepshow* films from the early 1980s, but there are actually no on-screen captions, apart from one intertitle signalling a time jump to a week later. Indeed, the only writing on screen is diegetic (such as names on folders).

The 'pan and scan' technique means there is actually very little movement within the frame and no speech movement shown. There are examples of very small movements, such hands

on a steering wheel, a swinging sign by the field or a single object, such as a car, which can be moved through the frame fairly easily, measured against the border of the road. Although the technique is relatively sophisticated here, the effect is not dissimilar to children's animation from many years ago, such as *Captain Pugwash* (BBC, John Ryan, 1957–75), where small objects, such as an arm, could move about an axis. There is some slight movement, not of figures on the screen but of the camera across the screen by zooming or slight tracking. Strangely however, this seems to be nearly always moving closer, i.e. revealing something in greater detail that is already visible, rather than the more conventional means for creating suspense in picture-based video like this, of starting with a tight shot and pulling back to reveal something hidden from view. The result of adopting the more distanced style is to keep the viewer slightly removed from events and as if we are repeatedly peering at a screen (which may mimic viewers' experience of viewing this on a small cellphone). A typical task for British Media Studies students used to be to produce a video version of a simple picture-book story. Although the purpose was to learn about the basic camera operations, what was produced often looked very like the style of 'N' (minus the CGI).

It is the small touches of CGI within individual shots which are new, such as a bead of sweat dropping down N's face, the play of light across the stones, revealing threatening faces, or the more surreal section during N's first appointment where we see footprints appear on screen, suggesting an increase in pressure on his fragile mental state. It seems such devices are better at conveying abstract ideas, rather than literal scenes. Most unsettling perhaps is the shifting dark shape in the midst of the stones, which is more threatening than the still frame of the face of the monster. As discussed in *Stephen King on the Big Screen* in relation to the hedge creatures in the two versions of *The Shining*, it is debatable how frightening an entity can be if it cannot actually move.

The narrative retells the account of a therapist, Dr Bonsaint, and one of his patients who stumbles across a ring of stones that seem to shift in shape and be the location for a portal whereby some evil, alien creature is breaking through the fabric of society, which can apparently only be kept in place by very precise obsessive-compulsive disorder-related behaviour. This compulsion (ultimately leading to suicide in each case) passes from the anonymous 'N' to first the therapist and then his sister. We basically have a blend of some interesting narrative contingency threads (how can people live with the limits of OCD) with a fairly predictable and extremely-drawn out meetings with stones that appear to move and a snake-like creature that emerges between the stones. However, unlike the novel *The Curious Incident of the Dog in the Night Time* (Mark Haddon, 2003), the exploration of compulsive behaviour in counting, touching and placing, has no driving narrative around it, just repetition to the fateful spot (in all, we follow characters visiting Ackerman's Field four times). The returning to the point of danger, like a poorly-lit basement, is such a cliché, even within the *Scary Movie* cycle (Keenan Ivory Wayans; I [2000] and II [2001], and David Zucker; III [2003] and IV [2006], that it seems strange that King uncritically embraces, claiming, 'Can you think of a single successful scary story that doesn't contain the idea of going back to what we hate and loathe?'[12]

Where it is innovative is not just in the size of the screen on which it is viewed or its viewing platform, but its duration and timing of release, as it was first transmitted in 25 bite-sized 90 second episodes before being released in a print form. With commercials and titles, each episode is closer to two minutes, i.e. each unit is filled with approximately one quarter advertising (close to ratios on network television). Its release pattern, one episode daily, also means that the very initial consumption experience was a little like a radio play with a cliffhanger.

The reasons for choosing this particular narrative for such a dual-media experiment are a little unclear. Perhaps the brutally-brief and mysterious title elicits audience curiosity, and the limited range of camera movement required, and the descriptions of sunset over the river, and Ackerman's Field lend themselves to animation in depicting a shadowy, horrific vision. However, the size of screen seems a drawback when considering the epic elements of the story – the place of horror is confined to one area but it is a relatively large one. Trying to frame a circle of stones, which appears to shift between seven and eight stones, feels a little like trying to fit everyone into a group photo.

The notion of a media text 'infecting' its viewer is interesting but explored more specifically in *The Ring* (in both Hideo Nakata's 1998 version and Gore Verbinski's 2002 remakes). What is perhaps more original here is the linkage of OCD symptoms, repeated viewing and audience-reception notions that the audience is necessary for a film to 'exist' (touching slightly on Berkeleyian notions of a tree falling in a forest only 'existing' if heard by someone or the similar Schröndinger's Cat conundrum). 'N' believes not only that he must secure the stone circle by ritual behaviour but that it was his act of viewing that somehow activated the evil presence in the first place. The artwork and a couple of quick cuts of Stonehenge imply that a similar purpose lies behind other mysterious stone circles, i.e. as a means to keep dark forces at bay (a feature not spelled out in the print version).

'N' was released in July 2008 shortly before *Just After Sunset* in November of that year, effectively acting as a teaser trailer for the book. DVD copies of 'N' were subsequently sold with special copies of the book, i.e. it becomes just another marketing and merchandizing tool. Editing choices, such as the jump cuts on N's folder or the more rapid cutting when N tries to back away out of the field, attempt to disguise the essentially static nature of the narrative. The relatively-restricted movement within the frame is a likely constriction of the budget and more precisely, the target screen size (mobile phones). As mobile screens develop, with devices such as the Apple iPad, there will almost certainly be a growth in similar experiments.

'You hope for Milky Ways; you settle for Skittles'
(Jon Bruno as Stephen King in *Monkeybone*)

The slasher film, and a very sanitized version at that, seems to be the generic default setting for these adaptations, not just in the *Corn* series but in the *Sometimes They Come Back* group. Original concepts with some notional generic ties to ghost or monster movie, slide into

what Robin Wood terms the 'teenie kill pic'. Even so, they are interesting for how blatantly derivative they are, often almost lifting whole plots from earlier films, such as the third *Sometimes* film, which feels almost like a parody of John Carpenter's *The Thing*. From its transgressive roots in the late seventies and early eighties, the slasher films discussed in this book (and also those with vampiric and zombie narrative elements) feel like mainstream, sanitized versions in which the main pleasure is spotting references, sometimes subtle, often not, to films with a stronger generic footprint. It is as if the narratives are drawn to a more contemporary manifestation but cannot break free of their generic roots. It seems the pull of closed knowledge narratives with experts who can solve problems and provide some closure at the end, is just too great to abandon.

Since many King plots involve outside forces, their capabilities are not limited by human science (although they still need to be clear and consistent), so in theory the nature of narrative disruption should be more flexible and open to a little more creativity. However,

Tudor distinguishes between two worlds of horror in the genre's evolution from 'secure' to 'paranoid' and King's adaptations most definitely belong to the former category, a world 'which is ultimately subject to successful human intervention'.[13] In this world, scientific knowledge may contribute to the problem but also to the solution and the oppositional qualities, which have been upset by the release of disruptive forces (such as normal/abnormal and secular/supernatural) are easily defined and ultimately and clearly redefined. Even the bleakness at the end of *The Mist* represents a *personal* tragedy, not necessarily a universal one – as the trucks rumble past David, we see humanity has survived.

Although ghosts or even vampires are in some sense human in theory, in these adaptations, there is no attempt to give them significant sentience, no attempt to humanize them – there are merely narrative ciphers to generate plot development. In terms of characters, there is a clear division between characters who are good or bad, knowledgeable or not, and likely victims or not. Watching such films becomes a consoling experience, rarely questioning film form (with rare exceptions like *It* or 'Umney's Last Case') so that following dominant modes of representation, we are placed in the best position to see everything and are secure in our own viewing position, not implicated by problematic theories of the gaze (such as a potential masochistic male viewer) as explored by theorists like Carol Clover.

Jeffrey Sconce discusses a relatively-new tendency in television dramas, what he terms 'world-building' in which programmes generate (and sometimes almost demand) an increased level of engagement with a fictional world in order to fully understand it, prompting dedicated fan-sites, fan fiction, and the whole paraphernalia of fan events (in connection with series such as s *Twin Peaks* or *The Sopranos* and particularly, the various manifestations of *Star Trek*).[14] Indeed, some narratives like *Buffy* (prompting the development of the eponymous Buffy Studies at some higher education institutions) became so complex over time that they explicitly excluded the uninitiated or uncommitted, creating the kind of niche viewing that has become termed 'narrowcasting'. This has given rise to whole viral communities, such as the 'Buffyverse'. By contrast, it might be said that King adaptations operate in a counter-direction, explicitly *not* expecting those kinds of reading strategies. No prior knowledge is

required, key details are repeated and character development minimal, which theoretically delivers a large audience but does so at the expense of narrative innovation.

Sconce traces the tendency for narrative experimentation, particularly in discrete self-aware, conjectural fantasy, in comics and even in series such as *The X-Files*.[15] It seems that King aspires to the unsettling nature of conjectural fantasy (Milky Way) but actually in televisual form only delivers the pleasures of cumulative serial drama (Skittles). In theory, King's televisual narratives are sequential but often they seem more cumulative, creating a more seamless blend with the commercials that permeate them. Whether we accept Paul L. Klein's cynical (or perhaps realistic) view of television producing the 'least objectionable program' in a steady stream of inoffensive, bland product, there does seem to be a 'flattening effect' on King's work. Adaptations can offer the appearance of slightly risqué entertainment, playing up expectations and generic associations that King still has (partly at his own orchestration) with the horror genre, which the reality of his narratives even in book form, rarely deliver.

As figures like Jane Feuer have argued, identifying genre is a key part of audience pleasure but in the case of King, he has had such a dominance in literary and adapted drama, that he has evolved into his own genre – 'the Stephen King adaptation'.[16] Since large numbers of viewers will have some experience of reading a King text and probably even greater numbers will have seen at least one adaptation (whether they are aware of it or not), there is no longer any need to explain what the brand represents (in marketing terms at least). Audiences associate his name with connotations of horror and the unexpected certainly but perhaps more importantly, the fulfilment of a viewing expectation (demonstrated in a circular logic by the longevity of his writing career and the continued process of adaptation and even re-adaptation of his works).

Even within a context of fragmenting broadcasting (perhaps especially so, then), according to Ellis, 'Broadcast TV retains a special place within the social discourse of the nation', although this may only manifest itself at times of major emergency, a sports event like the Superbowl or a rare occasion like a royal wedding.[17] A Stephen King adaptation expresses the enduring, but much-threatened possibility of a large number of people sharing a communal experience. It is unlikely to produce any 'water-cooler' moments but by *not* striving for niche-markets, it speaks to mainstream Middle America. In an age of multiple viewing platforms and ever-greater market segmentation, viewing a Stephen King adaptation on television allows viewers to participate in the experience/illusion of a shared culture, a shared literary and televisual culture in a way perhaps parallel to the experience of British viewers in relation to BBC costume dramas. No other modern writer has been so widely-read or frequently adapted. In that sense, his adaptations play a number of functions that John Fiske and John Hartley refer to in their concept of 'bardic television'.[18] Such programmes share a cultural consensus, examining individual cultural practices but ultimately affirming dominant value systems, thereby reinforcing a sense of communal identity and sense of belonging. Difference, the state of being alien, is seen as threatening and needs to be destroyed or repelled to defend the dominant culture. The programmes may dramatize a

lingering belief in the possible existence of supernatural/superhuman entities but they also show the limits (and possibly even culpability) of science, recourse to an explicitly Christian God (especially in apocalyptic narratives) and the ultimate vanquishing of the non-human force (albeit at a price, sometimes heavy), all of which reinforces the dominant culture.

As discussed in *Stephen King on the Big Screen*, political subtext in King adaptations is routinely removed (such as in *Hearts in Atlantis*). This holds up a mirror to contemporary American society, which seems to want its televisual drama to be 'politics-lite' (unless it addresses such subject matter explicitly in its content), to include some jeopardy but to restore order by the close of the narrative. The consideration of American society's passivity in the face of evil, present in the novels of *Salem's Lot* and *Needful Things*, is largely lost in adaptation in a pursuit of narrative action. As David L. Scruton observes, 'fear is a social act which occurs within a cultural matrix'.[19] If you remove the social and political context for a narrative, you also remove its capacity to evoke fear.

In effect, we are offered stripped-down versions of existing generic classics, either of film or literature, rendered more appealing for prime-time television by placing them in an American setting. *Salem's Lot* gives us Dracula in small-town New England, *Sometimes They Come Back* gives us the return of Banquo's ghost but without a hero of tragic depth like Macbeth and *Needful Things* is *The Exorcist* by way of *The Witches of Eastwick* in which the devil becomes an antiques dealer (a profession also used in the *Salem's Lot*). *Sometimes they Come Back Again* is a mainstream version of *The Thing* and *Kingdom Hospital* attempts to Americanize the Scandinavian eccentricity of *Riget*. Even *It* could be seen as a sanitized version of underground, cultish 'trash' clown horror, a subgenre all of its own.[20] Rather than the overt sexual perversity of Dr Frank-N-Furter from *The Rocky Horror Show*, Tim Curry's Pennywise gives us sugar-coated sexual ambiguity, especially denoted by the changeable tone of menace in Curry's voice and the ambiguity in the language itself (repeating first to Georgie and later to Audra, with increasing menace, 'Do you want it?') Like Jack Nicholson's Joker in *Batman* (Tim Burton, 1989), we identify with a charismatic, face-painted monster who transgresses moral codes but, like Ron Perlman's Collie Etragian in *Desperation*, is more interesting cinematically than any force for good with whom they are juxtaposed, having as they do all the best lines and being given free rein to deliver them with camp panache.

King-related material is now seen as a mark of quality drama for a mass audience but is only likely to get made and shown if audiences do not find it too disturbing. As Ben in *Salem's Lot* (2004) tells us, the majority, excluded from access to medical help, 'self-medicate with alcohol and televsion'. In *Needful Things* for example, the supernatural is toned down until it is the minor characters who act in an immoral but human fashion rather than much display of supernatural powers. Language is made polite rather than profane, violence suggested, cut or airbrushed rather than shown directly, the devil driven out of the village at no personal sacrifice to the hero, and the 'exorcism' is performed by the community coming together to reject the psychic bully rather than needing a priest in a test of religious faith.

So wherein lie the pleasures of a King televisual narrative? Perhaps viewers might hope for the occasional 'Milky Way', like *It*, a programme somehow smuggled past censorious

bodies that breaches broadcasting taboos (here conventions about violence threatened upon children), has innovative, transgressive monsters, a preparedness to stretch notions of borderline states and delivers a tightly-written seven-act structure with regular narrative climaxes. More commonly, the adaptations offer 'Skittles', entertainment that does not need specialized knowledge of either the book upon which the narrative is based or of a particular set of filmic codes in which the story functions. Apart from *It* and the confusions of *Riding the Bullet*, there are few examples of flashbacks, split screens, or any obvious device to subvert chronology. Simultaneous action or any ambiguity about whether actions actually took place or not – these play little part in these adaptations. Most narratives are closed, evil is vanquished and human life returns to a sense of normality, perhaps with a greater sense of what lies beyond the everyday but not with any sense of living their lives any differently. *Kingdom Hospital* is a unique exception in King televisual adaptations in its use of stand-alone narratives that operate within some small movement of plot from episode to episode, within a larger developmental arc.

Fiske refers to a notion he developed in collaboration with Hartley, which they describe as 'clawback', 'a process by which potentially disrupting events are mediated into the dominant value system without losing their authenticity'.[21] Although they are referring to news programmes and the use of the term 'authenticity' is fairly subjective, a similar process might be said to occur with Stephen King adaptations. The actions that we see beyond human abilities are always attributable to the powers that superhumans/extra-terrestrials have. There is not a single example in this book where an action occurs that cannot be categorized by the catch-all explanation of 'supernatural abilities', in the sense of beyond human knowledge, which are rarely questioned or fully explained. So, people return from the dead, vampires appear in small towns and ghosts appear in old houses, causing shock and possibly bloodshed but little serious debate about the possibility of such events. The films discussed in this book have very little sexual content (which is often in discrete episodes that can be toned down or cut, as in *The Mist* and *The Stand*) and appear to offer the pleasures of generic transgression but actually deliver fairly tame narratives that operate almost exclusively within generic bounds, i.e. ideal material for network television. Although King is fond of referring to Poe and tales such as 'The Premature Burial', like the two versions of *The Vanishing* (1988 and 1993), both directed by George Sluizer, television adaptations of King routinely adopt the choices made in the latter with rescue, escape, evil destroyed, and complete narrative closure rather than the original which terrifyingly, closes absolutely open-endedly, providing no solace for the viewer.[22]

King seems 'fireproof' in that despite poor critical reviews for films or books, neither seem to damage his commercial clout. Having diversified his product beyond one particular generic strand and by shifting away from the margins and into the mainstream in terms of censorious content, King can withstand shifts in public tastes and the rise and fall in popularity of any specific genre or director. At the same time, King's literary works have been absorbed increasingly into the US mainstream. Some American libraries continue to ban certain books but his works are often seen as the standard, possibly even representing 'the

literary Establishment' against which younger writers may be tempted to rebel rather than emulate. Similarly in terms of film, a Stephen King adapted horror narrative may seem quite alien to a viewer of *Saw* (James Wan, 2004) or *Hostel* (Eli Roth, 2005) and their numerous sequels, who seem drawn to more explicit and sadistic plotlines, based around time-based problem-solving, with a gruesome fate the result of failure, or the low-budget shocks of surveillance footage in *Paranormal Activity* (Oren Peli, 2007–09). In the specific case of the *Saw* series, there is also a developing sense of sequential 'flow' within the films themselves, so that the hero of *Saw II* (Darren Lynn Bousman, 2005), Detective Eric Matthews (Donnie Wahlberg), is captured and then becomes the first victim of Bousman's sequel *Saw III* (2006). However, at the same time, strangely moving in a contrary direction, far from the Barlow of *Salem's Lot* (1979) – a focus of fear and dread, vampires are currently portrayed as teen idols in the *Twilight* franchise. This is not a new tendency and can be traced back to the *Buffy the Vampire Slayer* series (Joss Whedon, WB Television Network, 1997–2003) and the *Interview With a Vampire* (both Anne Rice's 1976 novel and Neil Jordan's 1994 film). However, as audiences and cultures shift, interest in King's earlier work may well diminish, casting him as neither cutting edge nor particularly fashionable with younger audiences but popular none-the-less with TV producers who can use his brand name to provide an apparent commitment to quality programming and deliver a predictably substantial, older audience.

Notes

1. Zadie Smith, *The Autograph Man* (London: Penguin, 2003), p. 306.
2. Stephen King, 'Talking with Stephen King', *Time*, at www.time.com/time/arts/article/0,8599, 1687229,00.html, 2007. Accessed 23 November 2007.
3. Timothy Corrigan, *A Cinema Without Walls* (London: Rutgers University Press, 1991), p. 108.
4. Stephen King cited in Tony Magistrale, *The Hollywood Stephen King* (New York: Palgrave Macmillan, 2003) p. 15.
5. Stephen King, *Duma Key* (London, Hodder and Stoughton, 2008), p. 170.
6. Ibid., p. 494.
7. Shirley Jackson, *The Haunting of Hill House* (New York; London: Penguin, 1959), p. 246.
8. Stephen King, *Duma Key*, op.cit.,p. 181.
9. Stephen King, *Storm of the Century* (New York; London: Pocket Books, 1999), p. x.
10. Stephen King, *Duma Key*, op. cit., p. 440.
11. Stephen King, *Just After Sunset* (New York; London: Pocket Books, 2008), p. 531n.
12. Ibid., p. 535n.
13. Andrew Tudor, *Monsters and Mad Scientists: A Cultural History of the Horror Film* (Cambridge Massachusetts: Basil Blackwell Inc., 1989), p. 103.
14. Jeffrey Sconce, 'What If?', in *Television After TV: Essays on a Medium in Transition*, Lynn Spigel and Jan Olsson (eds.) (Durham, North Carolina: Duke University Press, 2004), pp. 93–112.
15. By contrast, King's *Dark Tower* series do excite this precise interest, with a plethora of graphic novel publishing, possibly because they have not yet been visualized on the big or small screen.

16. See Jane Feuer, 'Genre study and television', in Robert C. Allen (ed.), *Channels of Discourse, Reassembled: Television and Contemporary Criticism* (London: Routledge, 1992), pp. 138–59.
17. Ellis, op. cit., p. 282.
18. John Fiske and John Hartley, cited in John Fiske's *Introduction to Communication Studies* (New York; London: Routledge, 1990), pp. 75–76.
19. David L. Scruton, 'The Anthropology of an Emotion', in David L. Scruton (ed.), *Sociophobics: The Anthropology of Fear* (Boulder and London, 1986), p. 10.
20. See *Clownhouse* (Victor Salva, 1988), *The Clown Murders* (Martyn Burke, 1976), *Out of the Dark* (Michael Schroeder, 1989), *Funland* (Michael A. Simpson, 1987) or *Funhouse* (Tobe Hooper, 1981).
21. John Fiske, *Television Culture* (New York; London: Routledge, 1988), p. 236.
22. See Stephen King, *Just After Sunset*, op. cit. p. 538n.

References

Allen, Robert C., (ed.) (1992), *Channels of Discourse Reassembled: Television and Contemporary Criticism*, London; New York: Routledge.

Allen, Robert and Annette Hill (eds.) (2004), *The TV Studies Reader*, London; New York: Routledge.

Auerbach, Nina (1995), *Our Vampires, Ourselves*, Chicago: University of Chicago.

Beahm, George, (ed.) (1991), *Stephen King Companion*, London; Sydney: Futura Publications.

Beahm, George, (ed.) (1999), *Stephen King From A to Z: An Encyclopedia of his Life and Work*, Sydney: HarperCollins.

Browne, Nick, (ed.) (1994), *American Television: New Directions in History and Theory*, Studies in Film and Video, New York; London: Routledge.

Browning, Mark (2009), *Stephen King on the Big Screen*, Bristol: Intellect Books.

Clover, Carol J. (1992), *Men, Women and Chainsaws: Gender in the Modern Horror Film*, London: BFI.

Cawelti, John G. (1975), *The Six-gun Mystique*, Bowling Green: Bowling Green University Popular Press.

Collings, Michael (1986), *The Films of Stephen King*, Washington: Starmont House.

Conner, Jeff (1987), *Stephen King Goes to Hollywood*, New York: NAL.

Corrigan, Timothy (1991), *A Cinema Without Walls*, London: Rutgers University Press.

Coupland, Douglas (2008), *The Gum Thief*, London: Bloomsbury.

Darabont, Frank (1996), *The Shawshank Redemption: The Shooting Script*, New York: Newmarket Press.

Dery, Mark (1999), *The Pyrotechnic Insanitarium: American Culture on the Brink*, New York: Grove/Atlantic.

Dika, Vera (1990), *Games of Terror: Halloween, Friday the 13th and the Films of the Stalker Cycle*, Rutherford, New Jersey: Fairleigh Dickinson University Press.

Ellis, John (1992[1982]), *Visible Fictions: Cinema, Television, Video: Revised Edition*, New York; London: Routledge.

Ellis, John (2000) *Seeing Things: Television in the Age of Uncertainty*, New York; London: I.B. Taurus.

Fiske, John (1988), *Television Culture*, New York; London: Routledge.

Fiske, John (1990), *Introduction to Communication Studies*, New York; London: Routledge.

Fiske, John and Hartley, John (1978), *Reading Television*, London: Methuen.

Haldane, J.B.S. (1927), *Possible Worlds and Others Essays*, London: Chatto & Windus.

Herron, Don (ed.) (1988), *Reign of Fear: The Fiction and the Films of Stephen King*, Novato, California: Underwood-Miller.

Jackson, Shirley (1959), *The Haunting of Hill House*, New York; London: Penguin.

Johnson-Smith, Jan (2004), *American Science Fiction TV: Star Trek, Stargate and Beyond*, New York: I.B. Taurus & Co Ltd.

Jones, Stephen (2002), *Stephen Jones' Creepshows: The Illustrated Stephen King Movie Guide*, New York: Billboard Books.

Kaplan, Ann E., (ed.) (1983), *Regarding Television*, Santa Barbara, CA: Greenwood Press.

King, Stephen (1975), *Salem's Lot*, New York: New American Library.

King, Stephen (1978), *Night Shift*, New York: Doubleday.

King, Stephen (1978a), *The Stand*, New York: Doubleday.

King, Stephen (1981), *Danse Macabre*, New York: Berkeley Publishing.

King, Stephen (1985), *Skeleton Crew*, London: Futura Publications.

King, Stephen (1987), *It*, New York: Viking.

King, Stephen (1993), *Nightmares and Dreamscapes*, London: Hodder and Stoughton.

King, Stephen (1994), *Four Past Midnight*, New York: Viking.

King, Stephen (1996), *The Green Mile*, New York: New American Library.

King, Stephen (1999), *Storm of the Century*, New York; London: Pocket Books.

King, Stephen (2002), *Everything's Eventual*, London: Hodder and Stoughton.

King, Stephen (2002a), *From a Buick 8*, New York: Scribner.

King, Stephen (2006), *Cell*, London: Hodder and Stoughton.

King, Stephen (2006a), *Lisey's Story*, London: Hodder and Stoughton.

King, Stephen (2008), *Just After Sunset*, New York; London: Pocket Books.

King, Stephen (2008a), *Duma Key*, London: Hodder and Stoughton.

Lloyd, Ann (1993), *The Films of Stephen King*, New York: St.Martin's Press.

Magistrale, Tony (2003), *Hollywood's Stephen King*, New York: Palgrave Macmillan.

McCarty, John (1981), *Splatter Movies*, New York: St. Martin's Press.

Mittell, Jason (2009), *Television and American Culture*, Oxford: Oxford University Press.

Mittell, Jason (2004), *Genre and Television: From Cop Shows to Cartoons in American Culture*, New York; London: Routledge.

Monaco, James (2000), *How to Read a Film: The World of Movies, Media, Multimedia*, Oxford: Oxford University Press.

Schatz, Thomas (2004), 'Film Genre and Genre Film', in L. Braudy and M. Cohen (eds.), *Film Theory and Criticism*, New York: Oxford University Press, pp. 691–702.

Sconce, Jeffrey (2004), 'What If?', in *Television After TV: Essays on a Medium in Transition*, Lynn Spigel and Jan Olsson (eds.), Durham, North Carolina: Duke University Press, pp. 93–112.

Scruton, David L. (ed.) (1986), *Sociophobics: The Anthropology of Fear*, Boulder and London.

Silver, Alan and James Ursini (2004), *The Vampire Film: From Nosferatu to Bram Stoker's Dracula*, London: Limehouse Editions.

Sobchack, Vivian (1997), *Screening Space*, London: Rutgers University Press.

Smith, Zadie (2003), *The Autograph Man*, London: Penguin.

Tudor, Andrew (1989), *Monsters and Mad Scientists: A Cultural History of the Horror Movie*, Oxford: Blackwell.

Tzvetan Todorov (1975), *The Fantastic: A Structural Approach to a Literary Genre* (trans. Richard Howard), Ithaca, New York: Cornell University Press.

Williams, Raymond (2003 [1974]), *Television: Technology and Cultural Form*, Routledge, 3rd edition; originally published by Fontana, London, pp. 77–121.

Wood, Robin (1979), 'An Introduction to the American Horror Film', in Andrew Britton, Richard Lippe, Tony Williams and Robin Wood (eds.), *The American Nightmare: Essays on the Horror Film*, Toronto: Festival of Festivals.

Wood, Robin (1983), 'Beauty Bests the Beast', *American Film*, 8:10, pp. 63–65.

Wright, Will (1977[1975]), *Six-guns and Society: A Structural Study of the Western*, Berkeley: University of California Press.